Portfolio for Fashion Designers

Kathryn Hagen
Woodbury University

Julie Hollinger
Design Mentor at Woodbury University

PEARSON

Boston Columbus Indianapolis New York San Francisco Upper Saddle River
Amsterdam Cape Town Dubai London Madrid Milan Munich Paris Montreal Toronto
Delhi Mexico City Sao Paulo Sydney Hong Kong Seoul Singapore Taipei Tokyo

Editorial Director: Vernon Anthony
Acquisitions Editor: Sara Eilert
Associate Editor: Laura Weaver
Editorial Assistant: Doug Greive
Director of Marketing: David Gesell
Executive Marketing Manager: Harper Coles
Senior Marketing Coordinator: Alicia Wozniak
Marketing Assistant: Les Roberts
Project Manager: Alicia Ritchey
Associate Managing Editor: Alexandrina Benedicto Wolf

Operations Specialist: Deidra Skahill
Cover Designer: Bruce Kenselaar
Cover Image: Hawa Stwodah
Full-Service Project Management: Linda Zuk,
　Wordcraft, LLC
Composition: Aptara
Printer/Binder: Courier/Kendallville
Cover Printer: Lehigh Phoenix Color/Hagerstown
Text Font: 10 point Helvetica Neue Light

Credits and acknowledgments borrowed from other sources and reproduced, with permission, in this textbook appear on the appropriate page within the text. Unless otherwise stated, all artwork has been provided by the author.

Library of Congress Cataloging-in-Publication Data

Hagen, Kathryn.
　Portfolio for fashion designers / Kathryn Hagen, Woodbury University, Julie Hollinger, Design Mentor at Woodbury University. —1 [edition].
　　pages cm
　ISBN 0-13-502047-6 (978-0-13-502047-0)　1. Fashion drawing.　2. Fashion design—Marketing.
3. Employment portfolios.　I. Hollinger, Julie.　II. Title.
　TT509.H18 2013
　746.9'2—dc23　　　　　　　　　　　　　　　　2012006932

10 9 8 7 6 5 4 3 2 1

ISBN 10:　　0-13-502047-6
ISBN 13: 978-0-13-502047-0

*To hard-working fashion students all over the globe
and to fashion itself, which is their universal language.*

Fashion is the attempt to realize art in living forms and social intercourse.
—*Francis Bacon*

Contents

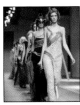

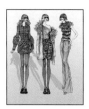

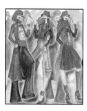

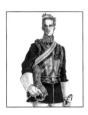

Chapter 10 Additional Categories 286

Chapter 11 Getting and Keeping the Job 316

Portfolio by Julie Hollinger

Index

Preface

Most people who have not been through a rigorous fashion design program would be very surprised at how complex and difficult it is to train for a career in this exciting but highly competitive field. For those who have survived three or four years of technical and creative demands, stress, deadlines, critiques, and sleep deprivation, finishing successfully is an enormous accomplishment. The ideal culmination of that sustained effort is the creation of a design portfolio that showcases the student's personality, creative vision, and strongest skills.

It is probably fair to say that those of you who will soon graduate from such a program are generally tired, busy, and stressed. Garments must be built, fashion shows planned, papers written, and so on. Even though you know it's important, your portfolio may end up a lower priority on your lengthy list of tasks. The tendency in this situation is to rush into the process and try to throw something together at odd moments, with little continuity of thought or planning, or to procrastinate until it is too late to do a good job.

This text is designed to save you from both of those unfortunate options. If you follow the steps laid out in these chapters, you will maximize your strengths and have an excellent chance of producing a portfolio that will open up doors to jobs and success. Of course your ultimate success also depends on your talent and work ethic. But, as instructors who have seen many young designers transition to the work world, we believe there is a niche for anyone who has good training and a passion for design. So follow along, work diligently, and take this process literally step by step and you'll be able to create a portfolio to be proud of.

MyFashionKit

MyFashionKit is an online supplement that offers book-specific learning objectives and video clips to aid student learning and comprehension. Note: An access code is needed for this supplement. Students can purchase an access code bundled with their book in their bookstore or at **www.myfashionkit.com** with a credit card.

Instructor Resource Center

To access supplementary materials online, instructors need to request an instructor access code. Go to **www.pearsonhighered.com/irc**, where you can register for an instructor access code. Within 48 hours after registering, you will receive a confirming e-mail, including an instructor access code. Once you have received your code, go to the site and log on for full instructions on downloading the materials you wish to use.

Acknowledgments

We'd like to thank our editor, Sarah Eilert, for her continuing support of our projects, as well as her encouragement, advice, and patience throughout this process.

Grateful thanks to our new associate editor, Laura Weaver, whose extreme zen patience and kind encouragement in guiding us through so many fine details entitles her to a medal of editorial valor!

The contributions of our editorial and production staff are greatly appreciated: Alicia Ritchey, Linda Zuk, and Janet Portisch, for their patient and effective oversight of this rather complex and lengthy project; and Becky Bobb for her fine editorial work.

Thank you, as always, to Vern Anthony and Pearson for supporting us financially and creatively in all our projects.

We are grateful to the following reviewers for their comments and suggestions: Veena Chattaraman of Auburn University, Hanna Hall of Kent State University, Cynthia Istook of North Carolina State University, Kathy Smith of University of Arkansas, and Sharon Smith of International Academy of Design & Technology.

A special, huge thank-you to all of our talented and generous former students, who are now amazing designers in the field, and who graciously allowed us to use their exciting work in this book. Your talent will inspire future designers and you also make us very proud!

Finally, on a very personal note, Kathryn would like to express her deep gratitude to her loving fiancé, John Charles Love, for his sound advice and endless support and tolerance of the ongoing and demanding book process. Julie extends her heartfelt appreciation to her loving and supportive family.

Portfolio for Fashion Designers

Chapter 1
The Big Picture

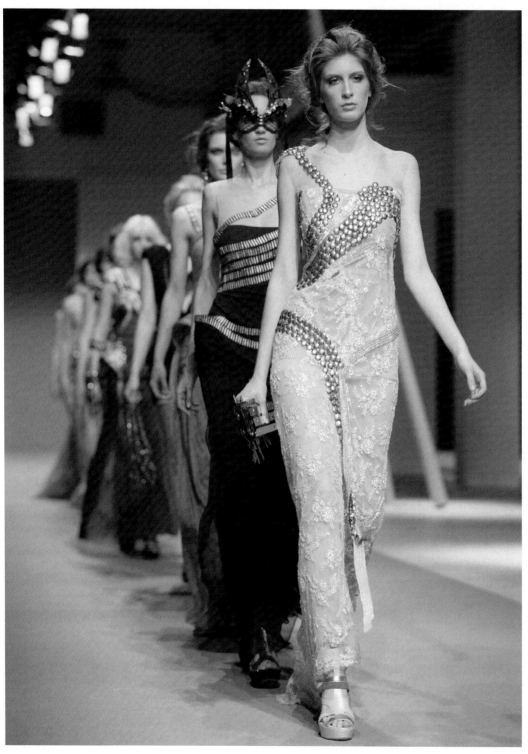

© Gordana Sermek / Shutterstock.com

Now is the most exciting time in fashion.
Women are controlling their destiny,
the consumer is more knowledgeable,
and I have to be better every single day.

—Oscar de la Renta

The Big Picture

Many young creative people dream of a career in fashion. Some, like you, attend design school and discover that it requires not only talent, but also hard work and a genuine passion for what they want to do. When these students graduate, finding that first design position in the competitive world of fashion is a worthwhile but challenging quest.

Some young fashionistas may be lucky and talented enough to have a position before they even graduate. They may have interned at a company that now wants to hire them. To land that first key job, however, most young designers must go through an extensive process. Identifying potential employers, setting up interviews, and writing resumes and cover letters are all generally necessary steps in the process of finding the niche that will allow you to begin your fashion career.

Central to that mission is the fashion portfolio. This book is the culmination of all the hard work and intense learning that have occupied three or four years of your life. It is also the visual representation of who you are as a designer. It gives potential employers information about you that can be both positive and negative. A well conceived portfolio can get you that great job. A poorly planned or executed portfolio can lose it. By opening this text, you have begun a carefully planned process of creating the exciting design portfolio that will help you to stand out from the crowd.

Strategic Planning: Ten Steps to Target Your Portfolio

Give me six hours to chop down a tree,
and I will spend the first four hours sharpening the axe.

—Abraham Lincoln

Although Abe Lincoln was never a designer, he did face enormous obstacles, and he understood that preparation is key to any endeavor. The Big Picture Plan that this chapter illuminates is, in a sense, the "business plan" for your book. Key information unique to you, identified through ten strategic steps, will help determine the ultimate look and content of your portfolio. By the end of this chapter, you will have written a target list that defines your key goals. Such thoughtful preparation leads to clear thinking and ultimate success.

Step One: Target Your Customer

Step Two: Consider Different Apparel Categories

Step Three: Further Define Your Muse

Step Four: Target a Specific Customer

Step Five: Target Your Dream Company

Step Six: Soul Searching

Step Seven: Identify Your Visual Influences and Strengths

Step Eight: Assess Your Designer Profiles

Step Nine: Identify Common Portfolio Pitfalls

Step Ten: Finalize Your Big Picture Plan

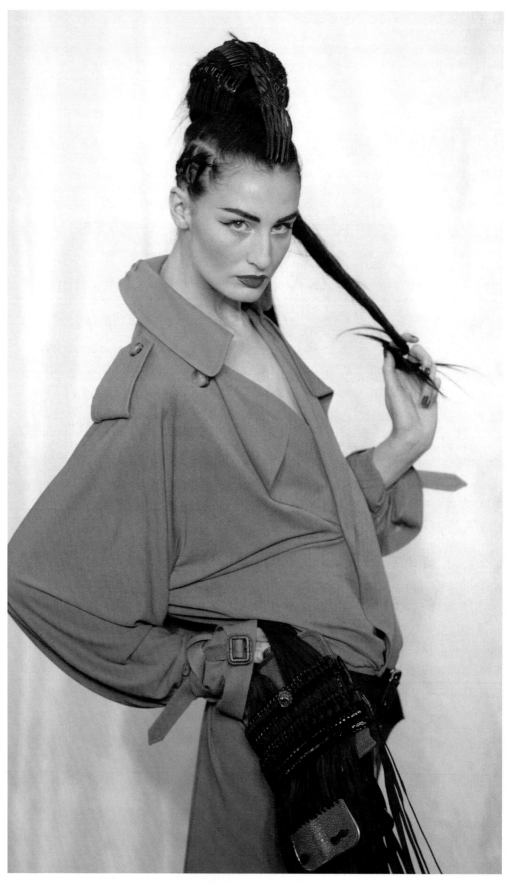

JOHN PAUL GAULTIER

Jean Paul Gaultier's bold, modern designs keep him in the forefront of fashion leaders.
© Daily Mail/Rex/Alamy

STEP ONE: Target Your Customer

Everyone has heard about designers and their special muses. Alexander McQueen had Isabella Blow, Yves St. Laurent had Loulou de la Falaise, and so on. Each of these designers had a target customer who inspired him to create wonderful collections.

But many designers are not quite that specific. Your target customer could be anyone from the cool guy in your English class to "young, hip urbanite females who like to go to clubs after work," to cuddly infants from birth to 6 months. All of these are valid targets because once you make that choice you can gear your portfolio to that specific market. So to begin the process of planning your portfolio, your first step will be to settle on a design category.

Perhaps you are already clear as to your career direction and the market you want to target. Lucky you! Other students struggle with this choice and just can't decide. But they are lucky as well, because their indecision probably means they are good at several design categories and find it hard to choose just one. If you are one of these students, you might need to consult with your professors to help determine your best choice. They will probably remember your strongest work, and be happy to steer you in the direction where you excelled.

In the next three steps, we will be looking at more subcategories and demographics, so you will probably want to go through all four steps before you finalize your target customer. Once you have chosen, you can also identify the companies that you want to interview with and gear your book toward those specific design firms.

Points to Consider

1. **Follow your passion!** You are more likely to be successful if you really love what you are doing. But also be realistic: Envision a real customer who would buy your designs and a real place (even if it is virtual) where your designs might be sold.

2. **Give it your best shot!** When targeting your portfolio, consider your biggest successes during your education. Many students enter a design program wanting to do evening gowns for the Oscars, but leave knowing they have a special talent for young men's casual separates or contemporary activewear. Don't ignore what you do well in favor of less realistic fantasies.

3. **Don't overthink it.** Your design category choice is not a decision "set in stone." You may well find yourself in five years functioning beautifully in a design category that you never considered. For example, well-known swimwear designer Rod Beattie (see Chapter 11) never considered bathing suits as a career. But when he was offered a job at La Blanca, he saw a good opportunity and went for it. Now he has industry recognition and his own label, so his adaptability paid off in a big way.

4. **Gender-confused?** Some students want to do both menswear and womenswear, but showing both in the same portfolio can be confusing for an employer. Consider completing three or four groups in one gender first, then if you have time, do two more groups for the opposite gender and another one or two when you get out of school. If you have an interview opportunity, edit your book according to the needs of that design firm. If they do both, then bring the extra groups. Doing one unisex group is also an option, but how many of these do we actually see in the stores?

5. **Location, location!** Different regions tend to specialize in specific design categories. For example, Los Angeles is known for its casual separates and streetwear, whereas New York tends more toward serious designer clothing. Manufacturers like Nike (in Portland) and Abercrombie and Fitch (in Ohio) offer less urban environments. Consider where you want to live when you make your choice.

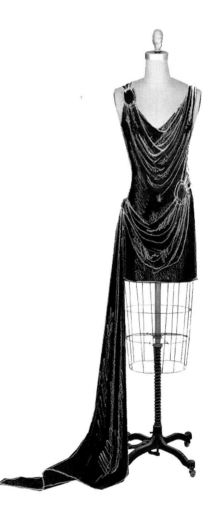

Designer: Carina Bilz

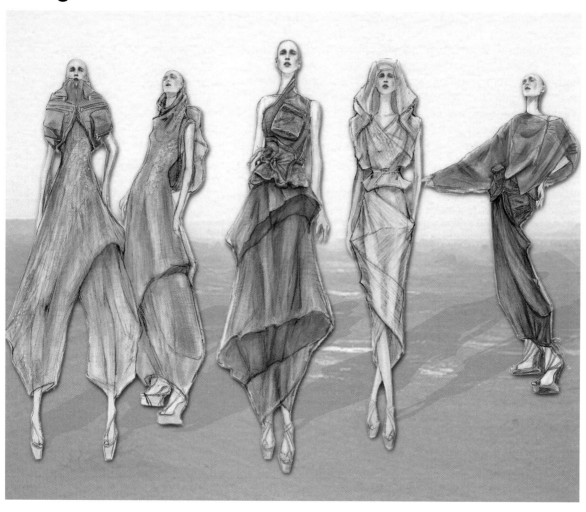

DESIGNER WOMENSWEAR

Carina designed this group under the direction of mentor Isabel Toledo in collaboration with Patagonia.

Design Categories

Haute Couture

Couture is simply a French word for fine, custom-made clothing. It is the most elite market, using extremely expensive fabrics and extensive labor, often including multiple fittings for each garment. The Haute Couture is an official organization of the most important design houses in Europe, most of which have long and prestigious histories, like Chanel or Dior. Of course, the person actually designing the collections is often a younger person carrying on the name and aesthetic of the *maison*. Karl Lagerfeld for Chanel is a perfect example of this. He does the couture line, but also has his own ready-to-wear label.

Couture Designers

Paris

Karl Lagerfeld for Chanel

John Galliano for Dior

Jean Paul Gaultier

Christian Lacroix

Balmain

Givenchy

Hanae Mori

Ralph Rucci

Valentino

Italy

Giorgio Armani

Roberto Cavalli

Dolce and Gabbana

Gianfranco Ferre

Gucci

Versace

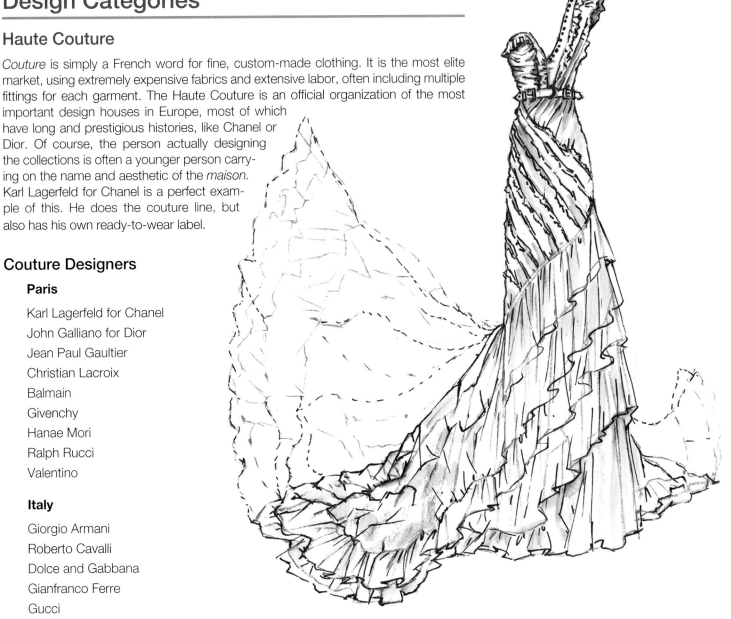

Designer

Designers in this category are generally well-known. Their customers are affluent and sophisticated rather than trendy. Quality and prices are high, and both specialty stores and designer boutiques carry their designs. You can see the collections of these key creators on Style.com and other fashion sites. Giorgio Armani, Veronique Branquinho, Miuccia Prada, Martin Margiela, Olivier Theyskens, Martine Sitbon, Donna Karan, Haider Ackermann, John Galliano, Rick Owens, Vivienne Westwood, and Yohji Yamamoto are all examples of this elite group.

Young Designer

This design category caters to a younger, more trendy, and status-conscious customer who is also affluent. The designers tend to be more hip rather than establishment. Venues are specialty stores and young designer shops in department stores. Stella McCartney, Giles Deacon, Phillip Lim, Anna Sui, Derek Lam, Junya Watanabe, Narciso Rodriguez, Rodarte, and Christophe Decarnin are prominent designers in this category.

Better Bridge

This category is geared to a wider target audience than designer clothing. The term *bridge* refers to secondary, less expensive lines of designer collections. Think DKNY or CK for Calvin Klein. These clothes are found mostly in department stores.

Contemporary

The customer for contemporary sportswear is looking for quality and current but not overly trendy silhouettes. Designer labels are not a priority, which means these clothes are more affordable. They are sold mostly in department stores or in the label's own stores. BCBG, Theory, Anthropologie, Leon Max, and Armani Exchange are good examples of contemporary lines.

Junior

The customer is young, from thirteen to possibly through college age. This category tends toward "fast fashion" as trends come and go rapidly, and quality is often secondary to the look. This age group has money and is one of the largest consumer groups. They love to shop at Forever 21, Pacific Sunwear, Abercrombie & Fitch, Old Navy, and Urban Outfitters.

Subteen

This category, often called *tweens,* has become increasingly important in recent years. Young girls ages seven to twelve are becoming more sophisticated due to their exposure to the Internet and they want to dress like their older sisters and friends. This group is extremely trendy, and again, quality is secondary. Major young-adult retailers such as Abercrombie & Fitch, Aeropostale, and American Eagle Outfitters are taking advantage of this trend by opening stores targeting these young fashionistas. dELiA*s, Hollister, and H&M are also favorite haunts of these mini-consumers.

Missy

This category is geared for a mature customer with an interest in a traditional, classic look, especially a mature business woman. The sizes are cut for a mature figure. This category is found mostly in department stores.

Plus Sizes

This is probably one of the fastest-growing categories in fashion. Demand for more fashionable clothing for larger sizes has changed this market into a more trend-conscious field. Department and specialty stores sell plus sizes, and Internet sales are also key.

Young actress Elle Fanning is a great example of a fashionable tween.
© Marka/SuperStock

Men

This category provides more sophisticated clothing for men who want good quality fabrics and detailing. Silhouettes are classic and slow to change, and can range from inexpensive business suits and weekend wear to designer clothing. Department and specialty stores are venues.

Young Men

Sportswear for younger guys features silhouettes that are fairly classic. Graphics and fabric treatments are important, but the styles can be sophisticated. The Young Men category is sold at Pacific Sunwear, Abercrombie & Fitch, Banana Republic, and Armani Exchange.

Boys

For boys ages ten to fifteen, graphics are key. Styles will be slightly less trendy than those for the older guys, and less expensive. Department stores are the primary venues.

Children

Children range in age from three to ten. Although these little people have more say these days over what they wear, parents still make the decisions, so practicality and quality have some importance. Fabrics tend to be sturdier and less expensive, but special occasion outfits can be pricier and in better fabrics. Most kid clothes are bought in discount or department stores, although there is also room for specialty stores like Baby Gap or Laura Ashley.

Toddlers

Practicality for new walkers is key in this one to three age category. Cute rules, but details need to be functional, or at least nothing they can put in their mouths. Sturdy fabrics and reasonable prices are important because their bodies change rapidly. However, some trendy, affluent parents still want their little kids to dress like miniature versions of themselves. The same stores that sell childrenswear will likely carry smaller sizes as well.

Infants

For these littlest people, clothing is soft, comfortable, and easy to get on and off. Garments are generally cute, but many savvy parents are into natural fabrics and more sophisticated styles. Gymboree and OshKosh are well-known brands, and even Burberry offers an infant line!

Young men tend to be more experimental than the more mature members of their gender. Strong graphics and bold combinations support their air of rebellion.
© K2 images/Shutterstock.com

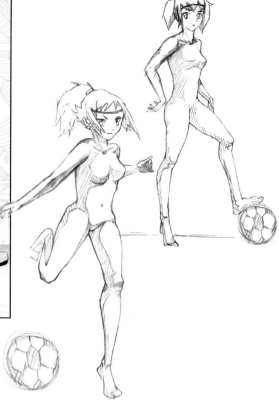

Knit panel for better
Mobility and fit

Mesh inset for
Ventilation
(with woven piping
on the sides)

Exposed elastic band
with overlaid waistband
(Stretch elastic drawcord)

Tapered bottom hem
for clean
finish with no irritation.

FABRIC: IM# ▓▓▓▓▓ HEATHERED DF OG FRENCH TERRY, ▓▓▓▓
IM# ▓▓▓▓▓ DF STRCH WOVEN (CONTRAST), ▓▓▓▓
IM# ▓▓▓▓▓ DF MESH (CONTRAST) ▓▓▓▓

Activewear Designer: Michelle Kwak

Designer Biography

Designer Michelle Kwak was born and raised in South Korea until the age of fourteen, when she moved to the US. As a fashion design student in California, she was such a stand-out that she had her first job offer before receiving her BFA in 2005. One of her first jobs was designing tennis outfits for Maria Sharapova's line. Her versatility has allowed her to expand into a variety of women's active lines, including tennis, dance, training, gym, and essentials.

Eventually the giant of all activewear called, and Michelle is now a Designer at Nike Global Running, creating both men's and women's lines.

STEP TWO: Consider Different Apparel Categories

If design involved only one kind of clothing, like dressy or casual, it might be rather dull. Fortunately, you have many design specialties to consider. These secondary categories were originally formulated at retail to allow customers to find what they wanted in a large department store. But designers may also focus on these categories exclusively. Activewear, for example, is a multibillion-dollar market with enormous global companies such as Nike and Adidas. Other categories that you might not even think of include men's furnishings or maternity wear. The design group on this page shows designer Selina Eugenio's interest in the pregnant customer, which is a growing segment in the market. More and more women are willing to invest in designer clothing when they are pregnant, and in fact often want complete maternity versions of everything they have in their closet!

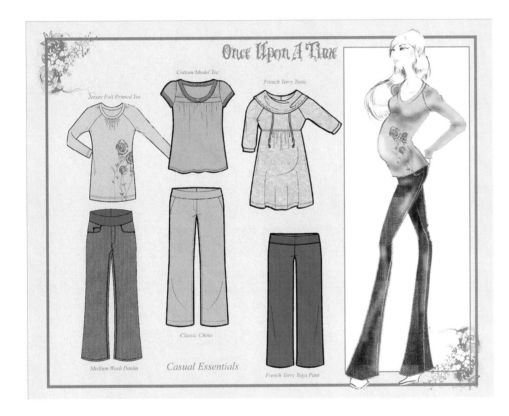

Designer: Selina Eugenio

Note the loose, fun approach to the illustration of the figure, which contrasts nicely with the very clean, precise illustrator flats. Selina made a point of turning her figure to the side so the tummy was obvious to the viewer. Since many pregnant women are fairly young, Selina kept her designs sporty and casual. The knit tops add to the comfort of the outfits.

Points to Consider

1. **Most of these subcategories will still target a wide range of customers.** Robes, for example, may be sold in a very expensive boutique, a mid-level department store, and a popular discount store like Target. The same robe company may have different lines to sell to all three price points.

2. **These secondary categories can often be broken down even further to provide more career opportunities.** *Accessories,* for example, covers a multitude of different items like shoes, hats, gloves, scarves, and so on. Major designers like Calvin Klein may have their name on multiple categories of clothing and accessories, but they are generally licensing their name to other companies who actually create the product.

3. **Target your interests!** As a young designer, you may be an avid snowboarder or love going to clubs on the weekends. These interests may pull you toward design categories that reflect your passion. Such impulses are worth paying attention to, because we generally are more successful creating something we really understand and care about. There may also be less competition in these fields than in contemporary sportswear, for example.

Menswear

Artist/Designer:
Alessandro Tomassetti

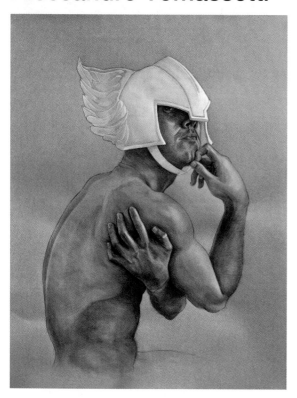

Drawing and armor design by Alessandro Tomassetti.

Although he closed his business recently to travel the world, Alessandro was creating beautiful white custom shirts for men, with orders coming online.

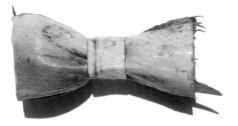

Bamboo tie by Alessandro Tomassetti.

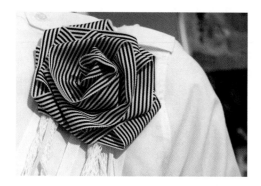

Striped boutonniere by Alessandro Tomassetti.

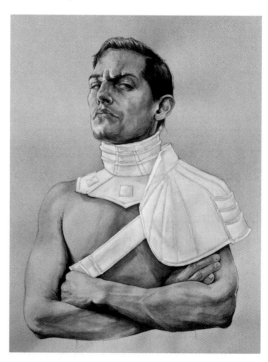

Drawing and armor design by Alessandro Tomassetti.

Divisions of Apparel

Accessories

Accessories is one of the largest categories in apparel divisions. Visit an accessory area in a large department store and you will see the numerous subdivisions that make up this specialized arena. Although accessories produced by huge companies like Gucci and Louis Vuitton have very high price tags, the latest bag or shoe often has a waiting list of buyers.

Item Categories

Belts, briefcases, gloves, handbags, iPod cases, luggage, jewelry, shoes, scarves, sunglasses, wallets, watches.

Brands

Dooney and Bourke, Framanti, Gucci, Louis Vuitton, Jantzen, Nixon Watches, Perry Ellis International, Salvatore Ferragamo Italia, and Swatch Group, to name a few.

Activewear

Categories

Cycling	Biking
Exercise	Hiking
Golf	Motorcycles
Motocross	Mountaineering
Running	Skateboarding
Skiing	Snowboarding
Swimming	Tennis
Team sports	

Brands

Nike, Asics, Adidas, Fila, Lacoste, K-Swiss, Nautica, New Balance, Organically Grown, Puma, Reebok, ShaToBu, Under Armour, Wilson.

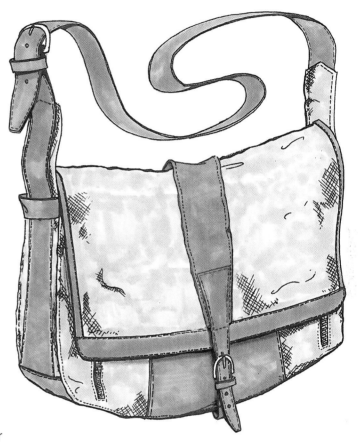

Distressed Leather Bag: Kirk Von Heifner

Blouses

Blouses (except military blouses) are for girls and women and are a more feminine version of a shirt. Innumerable wholesale blouse companies are listed on the Web. Of course, many retailers carry blouses from Express to Ann Taylor to Saks Fifth Avenue.

Bridal

Although she also designs exquisite eveningwear, Vera Wang is perhaps best known for being the first to create more "cutting-edge" bridal dresses. As wedding ceremonies have become more personal, the opportunity for brides to be more individualized is definitely the goal of the industry today.

Garment Categories

Bridal, bridesmaid, and flower girl dresses; bridal accessories.

Brands

Alfred Angelo, Ann Taylor, J. Crew, Jessica McClintock, Isaac Mizrahi, Maggie Sottero, Monique Lhuillier, Oscar de la Renta, Vera Wang, and White House Black Market. Even URBN (Urban Outfitters and Anthropologie) is getting in the game with its first bridal line, BHLDN.

Apparel Categories

Dresses

Dresses is a broad category that can include a variety of age groups. It generally refers to day dresses as opposed to cocktail or evening dresses. Two-piece dresses are also a part of this group. Lengths for skirts and dresses are: micro-mini, mini, tea length, ballerina length, full length, midi, and maxi. Every woman knows it is difficult to find the right dress for any occasion, so a good dress designer will never go hungry.

Garment Categories

A-line, empire, coat dress, jumper, maxi dress, peasant dress, shirtwaist, sheath, shift, sundress, tent dress, tunic dress, wrap dress.

Brands

Juniors: Ali and Kris, BCX, Material Girl, XOXO, Planet Gold, Rampage, Steve Madden, Trixxi. Women: Ann Taylor, Anthropologie, ABS, Calvin Klein, DKNY, Free People, Guess, Jessica Simpson, Nine West, Ralph Lauren.

Eveningwear

Many students go to design school planning to do eveningwear but end up going off on other tangents. But some passionate graduates will pursue this glamorous dream, and although the market may be a bit more limited, we have seen our talented alumni find jobs in this field.

Garment Categories

This category covers everything from red carpet gowns to cocktail wear, prom dresses, and debutante gowns.

Brands

Adriana, Papell, BCBG, Carmen Marc Valvo, David Meister, Eduardo Lucero, Monique Lhuillier, Tadashi Shoji, Jessica McClintock, JS Boutique, Isaac Mizrahi, Nicole Miller, Oscar de la Renta, Vera Wang.

Intimates (Lingerie and Loungewear)

Companies like Victoria's Secret and Agent Provocateur (Vivienne Westwood's son's company) have brought lingerie to the forefront of fashion. So popular is the trend that designers often forego the more substantial clothing and just let the lingerie carry the outfit. Loungewear is a close cousin to lingerie, as it is generally meant to only be worn around the house. This category can be very glamorous: Think Jean Harlow in the 1930s in chiffon and feathers or young and casual, like Diesel Intimates.

Garment Categories

Baby doll nighties; brassieres; bustiers, which originated as bras that extended to the waist and might include garters; camisoles; demi-bras, which cover only the lower part of the breasts; girdles; half slips; hose; panties, including briefs, bikinis, tap pants, and thongs; petticoats; sports bras; stockings; and tights.

Brands

Bare Necessities, Calvin Klein, Cosabella, Chantalle, Diesel, Gap, Hanes, Hue Hosiery, Juicy Couture, La Perla, Prima Donna, Spanx, and Victoria's Secret, to name a few.

Knits

Knits are such an important part of most people's wardrobes that we can't even imagine a time when they didn't exist. A designer who specializes in knits, especially sweaters, is probably on a productive and rewarding path.

Garment Categories

Separates, especially sweaters. Categories include hand knits, created with knitting needles, and cut-and-sew knits.

Brands

Most manufacturers produce both knits and wovens, so a list of them would be extremely long. Some companies like St. John Knits and Missoni specialize in very high-end knitwear suits and separates.

Designer: Ai Shimizu

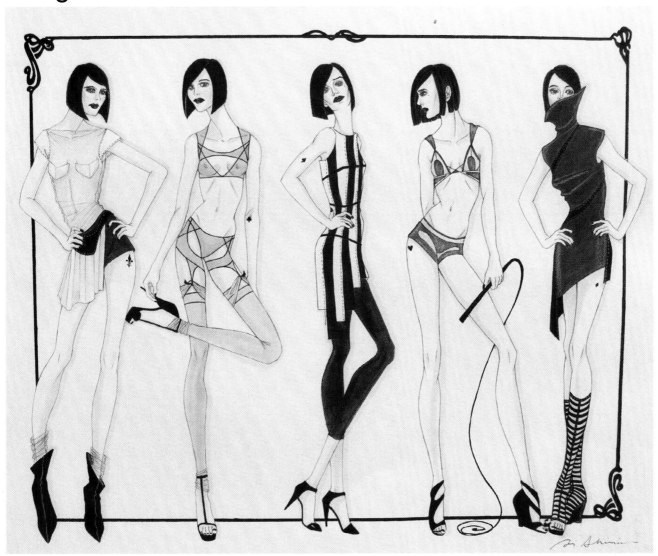

Ai is a design school graduate born in Osaka, raised in LA, and currently living in Paris who loves the precision of machine sewing and the warmth of the handmade touch. Her aesthetic is a juxtaposition of sharp tailoring and romantic flourishes and most days she can be found wandering around old bookstores and dreaming of silk. She also likes knitting, High Tea, and cloche hats.

Designer Statement

I worked at Escante for about two years, and unlike at a lot of fashion companies, I had the opportunity to draw since my boss preferred sketches to computer flats. My job was unique in that mostly everything was done over the Internet. This was the structure since my boss was in Mexico, the designers were in LA, and company headquarters was in Texas. So there was a lot of sending emails back and forth, and meetings in Texas or at trade shows like the International Lingerie Show in Vegas or the Costume Show in Houston. Once or twice a year I was sent to China to source for fabrics, trims, and lace and I would work on sketches based on what I could find there. While I was at Escante I was responsible for the main lingerie line, the sexy costumes line, a boxed lingerie line, and a corset line so there were a lot of different things going on at once but it was very rewarding to see my designs as finished products.

I did a lot of research online on lingerie blogs and the like to keep up on lingerie trends, though I find things change less dramatically season to season compared to fashion.

Designer: Lindsey Fackrell

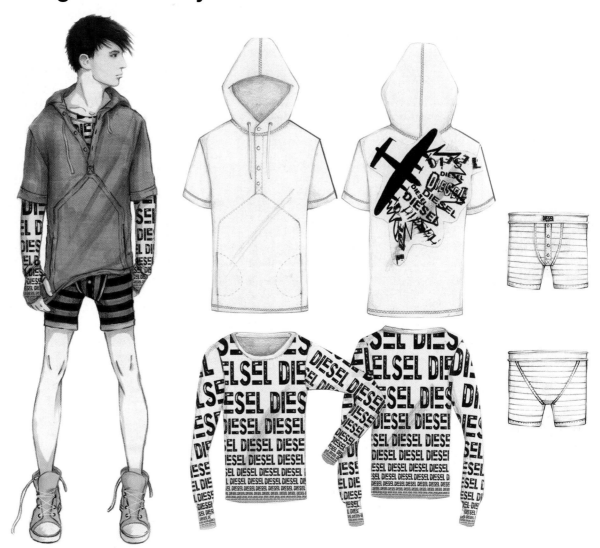

Lindsey created these fun tops and briefs as a design-school project in leisurewear with the hip company Diesel. Her customer was a young guy who likes cool graphics, layering, and knitwear comfort. Lindsey designed the graphics for the garments as well, hitting just the right note for her very contemporary muse.

Men's Furnishings

Ever since Calvin Klein put a guy in underwear on a billboard, men's undergarments have been big business. Young guys will probably look to lines like Diesel or Joe Boxer, while men probably go more for Hanes, Calvin Klein, or private-label brands in their favorite department stores.

Garment Categories

Sleeveless shirt (A-shirt, muscle shirt, singlet, tank top, wifebeater), T-shirt, undershirt, bikini, boxer briefs, boxer shorts, briefs (slip, Y-front), fundoshi, G-string, jockstrap (athletic supporter), compression shorts, thong, trunks, long underwear (long johns), socks, stockings, tabi.

Brands

2(x)ist, Abercrombie & Fitch, American Eagle, American Apparel, Andrew Christian, aussieBum, Bonds, BVD, California Muscle, Calvin Klein, C-IN2, Diesel S.p.A., DKNY, Dolce & Gabbana, Emporio Armani, Fruit of the Loom, Hanes, Hugo Boss, Jockey International, Joe Boxer, Mundo Unico, Pringle, Saxx Apparel, John Smedley's, Stanfield's, Under Armour, XTG Extreme Game.

Divisions of Apparel

Maternity

Maternity wear is big business because professional women are more willing to invest in attractive maternity outfits. Innovative companies like Pea in the Pod brought style to maternity wear, and today's customers expect to be chic, even with an expanded belly.

Garment Categories

Blouses and tops adjusted to leave room for the expanding belly, knit pants or added elastic panel, fuller-cut dresses, and nursing bras.

Brands

Blanqui, Bravado, Citizens of Humanity, Clarins, Elle MacPherson Intimates, Everly Grey, Ingrid and Isabel, J Brand, Japanese Weekend, Le Mystere, Maternal America, Michael Stars, Moody Mamas, Nom, Nuka, Olian, Paige Premium Denim, Ripe Maternity, Spanx.

Outerwear

Outerwear is essentially any garment made to be worn outdoors, and with the ever-increasing interest in outdoor activities, outerwear is another important design arena. It covers both more casual jackets worn for warmth and also more high-end fashion coats and dressy jackets. Technology plays an important part in this category as functionality is key for companies like North Face and Patagonia.

Garment Categories

Arctic jacket, anorak, or parka; baseball or football jacket; cape or cloak; down jacket; duffel coat; duster coat; field jacket; fleece jacket; flight jacket; motorcycle jacket; Mackintosh; pea coat; raincoat; trench coat; windbreaker.

Brands

Casual: American Eagle, Andrew Marc, Burberry, Burlington Coat Factory, Burton Snowboards, Columbia, Eddie Bauer, K2 Sports, Nautica, North Face, Patagonia, Pelle Pelle, Rocawear, Rugby, and Polo by Ralph Lauren.

Dressy: Aston, Austin Reed, Burberry, Cole Haan, Isaia, Joseph Abboud, John Partridge, London Fog, Marc New York, Ralph Lauren, Tibor.

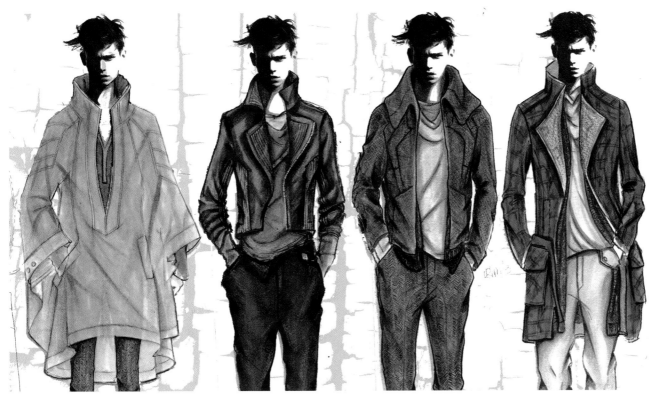

DESIGNER: RENATA MARCHAND

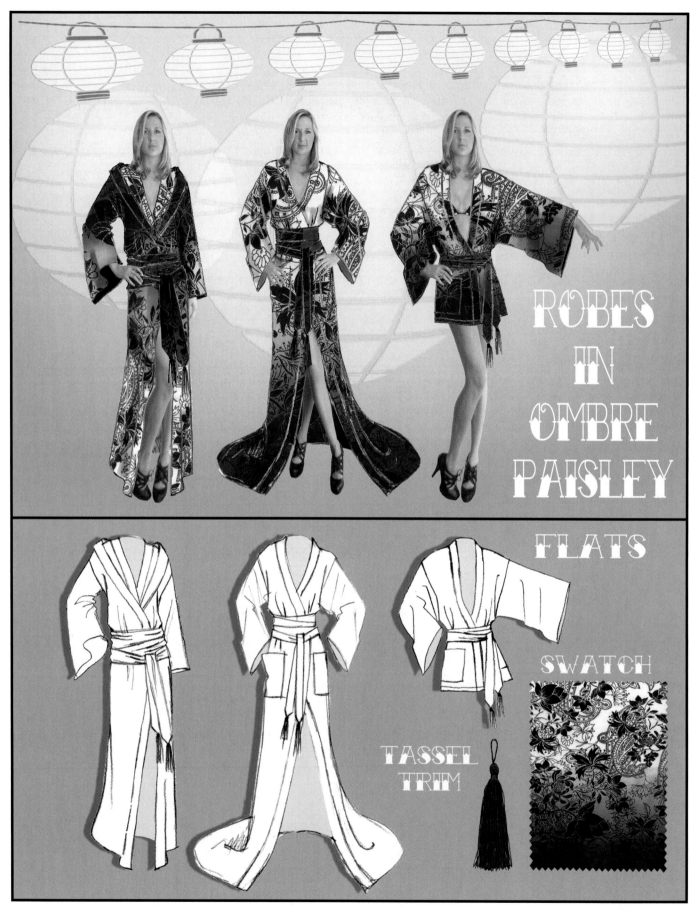

ROBES IN OMBRE PAISLEY

FLATS

SWATCH

TASSEL TRIM

DESIGNER: JULIE HOLLINGER

Divisions of Apparel

Robes and Sleepwear

According to a 2004 government survey, about half of men and women sleep in traditional garments like pajamas or nightgowns. That is a lot of customers for designers to target. The category covers a broad price range for both genders, from the nightgown or robe at Walmart or K-Mart to the luxury pajamas or robe costing many hundreds of dollars at a sleepwear boutique. This category may be combined with Loungewear.

Garment Categories

Robes: Bathrobes; spa robes, some with matching gowns or pajamas, for both genders and all age groups; peignoirs for women; and smoking jackets for men. Some robes may be unisex.

Sleepwear: Blanket sleepers (for infants), nightgowns, nightshirts, pajamas.

Brands

Brooks Brothers (velvet smoking jackets), Carters (baby robes), Flora Nikrooz, Hotel Collection, Jones New York, Lacoste, Morgan Taylor, Victoria's Secret, L.L. Bean, Nautica, Garnet Hill, Pendleton, Ralph Lauren, St. Tropez, and Tisseron.

Separates

Separates is a category of less expensive and more casual garments that mix and match. Designers who can create cool fast fashion for a good price point tend to do well financially.

Garment Categories

This category covers everything from tops to bottoms, skirts to vests, and so on.

Brands

Many private label brands like the Gap, Old Navy, and Banana Republic, and junior brands like Rampage, Juicy Couture, Aeropostale, XOXO, and Material Girl.

Shirts

Some designers specialize in shirts and create an amazing variety from essentially the same basic elements.

Garment Categories

Camp shirts, dress shirts, dinner shirts, Hawaiian shirts, Winchester shirts, poet shirts, tunics.

Brands

Alternative Apparel, Cluett Peabody & Co. (Arrow), Hendrix shirts, Last Exit to Nowhere, Lucky Merck Clothing, Tommy Bahama, Van Heusen, and Zachary Prell.

Menswear Designer: Danh Tran

Designer Danh Tran creates cool men's shirts for young guys by combining great styling with interesting fabrics and quality sewing. His shirts, though casual, have a certain elegance, and the attention to detail is obvious.

STEP THREE: Further Define Your Muse

When choosing a specific customer base or muse to target, it may be helpful to consider the specifics of each group in more detail. This kind of research will also be important to understand and relate to your customer in your future design positions. You may also want to consider which group you would relate to most easily. For example, if you have grown up in a middle class suburban environment, it may be harder for you to relate to a more affluent, older customer. At the least, you would have to do some research to get into his or her "head." The following are very general and speculative descriptions of customer bases. We will consider more specific characteristics in Step Four.

Couture Customer

Income: $800,000+ a year

Source of Income: Top professional or family wealth

Age Range: 40+ or younger celebrity

Residence: Affluent city neighborhoods

Leisure Activities: Charity and museum events, opera and theater, lunch with friends or for business, personal trainer workouts.

Favorite Designers: Armani, Rei Kawakubo, John Galliano, Victor and Rolf, Dior

Favorite Stores: Barneys, Designer Boutiques

Better Bridge

Income: $300,000 a year

Source of Income: Top professional

Age Range: 40+

Residence: Affluent homes, condos, town houses

Leisure Activities: Architectural conservancy, country/city club, philharmonic

Favorite Designers: Geoffrey Bean, Valentino, Bill Blass, Chanel

Favorite Stores: Nordstrom, Saks, Neiman Marcus

Young Designer

Income: $60,000–$150,000+

Source of Income: Executive professional, two-income household

Age Range: 30+

Residence: Artist lofts, condominiums, upscale neighborhoods

Leisure Activities: Art openings, night clubs, upscale restaurants, yoga classes, Sunday brunch

Favorite Designers: Jill Sander, Marc Jacobs, Narciso Rodriguez, Junya Watanabe, Yohji Yamamoto, Behnaz Sarafpour

Favorite Stores: Barneys, Maxfield

Contemporary

Income: $40,000–$120,000+

Source of Income: Professional

Age Range: 25+

Residence: Artist lofts, hip communities, beach cities

Leisure Activities: Art openings, museums, night clubs concerts, upscale restaurants, Pilates

Favorite Designers: BCBG, Marc Jacobs, Leon Max, Calvin Klein

Favorite Stores: Boutiques of above designers

Who is my muse??

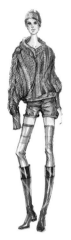

Define Your Muse

Missy

Income: All incomes $40,000–$150,000+
Source of Income: Professional career, retirement
Age Range: 50+
Residence: Better to moderate neighborhoods
Leisure Activities: Museum openings, better restaurants country club, LA Fitness, destination cruises, lunch with friends/business
Favorite Designers: Liz Claiborne, Carol Little, Jones of New York
Favorite Stores: Nordstrom, Saks, Neiman Marcus

Plus Sizes

Income: All incomes $35,000–$100,000
Source of Income: Professional or spouse
Age Range: 15–70
Residence: All kinds
Leisure Activities: Gardening, television and films
Favorite Designers: Specialty stores

Junior

Income: Up to $30,000 for those who are working
Source of Income: Entry-level jobs; parents
Age Range: 15–25
Residence: Parents' home, college dorms and apartments, low-rent residence
Leisure Activities: Movies, team sports, snowboarding, shopping
Favorite Designers: Betsey Johnson, Roxy, Lucky Jeans, Baby Phat, Juicy Couture
Favorite Stores: Hollister, Abercrombie, Roxy, Lucky Jeans, Old Navy, Forever 21, Volcom

Subteen

Source of Income: Parents of all income levels
Age Range: 10–15
Residence: Parents' home
Leisure Activities: Team sports, movies, shopping
Favorite Designers: Junior companies with a younger size range
Favorite Stores: Department stores, Target

Children

Source of Income: Parents
Age Range: 4–9
Residence: Parents' home
Leisure Activities: Play
Favorite Designers: Upscale parents will gravitate to children's boutiques or Baby Gap. Medium income will frequent department or discount stores.

Toddlers and Infants

Source of Income: Parents
Age Range: 1–3
Residence: Parents' home
Leisure Activities: Play
Favorite Designers: Upscale parents will gravitate to children's boutiques or Baby Gap. Medium income will frequent department or discount stores.

Menswear

Income: $70,000–$200,000+
Source of Income: Professional
Age Range: 30–60
Residence: Upscale homes or condos
Leisure Activities: Sporting events, athletic club, outdoor activities, movies, concerts
Favorite Designers: John Varvatos, Ralph Lauren, Kenneth Cole
Favorite Stores: Barney's, Brooks Brothers, Neiman Marcus, and other upscale department stores

Young Men

Income: $30,000–$80,000
Source of Income: Entry-level job to "young affluent professional"
Age Range: 22–26 pursuing an education; 26–30 for working professionals
Residence: Parents' home, college campus, hip neighborhoods
Leisure Activities: Sporting events, snowboarding, surfing, movies
Favorite Designers: Billabong, DC Shoe Co, Sean John, Monarchy, Armani Exchange
Favorite Stores: Abercrombie & Fitch, Diesel, Armani Exchange, American Rag, Politix

Boys

Source of Income: Parents
Age Range: 10–15
Residence: Parents' home
Leisure Activities: Sports, video games, movies
Favorite Designers: Mossimo, department or discount stores

Customer Characteristics for Retail

Retail Customers Defined

As a designer, you will want to understand how the retail stores you are targeting view and define their customers. Retail is very specific about this. They divide their female customers into three basic categories: **conservative, updated,** or **advanced**. The conservative customer is not interested in trends. She wants good quality that will last. The updated customer likes to stay in fashion, but is not a trendsetter. She does not want to stand out in a crowd, while the advanced customer is all about getting attention by the way she dresses. She not only shops the trends, she creates them.

These three categories also fit into three different economic strata: **budget, moderate,** and **better**. As you can imagine the Advanced Better customer will be very different from the Conservative Budget customer. The first might shop at Barney's or exclusive boutiques; the latter at K-mart or Walmart, where she can get inexpensive wash-and-wear clothing for a very low price. In the chart below you see more characteristics of these nine categories.

	CONSERVATIVE	UPDATED	ADVANCED
BETTER	This customer is willing to spend money for good quality, but she does not want anything extreme in terms of look or fit. Her goal is to look well-dressed without standing out at all.	This customer keeps up with the trends, so she wants to buy clothes that reflect what is happening in fashion for the season. She will not buy anything that is ahead of the trends or that looks too extreme.	This customer wants to buy clothing that is ahead of the season. She is a pioneer, and wants to stand out as a fashion leader, so she is willing to go a bit extreme. She also pays for quality.
MODERATE	This customer does not want to spend a lot of money, nor is she interested in being fashion-forward. She wants some level of quality and easy care, but is not concerned with designer labels.	This customer looks to reliable but stylish brands to stay looking reasonably up to date. She prefers easy-care clothes, but will compromise. She does not want to pay for designer labels.	This customer understands the trends and does not mind looking more extreme, but she cannot afford designer labels. She is less concerned about quality or care than the right look.
BUDGET/DISCOUNT	This customer is not really interested in fashion trends, nor does she want to spend money to stay current. She wants easy-care clothing that is understandable and wears well.	This customer is on a strict budget, so she looks to the discount stores like Target to provide looks that are not too dated. She will prefer wash and wear, as that is more economical.	This customer is looking to stand out, so the look is more important than the quality or care. She will go to sample sales and frequent resale or vintage shops to put together interesting outfits.

STEP FOUR: Target a Specific Customer

Once you have narrowed down your design category choices, you can deepen your profile of your chosen muse and arrive at some specifics. The more you know about the customer you are targeting with your portfolio, the more informed your decisions will be when you create your groups.

Points to Consider

1. **Who are you trying to appeal to with your designs?** You can think of one person—a celebrity or favorite model—or a general category, such as sophisticated urban single men over 30. Donna Karan targeted busy working women who had to look chic in a hurry but also wanted comfort. She built a fashion empire on that concept.
2. **Within one age range there are many options.** For example, is your junior a "girly-girl" or more of a tomboy? Fashion-forward or preppy? Of course, your groups could appeal to different junior customers within one portfolio.
3. **Where are these people going in your clothes?** They might be going to work, then out on a date. How do you create an outfit that goes smoothly from day to evening?
4. **Does your customer want to stand out or blend in?**
5. **What identities are you trying to project with your designs?** Think of defining phrases such as Urban Nomads, Skater Girls, or Chic Geeks. Then find muses that visually represent these groups.
6. **What is the body language of your customers?** Are they relaxed or on the go? Outgoing or subtly sophisticated?
7. **Is your customer neat and classic or casual and put together in unorthodox ways?** Highly accessorized or very minimal?
8. **What fabrics would suit your customer's lifestyle?**
9. **Can your target customer afford your designs?**
10. **Where does your customer shop?**
11. **Where does your customer live?**
12. **Does your customer work, and if so, where?**
13. **Does he or she have kids?** If so, how does that affect his or her lifestyle?
14. **Does your customer like to travel?**

NOTE: Being specific in terms of age is helpful for focus, but merchandising to attract a variety of customers can also be the goal. Rather than thinking of age, picture a certain lifestyle or aesthetic. Male athletes, for example, will have similar needs, whether they are twenty or fifty.

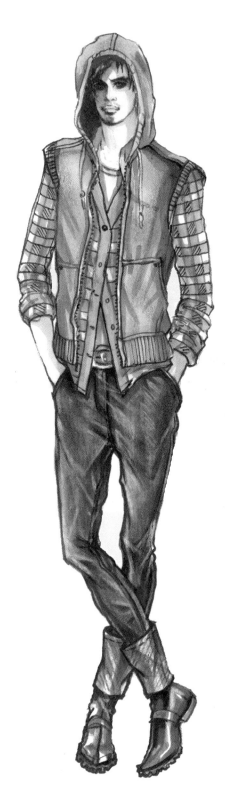

CUSTOMER PROFILE

Name: Dylan (Based on my little brother.)
Age: 18–21
LIFESTYLE: Lives in San Francisco, so he needs to layer for warmth.

Goes to art school and studies graphic design. Parents pay for his schooling.

Works part time in a book store so he has some money to spend.

Has a pretty girlfriend, so he likes to wear clothes that she appreciates.

Gets around the city on his skateboard. Strictly wash and wear. No ironing or dry cleaning.

AESTHETIC: Because he's artistic, he appreciates some color and pattern.

Knows how to layer pieces to look cool. Does not like to look like he tries too hard. Casual chic. Needs clothes that stay out of his way when he's skating. Likes graphics, but they have to be very subtle and tasteful. Invests in quality pieces. Classic accessories.

STEP FIVE: Target Your Dream Company

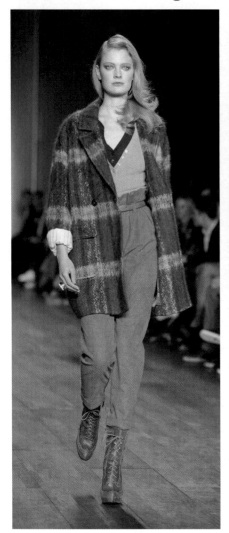

© Everett Collection Inc./Alamy

© hautemoda/Shutterstock.com

© Flash Studio/Shutterstock.com

Are You Tommy Hilfiger, Betsey Johnson, or Target?

Or none of the above? Maybe you love menswear or lingerie or clothing for extreme sports. Whatever you want to do, unless you are the brave soul planning a start-up right out of school, you will target your portfolio toward the companies where you would like to work. Identifying and researching those companies will help you plan your groups to appeal to their sensibility and style.

Chances are you have done a fair amount of research at this point, so you are probably pretty Internet-savvy. If you don't have a specific company in mind yet, start with a general category search like *junior swimwear manufacturers*. Choose at least three likely candidates, then start digging deeper to find what they are all about. There are also directories and databases of fashion apparel firms. Check with your school or professional organization. Periodicals like *Women's Wear Daily* and *Apparel News* are excellent resources for business information and job listings. They can help you identify employment trends and where the best opportunities might be found.

Deepen Your Research

Once you have identified the companies to target, you will want to explore them further to see if you are on the right track. There are several ways to do this:

1. Go to the stores that carry their brand (if possible) to get a real feeling for what they do.
2. Check them out in consumer publication databases like *WWD* and *Harper's Bazaar* or *Vogue*.
3. See if they show up in fashion blogs, and if so, what is said. There are blogs that talk about the business of fashion as well as the aesthetic pros and cons of various brands.
4. Call the corporate office and ask for the public relations department. Ask them to send you a press kit and/or annual report. It's important that you learn not to be intimidated on the phone, and this task is excellent practice.

What Questions to Ask

As you research, you will want to ask more specific questions about these potential employers. Save yourself the time and frustration of gearing your portfolio to the wrong employers.

QUESTIONS

- What do the companies you've short-listed have in common? If they are completely different, then your search might be too broad, which will make it difficult to focus your book.
- What do they have to say about themselves and their design philosophy? Does it mesh with yours? For example, if your passion is sustainability and they are indifferent, it might not be a good fit. Of course, if you are really proactive, you could take the job and encourage change.
- What types of customers do they profess to specialize in? Are they conservative, middle of the road, or fashion forward? Does the answer suit your aesthetic?
- Is their professed target customer consistent with the people shopping their line in the stores?
- Do they have more than one division? If so, do you target your book to one of those categories or gear it to several different areas to show your versatility?
- What is their price point? Would you be comfortable working within their limitations?

- Will you be asked to travel or relocate? Travel may sound great, but some designers spend up to six months overseas or relocate there entirely.
- Are they always looking for people? Or is their design staff very limited and stable? If people come and go quickly, you may be able to get a job, but the work conditions may be tough.
- What stores sell their products, and why?
- Will they fulfill the priorities that you have set for yourself as a future designer?

HINT: As you answer these questions about your target companies, take notes to keep them straight. Then compile your information in the form on the following page. Note taking is an important professional habit in the industry.

What Would It Be Like to Work for This Company?

You may wonder why you need to ask these questions. You're applying for a job, not marrying the company. That's true, but if you're hired, you'll probably spend more time at the office than you do with your significant other. You need to know that so many hours will be well spent and that the work you do will increase your knowledge and move you forward in your career. If you like to be home for dinner and they expect you to stay into the evening hours, you will not be happy in the long run. If you are hired, but it's not a good fit, you might not stay hired for long. You could have used that time to find a more compatible situation. Once you take a job, it is better if you can stay at least a year. Otherwise, your resume will start looking a little "flaky."

Targeting a Specific Company

After you have gathered your information on target companies, you may want to list them in order of preference. This will aid you in knowing where to put the emphasis in your portfolio. For example, if your favorite company does not observe the traditional fashion seasons, but rather ships once a month, you may want to emphasize *seasonless dress* in your book. But if the seasons are important to your #2 company, you may want to address that as well in a more minimal way.

Personal Contacts

A personal network can be your best resource for job opportunities and helpful advice. If you are lucky, your school will provide employment counseling and connections. They know you and what you are good at. Talk to your instructors as well. They may know people that they would feel comfortable recommending you to. If you have been a responsible student, they will probably be happy to write you a letter of recommendation.

Your fellow students and peers can also be a great resource. If you have made good friends, you can share valuable information about possible employment.

It is also important to reach out to people you know outside of school. Do you know anyone who has the kind of job you want? He or she might be able to advise you as to what the company looks for in the portfolios of potential hires. Creative professionals in related areas can also be excellent contacts.

Company Assessment Form

Make as many copies of the form as you have target companies. Keep them in a labeled folder so you refer to them as you develop your book. When it is time to set up interviews, you will have the information handy for review. These are all part of professional practice that will make you an invaluable and efficient employee and keep your stress level to a minimum.

STAIRWAY TO SUCCESS

COMPANY ASSESSMENT FORM

Company _____

Location? _____

Commute distance? _____

Necessity to relocate? _____

Moving arrangements? _____

Company size? _____

Target customer? _____

Type of customer? Who more specifically are they targeting?

A company set in traditions or looking for change? _____

Designers work independently? _____

Designers work in teams with a design director? _____

Freelance opportunities? _____

Looking for people now? _____

Personal contacts? _____

Design philosophy? _____

Stores where they sell their clothes? _____

Price point? _____

Notes _____

Designer: Renata Marchand

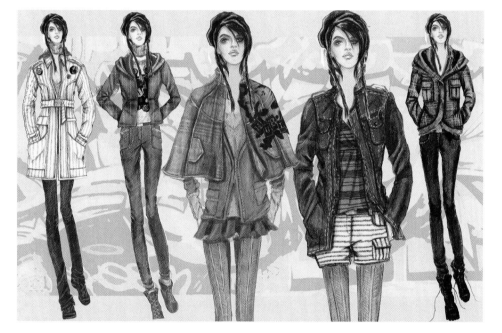

Renata designed this cool junior Fall group with Hurley in mind. She had interned there in the summer between junior and senior year, and the fit was great for her skills, so Hurley hired her as soon as she graduated.

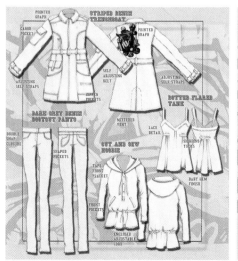

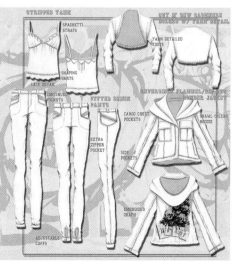

Notice how carefully Renata has composed her flats on the two pages. All her flats are in proportion to each other and show her details clearly. She has chosen a loose approach to soft pieces that conveys the feeling of a comfortable washed garment.

DESIGNER PROFILE: Kiernan Lambeth

If you are worried that your first job won't be your dream job, it may be helpful to read the professional odyssey of Kiernan Lambeth, who has aquired a wonderful range of experience since he graduated from design college in 1998. Every job is an important learning experience and when you stop learning it may be a good time to move on.

Kiernan's Job Experience

I've been very fortunate that my career has grown organically. I nurtured every connection, always left on good terms, and never burned a bridge. As a result, I've never used a recruiter or headhunter to get a job. Every position I got was through my network or someone who approached me. It's a small industry. Your reputation and professionalism will make or break your career.

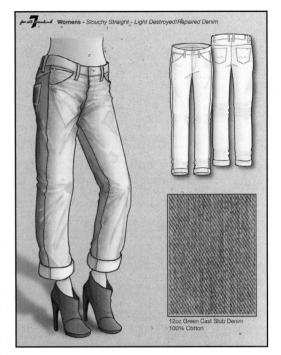

1. **Nike Internship:** Interned at Nike between junior and senior year. Amazing experience and my first glimpse of the corporate world.
2. **Earl Jean—Women's Denim:** My first job. A truly entrepreneurial experience with a small brand growing exponentially. I unintentionally fell into focusing on denim in this job.
3. **Eisbar:** Denim, graphic tees, some sportswear. I left Earl Jean to strike out on my own with an ex-lawyer who wanted to get into the fashion business. Three years of mistakes, learning, and doing every job that exists in an apparel company.
4. **Allen B (ABS)—Men's Collection:** Left my startup to gain experience with a bigger, more stable corporate brand. We had amazing resources and an awesome work environment, but I learned nothing in this business comes easy or is a sure thing. We had trouble building our men's collection with the same business model as the women's. Had a great time, but an opportunity to work in New York proved too attractive to pass up.
5. **Bluenotes—Guys' Denim and Bottoms:** Moved to New York to work at Bluenotes, American Eagle's re-vamp of a Canadian Urban-Outfitters–style chain store. Great job, but AE decided to cut their losses and sell off the brand. Promoted to work on American Eagle men's denim.
6. **American Eagle Outfitters—Men's Denim:** Spent about 2½ years at AEO where I really got deeply into denim. Traveled a lot for inspiration and factories, and put together outstandingly successful lines. Learned the corporate game and the pros and cons of bureaucracy. Loved the job, didn't love New York.
7. **A&F—Men's and boy's denim:** Left AEO to go to the arch-enemy, Abercrombie & Fitch. Was so curious about this brand and all the mixed reviews. Moved to Columbus, Ohio, and only stayed 7 months after I realized it was really not a good fit for me.

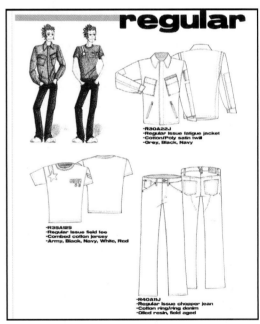

8. **Quiksilver—Young Men's Global Denim:** Made my way back to the West Coast and back to my Orange County roots working on denim for Quiksilver. Awesome company, great team, and a fun experience. Unfortunately the recession hit in 2008 and over half the design staff was let go.
9. **Freelance:** For about 5 months I was freelancing and working on a little side-project denim collection—Special Fabrications. I also traveled to Russia for a week on a consulting gig. Also did washes for the denim mill Tavex.
10. **7 For All Mankind—Men's and Women's Denim:** After a stressful period freelancing, I got a job consulting at 7FAM, which blossomed into a full-time gig. I got the connection through my old VP at Quiksilver. His close friend was the VP at 7FAM and he put me in touch with her, the rest was up to me. We hit it off and it turned out to be one of the best jobs I've ever had! Things moved very quickly and she embraced a lot of the changes I brought to Men's. A great manager, she gave me a chance to manage the Women's team as well. She ended up leaving for the Gap and taking a lot of others with her, ushering in a huge change in the team. Then an amazing opportunity came along that I couldn't resist. . . .
11. **Lamb & Flag—Men's and Women's Denim and Accessories:** My current job. Lamb & Flag is a new retail concept being launched by Kellwood. It will be launching around September of this year with a store and ecommerce. I'm working with a small team, many of whom I've worked with at various companies over the years. It's a startup, but with the backing and resources of Kellwood. **We are creating everything from scratch, it's a blast!**

Designer: Kiernan Lambeth

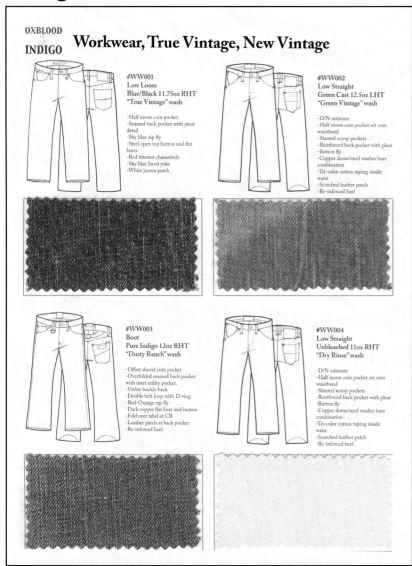

OXBLOOD & INDIGO

Workwear, True Vintage, New Vintage

#WW001
Low Loose
Blue/Black 11.75oz RHT
"True Vintage" wash

-Half moon coin pocket
-Seamed back pocket with pleat detail
-Sky blue zip fly
-Steel open top button and flat burrs.
-Red interior chainstitch
-Sky blue faced yoke
-White jacron patch

#WW002
Low Straight
Green Cast 12.5oz LHT
"Green Vintage" wash

-D/N outseam
-Half moon coin pocket set over waistband
-Slanted scoop pockets
-Reinforced back pocket with pleat
-Button fly
-Copper dome/steel washer burr combination
-Tri-color cotton taping inside waist
-Scorched leather patch
-Re-inforced heel

#WW003
Boot
Pure Indigo 12oz RHT
"Dusty Ranch" wash

-Offset shovel coin pocket
-Overfolded seamed back pocket with inset utility pocket.
-Utility buckle back
-Double belt loop with D-ring
-Red-Orange zip fly
-Dark copper flat burr and button
-Fold over label at CB
-Leather patch at back pocket
-Re-inforced heel

#WW004
Low Straight
Unbleached 11oz RHT
"Dry Rinse" wash

-D/N outseam
-Half moon coin pocket set over waistband
-Slanted scoop pockets
-Reinforced back pocket with pleat
-Button fly
-Copper dome/steel washer burr combination
-Tri-color cotton taping inside waist
-Scorched leather patch
-Re-inforced heel

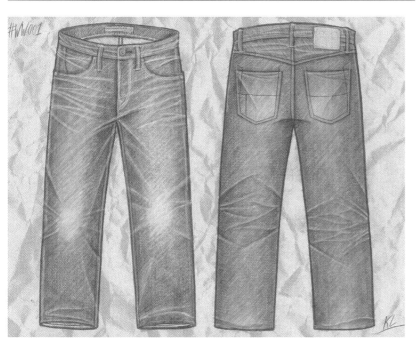

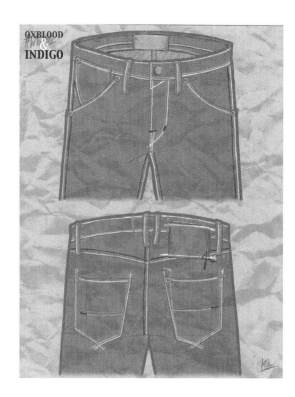

OXBLOOD & INDIGO

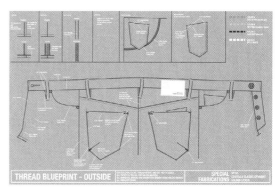

THREAD BLUEPRINT - OUTSIDE

SPECIAL FABRICATIONS

Kiernan has provided us with some great examples of denim line sheets, tech packs, and a careful, precise rendering of a distressed treatment in great detail, both front and back. Note how every aspect of the top-stitching, belt loops, rivets, buttons, and seaming are spelled out in the above sketch. Attention to such detail and the ability to add subtle touches to familiar elements are qualities that make a successful designer.

Designer: Courtney Chiang

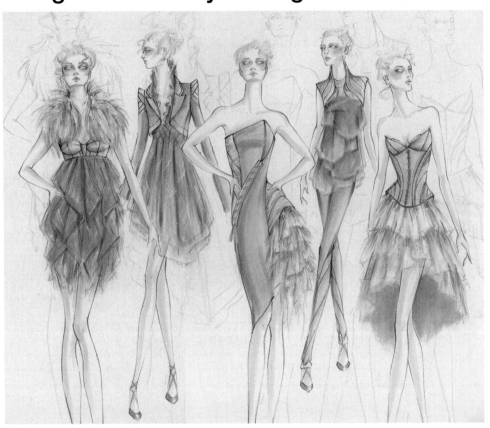

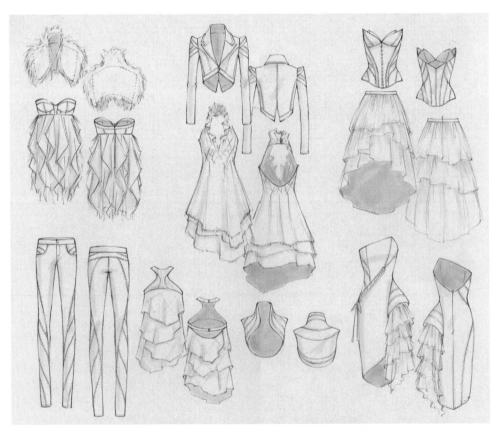

Courtney's beautiful silhouettes, delicate trims, and dramatic treatments make this monochromatic eveningwear group both exciting and appealing. Note the variation in the line work on her flats. The "harder" pieces are drawn with a bolder line.

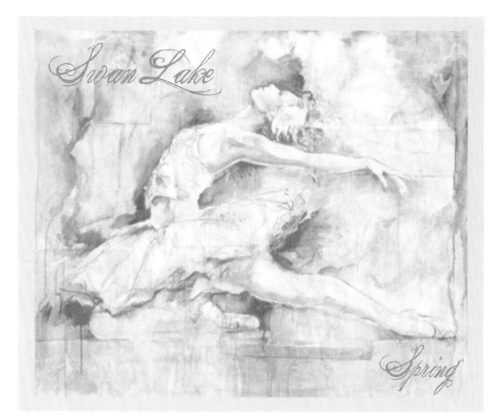

Mood board for Courtney's portfolio group, Swan Lake. See facing page.

A dress from Courtney's new line.

Designer Statement

As a designer, I strive to create designs that are feminine and simple yet sophisticated. My designs focus on easy and relaxed drapes combined with detailed hand work such as beading, lace appliqué, fabric dyeing, and fabric manipulations. Spring 2011 marked the launch of my first collection.

Starting a line straight out of college has been time-consuming and stressful to say the least. It has taken serious dedication and passion, but to see all the hard work come together into a finished product is unbelievably fulfilling and rewarding. The road I've taken definitely has its highs and lows and sometimes it feels like every day is a struggle for me to jump on board with this fast-paced industry. In the end though, the necessity to learn quickly on the job has forced me to learn, grow, and develop as a designer.

If you are passionate about starting up a line right out of school I recommend getting as much work experience as possible while still in school. I know that school can take up most of a full-time student's time, but even a summer internship can provide invaluable knowledge and insight into the fashion industry. And don't limit yourself to design positions. Helping with production, public relations, customer service, fabric sourcing, etc. will allow you to learn about other aspects of starting a line that you may not learn while in design school. The people and companies you come in contact with while working or even in school can prove to be helpful in the future, so it's important to network.

STEP SIX: Soul Searching

Good interviewers can assume a great deal from looking at your portfolio. They are experienced at picking up subtle and not-so-subtle information about who you are, what you believe in, the level of your passion for what you do, how much pride you take in your work, your level of clarity, organization, time management, and so on.

You may be tempted to take a cautious approach to what you put in your book, for fear that something more bold might turn a potential employer off. But having your real personality come through—even though you might "disguise" it in a marketable approach—is important. On the other hand, if your work is too extreme, you may not find anyone who relates to what you do.

We had a very talented student a number of years ago who drew very distorted, full-figured, and strange—but wonderful—drawings of his female muses. His illustration faculty loved his work, but knew it probably would not translate into the swimwear market where he wanted to work. Although he was advised to tone down his illustrations, or at least to include some more "normal" fashion sketches, his conviction led him to do his entire book in that mode.

As you might guess, no one looked past his wild drawings to appreciate his great designs. He eventually re-did his entire book and landed a good job. It was a hard lesson for him: You need to know and express yourself, but you also have to know your audience. Fashion is a creative field, but it is also a business with a specific design vocabulary. You have to speak the visual language that an employer can relate to.

It is in your best interest, therefore, to evaluate yourself so that you know in what areas you will not compromise and where you can be flexible to reach your goals. Self-evaluation is tough. We all have blind spots when it comes to our assets and weaknesses. A lack of self-awareness can lead you down the wrong path in terms of your goals or make you shortsighted in how you approach your book. Knowing your strengths and weaknesses will allow you to emphasize the right things and downplay what does not enhance your value in the eyes of a potential employer.

So take the time to read the next Designer Profile, and think carefully about what you really are good at and what causes you problems. Recognizing those things about ourselves honestly and accurately is a great step toward maturity in both our professional and private lives.

DESIGNER PROFILE: All About You

Do an honest assessment, just for your benefit. No one else has to see your results, but you can refer to this list as you make important decisions in the portfolio process.

1. Education in my profession (check all that apply):

Self-taught _____ Non-credit classes _____
Certificate or Associate Degree _____
Bachelor's Degree _____
Advanced Degree _____
Internships _____

Employer requirement?

2. Education or Work experience in a related or supporting profession (check all that apply):

Retail Sales _____
Merchandising _____
Styling _____
Retail Buying _____
Costume or Wardrobe _____
Patternmaking _____
Clothing Production
Painting, drawing, or other art fundamentals _____
Photography _____
Graphic design _____
Marketing _____
Advertising _____
Costume or Wardrobe _____
Patternmaking _____
Graphic Design _____
Painting, drawing, or other art fundamentals _____
Photography _____

Would this matter to your employer of choice?

3. Software training (check all that apply):

Photoshop and related imaging software _____
Two-dimensional illustration program (Illustrator, Freehand, etc.) _____
I don't have software training _____

What does the job require?

4. How do I like to work?

Alone _____
Collaboration or partnership _____
As a team member _____
Doesn't matter _____

Is the company very team-oriented?

5. What's my preferred working environment?

I can work anywhere. _____
I need a private space. _____
I like to have other people around. _____

What is the work set-up at the companies of my choice?

6. Select the statement that fits you best:

I will be most happy free-lancing and having flexibility. _____
I need a secure job so I can pay my bills. _____
I like to mix steady work with some extra freelance projects. _____
I am not that picky about the type of design work I do. _____
I will only design for my type of customer. _____

Working for someone else when you get out of school is probably an easier way to get the bills paid, and is a different but important part of your education. But if you want to work freelance, a great portfolio becomes even more critical.

7. Location:

I want to stay where I am to get a job. _____
I want to go somewhere else to live and work. _____
I am willing to relocate although it's not ideal. _____
I don't mind moving to a nearby town, but I want to stay in the general area. _____

Do take your feelings on this seriously. If you are forced to move somewhere that you don't like, that can undermine your job success.

DESIGNER PROFILE: Strengths and Challenges

Put a check beside any traits that apply to you. When you are finished, analyze what you bring to the table professionally.

STRENGTHS:

1. Neat _____
2. Organized _____
3. Able to focus for long periods of time _____
4. Create systems for improved efficiency _____
5. Always on time _____
6. Good communicator _____
7. Able to facilitate group consensus _____
8. Natural leader _____
9. Create and manage budgets _____
10. Good at networking _____
11. Outgoing in social situations _____
12. Great at researching _____
13. Adapt quickly to unfamiliar situations _____
14. Natural problem-solver _____
15. Maintain cool in stressful situations _____
16. Take criticism well _____
17. Give honest but tactful feedback _____
18. Well-dressed with a sense of personal style _____
19. Well-groomed and polished _____
20. Strong sense of self _____
21. Enjoy the spotlight _____
22. Function well on little sleep _____
23. Love to travel _____
24. Welcome challenges _____
25. Enjoy differences in people around you _____
26. Welcome change _____
27. Seek and enjoy ever-increasing responsibility _____
28. Enjoy talking to people to learn new things _____
29. Ability to prioritize effectively _____
30. Decisive _____
31. Always meet deadlines _____
32. Your glass is half full. _____

CHALLENGES:

1. Messy _____
2. Disorganized _____
3. Short attention span; ADHD _____
4. Not a multi-tasker _____
5. Often late _____
6. Shy and afraid to say what you think _____
7. Tend to be a loner _____
8. Want someone else to lead _____
9. Often in debt _____
10. Poor time management _____
11. Uncomfortable at social functions _____
12. Impatient; tend to embrace obvious solutions _____
13. Lack of spontaneity _____
14. Often overwhelmed by problems _____
15. Take criticism too personally _____
16. Often get defensive _____
17. Too blunt with feedback _____
18. Unwilling to give negative feedback _____
19. Generic or sloppy personal style _____
20. Insecure _____
21. Hate being the center of attention _____
22. Need at least eight hours sleep to function well _____
23. Afraid of flying, strange places, being too far from home, etc. _____
24. Like to work with people who are of similar background _____
25. Hate change of any kind _____
26. Dislike talking to strangers _____
27. Resist making decisions _____
28. Avoid responsibility _____
29. Lose things often _____
30. Tend to gossip _____
31. Have trouble leaving personal problems at home _____
32. Hold grudges _____
33. Your glass is half empty _____

STEP SEVEN: Identify Your Visual Influences and Strengths

Designer Profile

Use a separate paper to write your thoughts about each category. Try not to skip any. You probably have some influence from each of these elements if you really think about it. Once you have defined your ideas, then try to write a few words about ways each one might influence your work.

FINE ART: List your favorite painters, sculptors, illustrators, and photographers, and your favorite period or movement in art. Describe the qualities that attract you; for example, color, subject matter, composition, graphic approach, line quality, classicism, figurative elements, simplicity, or a bold approach.

ARCHITECTURE: List your favorite architects, and your favorite period of architecture. Describe the qualities that attract you, such as design philosophy, materials, forms, color, or historical significance.

MUSIC: List your favorite singers and/or music groups and the qualities that attract you.

SPORTS AND HOBBIES: What sports did you or do you pursue? What are your hobbies? How might these activities influence your concepts?

BOOKS, FILMS, PLAYS: List your favorites, why they affect you, and potential influences.

Think about the clothing the characters might wear.

PERSONAL CULTURE: Where do you live and work? How has that environment affected you?

ETHNICITY: What is your cultural background?

FRIENDS and FAMILY: Who are your close friends and how do they influence you? What kind of work do your parents or siblings do that might influence your concepts?

SUBCULTURES: What subcultures are you familiar with or do you participate in? For example, Punks, Goths, Ravers, Trekkies, Skaters, etc.

SPIRITUAL BELIEFS: What is your religion or moral philosophy?

OTHER INFLUENCES? You may have other elements or incidents that have happened in your life that have an influence. Write about these and how they might affect your work.

Beautiful craft objects like Julie's Bauer pottery collection can be wonderful inspiration for color and design.
Photo: Julie Hollinger

BEYONCÉ

Some designers make a good living designing exciting stage outfits for performers.
© Everett Collection Inc./Alamy

DESIGNER PROFILE: Visual Strengths

Once you have identified your customer, you can use that information to target the look of your book. If you decide to do childrenswear, for example, chances are you will take quite a different approach from your friend who is doing young men's skater looks. The following list will help you identify your strongest skills. Make full use of these skills in your portfolio. Avoid those areas that present challenges or strategize effective solutions for them.

Evaluate your skill level with each element on a scale of with 10 being the strongest.

Drawing female figures _____

Drawing male figures _____

Drawing children _____

Drawing fashion faces _____

Drawing hands and feet _____

Drawing clothing on the figure _____

Hand rendering of figures/clothing _____

Computer rendering of figures/clothing _____

Realistic illustration style _____

Stylized illustration style _____

Hand-drawn flats _____

Computer-drawn flats _____

Complex fashion poses _____

Complex layouts with multiple figures _____

Computer layouts of figures _____

Graphic design elements _____

Humorous elements _____

Text relating to your groups _____

Putting together fabric boards _____

Fabric treatments _____

Construction samples _____

Knitting samples _____

Airbrush techniques _____

Use of hand-drawn backgrounds _____

Computer backgrounds _____

Computer special effects _____

STEP EIGHT: Assess Your Designer Profiles

If you have completed all the designer profiles, you should have a picture of yourself as a creative professional. This self evaluation defines your work experience and your key skills, as well as the areas you will want to work on. For example, you may need to brush up your computer skills for certain companies, or work on time management in order to thrive in your ideal but high-pressure work environment.

One of the most important issues for many companies is interpersonal skills. They want you to work well on a team and have a positive attitude. If you identified any attributes that would undermine you in this area, you might consider counseling—or meditation. In addition, your boss will want you to be vocal and represent the company in public. If expressing your ideas is hard for you, a speech class can be very helpful. Writing down your ideas and practicing your delivery in class can also be effective.

Recognizing your challenges as well as your strengths is an important step toward being an effective professional. Your portfolio is a personal statement about who you are creatively, so you want it to say what you really mean and reflect who you are. Mining your visual skills will ensure that you keep the quality high.

ALL ABOUT YOU: 1. What are my three most important work skills? 2. How can I best feature or make use of those skills in my portfolio? For example, if you had advertising experience, you might make that your overall theme. 3. What are the gaps, if any, that I need to work on to maximize my value? (For example, styling, computer skills, construction, etc.) 4. What is my ideal work location and environment? 5. Do these ideals mesh with my target employers? What compromises am I willing to make, if any?

STRENGTHS AND CHALLENGES: 1. What are my five key strengths professionally? 2. What are my five greatest challenges? 3. What strategies will I use to maximize my strengths in this process? 4. What strategies will I use to minimize or correct my challenges? (For example, if you are chronically late, you might force yourself to be a half hour early to class or other obligations for the rest of the semester. A challenge like intolerance and impatience with others might require some kind of counseling.)

KEY INFLUENCES: 1. What five key inspirational elements do I want to consider focusing on? 2. Do I want to use one of my inspiration elements as an overall portfolio concept that will tie together my groups? (For example, if you love interior design, each group might be based on a different room in a beautiful house from Architectural Digest.) 3. If so, what themes might I consider and how might I use them? Hint: Think of several ideas for each theme, then edit down to the best one.

VISUAL STRENGTHS 1. What are my five key visual strengths? 2. What are my five greatest visual challenges? 3. What strategies will I use to maximize my strengths in this process? (For example, if you are great at rendered flats, make sure to feature those in a group.) 4. What strategies will I use to minimize or correct my challenges? (For example, if your fabric boards are weak, make a point of asking your faculty to give you a little extra feedback on this key element.)

NOTE: Remember to also mentally review your design education and the projects that brought you the greatest success. Don't ignore what you already do well.

If you are confused about any of these topics, don't hesitate to ask your faculty, especially the instructors who have worked with you extensively. They probably understand your strengths and challenges and can suggest ways you can address them.

Positions in Fashion

As a young person who is thinking of entering the fashion field, you will want to have an idea of what positions will be available when you get out of school and what those jobs involve. Many students think only of being a classic designer in a glamorous company, and that is a wonderful goal. But there are other options and being versatile and open to different opportunities can be a valuable asset for someone entering the job market. Be aware that every job will vary depending on the company, and the job list for associate and senior designers will be somewhat interchangeable.

INTERNSHIPS: The internship is a great way to get some experience in the industry before you graduate. Some internships are paid and some are not. The unpaid positions generally should be for credit and arranged through your school. However, if you are willing to work very hard for free, you may be able to get a summer job at your dream company that can eventually lead to a real job, so it is a definite plus on several fronts. In tough economies, some graduates find themselves in unpaid internships, but if you excel, you are likely eventually to get hired. Be prepared to spend your time running errands, steaming clothes, filing, and packing samples, but you will learn a lot in the process and make valuable connections for the future.

ASSISTANT DESIGNER: This is generally an entry-level position, which means you would be hired right out of school. The duties of this position will depend somewhat on the size of the company, the number of assistants, and the way the design room is set up. An assistant should expect to perform the following duties: Creating Illustrator or hand-drawn flats, filling out spec and cost sheets, helping with first patterns, cutting samples, ordering, receiving and organizing fabrics and trims, and assisting the designer with all day-to-day tasks such as getting ready for fittings and checking in samples.

ASSOCIATE DESIGNER: This position generally requires two to four years experience. An associate has more responsibility and will generally answer directly to the senior designer. The job might include the following tasks:

Help in developing a group of garments and/or accessories.

Manage workers involved in creating patterns, samples, and/or finished garments.

Identify target markets for designs, looking at demographics.

Provide sample garments to agents and sales representatives.

Consult production staff for fashion shows and other productions.

Research the styles and periods of clothing needed for film or theatrical productions.

Create fabric treatment samples as needed.

Stay current on latest fabrics and trims, and text fabrics to create accurate garment labels.

Attend fashion shows and review fashion magazines.

Examine sample garments on and off models; then modify designs to achieve desired effects.

Select all fabrics and trims to be used for the line.

Advise on production techniques to achieve correct results.

Sketch apparel or accessories and define details.

Work on and/or oversee design teams to create product.

SENIOR LEVEL DESIGNER: This position generally requires five or more years experience. The senior designer often handles a great deal of the business end of things, and makes sure that creative teams are working efficiently and have consistent direction. Maybe fifteen to twenty percent of the job is creative. Tasks may include any of the following:

Monitor overseas factories and address problems.

Review new samples and attend fittings.

Meet with design teams to review sketches and provide feedback and direction.

Meet with the sales team and hear sales reports and discuss what could be improved.

Meet with fabric people and trend forecasters.

Meet with the CEO to discuss problems, go over budgets, and complete employee paperwork.

Take responsibility for entire product design process to include color, print, fabric and trim research, concept board creation, sketching, and fit related to styling.

Identify latest trends, and develop concepts for product lines and seasonal themes.

Ensure that product is consistent with market trends as well as business strategy.

Provide direction for all colorways and fabric and trims.

Work with technical designer to ensure tech packages are accurate and complete.

Do design presentations for buyers.

Menswear Designer: Nurit Yeshurun

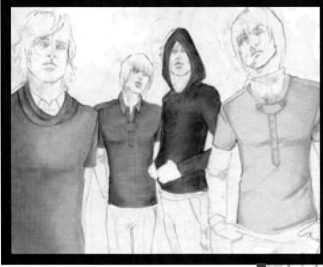

Nurit Yeshurun is a menswear designer at John Varvatos for Converse. Nurit's obvious artistic skills, her ability to create a very specific mood with her sketches of hip young guys, and her visually compelling flats have contributed greatly to her success. Notice that Nurit puts just as much care and style into her cutting-edge flats as she puts into her well drawn figures.

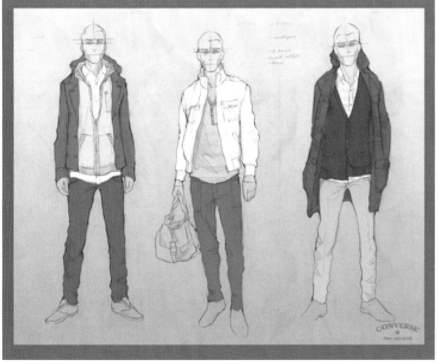

Anyone who worries that a woman can't make it in a man's world should look at Nurit Yeshurun's design career. Nurit began her career designing dolls at Mattel, but she soon moved to New York to enter the exclusive world of cool menswear, starting at Macy's, moving up to Calvin Klein, then joining the very hip company John Varvatos. Working in the Converse Division, she actually doubled the sales numbers in less than a year. As the men's woven designer, Nurit designs all the woven shirting and knit and woven bottoms, as well as the denim and accessories. She also plans the look books for buyers, executes all the tech packs and CAD design, works with the production team to make sure deadlines are being met, and teams with the tech designer to refine the fit on all the garments. Nurit is the winner of the National Council of America Nationwide Design Competition.

Born Country

Tech/Assistant Designer: Summer Spanton

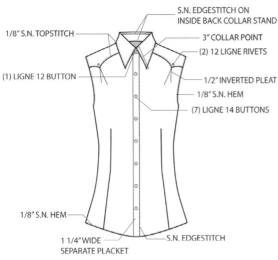

S.N. EDGESTITCH ON INSIDE BACK COLLAR STAND

1/8" S.N. TOPSTITCH

3" COLLAR POINT

(2) 12 LIGNE RIVETS

(1) LIGNE 12 BUTTON

1/2" INVERTED PLEAT

1/8" S.N. HEM

(7) LIGNE 14 BUTTONS

1/8" S.N. HEM

1 1/4" WIDE SEPARATE PLACKET

S.N. EDGESTITCH

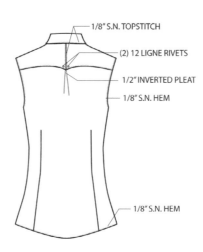

1/8" S.N. TOPSTITCH

(2) 12 LIGNE RIVETS

1/2" INVERTED PLEAT

1/8" S.N. HEM

1/8" S.N. HEM

Awesome Denim

GRAPHIC PLACEMENT

☐ DISCHARGE FOLLOWED BY WHITE WATER-BASED S.P.

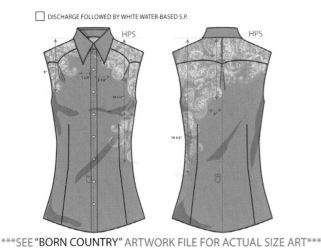

HPS

HPS

SEE "BORN COUNTRY" ARTWORK FILE FOR ACTUAL SIZE ART

Summer's Job Statement

As a tech/assistant designer, my main goal is to make the senior designer's life easier. I take her creations and bring them to fruition through sample management and tech pack creation and management. I help with fittings, dye approvals, graphic approvals, and wash and treatment approvals. I update the tech packs as needed and keep everything flowing smoothly between the production team and the design team. I am the liaison and organizing agent for the two.

On an average day, I will arrive around 8:00 a.m. I look at the current samples in development and check on their status in the cutting, sewing, dye, and wash departments. I file any necessary paperwork and update spreadsheets and notebooks. Then I take care of any labeling, tagging, etc. of finished samples and salesman duplicates. When I'm done with the samples, I work on tech packs and fittings and any little things that come up throughout the day. If we are in a lull, I will research online for interesting details or washes that can be used in the upcoming season's line.

Responsibilities:

Line sheets

Tech packs

Technical flats

Sample management

File management

Production liaison

Graphic proofreading

Anything else my senior designer needs.

Positions in Fashion, continued

ENTREPRENEUR: The ups and downs in the economy have engendered a whole new entrepreneurial spirit. Designers are creating their own "recession-friendly" lines and offering them for sale on the Web. Because there is a lot of competition there as well, the budding entrepreneur designer needs to create unique, striking garments or accessories that will draw the customer in and inspire those impulse buys.

FREELANCER: A freelancer is someone who generally works with different companies as an independent contractor, although some will do periodic projects for the same company. The upside of freelancing is you can be very independent and take jobs that suit you and your schedule. You can probably work mostly from home, and you may have the opportunity to do a variety of different things.

The downside of freelancing is you do not receive a regular paycheck and there are no guarantees. No one will pay for your health care or retirement. If you already have developed a client base it will be easier, but you also must be an extremely organized and business-minded person. If you want more structure, you can sign with an agency who will help you find work but will also take a percentage of your profits. If you work with an agency, you will want to stay in contact with them so you don't get lost in the crowd of fashion hopefuls.

When you begin freelancing, set a rate and try to keep it consistent. (People do talk to each other.) Research what other people doing the same jobs are making and decide where you fit based on your experience and what you have to offer.

PATTERNMAKERS: Most patternmakers are key people in their company and have many years of experience in the fashion industry. They need to work closely with the designer to interpret their ideas and also to be able to develop and correct patterns so the garments fit properly. They are also paid more according to their experience.

SPEC TECH: This entry-level position involves measuring garments accurately to create samples and production overseas. This job usually evolves into a technical designer position after several years experience.

TECHNICAL DESIGNER: A technical designer's responsibilities may actually cover two or three positions: those of a patternmaker, a tailor (for more high-end companies) and those of a spec tech who measures garment samples.

GRAPHIC DESIGNER: New, cool graphics are continually needed in casual clothing, especially for younger people. Graphic designers prepare sketches or layouts— by hand or with the aid of a computer—to illustrate their vision for the design. They select colors, artwork, photography, style of type, and other visual elements, which can be combined to create the finished image. Designers also select the size and arrangement of the different elements on the page. Designers then present the completed design to the designer or creative director for approval.

VISUAL MERCHANDISE COORDINATOR: This position, whether in wholesale or retail, is responsible for all the elements of visual display in a store, including decorating windows, creating interior displays and build-ups, lay-ins, store lighting, and all graphics. Coordinators also plan and build floor sets, train visual merchandisers, and act as liaison between store management and corporate. Making sure all areas are clean and well organized, keeping up display inventory, and reporting to the store manager are also under this position's purview.

MERCHANDISER: A merchandiser functions as an important liaison between sales, planning, and design teams. Merchandisers must develop a monthly merchandise line plan and do analysis of retail sales history to make informed recommendations for the collections. Researching the market is important to provide direction and marketing strategies to the design team. Merchandisers update and maintain buy sheets, work with salespeople to make sure they get the merchandise they need, provide input on various budgetary issues, and interpret sales patterns and trends for weekly departmental meetings.

STYLIST: A stylist is someone who is good at putting outfits together and adding great-looking accessories. This could be for a fashion photo shoot or for a celebrity going to a special event. Stylists also want to develop relationships with design firms so they have access to the latest samples in clothing and accessories.

COLORIST: If you love color, this is an interesting position. The main responsibility of a colorist is to monitor color standards and lab dips for manufacturers or fabric houses. The key technical tool for this task is called a spectrophotometer, which is used to read colors and help with quality control. It is able to call out and correct any tolerance issues by taking pictures of the fabric color from all angles.

STEP NINE: Identify Common Portfolio Pitfalls

Before you make your final Big Picture decisions, it is worthwhile to review what we see, after twenty-five years of teaching portfolio, as the common portfolio pitfalls. These "traps" have kept even our stellar students from doing their best work or completing their books. Understanding these pitfalls and considering some possible solutions can help you avoid "tripping" during your portfolio process.

Major Pitfalls

1. LACK OF A BIG PICTURE PLAN

The temptation to plunge into portfolio creation without planning ahead has led many good students to a disorganized process that lacks continuity and ultimately has prevented some of them from finishing their books.

DO: Use this chapter and the next to prepare a workable plan. You can always make changes if better ideas occur.

DO: Make sure realistic deadlines are built into your plan. Poor time management is one of the biggest traps.

2. LACK OF DESIGN FOCUS

You may be tempted to try to demonstrate your versatility by creating groups that appeal to several different markets.

DO: Make a clear choice about what design category you want to target.

DO: Peruse the design categories and apparel divisions to help you make a choice.

DO: Create separate books if you are certain you want to cover more than one design category.

DON'T: Try to mix design categories. This will confuse your potential employer. You can include some unisex looks and ideas, but keep in mind that companies that serve both genders will have separate divisions with different designers for each.

DON'T: Try to do two portfolios at once. Complete at least three groups in one category before you start the next book. Otherwise you may never finish either one.

3. **LACK OF CUSTOMER FOCUS**

Trying to appeal to too broad a customer base is a common trap.

DO: Read the customer profiles to determine the best customer base for your designs. For example, if you favor expensive fabrics, then consider focusing on designer, better bridge, or even couture.

DO: Research your chosen customer fully, and put a face or faces to your muse. Imagine where your customers go and what activities they do when wearing your clothes. The better you envision the lifestyle, the more focused your designs will be.

DO: Make decisions as to the use and order of seasons depending on where your customers live and their lifestyle choices. If your book is "seasonless," make that clear and have a good reason for making that choice.

DON'T: Design basics for a generic customer. Make sure your customer is interesting to you, so you are stimulated to produce interesting ideas.

4. **LACK OF A CONSISTENT LOOK OR CONCEPT**

Although you do want to display your visual and creative versatility, if there is no recognizable aesthetic point of view your book will probably lack impact.

DO: Consider your designer profile when formulating the look and concept of your book.

DO: Have a variety of approaches in solving each group, but see that certain elements connect them visually. This will become more clear as you move through the chapters on design.

DON'T: Use the same style of drawing for all your groups. That gets boring and shows a lack of imagination and versatility. But have an underlying aesthetic that ties your groups together.

5. **MESSY AND DISORGANIZED BOOK**

Even the most exacting students can turn out a messy and disorganized book if they get rushed and lack a plan. No employer wants somone who seemingly does not take pride in his or her work.

DO: Consider how to showcase your strengths and minimize your weaknesses when planning your book. If you tend to be messy, keep things simple. Wear gloves, and keep your workspace in order.

DO: Keep the elements for each group in a separate box or folder.

DO: Consider making an inspiration board and a master sheet for each group. (See Chapter 2.)

DON'T: Wait to assemble your book until the last minute. Inevitably problems will arise that keep you from meeting your deadline. Rushing also leads to poor craftsmanship.

6. **UNFINISHED BOOKS**

It's really sad to see a good student end up with a poorly developed or unfinished portfolio, but it happens more often than one might expect. It's generally harder to finish a book after graduation, and you may miss important interviews as a result.

DO: Make a calendar with a definite deadline for each group. Set aside realistic blocks of time to get important tasks accomplished, and don't neglect details like your resume or cover letters.

DON'T: Allow yourself to become too obsessive about anything, or to get stuck on any one group. This is often what keeps students from finishing. Keep in mind that you can make adjustments later.

DON'T: Let other people distract you. This process is too important for you to be side-tracked by guilt trips or negative attitudes. Keep a positive mood, even when you feel exhausted. It will all be over soon and a good job will be your reward!

STEP TEN: Finalize Your Big Picture Plan

If you have followed all the steps in this chapter you should be ready to commit to your personal Big Picture plan. This does not mean things can't change as you go along. Epiphanies happen, even mid-process, but your book development will go more smoothly if you can focus now and stay on that track.

NOTE: The second question applies only if you are planning to create additional groups for a second portfolio. In the third question, you may have one muse for your entire book or one category of customer, or you may be thinking of different muses within the same general garment category. For example, you may be doing a portfolio designing uniforms for team sports, so you might use a different athlete for each group as your muse.

1. My chosen design category is _____

2. I am also interested in creating groups for _____

3. My muse/customer is:

 Group One: _____

 Group Two: _____

 Group Three: _____

 Group Four: _____

 Group Five: _____

4. The companies I plan to target with my book are:_____

5. My ideal region for work is _____

CHAPTER SUMMARY

What we do on some great occasion will probably depend on what we already are; and what we are will be the result of previous years of self-discipline.

—Henry Parry Liddon

By now you probably have the message: In order to create a successful portfolio, we really believe in thinking things through and planning ahead. If this method works well for you in your portfolio process, the hope is that this will also encourage you to plan ahead in all important projects in your life.

Planning ahead leads to what we call "clarity" of vision. Vision is what you want when you are up against creative challenges like producing an exciting portfolio. Given all the decisions you have made in going through this chapter, your self-awareness as a creative person and a designer should be expanded in ways that will enhance that vision.

If we can continue that awareness throughout the portfolio process, good things should result. When someone looks at your book, they will see that all the elements, although exciting and stimulating visually, are also in harmony and present a clear picture of who you are as a design professional and a mature, focused human being. Your creative personality should come across, loud and clear. That is very appealing to the employer who is looking for someone who has the clarity and confidence to be themselves.

Consider:

- If you can have clarity about your own point of view, then it is easier to work with others and not feel threatened.
- If you make compromises, you know exactly what you are doing and why.
- When you start a new project, you bring your unique set of tools to the table and you have confidence in your ability to produce good work.
- You have clarity about the audience you are talking to and why. That includes employers and future customers.
- You are ready to formulate a portfolio that expresses your vision for your creative future.

We will be discussing your strengths and challenges more as we go through the various chapters, and we will help you make good use of both. So do trust the process and relax. We have watched our students succeed and produce beautiful portfolios following these basic principles for many years. It's time to gather your resources and move forward.

Designer: Carolyn Chon

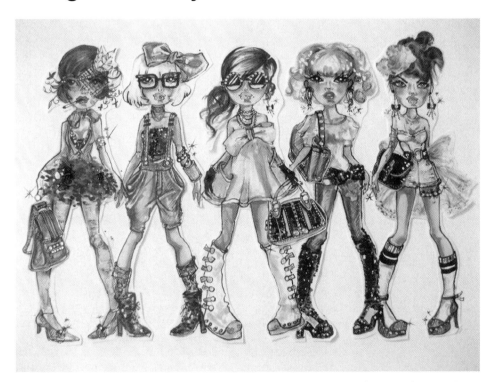

Licensing agreements are an important area of the fashion industry that adds an enormous amount of income to the fashion business. Many famous designers like Calvin Klein or Ralph Lauren lend their names to multiple products that they actually have little to do with in terms of design.

Carolyn Chon Statement

Mighty Fine (the company I worked for) had licenses for Hello Kitty, Disney, Peanuts, Marvel, Sesame Street, NBA, David Bowie, Blondie—just everything you can imagine.

We paid every licensor an annual fee and also a royalty fee for every design we sold using their licensed characters.

These wonderful illustration figures and designs were done by Carolyn Chon, who is a natural at creating a cute young junior look. For more on Carolyn, see Chapter 11.

If you have been very methodical about going through the steps in this chapter, you will probably be able to complete these learning tasks in no time. The tasks are designed to give you extra fuel for making good decisions by pushing you to think more deeply about the issues that we have covered.

TASK LIST

(Check these off if you have completed or mastered them.)

1. I am able to tell the difference between a Better Advanced customer and a Moderate Updated customer.

2. Write three different customer profiles for your chosen age group and category using the form on the facing page.

3. Write a paragraph about your ideal celebrity muse.

4. Create an assessment form for each of three companies that you have identified as potential target employers. Number them in terms of your priority.

5. Write a paragraph about three potential contacts that you can approach to interview about the fashion business. These can be in retail or wholesale occupations.

6. List your three favorite retail stores and write a brief paragraph about each one and why you like shopping there.

7. List your three favorite design influences and explain why you admire them.

8. Complete all three designer profiles, then write a one-page essay explaining what you have learned about yourself.

9. List three "pitfalls" that hinder your own success in school, and explain how you will avoid them in the future.

10. Complete your Big Picture questionnaire so that you feel confident enough to move forward to Chapter 2.

If you read our designer profile of Kiernan Lambeth carefully, you might wonder how he managed to get so many great jobs. One of his major secrets is revealed in this design board that he did for 7 For All Mankind, and that is careful preparation and attention to detail.

Our next chapter will deal with that important skill: gathering all the necessary tools, both real and metaphorical, to accomplish your tasks in the most efficient and effective ways.

KIERNAN LAMBETH

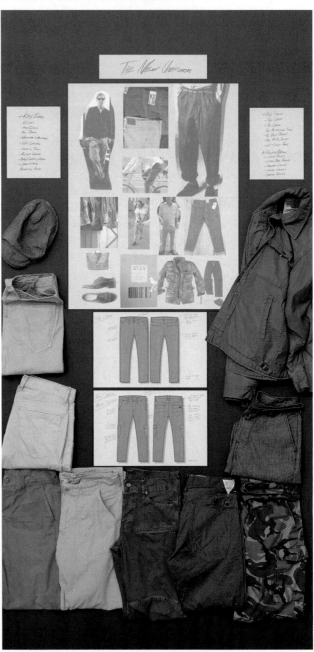

Final Boards, Fall 2011, "The New Uniform": Concept presentation boards for Fall 2011 7FAM global meeting.

YOUR CUSTOMER PROFILE

1. Name, age range, and gender _____

2. Where does your customer live? _____

3. What kind of job (if any) do you envision your customer having? _____

4. Married or single? _____

5. Education? _____

6. What stores do you imagine your customer frequenting? _____

7. Body type? _____

8. Describe your customer's aesthetic tastes? _____

9. What hobbies or activities would you picture your customer enjoying? _____

10. Where is your customer going in these clothes? (You may need to answer this later.)

 Group I: _____

 Group II: _____

 Group III: _____

 Group IV: _____

 Group V: _____

11. In what price range would your customer be comfortable when purchasing your products? _____

12. Who would be your customer's favorite designers, besides you? _____

13. Is your customer an "investment shopper"? _____

14. Add any other thoughts you have about your customer: _____

Chapter 2
Gather Your Resources

YOHJI YAMAMOTO FALL 2011
© Daily Mail/Rex/Alamy

What will it take to get your place on the runway?

Design Inspiration

Drawing Inspiration

Strong Images that Create a Mood

Exciting Groups

Effective Seasonal Timing

Strong Technical Flats

Great Resume and Business Cards

Good Time Management

What Will You Need?

Congratulations! Now that you've formulated your Big Picture plan, you can begin to assemble the tools and resources that you will need to create a great portfolio. The ten steps in this chapter will help you collect everything you need to complete the entire portfolio process. Some of your "collectibles" will be actual tools like scissors and book-binding tape. Others will be in the form of visual research and edited projects that you have already completed. All the steps are designed to save time and make you more efficient so you can avoid the stress of shoddy or incomplete work.

A New Set of Pitfalls

Even when you have a concrete plan targeting customer and design categories, it's easy to lose focus and spin off in directions that slow you down. For example, you may have a vague idea of how you want certain illustration figures to look, but the resulting figures don't meet your expectations. You may draw and redraw but under time pressure it's hard to do your best work. When things don't gel, you may start to panic. Efficiency and planning go out the window.

We have seen too many good students who, at the end of the semester, are still trying to perfect that first or second group. This situation can kill their chances to get effective feedback and to accept the best interview opportunities. Preparing carefully and assembling all the necessary tools can help you avoid this heartbreak.

The first step is choosing your portfolio case. The case helps you realistically lay out your work and assemble groups as you go. Using or adapting previously completed projects can give you a head start, and collecting inspiration images will help you fulfill the vision in your head. Later, the miniature mock-up of your portfolio (Chapter 4) will provide a concrete but flexible path forward that will keep your ideas in focus.

Even if you complete all ten steps diligently, you may still have bumps in your portfolio road. But good preparation will help stave off panic and your awesome problem-solving skills will allow you to find solutions to any dilemma. This, of course, is all great practice for the design industry, where crises are just a part of the exciting daily routine.

TEN STEPS

1. Purchase Your Portfolio Case
2. Gather Your Tools
3. Determine Your Portfolio Seasonal Order
4. Review and Update Past Work
5. Develop Your Design Concepts
6. Collect Design Inspiration and Create Inspiration Boards
7. Collect Inspiration Images for Illustrating Your Groups
8. Collect Flat Templates That Relate to Your Design Concepts
9. Introduce Yourself
10. Improve Your Time Management

STEP ONE: Purchase Your Portfolio Case

Telling designers what kind of portfolio to buy is like telling them what to wear. Both are matters of personal style that require time and research to make thoughtful choices. You don't want to go into a critical job interview with a portfolio that does not represent your aesthetic or does not function smoothly and efficiently in an interview situation.

The good news is that you can do much of your preliminary research online at websites of art suppliers like Dick Blick or Utrecht. Before you buy, however, you will probably want to go to an art store to "test-drive" the choices. Size is important, and materials can make a big difference in price. Subtle features, like extra pockets or elastic straps to hold pages in place, are hard to understand on a computer screen. Below you see examples of some of the more common case styles.

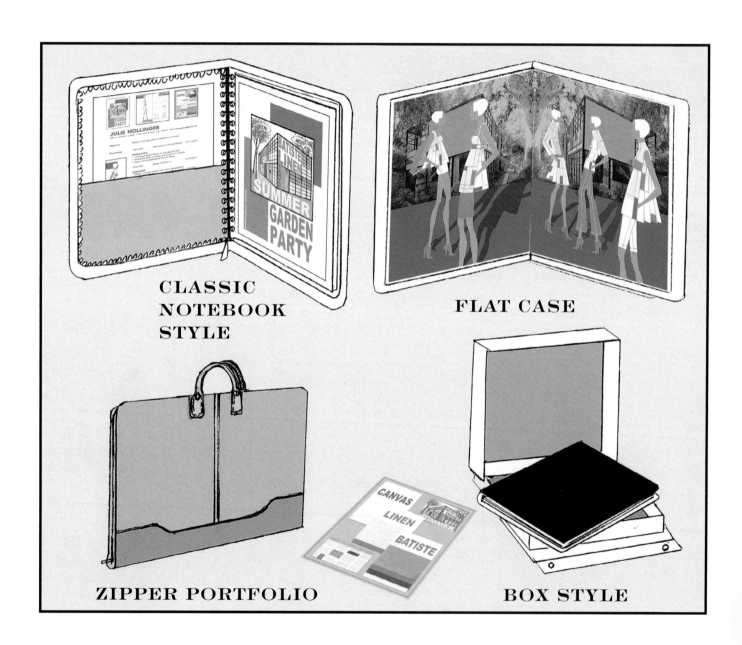

CLASSIC NOTEBOOK STYLE

FLAT CASE

ZIPPER PORTFOLIO

BOX STYLE

Things to Consider

1. Think about your height and strength. If you are quite petite, you probably don't want to buy anything larger than a 14" by 17" case. If you have your heart set on a larger format, you may want to do an 18" by 24" book, then shrink it all down into a mini version, say 10" by 12". If you have done a good job in drawing and rendering, especially your details, your images should look great in the smaller size.

2. Hard or soft portfolios is a choice you will have to make. The look is of course the primary issue, but also consider your comfort in carrying your portfolios around. If you will be driving to your interviews, it is easier to handle a more bulky portfolio. If you're on public transportation, think twice about a hard portfolio with sharp corners.

3. Screwpost portfolios are a clean, high-tech alternative to spiral or three-ring binders. They come in acrylic, both clear and matte colors; aluminum, which also looks very sleek and modern; and both simulated and real leather. They are priced accordingly. They hold up to 15 pages as purchased, and up to 40 pages with an extender kit, which is sold separately. Pina Zangaro, an online vendor, is one of the key producers of this style. The main disadvantage to the screwpost style is that the book will not lie completely flat.

4. Clear acrylic cases can look very cool and modern, but take care to keep them from getting scratched.

5. Custom leather portfolios in rich colors can bring a real aura of luxury to your presentation. The House of Portfolios Co., Inc., in New York offers this service.

6. Box portfolios can hold separate card stock pages, which makes an attractive presentation. The disadvantage is that your pages may get handled a lot and start to look worn.

7. Standard portfolios hold 15 to 20 pages. Extender kits are available if you need more pages.

8. Presentation jackets can hold and protect your portfolio. Pina Zangaro has them in 8.5" by 11", 11" by 14", and 11" by 17" sizes.

9. Consider a padded transport jacket if you must take your portfolio traveling or ship it to a potential employer. This could be a good investment if your portfolio will be "man-handled" in baggage.

10. Adhesive strips are handy to attach images to the black insert pages. You do not want your images sliding around when they are being viewed.

SCREWPOST PORTFOLIO AND CASE

ALUMINUM BOX PORTFOLIO

STEP TWO: Gather Your Tools

The tools you will be using to create your groups are largely the same ones you have been using for all your projects. A few new things will be added to the list, but your primary goal is just to make sure that you have what you need so you can work efficiently and effectively. Here is a list of things to begin budgeting for:

The Portfolio: We have discussed various case styles. If you can buy the case early in the process, you will know what you still have to spend on other items. However, if you buy your book early, don't over-handle it. The plastic pages are delicate and need to be replaced periodically if you change jobs.

General Printing: If you do a lot of work on the computer, getting things printed in larger sizes on custom paper can really add up. Students tend to wait until the last minute so school printing services get backed up. An outside printer is likely to be much more expensive, so try to plan ahead.

Computer Printer: Being able to test your work by printing it out is an important part of the process. If you are working on a computer at home, you need a decent color printer. A reasonable tabloid-size (11" by 17") printer is made by Hewlett Packard and probably other manufacturers. For those of us who do a lot of creative work, it could be a smart investment.

HOW TO ATTACH SWATCHES

Start thinking now about how you will display your fabric swatches. It is critical that they stay neat and attractive, but are still available for potential employers to touch. A good set of pinking shears is necessary to prevent fraying, unless you want to frame all the edges of your swatches. You could cut out small areas of your plastic sheets with an Exacto knife so the fabrics are exposed. One of the most ingenious and high-tech approaches is to hang separate metal rings from the book to hold extra swatches for those who want to touch. This graphic gives you step-by-step instructions.

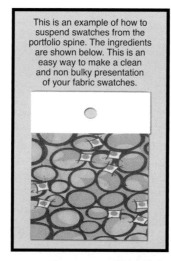

This is an example of how to suspend swatches from the portfolio spine. The ingredients are shown below. This is an easy way to make a clean and non bulky presentation of your fabric swatches.

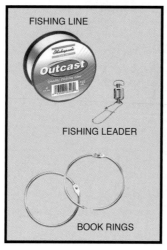

FISHING LINE

FISHING LEADER

BOOK RINGS

FISHING LINE

LEADER
SWIVELS WITH
FAST-LOCK SNAP

BOOK RING

Good Paper for Rendering and Printing of Design Groups: Don't be satisfied with inferior paper. If you are going to try rendering on an unfamiliar surface, do it early in the process, and give yourself time to make mistakes. Experimenting under time pressure often leads to disaster.

Marker Paper: Marker paper has a wonderful silky surface and makes tracing easy, even without a light box. It's inexpensive, so doing things over, which needs to happen sometimes, is not such a big deal. Borden & Riley 100% rag marker paper is our favorite brand and the least expensive paper as well. But marker paper is flimsy so it really needs to be mounted on a stiffer surface like bristol.

Canson Paper: Our students have become very skilled at working on Canson paper, either white or a color, and their books really benefit. The surface has a soft, fine art feel, but it's sturdy and looks clean and professional. It is difficult to trace your underdrawings with the darker colors. White and dove work well with a light box. One great way to speed up the process is to scan your drawings and print them out on the Canson for rendering. You can print a background at the same time.

Bristol Paper: There are a lot of different bristol pads to choose from. It is sturdier than marker paper, but the surface tends to be slick, which is not as conducive to layered marker renderings.

Vellum: This is a fun surface to render on, and it can look interesting and even high-tech. Vellum can also be put over another image for use as a background. Try it. You might enjoy the effect.

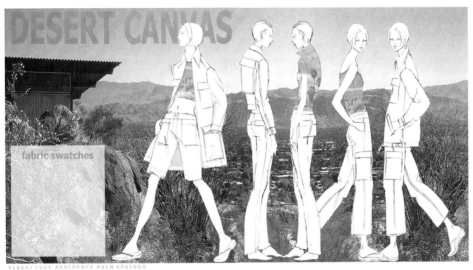

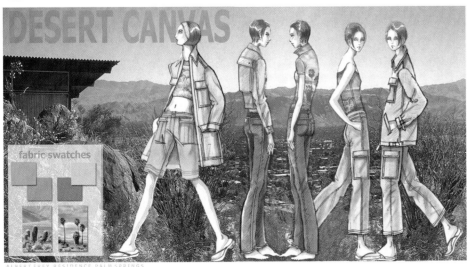

CANSON LAYOUT

Julie printed out her colored background on the Canson paper with her tabloid printer, leaving the unrendered spaces where the figures go. She then hand-rendered the figures and the outfits and added her fabric board. If she makes a mistake, she can just print it out again. She can also experiment with the colors of her background by using various adjustments in Photoshop.

Rendering Tools

Once you have chosen the marker colors and other elements for a group, buy extra. It is really frustrating to be "on a roll" rendering and then run out of an essential marker color or colored pencil. You may be tempted to "make do," but that is rarely an ideal solution. Having to revisit the art supply store takes valuable time.

NOTE: We will talk much more about rendering in Chapter 7.

1. **Copic markers and Prismacolor pencils** are our primary tools of choice. You can combine and blend them for numerous effects and create new shades from one marker tone. Copic markers are permanent brush markers with an alcohol base.
2. **Pantone markers** now come with brush tips and refills as well, so check them out. Both Copic and Pantone have more than 300 colors. Prismacolor markers are less expensive, but the chisel tip is less advantageous for rendering, and they don't have refills. They do have some useful colors.
3. Pantone and Copic **refill inks** can also be used with a **Q-tip** (buy hundreds) for rendering. The technique is fast and clean, once you get the hang of it. **Cotton balls** are handy for rendering large areas.
4. **Tombo brush markers** are also good for certain effects, but they can smear. Their black is especially black, so they are great for adding strong shadows on black garments, accessories, or hair.
5. Make sure you have good **neutral skin tones** for your figures that are not too peachy or gold. Kid's figures are possibly an exception. Plan to do different skin tones and buy accordingly. If your book is all one ethnicity, you do not look very "global" in your thinking. (See Chapter 7.)
6. **White gouache** is wonderful for highlights, adding texture, and creating dimension. Some students still use gouache for rendering as well. If you are good (and reasonably fast) at painting, then go for it.
7. **Dr. Martin's Bleedproof White** is a gouache substitute. It gets dry, but will revive with a little water.
8. **Tiny brushes** (00 and 000) come in handy for adding highlights to details like buttons and to add stitching.
9. **Gel pens** can also be great to add highlights and stitching, but get good quality pens at an art store. The cheap ones fade quickly.
10. **Metallic pens, powders, pencils, and gouache** are terrific for adding certain kinds of shine.

Art Papers

1. To tie all your elements together, mount your mood boards, fabrics, and illustrations on paper that color-coordinates with or relates to your concept. For example, you might use creamy textured rice paper to enhance an Asian theme with neutral tones. Carefully choosing these elements will make your book look more expensive and professional.

 NOTE: You do not want to mount anything on the black paper that is between the plastic sheets. The paper itself is flimsy and cheap, and black will deaden any color you put on it. Any shade of gray, or a soft neutral in warmer tones, will be a better choice.

2. Once you have chosen your mood images, take them to a good art store and put them against different colors of fine paper. (Canson is a good brand and not too expensive.) You will see pretty quickly which shade makes the image look best. If you are color-challenged, ask someone to help you choose.

 NOTE: Be wary of paper that is too textured, patterned, or heavy. Pattern can be very distracting, and thick paper can weigh your book down and make your pages difficult to turn.

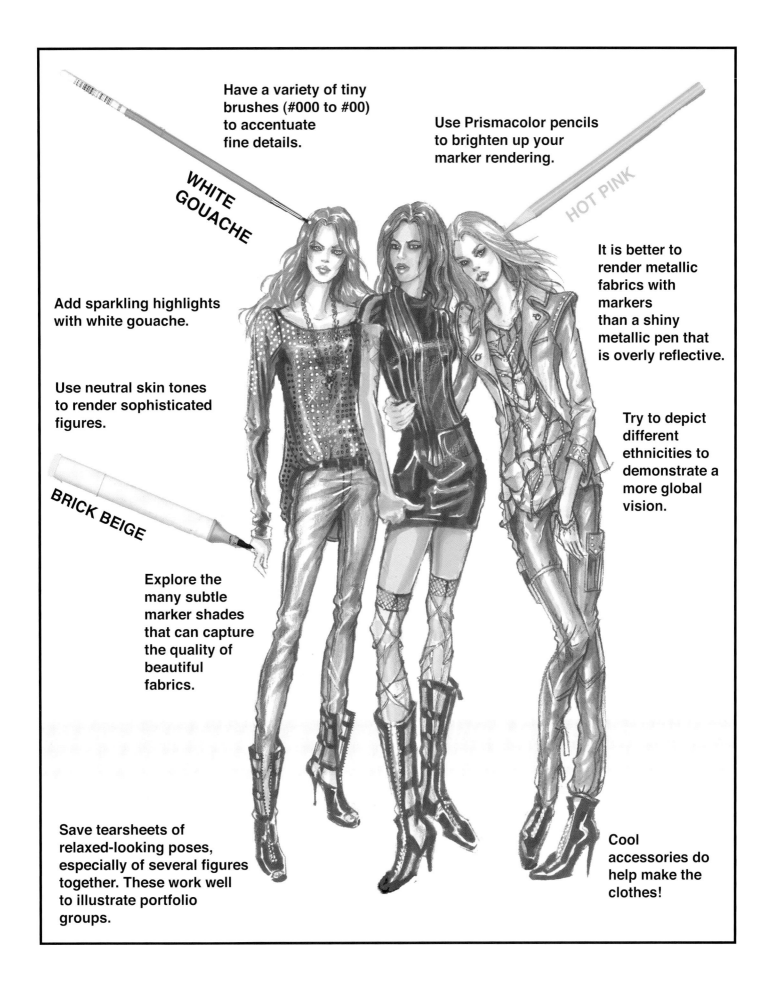

Have a variety of tiny brushes (#000 to #00) to accentuate fine details.

Use Prismacolor pencils to brighten up your marker rendering.

WHITE GOUACHE

HOT PINK

It is better to render metallic fabrics with markers than a shiny metallic pen that is overly reflective.

Add sparkling highlights with white gouache.

Use neutral skin tones to render sophisticated figures.

Try to depict different ethnicities to demonstrate a more global vision.

BRICK BEIGE

Explore the many subtle marker shades that can capture the quality of beautiful fabrics.

Save tearsheets of relaxed-looking poses, especially of several figures together. These work well to illustrate portfolio groups.

Cool accessories do help make the clothes!

STEP THREE: Determine Your Portfolio Seasonal Order

With the consumer calling the shots, everything is in fashion all year round.

Sameer Reddy,
Newsweek, March 19, 2010

Seasonless dressing and lightweight layering: That's our mantra.

Michael Fink, vice president of Saks Fifth Avenue.

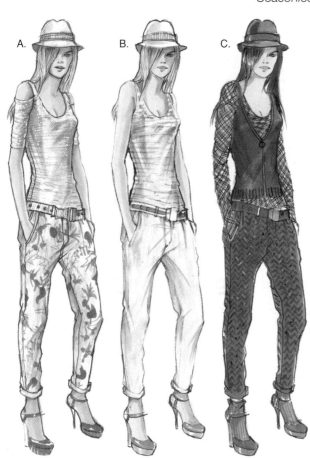

A. B. C.

SUBTLE SEASONAL STYLING

These three figures illustrate what could be a more subtle nod to seasonal differences. The garments are all casual and fairly lightweight and could easily lend themselves to layering. The Spring outfit (A) has more of a sleeve and is reminiscent of the gardens that bloom at that time of year. The Summer top (B) is sleeveless and is in warmer sunny tones. The Fall outfit (C) is in autumn colors and has a light sweater vest. A jacket could easily be thrown on top if temperatures dropped. The herringbone trouser might be lightweight wool or even a cooler synthetic. Adding socks also "warms up" the look.

Before you begin planning your portfolio groups, you will want to consider the issue of seasons. The classic portfolio cycles through the different seasons to show versatility and understanding of the issues involved in each one. (See Julie Hollinger's portfolio following Chapter 11.) However, you may want to address the growing trend in the industry toward "seasonless dressing." This trend results from wildly fluctuating temperatures, the tendency of people to layer lighter garments rather than wear heavy sweaters and outerwear, and the fact that in this global environment many people travel rapidly from climate to climate and they need clothing that has that versatility.

"What excites us about the seasonless approach is that after decades of forced obsolescence by design in retail, people are beginning to rewrite the rules on what is an acceptable rhythm in the fashion cycle." said Brian Janusiak, founder of Project No. 8, a fashion and design outpost in New York. This trend can also be great for designers trying to start their own line, because they can sell the same articles over an extended period of time and have an easier time with financing their business. It is also great for consumers because they have more choices and are not limited to any specific type of garment in a season. Seasonless dressing also encourages new technology in fabrics and fibers in the quest for easy-care light-weight textiles that suit this philosophy.

If you as a designer buy into the concept of seasonless dressing, what exactly does that mean? In reality, every designer is approaching the problem in his own way. The design partners at Badgely Mischka, for example, are using lighter weight "feathery tweeds" and just touches of fur for their fall collections. Their glamorous gowns have been pared down as well.

On the other hand, showing resort wear and chiffon dresses in the dead of winter can get confusing for some consumers. If you live in Minnesota, chances are a chunky sweater or heavy wool coat is going to look just right. You might want to research your target employers and favorite designers to see how they handle the season issue. A seasonless book is potentially more challenging in trying to achieve an interesting variety of looks. Think about how you and your peers dress. Is it seasonless? If so, you probably already have an innate understanding of styling techniques to keep it interesting.

Keep in mind that you can also take both stances in your book. You can do one or two groups that you clearly define as seasonless, and then three or four that reflect obvious seasonal thinking. This is a great way to show your awareness and versatility!

American Fashion Timetable

Spring Clothing: Prep in August, show in October, reach stores January/February, sell through March and April.

This important season is worn from the end of February to summer, so fabrics vary in weight. It is less bare than summer clothes, especially early in the season. Necklines are a little higher and sleeveless styles are unusual. Lightweight jackets are important. Spring colors tend to be lighter, pastels or soft patterns, or pale neutrals (think beige, putty, taupe, tan, or cream). Linen is a classic spring fabric. Spring wools are lightweight. Shorts would traditionally be worn with knee socks or tights.

Summer Clothing: Prep in November, show in January, reach stores in April, sell through June.

This short season is less important in terms of sales. Summer clothes are the most revealing. Many garments on the runways today look like bathing suit tops or bottoms. Necklines and backs tend to be more revealing, and skirts are generally really short or really long. Fabrics are light and cool. Common colors are either hot citrus colors or white. Prints tend to be bold and intense.

Fall I Clothing: Prep in January, show in March, reach stores in May and June, sell through October.

Transition or Fall I is the bridge season between summer and fall. The weather toward the end of August is still warm, but the mood has begun to change. Customers begin to shop, thinking of going back to school and work.

Fall II Clothing: Prep in February, show in May/June, reach stores in July through October, sell through December.

This is the most important of the two fall categories, and involves the bulk of real winter weather clothes: sweaters, wool suits, skirts and trousers, coats, and jackets. Most areas of the country are really cold in winter, so heavy coats, closed and high necks, long sleeves, and multiple layers have been the standard. Even warm climates have a chilly couple of months so most customers like to have some warm winter-type clothes.

Resort/Holiday: Prep in June, show in August, reach stores in November/December, sell through February.

This has traditionally been a short season that takes place after Fall II. This season addresses two major activities: holiday events and winter vacations, usually to warm locales. It could include skiwear.

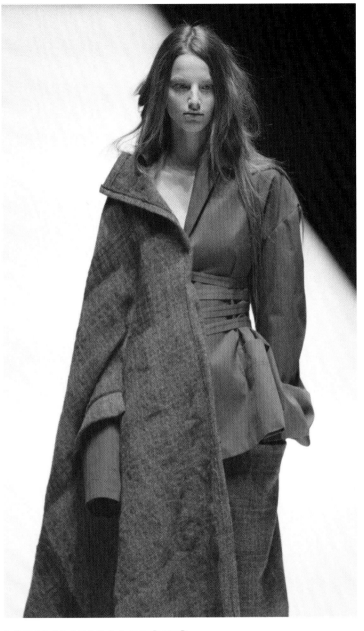

YOHJI YAMAMOTO

The rich winter fabrics make this an obvious Fall II outfit in designer Yohji Yamamoto's Fall Runway Collection.
© *Daily Mail/Rex/Alamy*

TO RESEARCH COLORS FOR THE CURRENT SEASON

fashiontrendsetter.com/content/color_trends.html
promostyl.com
thecolorbox.com
Here and There color boxes
Textile View magazine
Cotton Inc. and other fiber organizations
Current color cards

STEP FOUR: Review and Update Past Work

One way to avoid the danger of running out of time is to make use of work in your portfolio that you have already completed. Some classes may require all new groups, so make sure to discuss it with your portfolio advisor before you get too attached to the idea. It is certainly possible to do all original groups if you stay on task and manage your time, and you can always adapt your best ideas to new formats.

If you can use work you have already completed, that does not mean that your problems are solved. The work has to be suited to your target customer and age-group, and it must still feel current. You may have to create a group from individual sketches in Photoshop, and re-render certain fabrics to look more current. (See the updates shown on the facing page.)

Chances are, however, that you have done work you are proud of, and it would be a shame not to show it if it fits the bill. One or two "recycled" groups is realistic and very helpful in getting your portfolio process moving. The goal is to create a true representation of your best creative output, so reinventing the wheel is not practical or necessary.

So before you begin gathering your fabrics and planning your portfolio mini mock-up, (Chapters 3 and 4), we recommend that you revisit past design projects to determine if any of them fit into your portfolio plans. It would also be wise to get some opinions on the groups from instructors and peers to see if your high opinion of them is still shared.

Points to Consider

1. **We tend to be more objective about past work.** When considering older work, don't try to force something into your book that is too far off track. For example, a beautiful eveningwear group could be redesigned for a swimwear portfolio, but don't just put it in your portfolio because you like it and it's done.
2. **Consider what projects you got good grades on.** If your instructors liked the work, even if it was done last year, then chances are it has held up pretty well.
3. **Decide which work really expresses who you are as a designer.** Even if the group needs a complete makeover, you can benefit from the creative thinking you have already done.
4. **Ask yourself, "With some 'retooling' could this group look both current and exciting?"** If you are not sure the answer is yes, get a second and even a third opinion.
5. **Changing a couple of fabrics will give the group a whole new look.** You might also re-render certain garments to move the group into a different season. If you already have the silhouettes and the figures, rendering new garments, scanning them into the computer, and placing them on the figures can be a fairly easy job.
6. **Consider changing your muse.** The group might benefit from a more exciting or current muse. Scan the original and add several new hairstyles or different faces. You might be surprised at how the group comes alive.
7. **A more current shoe or hat can really update a group.** Fingerless or short gloves add a sporty look.
8. **Adding a background might give your concept more impact.** Think about several solutions, then find the images that support your ideas. Scan it and see how it looks.
9. **Combining individual figures into an exciting group composition may create a whole new dynamic.** Play with them in Photoshop, and consider changing the perspective of some of the figures by moving them back or forward in space. Don't be satisfied with obvious solutions.
10. **If you designed your group a year ago, chances are you are a better illustrator now.** Think about re-illustrating. It might be more than worth the effort.

Updating Your Previous Work

Using Existing Work and Updating it Can Be a Quick Way to Add a Fresh Look to Your Book.

A

These two images show a Fall look (A) moved forward to a Spring look (B). Often manufacturers and designers revisit styles that have sold well and update the look to work into the next season. You may have a group you designed previously and decide to refabricate or recolor to a new season. Refreshing designs that work is a quick way to add new groups to your portfolio.

B

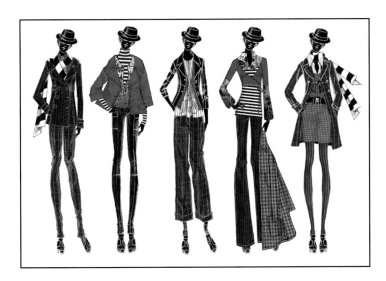

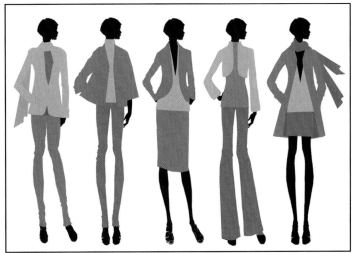

Updating your group here shows again an example of refabricating, recoloring, and rethinking design. As you can see, the overall silhouettes and proportions are the same, but the details of the actual pieces have been rethought. Also, a second skirt has been added to balance the group. This middle outfit retains the same volume as the full pant in the previous group on the left.

STEP FIVE: Develop Your Design Concepts

When you have decided which groups, if any, you can use from your past work, you can begin to develop ideas for the rest of your concept groups. You can approach this in a number of ways, so there is no one right answer. You may already have methods that you have developed in the classroom or from your own exploration. But some steps you might consider are:

1. **Analyze the groups you already have, if any, and think about what additional groups would best create a balanced portfolio.** You can also consider whether the existing group lends itself to any general theme like Baroque Architecture or Film Noir. If so, then all your other groups can be built around the same theme.

 Example:

 Your muse is a young, junior girl who is edgy but feminine, and shops at stores like Rampage or Forever 21. You have a rendered dress group of asymmetrical silhouettes in soft spring prints. This would make a good third group in your book. You like to design separates, so you start with a seasonless denim group, developing fabric treatments with elaborate stitching and varied types of studs. You add soft feminine print tops and cute platform shoes for contrast. Your second group could lean more to Fall, using corduroy, delicate plaids and stripes, subtle graphics, and cute accessories like fingerless gloves and scarves, and lots of layering. Tailoring details add interest. Your third group might be a holiday theme, mixing dresses and separates. The fabrics are stretch velvets and lace with fun sequin details. If you have time to do a fourth group, you might do rendered flats, rather than figures, in Adobe Illustrator to show off your computer skills. This could be a blouse or sweater group with embellishments like appliques and embroidery.

2. **Research current trends at sites like Style.com, Stylelist, Daily Candy, Trendhunter, etc. (The search term *fashion trend* yields more than 24 million results.) Pick out a few that suit your aesthetic and muse.** For example, the key trends for Style.com, Fall 2010, were "Fifties Something," "The Gold Economy," "Under Wraps," "Man Up," and "The Long View." Just these brief descriptions probably generate interesting images in your mind, and because designers tend to follow similar trends, you can be inspired by several different but similar points of view.

3. **Compare the most recent color forecast to the colors you used previously and use that information to find great fabrics for your new groups. You can also update finished groups with more current colors.** A number of current color forecasts are available online, including the Pantone ten best colors for the season. The example shown is for Spring 2011, found at http://www.fashiontrendsetter.com/content/color_trends/2010/Pantone-Fashion-Color-Report-Spring-2011.html.

4. **Add your personal point of view.** Look at the trends and colors that turn you on, then think about your special interests, and picture how those influences might meld. For example, you like the "Man Up" trend for womenswear, but your passion is hiphop music. You like Lil' Kim's look and attitude, so you make her your muse. You design a group of cool man-tailored separates with a hiphop edge and graphic Tees to add a casual feel, demonstrating your talents for creating cool, sophisticated images. Or maybe you are really good at knitting, so you design beautiful Armani-type menswear-inspired separates worn with beautiful hand-knit sweaters and accessories. NOTE: Good design, accompanied by well-made samples or original fabric treatments, makes an impressive combination.

Pantone Fashion Color Report for Spring 2011

Designer: Alexsandra Del Real

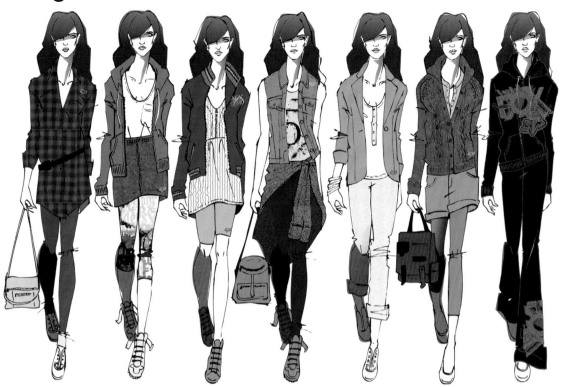

CONCEPT: BLURRED LINES

Designer Alexsandra Del Real uses a seemingly simple concept of blurred lines to create this graphic, eye-catching group.

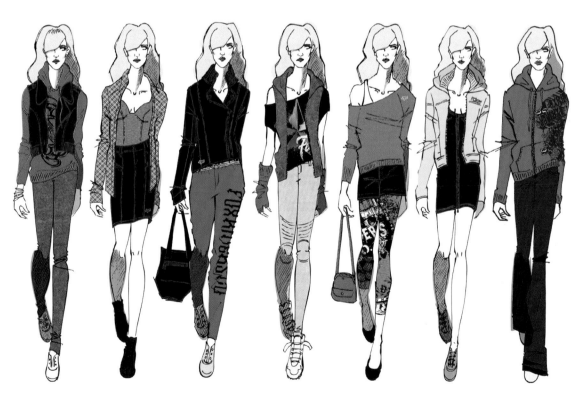

CONCEPT: MOTOGROUP

Alexsandra's cool-girl group is built around the sport of Motocross, in which riders race motorcycles or all-terrain vehicles on off-road tracks.

Croquis Book or Design Journal

Potential employers of course want to see a finished and polished portfolio of your work, but many also want to see your *work or design process,* which can be shown in a *croquis book, also called a design journal* or a *designer sketchbook.* All of these are essentially the same thing: a book that contains evidence of your design process, shown through your quick sketches of entire outfits, single garments (like a group of trousers), or ideas for details in general, or more specifically, for the group on the facing page. Showing that you can effectively develop an idea through a book of confident, quick sketches is generally very impressive to someone who understands design. You can also include fabric swatches, notes, and ideas for groups as well as your inspiration images. A book that is "chock full" of great ideas makes you more appealing to the manufacturer or head designer.

Choosing the correct sketchbook is also important. Find a book that looks elegant and also inspires you to draw. If you like to edit your sketches, you can also glue pages into the book. Do this carefully and with style, and your book can look like a very creative collage.

You can also keep an inspiration sketchbook as shown on the facing page. This is a book dedicated just to images that inspire you, and also sketches you might do from designers' runway collections that you admire and want to study more closely. You will always understand an outfit better if you actually sketch it, because you will see where the proportion has to be pushed and also become aware of subtle details. Just as painters have found great lessons in copying their favorite paintings, so will you grow by taking the time to sketch the latest designs that excite you. Of course, sketching from the great masters of the past like Balenciaga, Claire McCardell, or Christian Dior will bring you enormous insight as well.

A design group inspired by Swarovski crystals. Many more sketches might be drawn before the final group is considered finished.

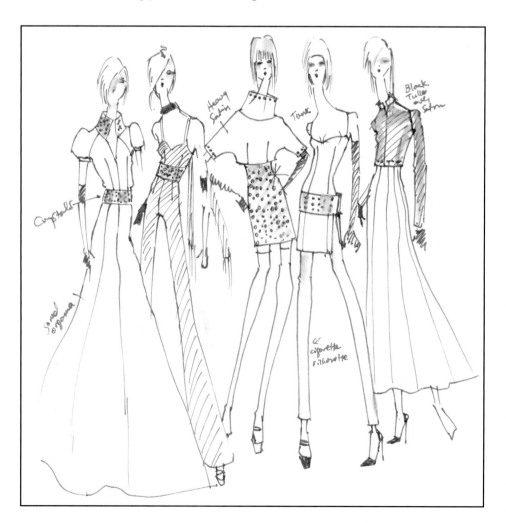

KEEP YOUR RESEARCH AND TEARSHEETS IN A SKETCH BOOK

Carry your sketch book with you and make quick sketches of ideas as you travel or do research for shopping reports.

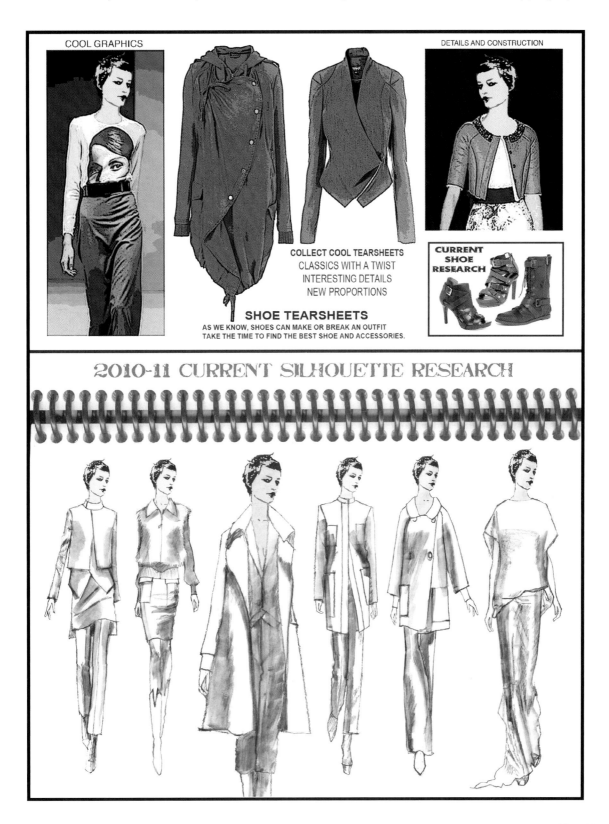

COOL GRAPHICS

DETAILS AND CONSTRUCTION

COLLECT COOL TEARSHEETS
CLASSICS WITH A TWIST
INTERESTING DETAILS
NEW PROPORTIONS

CURRENT SHOE RESEARCH

SHOE TEARSHEETS
AS WE KNOW, SHOES CAN MAKE OR BREAK AN OUTFIT
TAKE THE TIME TO FIND THE BEST SHOE AND ACCESSORIES.

2010-11 CURRENT SILHOUETTE RESEARCH

Sketching silhouettes gives you a more accurate feeling for the way a garment is constructed. When you do this with current designs (as well as historical research) you are feeding your own brain/design computer. When you are ready to start your new croquis, your subconscious will have been working on new ideas with the latest design providing inspiration. This is a very different process from simply copying what someone else does.

STEP SIX: Collect Design Inspiration and Create Inspiration Boards

Collect Design Tearsheets

No designer works in a vacuum. Nothing is certain but change. These are important truisms in the fashion world. Most successful designs reflect the culture in which they are created, and that means that when certain visual or conceptual ideas are "in the air," most good designers will pick up on that trend, almost as though it is passed through telepathy. For example, bigger shapes suddenly looked exciting in 2010 after a decade of shrunken silhouettes. Designers are having a great time with these extravagant shapes that reflect this change.

So looking and reacting to what is happening in fashion is a critical part of a designer's work. Creative people generally need to input visual data, whether it is clothing research or the latest artwork in galleries, in order to turn out ideas. Collecting such data for each design group from fashion magazines and other less obvious resources is your next step in the portfolio process. When you see an image that relates to your concepts, either tear it out (if it's your magazine) or photocopy it. Start right away to sort these images into folders labeled specifically for each group. The images will be edited and become part of your inspiration boards.

Gather Interesting Detail Ideas That Go Well With Your Concept

Along with great looks and silhouettes, you will also want to collect the following:

- Interesting stitching details
- Buttons or other fastenings
- Interesting drape details
- Fabric treatments
- Pocket treatments or styles
- Cool seaming
- Asymmetrical collars or fastenings
- Ideas for cool graphics

Collect a Variety of New Silhouettes Suitable to Your Customer

- What is happening in fashion currently? Putting words to the trends in silhouettes—for example, "oversized" or "extreme shoulders"—can help you answer that question.
- Collect five to seven tearsheets of what you feel are the most current and interesting shapes for each of these garments below. (Alternatively, you can collect tearsheets of the kind of garments you are doing for your group; for example, Activewear if you are doing a ski group.)

Coats Jackets Tailored Jackets Day Dresses Tops

Blouses Shirts Vests Skirts Short and Long Pants

Eveningwear Cocktail Dresses Swimwear Lingerie Sleepwear Activewear

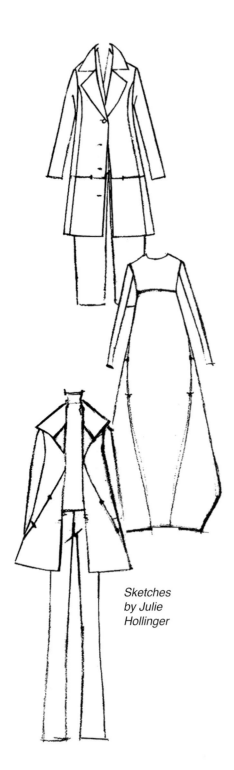

Sketches by Julie Hollinger

Collect Design Inspiration

Collect Tearsheets of Current Accessories that Will Enhance Your Look

Take the time to ask yourself questions about accessory choices as you plan each group. Make sure that your decisions support the look and attitude of your muse, and be cautious about making choices that are too obvious or that match too perfectly. Remember, you do not have to buy the Manolo Blahnik or Vuitton bags, you just have to draw them!

Collect Historical Research

We ignore the past at our peril. The past, whether it is five years ago or five hundred, is an endlessly rich source of information and ideas. What periods, historical figures, military uniforms, ancient architecture, and so on, might inspire a particular group? For example, if I wanted to work at Calvin Klein, I might create different concepts for my groups, based on modernist architecture from the 1930s and 1940s, to achieve his minimalist aesthetic. For John Galliano, I would probably look at baroque furnishings. Nature photographs would suit Roberto Cavalli, and Viktor & Rolf would have to be some form of conceptual art.

Create Your Inspiration Board

The inspiration board is a tool for your use that can serve as your "touchstone" during the design process. It can also be a means to communicate your concept to design instructors or peers. It is easy to drift from a concept if you are not focused, so this is a excellent tool to help you stay where you want and need to be. Of course, sometimes concepts are not working and you find better ideas in the process, but make sure you are changing paths with the awareness of where you originally wanted to go.

EXAMPLE OF A WORKING INSPIRATION BOARD

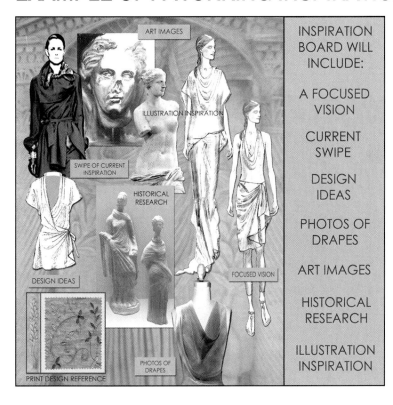

INSPIRATION BOARD WILL INCLUDE:

A FOCUSED VISION

CURRENT SWIPE

DESIGN IDEAS

PHOTOS OF DRAPES

ART IMAGES

HISTORICAL RESEARCH

ILLUSTRATION INSPIRATION

Assemble or collage your most inspirational elements onto a board, but allow for the possibility that you might want to remove certain images as you go along. Straight pins or double-stick tape work well.

Add more images or elements as they become relevant.

Remove any images that don't add to your current vision. Don't allow your board to become cluttered.

STEP SEVEN: Collect Inspiration Images to Illustrate Your Groups

While collecting imagery for your design groups, you will also want to find things that will inspire you when illustrating. Focusing on this in the beginning will pay off, because you won't be throwing something random together at the last minute. Keep a separate folder for each group so each one has its own unique mood. Even if cohesion is your priority and you want only subtle differences in the look of each group, approaching each concept with inspired focus can help create visual excitement.

Points to Consider

1. The design and illustration of a group are intimately related. One plays off the other.
2. Your design concepts will dictate the look of your muse and your muse will influence your designs.
3. Never conceive a design group with a generic look for your figure.
4. Seek inspiration in unexpected places, so your work won't look like everyone else's.

Gather Tearsheets, Photos, or Art Images Relating to the Look of Your Customer and/or Your Muse.

Celebrities: Celebrities can make exciting muses, and everyone knows who they are.

Fashion Models: Models look great in clothes, and it's easy to get photos from different angles.

Friends: If your friends are cool, use them as muses. Take photos.

Yourself: If you have a distinctive look and you are good at posing, you may want to have someone photograph you. Some designers make excellent muses for themselves.

Images from Paintings, Drawings, or Illustrations: If you love another artist's work, you can be inspired by his or her approach, but make it your own.

EXAMPLE OF A WORKING ILLUSTRATION INSPIRATION BOARD

As you plan your design groups, envision how the final illustrations might look. Start now to collect images and attach them to a board that you can see as you work. Just as you did in the design board, allow for adding and removing images as you go. When you are ready to start the actual group illustrations, put the board in front of you so you can remember all the good ideas you had along the way to create visual excitement.

YOUNG URBAN STREETGUY GROUP

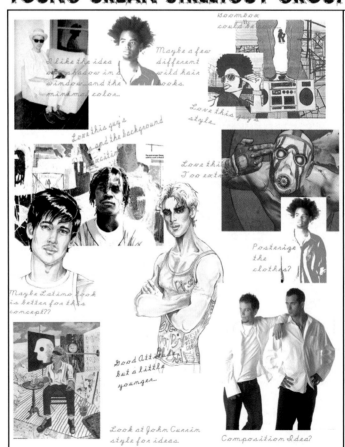

YOUR BOARD MAY INCLUDE:

MUSE IDEAS
THESE CAN BE PHOTOS OR DRAWINGS

COMPOSITION AND POSE IMAGES

COOL PRO ILLUSTRATIONS THAT RELATE TO YOUR CONCEPT

POTENTIAL BACKGROUNDS

FINE ART INSPIRATION

COLOR INSPIRATION

RENDERING IDEAS

NOTES

ANYTHING THAT INSPIRES GOOD ILLUSTRATIONS

Designer: Renata Marchand

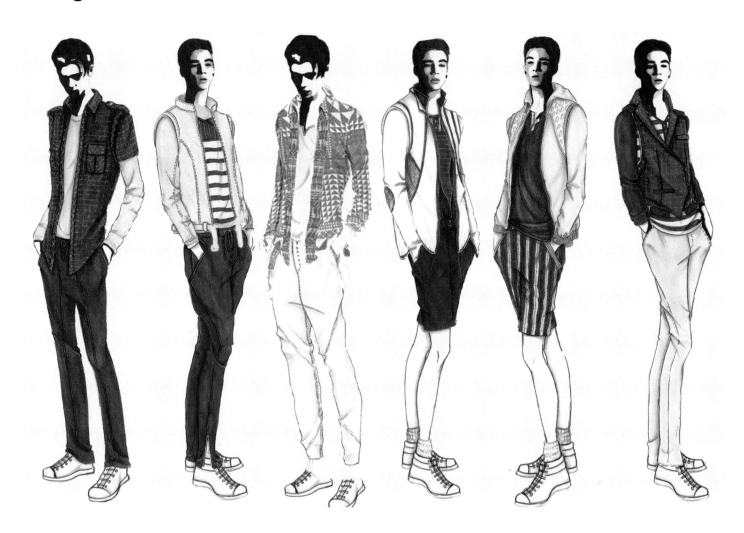

Renata created this cool mood image suggesting a rebellious populace that is subtly reflected in her edgy menswear group.

SWIMWEAR FLAT TEMPLATES

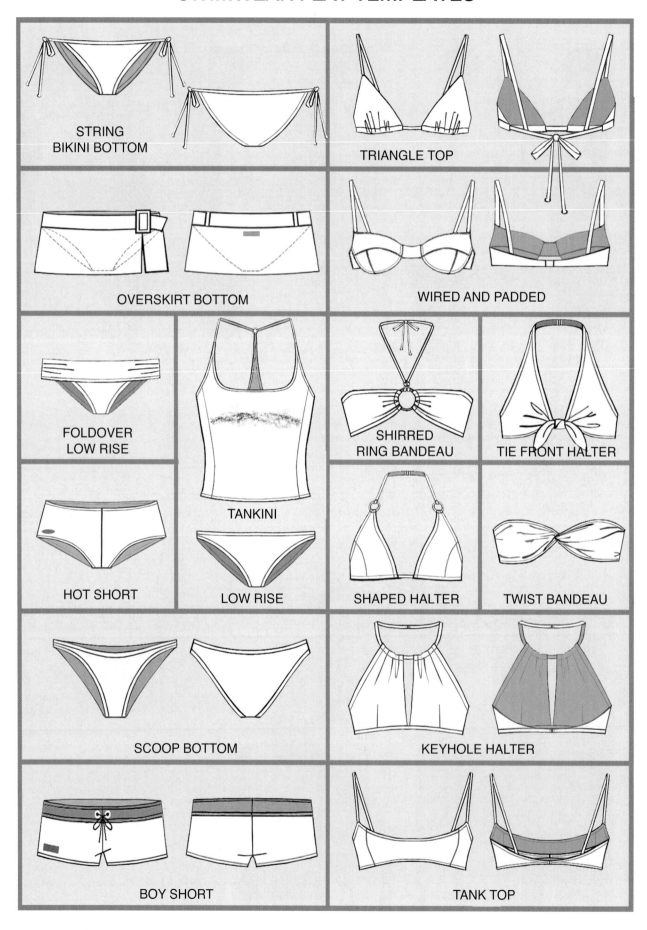

STRING
BIKINI BOTTOM

TRIANGLE TOP

OVERSKIRT BOTTOM

WIRED AND PADDED

FOLDOVER
LOW RISE

TANKINI

SHIRRED
RING BANDEAU

TIE FRONT HALTER

HOT SHORT

LOW RISE

SHAPED HALTER

TWIST BANDEAU

SCOOP BOTTOM

KEYHOLE HALTER

BOY SHORT

TANK TOP

STEP EIGHT: Collect Flat Templates That Relate to Your Design Concepts

Technical flats are the equivalent of an architect's blueprints. When designers draw flats, they are spelling out the content of their designs in terms of proportion, style lines, construction, details, fastenings, and so on. If the design is going overseas to a sample maker, then the flat becomes a *spec* with exact measurements and specifications. Often a specialist does all the specs for a manufacturer. People in the industry love good designer illustrations but to see the real content of a garment, they look at the technical flats, and it is flats that are used in day-to-day business in the industry.

The ability to draw beautiful but readable flats is an art, whether they are drawn by hand or in Adobe illustrator. Hopefully, by this point you are an expert at putting your ideas into flat form. But no matter how skilled you are, having the right templates to draw over can save you from "reinventing the wheel." Figure templates can help you create flats that are accurate proportionally, while the right garment templates allow you to draw silhouettes quickly and accurately without worrying about symmetry or the angle of a lapel. You can create some of these templates yourself if necessary, which can still save you lots of time when you are under pressure. But we have devoted a whole chapter to providing you with some good basic templates.

There are different stylistic approaches to flats of course. Ideally you are proficient at highly technical flats and artistically loose varieties as well. Computer flats for most companies are an absolute requirement for entry-level jobs, but different companies will require different styles of flats, and may also use special software, so it pays to be flexible.

Things to Consider

1. **An entry-level designer will probably be asked to produce the line sheets of all the season's styles.** Accuracy is essential as these sheets are used by salespeople, for buyers, for production purposes, and so on. Your portfolio should showcase your ability to fulfill this important task. Knowing how to flat garments that are not your designs with accurate proportion and details is key.

2. **You will probably also be creating "tech-packs."** These use flats as a basis for analyzing every aspect of a production garment, from graphics to trims to stitch lines, and so on. Showing that you are very aware of details in your own designs will convince an employer that you would be effective at this job.

3. **Creating flats in the industry ultimately requires a certain level of speed and accuracy.** Continuing to work over good flat and figure templates will help you be successful.

4. **Do not leave your portfolio flats until the last moment, so they become sloppy or inaccurate.** Flats are a critical part of your presentation, and your groups are not complete without them.

5. **Different companies like different styles of flats.** Some will want realistically proportioned flats, while others want flats that reflect the exaggerated proportions of the fashion figure. Others may want very technical-looking flats, while loose flats with "personality" may get you a different job. After all, flats can be a good selling tool, so being versatile is important.

6. **Some portfolio groups may have flats only.** This can look terrific, especially if the designs are elaborately detailed and stitched or very graphic. Fully rendered flats can also look very exciting.

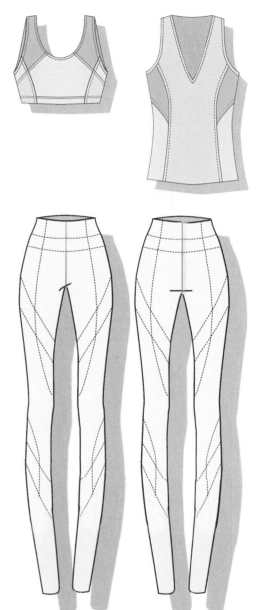

Technical flats created in Adobe illustrator are well-suited to graphic Activewear.

STEP NINE: Introduce Yourself

Plan Your Process for Creating Resumes, Cover Letters, Business Cards, and So On

One of the key elements of your portfolio is your personal resume. This page is the classic format that tells the potential employer what education and job experience you bring to the table. Cover letters, business cards, and "leave-behinds" are all key tools to help you get that dream job. We talk about these much more in Chapter 11, but we suggest that you start thinking about these important elements now, and plan a time to focus on them so you are not rushed. Our students actually create their resumes before they start the portfolio process, so they can focus on their design work. Though you may not want to do this so early in the process, leaving it until the last minute when you have an important review or interview is probably not practical.

Although you can find many resume templates on the Web, as well as books for creating resumes, these resources are rarely geared to the creative individual. We have provided examples of materials to accompany a fashion portfolio that might be helpful. You can personalize your resume with creative touches so it feels like a representation of who you are. This can make the process more fun and rewarding. So take the time now to at least skim the information about these key ingredients and you can be planning your strategy as you do your book.

RESUME	LEAVE BEHIND PAGE
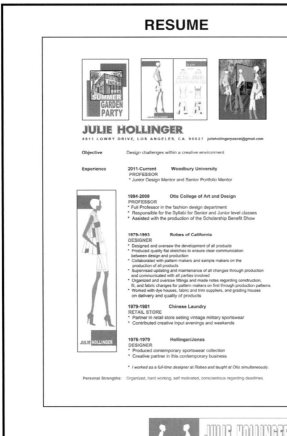	

BUSINESS CARDS

STEP TEN: Improve Your Time Management

What are effective ways to plan and budget your time?

1. **Set aside specific times to work on your portfolio and stick to them.** Be realistic about how much time you have and how much you need to do a good job. Working within a set time period can make you more efficient. For example, I might give myself two hours to plan my group layout and do ten flats. If the flats are a little rough at the end, I will move on but budget time for "polishing" the flats in my next session.
2. **Set goals for what you need to accomplish each week and take them seriously.** There is a temptation to indulge your "perfectionist" tendencies and obsess. If you know you're likely to fall behind, give a friend permission to call you on missed deadlines. Then be appreciative when they do!
3. **Allow extra time for unexpected problems.** It's inevitable that the printer will be closed, the art store will run out of your markers or paper, your cat will get sick, and so on. That's life, so plan for delays.
4. **Know yourself.** If you work better at night, then use that time for design work. If you are more of a morning person, then use weekends for design, and save late weekday hours for activities that require less brainpower.
5. **Don't underestimate the amount you can accomplish in a very short time.** That twenty minutes at lunch time, before your next class, can be a productive research period in the library. One hour of drawing flats before you study for an English test can clear your mind and calm your nerves. Just getting something done every day will help you feel that you are moving forward, and keep you connected to your process.
6. **Remember that your subconscious keeps working on problems even when you are sleeping.** If you look over materials that address something you need to solve, you may wake up with a solution in the morning.
7. **Don't become too isolated.** Get out occasionally and soak up the atmosphere of the outside world.
8. **Don't try to do all your groups at once.** This sounds strange, but we have often seen students jump from group to group, never finishing anything. It's helpful to gather the materials you need in the beginning of the process, but then focus on one group at a time.
9. **Put groups in your portfolio as you go.** Assembling them will help you see if there are any problems that need to be addressed. You can also get more effective feedback and generate a sense of accomplishment.

MY PORTFOLIO CALENDAR

Sunday	Monday	Tuesday	Wednesday	Thursday	Friday	Saturday
MENSWEAR SHOW	BEGIN WORK ON THIRD GROUP	CROQUIS- 4 HRS. TRIM AND BEADING	1 KNIT SWEATER SAMPLE DO FABRIC TREATMENTS	2 CROQUIS: 4 HOURS CLASS-8-4	3 PICK UP SAMPLES SILKSCREEN PRINT	4 DRAW AND PRACTICE RENDER FIGURES
5 WORK ON RENDERING- 3 HRS	6 CRITIQUE ON PRACTICE RENDERING REFINE-5 HRS.	7 LUNCH WITH MOM	8 PICK UP SWEATER SAMPLES CROQUIS-3 HRS	9 CLASS 8-7	10 LOOK FOR POSES 2 HOURS	11 RENDER FIGURES 7 HRS.
12 ROSE BOWL- FIND SAMPLES	13 BEGIN WORK ON FINALE GROUP CROQUIS: 4 HRS	14 CROQUIS: 4 HRS.	15 CRITIQUE ON CROQUIS BEGIN FIGURES 3 HOURS	16 GO TO LIBRARY AT LUNCH FOR MOOD IMAGES REFINE FIGS-2 HRS.	17	18 TRANSFER FIGURES- HIT COMPUTER LAB FOR HELP
19 RESEARCH ON INTERNET	20 CRITIQUE ON RESEARCH AND MOOD IMAGES	21 ASSEMBLE THREE GROUPS FOR FEEDBACK	22	23 PRACTICE RENDERING- 5 HOURS CLASS-3-6	24 MID-TERM EXAM	25 RENDER FIGURES 7 HOURS
26 FILM SOCIETY	27 Render Finale Group-5 hrs. CLASS-8-4 GO TO FABRIC STORE	28 6 hrs. →	29 3 hrs. → FASHION SHOW REHEARSAL	30 CLASS-8-6 3 HRS. last minute touches	31 PORTFOLIO DUE!!!!	SLEEP

Creating your own time-management calendar is a great way to divide your time and tasks in a realistic way. The students who seem to handle things with ease and meet their deadlines tell us that they plan their week very specifically, with both the time allotted and the task to be completed. It does not mean they never veer off schedule, but they do take the plan seriously and stay with it as much as they can. If circumstances change, they can always adjust the schedule to take those issues into account. If you meet an important deadline, reward yourself in some small way. An extra hour of sleep, a movie on Friday night; little things mean a lot.

CHAPTER SUMMARY

Is Your Foundation in Place?

The essence of this chapter is your creation of an inspirational foundation from which your best work will grow. You have gathered some necessary tools so you can operate at maximum efficiency. Diligently using these same methods in the workplace will help you develop work habits that will serve you well for the rest of your life. Because designer jobs are so complex and multi-tiered, your understanding of careful preparation and organization will be invaluable wherever you work. Your recognition that working in a vacuum is never ideal will push your growth beyond unnecessary boundaries.

If you have followed the step-by-step plan in this chapter, your task list (see below) should be largely complete. But go through the list to make sure that you have not skipped any tasks. It is easy to avoid the tasks that are less comfortable or more work intensive and find yourself stumbling over them at a less convenient time.

Work process is an individual thing to a certain extent, so you may have a different method for organizing your work or budgeting your time. For example, office supply stores sell many professionally created time-management systems, and you may want to invest in one of these. You may like a file folder with multiple pockets rather than individual folders. There is no right and wrong, as long as you create a good system that works well for you.

TASK LIST

Check these tasks off as you complete them.

1. Purchase your portfolio case.
2. Make a list of all the supplies you are sure you will need.
 Pencils: _____
 Paper: _____
 Markers: _____
 Fabric Display Items: _____
 Other: _____
3. Make a second list of things you might need, but are uncertain about at this point in the process.

4. Purchase all the items you know you will need.
5. Determine your season order.
6. Review past work for potential inclusion in your portfolio.
7. Plan for updating past work as needed.
8. Create concepts for all four or five groups.
 Concept 1: _____
 Concept 2: _____
 Concept 3: _____
 Concept 4: _____
 Concept 5: _____
9. Create labeled folders for each group to hold design and illustration inspiration.
10. Collect design inspiration for each group:
 Group 1:
 Group 2:
 Group 3:
 Group 4:
 Group 5:
11. Collect illustration inspiration for each group:
 Group 1:
 Group 2:
 Group 3:
 Group 4:
 Group 5:
12. Create a sketchbook for jotting down and sketching your ideas and keeping general inspiration.

13. Create folders and collect garment templates for each group. For example, your templates for your summer group, which will probably be fairly bare and light-weight, will be quite different from the garment templates for your fall groups.

14. Read the section in Chapter 11 on resumes and business cards and plan when you will create these key elements for your book.

15. Make copies of the calendar template below, and begin to fill in your time management plan. NOTE: You will probably want to enlarge them so you can write in the spaces easily.

MONTHLY PLANNING CALENDAR

Chapter 3

Develop Your Fabric Boards and Master Sheets

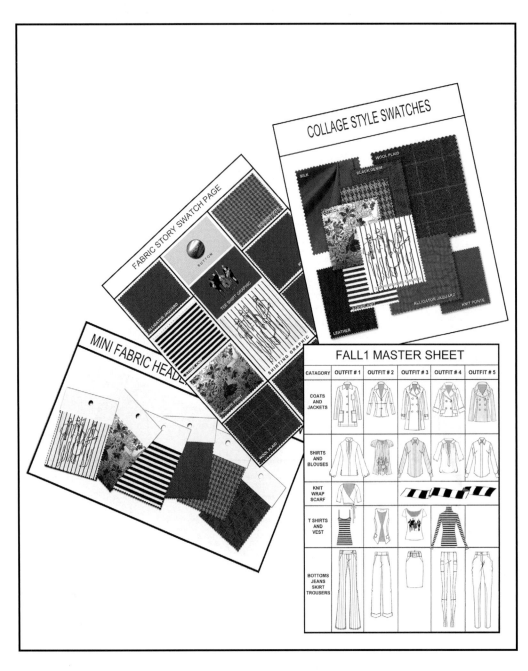

On matters of style, swim with the current, on matters of principle, stand like a rock.

Thomas Jefferson

Fabric Savvy

Fabric is the medium of fashion designers. Many designers start with fabrics when they begin a new season. A beautiful wool, lace, or yarn will inspire an entirely new direction. If you want to create expensive, sophisticated clothing, your fabric choices must reflect that quality. On the other hand, if you want to do cool street "fast fashion," you have to be realistic in what fabrics you can use, and keep the prices within your customer's budget.

Having been through a fashion program, chances are you have had a course in textile science. You've probably studied fabrics so that you know the "hand" of different fibers, how wool feels compared to cotton or silk, how an expensive jersey fits the body in a way a cheap fabric never will, how a fine weave has a sheen that a coarse weave does not, and so on. An experienced designer can feel a fabric and know exactly how it will drape and what kind of design will suit it best. Developing that kind of expertise should be one of your goals.

Fabric Conventions

Working in the industry, you will likely meet with fabric people on a regular basis. Even better, you may be sent to various fabric conventions that happen all over the world. Probably the most famous and popular convention is Premiere Vision in Paris, which attracts hundreds of the most prestigious fabric mills and textile manufacturers every year. It is easy to see how fashion trends get started, because many designers are seeing the same new and exciting fabrics. Certain things are bound to stand out, and certain fabric houses like Sophie Hallette will cater to a number of the top designers, so there will be some obvious similarities. If you live in a city with a garment district, like New York or Los Angeles, check out the "jobbers" as well. They are business people who buy leftover fabric from manufacturers and resell it for much less.

Fabric Boards

Putting together effective fabric stories that reflect your concepts is one of the key skills you will display in your portfolio. How you choose, edit, and arrange those swatches will tell a potential employer a great deal about you as a designer. It is hard to create an exciting group with a dull set of fabrics. One or two gorgeous fabrics can make a beautiful group, but fabric stories are generally more visually compelling when they involve interesting combinations of different textures, shades or colors, and kinds of fabric. A designer cannot just throw any combination together and hope it works. He or she needs a reason for each choice made, and that kind of thought requires time, practice, and focus. A word of caution: Although taste in fabric can be quite personal, avoid choices that no one else can relate to. Get feedback, study the fabric strategies and examples in this chapter, and be willing to head back to the fabric store for additional choices.

Master Sheets

Once your fabric boards are in good shape, you can start to assemble your master sheets. These are a great tool to keep you and your designs organized and your groups well-balanced. So follow the steps carefully and have fun!

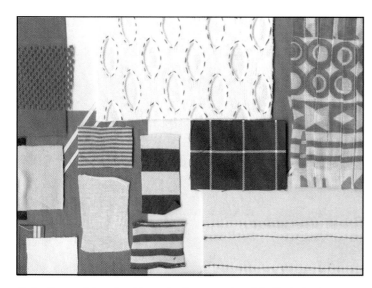

Note the variety of pattern, texture, and solids that designer Marcus LeBlanc has put into this fabric board. This gives him a lot of cool options when designing the group.

TEN KEY STEPS

1. Review Textile Strategies
2. Review Your Concepts and Inspiration Images
3. Collect Swatches, Trims, and Fastenings for All Your Groups
4. Plan and Create Fabric Treatments for All Your Groups
5. Build Your Fabric Boards
6. Add Swatches to Your Master Sheets
7. Sketch Rough Silhouettes for Your First Group
8. Place Your Favorite Silhouettes on Your Master Sheets
9. Repeat Steps 5 Through 8 for Your Remaining Groups
10. Check the Balance of Pieces Among Your Groups

STEP ONE: Review Textile Strategies

Being organized in your fabric choices and use will save you enormous time and create much stronger groups. Consider the various strategies below before you go fabric shopping, and make sure you have taken them into account as you build your fabric boards.

1. **Building Around a Print or Pattern.** As we have said, fabric stories are often built around a pattern of some kind. A complex plaid (like the tartans below) or print might have three or four colors plus black or white. These colors are probably going to go well together and relate back to the plaid or print. Consider also that you can use pattern in unexpected ways, like a tailored jacket out of tartan plaid, as shown below. Research venerable companies like Burberry, Missoni, and Pucci that have built their business around pattern. Just a reminder: In the industry a *print* is applied to the surface of a fabric, while *patterns* are woven into the fabric itself.

2. **Variety Adds Interest.** Other types of fabrics to consider adding to your board are: matte, shiny, plush or furry, sheer, patterned, raised or flat, striped or linear, nubby or napped, base fabrics like denim or corduroy, hand knits, and, of course, fabric treatments. Interesting contrasts of texture, surface, color, and so on, will help you create a visually striking fabric board.

3. **Think Garments.** When you make fabric decisions, you need to think about the actual pieces in your group. If you want to use a fabric on only one collar or even one full garment, then you probably should make another fabric choice that you will use several times. In the real world, a company has to buy huge amounts of yardage to use a particular fabric, so a real commitment within the group is required.

4. **Fabric Treatments.** Fabric treatments are very important in the industry these days. Savvy customers want unique items, and they are willing to pay for the extra labor involved. Ideally, you have developed a talent for treatments already, but if you haven't, you may want to research to get some good ideas. (We will talk more about treatments in Step 4.) A treatment can be as simple as adding some strategic shirring or a custom stripe or as complex as assembling a collection of disparate elements from the bead shop or the hardware store. Doing some preliminary thinking about your approach to treatments in each group will help you to see the possibilities of more subtle fabrics when you are making your choices.

© Ruth Black / Alamy

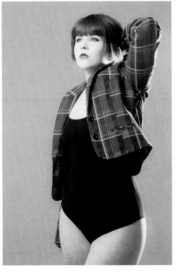

© FashionUK / Alamy

© Christopher King / Alamy

You can use Photoshop to match colors from your "core" fabrics. Simply scan your swatch and use the eyedropper tool to get a good match for rendering.

5. **Ratios.** When you begin to formulate your groups, you will want to consider various ratios that are especially important at the retail end. Buyers will judge a group based on the balance of these ratios, so you will want your future employers to see that you understand these important concepts.

 A. **Balance of Pieces in the Group:** A contemporary group of five outfits will generally have: two or three jackets, two or three pants (including shorts), two or three skirts, three solid tops (a mix of knit and woven), two novelty tops (patterned or yarn-dyed), two or three hand-knit sweaters, and two outerwear jackets (optional).

 B. **Balance of Solids to Fancies:** Generally a group should not have all solids or all prints or patterns. You want a balance of these elements.

 C. **Balance of Knit Tops to Woven Tops:** Think about including both knits and wovens when you select your top-weight fabrics.

 D. **Balance of Hard to Soft:** Buyers will generally want to see a balance of hard pieces like jackets or trousers to less-constructed pieces like blouses or soft skirts. See an example of this mix in the illustrator flats below, created by designer Lynn Quan. Lynn's strong design sense and great computer skills got her a position at Nike in Oregon.

ILLUSTRATOR FLATS: LYNN QUAN

HARD SOFT SOFT MEDIUM HARD

6. **Weight Matters:** In choosing fabrics you will have to consider what garments require *top-* or *blouse-weight fabrics* like tops or shirts, what will suit *medium-weight fabrics* like jackets or skirts, and what will need *bottom-weight fabrics* like shorts or trousers. The season you are working on also helps determine the weights you will consider. *Winter-weight fabrics* will be too warm and heavy for Transition or Spring. *Light-weight fabrics* are great for warmer seasons, but if they require a lining it will add to the cost of the garment.

7. **Fabric Hand:** How a fabric feels to the touch does matter, and this is why you must have your swatches in your portfolio displayed so they can be touched. Consumers will generally be attracted by color, but if the feel of the fabric is unappealing, they will often move on. Experienced designers will be able to touch a fabric and know immediately how it will drape, hold its shape, seam easily or with difficulty, and so on. They will also know when it might need *interfacing,* which is a stiffer fabric that adds body to strategic areas of a garment. If you have a soft, drapey fabric for your tailored jacket, for example, your potential employer will know that you do not really understand how to use your materials correctly, so you want to plan your choices carefully. "Because I like it" does not work in the industry where a poor fabric choice can cost the company a lot of money. Also, if you choose a cheap, *boardy* fabric (stiff and unappealing) just because the color works with your group, your taste in textiles will be questioned, so don't settle for poor quality.

Making Good Color Choices

When you are choosing fabrics for your groups, the element of color is especially critical. Many customers look first for "their" colors when shopping. If a garment is in a shade they like, they will often take the next step of trying it on. So most employers in fashion will want to see that you can use color effectively. The Fall 2011 collections were, in fact, full of intense color. Designers who normally stick to neutrals were breaking out with bold shapes in intense shades. But many young designers want to design only in black and white because that is how they dress. Resist this impulse. Force yourself to take a variety of approaches to color on your fabric boards so you demonstrate that you are versatile and have a good "color eye."

Before we talk about color choices, let's review the three dimensions of color:

1. **Hue:** The term *hue* refers to the warmth or coolness of a color. Because today's customer is often savvy about which is more flattering to her personal palette, an awareness of this issue is key. Most fabric combinations will tend toward one or the other, as mixing warm and cool successfully can be challenging.

 Warm hues, of course, are the fire colors: red, yellow, and orange, and cool hues are their opposites: green, blue, and violet. Warm hues are more visually "aggressive" (think red accents in a blue and green painting), and therefore emphasize the form of the body. Cool hues recede visually, so they minimize forms. A designer who is doing plus-sizes might well consider these characteristics and tend more toward the cooler hues.

 Warm and cool colors can also have different psychological effects. A room painted in warm hues, for example, can make people literally feel warmer. Cool hues can have the opposite effect. Red is acknowledged to be the color of aggression, while blues and violets are more soothing. Note, for example, that yoga outfits are often in soft, cool colors that contribute to the meditative atmosphere of the discipline. Also consider that points on the body where light meets dark (value contrast) will call attention to that area. It pays to have an awareness of hue when you are designing and illustrating your groups. Even your accessory choices should be made with these principles in mind.

2. **Value:** When you add white to a color, it gains in *value* because it becomes lighter. Adding black results in a lower value, because the resulting color is darker. As most people know, very light colors will tend to make the body look larger, whereas darker values are more slimming. But it is interesting that very dark colors or black also call more attention to the forms of the figure, whereas the middle values tend to act more as camouflage.

NOTE: Many popular fashion colors have both white and black added, which creates a more subtle, grayed-down version and may be easier to wear. When you add both white and black to a color the result is called a *tone*.

This glamorous gown is done completely in green, but in a variety of hues, values, and level of intensity. The pairing of shiny, heavy-weight, cool-hued satin with diaphanous and warm-hued tulle creates wonderful contrast.

© NemesisINC / Shutterstock

Note how designer Betsey Johnson boldly contrasts warm and cool hues in her outfit. The pale gray top acts as a "buffer" between the two garments. What do you think is the intensity level of the yellow in her jacket? Would this outfit work better or worse if the intensity were greater?

© Everett Collection Inc / Alamy

3. **Chroma or Intensity:** The third dimension of color is *intensity* or *chroma*. These two terms are interchangeable and both refer to the saturation of a color. High-chroma colors are strong and brilliant. Low-chroma colors are muted and even dull. Notice that colors can be described using both value and intensity. For example, a maroon is low in value because it is dark, and low in intensity because the saturation of red is weak. But a tan, on the other hand, can be high in value because it's light in color, but low in intensity, because there is less actual color content.

Color Harmonies

A tool that designers can use to help them choose colors is the principle of color harmonies. There are actually books like *Color Harmony* by Hideaki Chijiiwa that are primarily pages and pages of various "pleasing" color combinations. Chijiiwa presents various groupings of colors with titles like Striking, Tranquil, Young, and Feminine. Your imagination can probably picture what those colors might be. She also shows:

1. *Related color harmonies* have one hue in common, such as red-orange and yellow orange.
2. *Monochromatic color harmonies* are three or four shades and tints of the same hue. The green dress on the opposite page illustrates this as all the fabrics are some shade of green.
3. *Analogous color harmonies* are colors that sit next to each other on the color wheel, like blue-green, blue, and blue-violet.
4. *Contrasting color harmonies* have no hue in common. An example would be color combinations like the blue and yellow outfit on the facing page.
5. *Complementary color harmonies* use opposites on the color wheel like blue and orange, red and green, or yellow and violet.
6. *Vivids with darks:* An intense color provides interesting contrast to a dark, dull color.

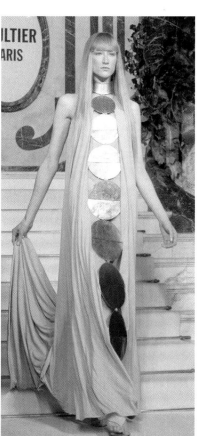

The very graphic use of monochromatic neutrals in this Gaultier gown provides an easy elegance and creates the illusion of increased height and decreased bulk. Note how the weightier darks are used closer to the bottom of the dress.

© *Trinity Mirror / Mirrorpix / Alamy*

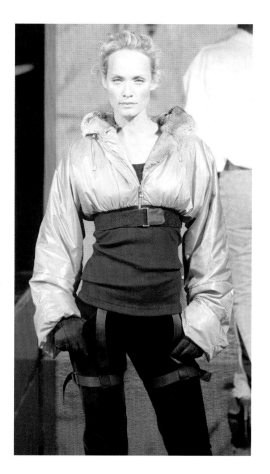

Combining bright accent colors with deeper neutrals is a time-honored fashion recipe. Placing the stronger color and soft texture of fur next to the face keeps the viewer's attention on the wearer. The neutrals keep the waist and hips looking slim and the long unbroken silhouette from the bust down adds to the illusion of height.

© *Daily Mail/Rex / Alamy*

Color Strategy

Helpful Hints

1. **You can think of color generally in six categories:** warm, cool, light, dark, vivid, and dull. Vivid colors are the basic hues without mixing, light colors mix the basic hues with white, and dark colors are mixed with black. Both create *shades*. Dull colors are mixed with gray.

2. **When you choose color, keep your concept in mind.** What mood do you want the color to project? Specific colors create very different moods so don't choose any fabric that contradicts your basic vision. For example, if you are designing a tranquil, cool group for spring, you do not want to add that hot-pink corduroy, no matter how much you love it. Save it for another group.

3. **Avoid the same color combinations we see every day,** like black and white, or light blue with darker blue. You may love it, but what does it tell an employer about your color creativity?

4. **Consider the value (or shade) before you choose the hue.** Do you want a light collection, or a moody darker collection? Of course you can combine the two, which may add needed depth and contrast.

5. **Limit the number of colors in your collection.** Three is good, five is a lot. Remember you generally want different textures, patterns, and weights of fabrics in your core colors, rather than too many different hues.

COLOR HARMONIES

Related Color Harmony
Both have orange in common.

Monochromatic Color Harmony
Different tints of the same hue.

Analogous Color Harmony
Colors that are next to each other on the color wheel.

Contrasting Color Harmony
Colors that have no hue in common, and three colors between them on the color wheel.

Complementary Color Harmony
Opposites on the color wheel,, like red and green, blue-green orange-yellow, etc.

Achromatic Color Harmony
Combining any color with gray, black, or white. This is a good formula for success.

6. **Although sometimes a designer can go crazy with intense color, in general you want to use caution with vivid colors.** Think of accents, rather than whole outfits. If you look at runway shows over several seasons, you will see a lot of neutrals, because they are easier to wear and to mix with other things you already have at home. Neutrals also often reflect nature and therefore seem familiar to the viewer.

7. **More conservative customers generally prefer conventional colors.** Your fashion-forward customer will wear the more unusual shades like the dull yellow-green that has been trendy for the last few seasons.

8. **Beautiful art can be a great source for color ideas.** Painters with a poor sense of color are unlikely to survive historically.

9. **Interior designers usually have wonderful taste in color.** Check out the magazines that feature good space design.

10. **In fashion, most colors are given descriptive names like "cotton-candy pink" or "moss green."** Get in the habit of naming your color choices, and make sure the names reflect your concept or theme.

11. **The Pantone Color System is used by many designers for color reference.** Pantone has a color trend forecasting service that generates a new color set (in the shape of a fan) each year that is used by a number of different industries including fashion. They also provide computerized color matching services that ensure color accuracy for textile design, etc.

12. **Colors go in and out of fashion like everything else.** The combination that looked new and exciting two seasons ago may look trite and overdone today. Stay current with color!

Activewear Designer: Michelle Kwak

GYM TRAINING DANCE
#412351 KNIT CAPRI

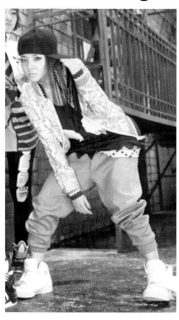

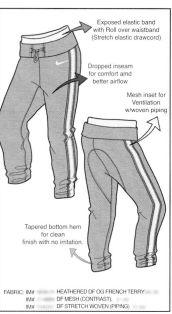

Exposed elastic band with Roll over waistband (Stretch elastic drawcord)

Dropped inseam for comfort amd better airflow

Mesh inset for Ventilation w/woven piping

Tapered bottom hem for clean finish with no irritation.

FABRIC: IM# HEATHERED DF OG FRENCH TERRY
 IM# DF MESH (CONTRAST),
 IM# DF STRETCH WOVEN (PIPING)

Create poses that really show the important details.

Designer Statement: Michelle Kwak

Designers have different methods for research. I read about the sport and the common injuries because I want my designs to improve the safety and comfort of the athletes. Also I learn about the most frequently used muscles, so I can support and protect them through material and seam construction.

We also interact with athletes, at both professional and high school levels. We begin each season with a focus group and their feedback is the basis of our design process. We show them samples and ask questions and take video footage of their reactions.

To find the right fabrics, we have a fabric library, a material developer, and vendors from Asia who bring us ideas. We also go on inspiration trips to gather samples. When we have developed some ideas with a new fabric, it is given to the material developer to proceed with the process.

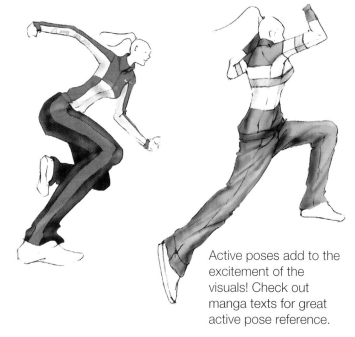

Active poses add to the excitement of the visuals! Check out manga texts for great active pose reference.

The repetitive graceful pose, with subtle movement and the focus just on the garment, allows us to fully admire the functional yet attractive design.

More Fabric Savvy

The Business End of Textiles

There is so much to learn about fabrics. As a designer who "lives and dies" by the cloth you use, you will spend the rest of your life checking out the latest trends and enhancing your knowledge. You may go to amazing textile shows like Premiere Vision in France and rub shoulders with Couture designers, or research less expensive mills that can provide a similar "look." The less expensive fabric might have fewer colors, a less complex pattern, or alternative fiber content but still have that cutting-edge look that you crave. If you are experienced you can probably have a pretty good idea how this fabric will look "made up," but you will not know for sure until you see that first prototype. If it looks as expected, sample yardage (15 to 60 yards) will be purchased. If it doesn't, you will either change the fabric or the style. Designers have to be ready to regroup and adapt on a moment's notice.

Interesting fabrics are key ingredients that help manufacturers differentiate themselves from their competition. There have been so many innovations in fibers and knitting and weaving techniques in the last few years that designers (and consumers) have an enormous selection of goods to choose from. The more you know about the various fibers and yarns, the more valuable you will be to your company.

Dyeing Facts

Dyeing fabrics can be an important aspect of a designer's collection. Techniques like *dip-dyeing* can add great interest to a garment, and you can create samples to show that you understand the process.

Once you are employed, you will want to understand the three basic dyeing techniques: yarn dyeing, piece dyeing, and garment dyeing.

Yarn dyeing: The yarns are dyed before they are woven or knitted.

Piece dyeing: The yardage is dyed before it is made up into garments.

Garment dyeing: The garment is constructed from undyed cloth, then dyed with other garments in a big vat.

About Prints

1. *Screen printing* and *roller printing* are the two main industry techniques.
2. *Roller printing* is expensive, as special rollers must be made for each print. Generally this requires an order of 5,000 yards or more. As each color requires its own roller, more colors equals greater expense. Because the process is so expensive, a hand-screened sample called a *strike off* is usually made first.
3. *Direct printing* is the technique of putting a dark pattern on a light ground. *Dye and discharge* is a more expensive and complex method to do the same thing with a more refined look.
4. *Screen printing* uses separate screens for each color. There is both a hand technique and an automated rotary method. Prints need to be relatively simple to screen effectively.
5. Every *all-over print* has a repeat where the pattern duplicates. These repeats are both horizontal and vertical.
6. A *one-way print* has a top and bottom and every pattern piece must be cut in the same direction which adds to the cost. A *two-way print* has a motif that goes both up and down which allows it to be cut in either direction.
7. A *border print* is placed at the edges of the fabric, either paired with a solid or a compatible print.
8. A *placement print* is printed on a garment at exactly the same spot. For example, a design motif might be printed on the back of a shirt.
9. *Recoloring prints* is fairly common to get them to match the rest of a specific group.

This all-over print will repeat this essential pattern both horizontally and vertically. The placement of the print will be considered when laying out the pattern, so the repeat will match up at the seams.

As a designer choosing fabrics for a line, you will need to understand the pros and cons of various fibers and also stay on top of what is new. For example, the introduction of *microfibers* has added a variety of different surface characteristics and also produced fabrics that are light-weight but highly durable. These versatile fibers function especially well for athletes who want clothing that "wicks away" sweat and keeps them relatively dry and comfortable. Because these fibers are light-weight and drape beautifully, they also lend themselves to collections geared toward seasonless clothing.

Some Fiber Facts

1. *Yarns* **are made up of various fibers** that are either *natural,* like cotton, wool, silk, and linen; *cellulosic,* like acetate, rayon, and tencel, which are manufactured from natural materials; or *petroleum-based,* like polyester, nylon, and acrylic.

2. **Yarns are measured by thickness;** the higher the number, the finer the yarn. Most fibers are twisted into yarns. Fibers can be short or long, but better-quality fabrics are made from long fibers. Yarns can be described as "low-twist" or "high-twist." High-twist yarns are generally more durable, with the exception of crepe and some novelty yarns.

3. *Protein fibers* **come from the coats of animals and from caterpillar secretions to make silk.** These are fairly expensive and considered to be luxury fibers.

4. **Every fiber has good and bad traits.** Some fabrics are blends of natural and polyester-based fibers, so they combine the good qualities of each one. *Blends, mixtures,* or *combinations* are terms for these "hybrids."

5. **Fibers are made into cloth by three techniques**: *knitting, weaving,* and *felting.* Weaving combines *warp* and *weft* threads that are interwoven on a loom. Knits are one continuous thread that is created with interlocking loops. In felting, a much less common technique, the fibers are pressed into cloth form.

6. *High-bulk* **yarns do not stretch.**

7. **Cellulosic fibers are absorbent,** can be cool during hot weather, tend to wrinkle, do not produce static, are heavier than other fibers, and tend to mildew in damp weather.

Fiber Characteristics

FIBER NAME	POSITIVE CHARACTERISTICS	NEGATIVE CHARACTERISTICS
Cotton	Comfort, easy care, good durability, softness, moisture absorbency, air permeability, pliability, easy to launder, may be dry cleaned.	Requires ironing, unless a wrinkled appearance is intended.
Flax (linen)	Strong and cool, comfortable, easily laundered or dry cleaned, may be very smooth or very rough.	Wrinkles easily if a special finish is not applied.
Silk	Strong, flexible, durable, warm, absorbs moisture, soft, drapable, luxurious appearance. Some are hand washable.	Pressing requires expert techniques. Somewhat expensive to buy and maintain.
Wool	May range from very thick and stiff to very sheer, warm, comfortable, stretches and recovers, absorbent, flexible, resistant to wrinkling, tailors very well, looks and feels good, can be made washable.	Tendency to shrink if not handled properly; dry cleaning is generally required.
Rayon	Varies in weight from very heavy to very sheer, varies in hand from very soft and limp to very firm and stiff, easily pressed, absorbent, comfortable, soft.	Requires special handling if laundered; dry cleaning usually preferred; may stretch when wet and shrink when dry.

(continued)

FIBER NAME	POSITIVE CHARACTERISTICS	NEGATIVE CHARACTERISTICS
Lyocell (Tencel)	Close to cotton in its characteristics; may be made washable or dry cleanable; soft, smooth hand.	May shrink during laundering if a special finish is not applied.
Acetate	Bright appearance and good luster, lightweight.	Low strength, weaker wet than dry, poor elastic recovery, poor wrinkle recovery, may experience relaxation shrinkage, exposure to high temperatures may cause shrinkage, not cool to wear, builds up static electricity, softens with the application of heat.
Triacetate	Bright appearance and good luster, resilient, good wrinkle recovery, good resistance to stretching and shrinking, lightweight.	Low strength, weaker wet than dry, not cool to wear, builds up static electricity, softens with the application of heat.
Nylon	Light in weight, very strong, good abrasion resistance, drapable, good elasticity, wrinkle resistant, maintains its shape, dries quickly after laundering, an easy-care fiber.	Needs very low cleaning and pressing temperatures, has an affinity for oil-borne stains.
Polyester	Medium in weight, good elasticity, excellent wrinkle recovery, relatively strong, good wicking ability, easy care; new micro denier fibers have many exceptionally good properties.	Nonabsorbent, needs very low cleaning and pressing temperatures if not heat set.

Source: Figure 12.3 from *Individuality in Clothing Selection and Personal Appearance*, Seventh Edition, by Marshall, Jackson, Kefgen, Touchie-Specht, and Stanley. Upper Saddle River, NJ: Prentice Hall, 2004.

Smart Fabrics

One of the most interesting and cutting edge developments in textiles is the emergence of what can be termed *smart fabrics*. These are fabrics that are designed to embed new technologies in our lives through clothing. The recent IntertechPira Smart Fabrics conference in London gives us a taste of things to come; for example, denim fabric that lights up when pressed by the wearer. Such effects can be produced by optical fibers that actually emit light. Another method is to embed LED lights invisibly into fibers, using batteries and electronics. Sensor systems that can alert medical personnel to serious health issues can also be built right into garments.

In 2009 the Danish School of Design, in collaboration with research scientists, created what they termed the Climate Dress, which had a sensor system that could indicate problems with the level of CO_2 in the air.

Other technologies are seeking to help soldiers at the front, monitoring heat stress and protecting against bomb blasts, to name just two of the many possibilities. Nanotechnology can be built into fibers to create clothing that self-cleans and even protects against bacteria. The elderly population may welcome clothing technology that is comfortable yet functional in ways that allow them to remain in their own homes.

Much work is being done to study the potential needs of future populations and the ways that new fabrics could address these crucial issues. Because of the burgeoning world population and environmental pressures, we may face shortages of the goods needed to produce clothing in the not too distant future. Rationing may result. If designers can create garments that can serve multiple functions, it will help to offset this problem.

STEP TWO: Review Your Concepts and Inspiration Images

The example below shows a mood image and the fabric board that resulted from or relates to the visual inspiration that it provided. The colors and textures in this architectural image are reflected in the fabrics and also the treatments that have been applied to them. Looking at the interesting variety of subtle fabric choices, it's likely you, as a designer, can already envision a group of sophisticated Spring separates for a contemporary woman. This group is so versatile that it could probably work for a menswear group as well.

At this point in our portfolio progress, you have probably not chosen your final mood image for each group, but you will want to at least edit your design inspiration images down so you can make fabric choices that are not too scattered. Your task then is to use these design inspiration images for each group to inspire your initial fabric choices and treatments. Of course, you will also be considering all the other aspects we discussed in Step One.

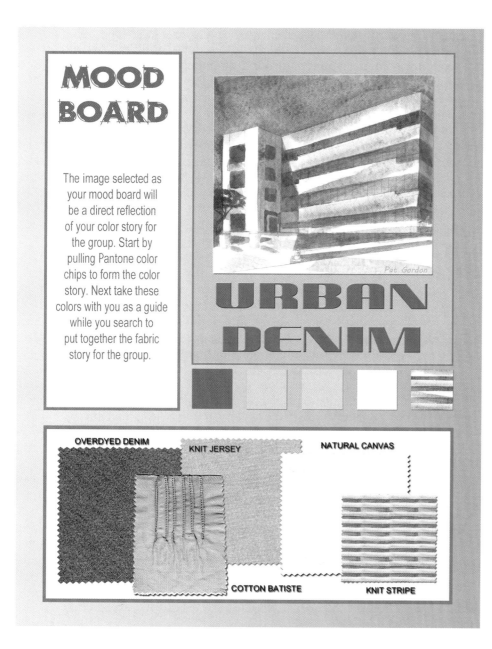

Notes

1. **Organize** your images from the different groups in separate folders so you won't get confused at the fabric stores.
2. **Keep your customer in mind.** You might even want to keep a customer profile in each folder so you can focus on their needs and lifestyles. For example, you won't want to buy too expensive or hard-to-care-for fabrics for Childrenswear, or even Tweens. Your older, budget customer also wants wash and wear.
3. **Research the latest fibers before you go**. For example, if you need wash and wear, you may want some kind of synthetic. Polyester, for example, was shunned by savvy customers for decades, but now it is back in the form of microfilaments and fleece. Employers will appreciate if you understand the latest trends and act on them in your groups. They may even get advertising revenue from certain innovative fiber companies if they use their product, so they will doubly appreciate that you are able to tune into new developments.
4. Established designers do often have the luxury of working with fabric houses to create their own custom fabrics. Trina Turk is a good example of this: She recently produced fabric designs that are also being used in interior design. If you have a talent for surface design, you can create your own pattern and feature it in one of your groups.

STEP THREE: Collect Swatches, Trims, and Fastenings for All of Your Groups

You may be able to collect fabrics and other elements for all your groups in one trip to your favorite fabric stores, but chances are you will have to go several times to get just the right samples to make a great board. This element of your portfolio process is too important not to get exactly what you envision for your groups. Good fabrics and the trims and fastenings that go with them can turn you on and keep you focused. They also contribute to great design! Keep in mind that there are many kinds of trims that can add interest. These include ribbons, rickrack, binding, zippers, belts, snaps, and other kinds of fastenings. Keep track of the prices for these smaller items so you can fill out a cost sheet if necessary.

Helpful Hints

1. **Collect more swatches, trims, zippers, buttons, and so on, than you will need.** Having a number of choices may save you a trip if something doesn't work out.
2. **Make friends with the employees at the fabric store.** If they like you, they will cut as many swatches as you need, but don't be greedy. They have some interest in helping future designers, but they also have to do their job.
3. **Although you need only a swatch, not yardage, don't choose expensive fabrics for casual younger groups or cheap fabrics for sophisticated groups, unless you can make an inexpensive fabric look fabulous with a cool treatment.** Your future employer will want to see that you understand the difference.
4. **Pin your swatches to a piece of paper (you can use the form at the end of this chapter) and keep notes as to where you found the fabric and what it is.** You never know when you might need more of the fabric for a treatment or a different presentation, and you will want to know fabric content to label it in your portfolio. It's also easy to lose key swatches when you are working in class.
5. **Remember to include both basics and novelties for each group.** Too many complex fabrics in one group will probably look too busy. The viewer's eye needs to rest on something more simple. Think contrast!
6. **Don't choose colors that don't quite work with key fabrics unless you are willing to change them yourself.** You can use dye or simply dip a too-bright fabric in tea or coffee. Even a marker can work in a pinch, but it might affect the texture of the fabric.
7. **Be willing to travel off your beaten path.** If you're going to the same fabric store as your peers, chances are you will make some similar choices. Your convenient neighborhood store may not have much that is really current and interesting. You may even want to purchase color cards from online companies.
8. **Trims are one of the key elements that can tie your group together, so don't underestimate their importance.** You don't have to use them, but it's good to have choices.
9. **Think about top-stitching and what colors you might consider using.** Buy the matching thread colors so you can make samples.
10. **Buttons, hooks and eyes, twill tape, and other fastenings help to provide the "detailing" that add up to good design.**
11. **Collect antique buttons and other fastenings from antique stores and swap meets.** They can be great inspiration and also might come in handy for one of your groups.

Cool ties, zippers, appliques, and other details take your designs to a different level.

Beautiful buttons are just one of the fun elements that you can collect at the fabric store.

STEP FOUR: Plan and Create Fabric Treatments for All of Your Groups

Fabric treatments are one of the key elements that can make your design groups truly unique. Because of their importance in retail, successful companies like BCBG, Anthropologie, St. John, and MaxStudio depend heavily on treatments to add excitement to their collections. As we have discussed, affluent customers tend to want unique items that stand out from the basics, and they are willing to pay more for the labor costs. Of course, many denim companies have grown and prospered because their treatments have kept jean lovers coming back for more. It would be a mistake to underestimate the importance of good treatments in your portfolio, and as you know, quality treatments cannot be thrown together. They take time to develop, and may need to be redone a number of times to reach their full potential.

ALEXSANDRA DEL REAL

Alexsandra Del Real added the subtle contrast of ribbed cuffs to this fleece hoody, which is a simple but effective detail. Alexsandra works for Fox Racing where she was recently promoted to Design Manager, so she oversees a design team. She also created this beautiful neck treatment on a zip sweater for her former job at Free People. She used cut-and-sew sweater knits and fringe to form a striking and colorful design.

Things to Consider

1. **Treatments are an element that you can be working on throughout your portfolio process.** But it is helpful to think about the different approaches you might take to each group and develop a strategy. For example, you would not want to end up with only stitching details in your designs because you ran out of time.
2. **You may already have some great treatments that can be used in or adapted to your new groups.** Don't reinvent the wheel if you have successful ideas in hand.
3. **The most interesting treatments are generally not one-dimensional.** Combining several elements and thinking in layers will add to the interest. For example, distressing, dyeing, appliques, and embroidery combined could produce an amazing treatment.
4. **Collecting cool elements for treatments can really take you to unexpected places.** Check out hardware stores, gift shops, bead stores, import shops, swap meets, craft stores, and so on. The more unusual your elements are, the better your chances of creating something no one has seen before. On the other hand, you cannot just attach strange things to your garments and call it a treatment. The elements you choose must make sense in the context of your concept, and they need to integrate into your design.
5. **Many of the best treatments involve nothing more than manipulating the fabric in an unexpected way.** Fabric can be folded, twisted, gathered, ruched, and pleated, to name a few methods.
6. **Elastic can be applied in unexpected places to create interesting effects.**
7. **Distressing can change the surface of any textile.** You can sand, scrub, shred, burn, acid wash, bleach, or run over fabric with your car.
8. **Common techniques like quilting or patchwork can be reconfigured into amazing patterns.** Buy some yardage so you can "play."

Lolly Zhong: Denim Design for Seven Jeans

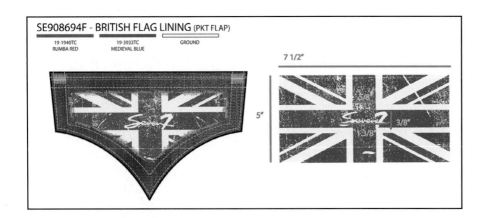

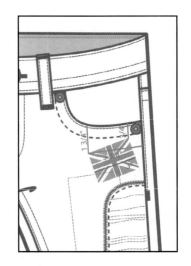

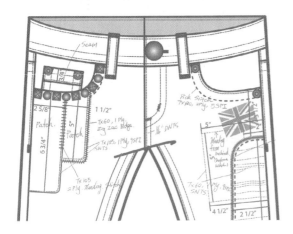

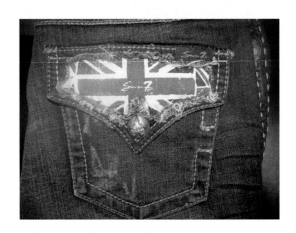

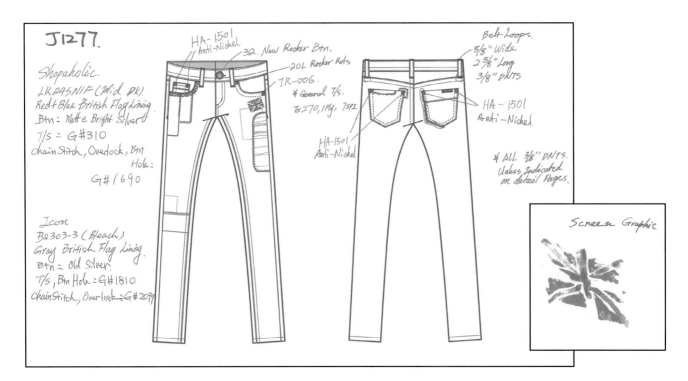

Denim Treatments

Real World Treatment Experience

On these two pages we get a chance to see how denim designer Lolly Zhong, who works for 7 for All Mankind, creates and presents her treatment ideas so they can be executed as she envisioned them.

First she develops detailed technical drawings of her ideas, called *tech packs,* which show all aspects of each design, such as stitching details, placement on the jean, and so on. She then sends these overseas to the factories that make up finished samples or *protos.* This process takes a number of weeks, so it's critical that she plan ahead.

Because Lolly works in a complex and multi-layered industry, it is essential that she keeps track of every detail that she adds to her samples, including thread color, type of stitch, and so on. If you create sample cards like these that show your attention to detail, your work will look highly professional and impressive!

Of course this same method and attention to detail can be applied to any fabric or design, whether it's crystal-beaded satin or lightweight fleece. Fabric samples are a great way to distinguish yourself from the crowd.

The payoff can be great for creating samples like these for your portfolio. Making a denim jean look new and different, when there are so many versions being produced globally, is extremely challenging. Someone like Lolly, who can create these cool details, will never go hungry.

Designer Statement: Lolly Zhong

After my internship at a denim company, I fell in love with this magical fabric (there are soooooooo many shades and washes you can develop with just one fabric, and depending on the designs and treatments, it can expand to thousands of options and looks). And since then, I've been working for denim companies.

I'm currently working for Seven 7 Licensing LLC. It's part of the Sunrise Brand (a privately owned company that used to be Tarrant). I've been here $4\frac{1}{2}$ years now as associate denim designer for the junior division (including Seven 7 junior denim and wovens; bebe, Superdry, DKNY, Express licensed denim and woven bottoms).

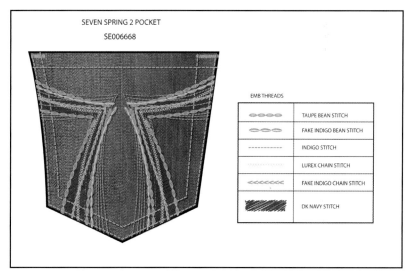

SEVEN SPRING 2 POCKET

SE006668

EMB THREADS	
	TAUPE BEAN STITCH
	FAKE INDIGO BEAN STITCH
	INDIGO STITCH
	LUREX CHAIN STITCH
	FAKE INDIGO CHAIN STITCH
	DK NAVY STITCH

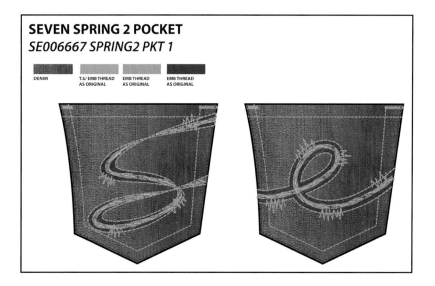

SEVEN SPRING 2 POCKET
SE006667 SPRING2 PKT 1

DENIM	T.S./ EMB THREAD AS ORIGINAL	EMB THREAD AS ORIGINAL	EMB THREAD AS ORIGINAL

More Treatment Strategies

1. **If you are good with color and a brush, you could create your own hand-painted designs that feel very modern and cutting edge.** For example, Style.site.com recently featured prints inspired by mixtures of small rocks and minerals and patterns in nature. The earthy neutral textures look very fresh. Think of other elements in nature that might inspire cool patterns.

2. **Check out passementerie.** This fun technique is the art of making elaborate trimmings or edgings using applied braid, gold or silver cord, embroidery, colored silk, ribbons, or beads. Other styles can also include applying tassels, fringe, ornamental cords, pompons, and rosettes.

3. **Metal studs are an easy way to add strong texture to a garment, and they are certainly popular with the younger crowd.** You can buy packages of 100 on the Web for about five dollars, and they come in a number of different finishes and shapes, including pyramids and cones. Spikes provide an even stronger visual effect, but they run about 75 cents apiece. The site www.studsandspikes.com has more specialty studs that are quite a bit more expensive, but are probably more suitable for higher end designs. Other sites are www.kitkraft.biz and http://www.crustpunks.com/studs-c-21.html. Go to http://www.instructables.com/id/How-to-add-studs-to-clothing/ for instructions on applying studs to your treatment samples.

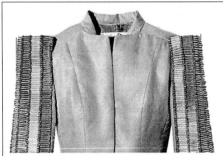

Galliano added ribbon to jacket sleeves.

Christian
Louboutin

Fendi applied an elaborate pattern of studs
to this beautiful jacket.

USING FABRIC CARDS TO CREATE TREATMENTS

URBAN PLAIDS

Fabric cards that include a selection of potentially compatible fabrics can give you good ideas for treatments. The plaids shown here, for example, could lend themselves to:

1. A great patchwork.
2. Color-blocking.
3. Appliqueing one on top of the other.
4. Using one as bias trim for another.
5. Layering into a flouncy skirt.

They could also give you ideas for creating your own more free-form plaids or stripes that could be used by themselves or combined with the originals. You could also dye your swatches to combine unusual colors that you create, or use Photoshop to create alternative colors of your plaids to demonstrate your understanding of different colorways.

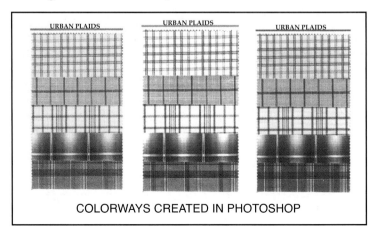

COLORWAYS CREATED IN PHOTOSHOP

Designer: Alexsandra Del Real for Fox Run

REAL WORLD TREATMENTS

Shirring

Applique

Self-Binding

Screen-Printing

Faux Top-Stitching

Alexsandra's Statement: Work Process

At the start of the season we do boards that my team and I build. We spend a few weeks shopping and researching online. At Fox I've had the opportunity to "vibe" shop in Australia, Japan, Hong Kong, and Argentina.

Then I do some hand sketches while I'm at the factories in China. I sketch croquis figures and transfer these to illustrator/Photoshop and fill with temporary art/print placement as a general overview of what the delivery would look like. We try to work out colors and see what prints would look like in a body, but a lot of it is just "vibe."

This is then presented to the design team along with samples, art inspiration, etc. The garments you see are samples going into production. We also do tech packs and you see how an applique is put into tech detail.

After I get back from Asia I will get a proto and start working on colorways and a complete tech pack.

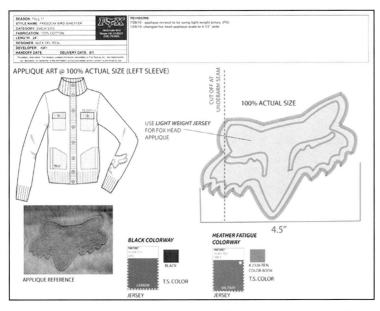

Tech pack page showing applique details and placement on the garment.

Many treatments are worked out first in CAD.

TREATMENTS

SHIRRING DRAPING WITH EMBELLISHMENT

chiffon shirred and embellished contrast the draped stripes

CRAFT EMROIDERY

multi colored yarns stitched flowers, hearts and a variety of shapes

LACE APPLIQUE

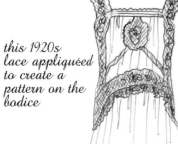

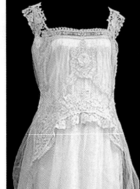

this 1920s lace appliquéed to create a pattern on the bodice

APPLIED STRIPES DRAPED

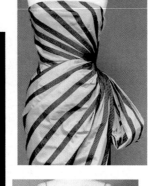

using ribbons create a stripe draping stripes is visually graphic

APPLIQUED LEAVES

a leaf shape placed in patterns and applied

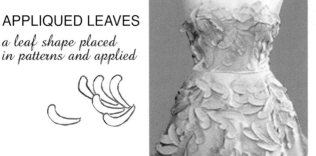

DECORATIVE RUFFLES

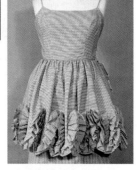

ruffles draped in an up and down pattern creates shape on the hemline

ABSTRACT SHAPES DRAPED IN LAYERS

gracefully placed abstract shapes layered for volume

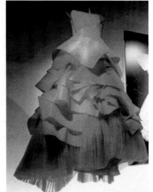

COLOR BLOCK SHAPES MITERED STRIPES

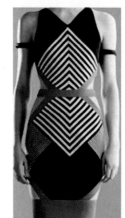

taking geometric shapes and color blocking creates a graphic pattern modern African

as the ribbon is stitched on one side it falls and drapes over as it bends around the curves

RIBBON STITCHED INTO A FLOWER

Books on treatments, such as *The Step-by-Step Needlecraft Encyclopedia* by Judy Brittain, are good for reference.

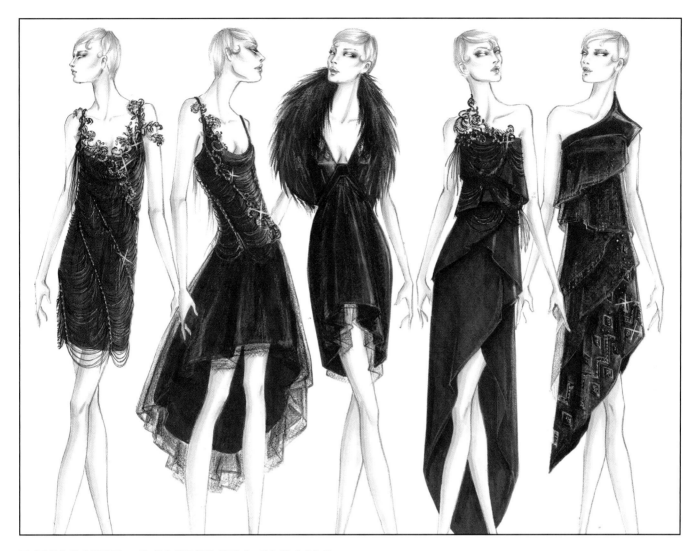

DESIGNER: COURTNEY CHIANG

Courtney's beautiful use of a variety of treatments makes this all-black group sexy and exciting.

NOTE: When you place a number of treatments in a group, try to vary their placement on your garments. Note that designer Courtney Chang has used elaborate embellishments to call attention to the bodice area, which frames the face, but has also taken her details to the waist and hem.

STEP FIVE: Build Your Fabric Boards

This step is exciting, because you are now developing the actual content of your portfolio. You will likely go through several editing and reconfiguring stages for your fabric boards, but plan your arrangements as seriously as you would plan your final solutions. Try to think of each group a little differently. See the example on the facing page to get some ideas, and also remember to look back at boards you have already created for other projects. As you arrange your fabrics, the groups will gain solidity in your inner vision, and you will move toward the actual design process.

Helpful Advice

1. **There is no correct number of fabrics to use in a group.** Much will depend on the number of garments and the direction of your concept. More is not necessarily better, so don't be afraid to eliminate fabrics as it becomes clear you don't need them, or if they are in conflict with something you like better.
2. **If two fabrics on your board are quite similar, pick the better one.** Well-merchandised fabrics will lead to more effective design content, so find a substitute with more contrast.
3. **Because your group concepts will have different personalities, you want to support those moods with your fabric boards.** The examples on the facing page are all from a beautiful, fairly classic Fall sportswear group, so the mood they convey is elegant, sophisticated, and controlled.
4. **Another group, for example, might be more about loss of control:** for example, hand knits that change shape and texture and become quite sculptural, woolens that are washed and combed in unexpected areas, fringe that is layered and made of several different fibers, and so on. Like a drawing, a fabric board can be extremely "loose" if that suits the mood, especially if it involves beautiful yarns and unexpected fastenings and treatments. It could also be highly technical, if function and performance are the key issues. There is no single right answer to any of these problems, except that every element must support your concept.

CONCEPT: Cave Painters Visit London's Savile Row

The mood of this fabric group comes directly from the image of cave paintings that would introduce this group in a portfolio. The subtle, earthy colors are reflected in the fabric color story, and the textures are represented by the elegant treatments. The yarn would ideally become a hand-knit sample that could add a "primitive" element to the evocative graphic.

FABRIC PRESENTATIONS

COLLAGE STYLE SWATCHES

FABRIC STORY SWATCH PAGE

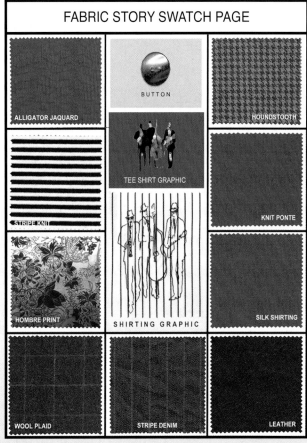

MINI FABRIC HEADERS AS A PRESENTATION

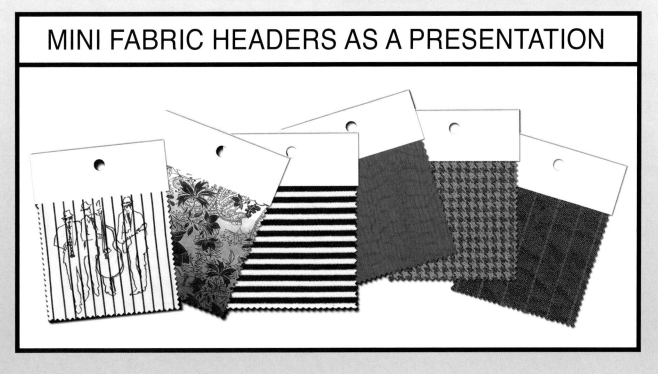

Sportswear Master Sheet Group 1					
Fabric	Outfit #1	Outfit #2	Outfit #3	Outfit #4	Outfit #5
STRIPE DENIM	ADD YOUR SWATCHES TO THEIR CORRECT PLACE ON THE CHART.				
Hand Knit knit a sample					
bottom weight can be a base cloth					
LEATHER					

STEP SIX: Add Swatches to Your Master Sheets

Once you have assembled your fabric boards and the components that accompany them, you are ready to start the preliminary design process. This involves the creation of master sheet "roughs" that will form the basis for your design croquis. We have provided you with a master sheet template on page 99. Make a copy for each design group and label each one accordingly.

Beginning with your first group, cut small pieces of your swatches and add them to your master sheet as shown. Pay special attention to the labels and consult with an instructor if you are not sure which category a particular swatch falls into. It is very important that you are using the correct weight fabrics for your garments.

Also note that this template is geared to a sportswear group with a number of fabrics. You may not have as many as this, or you may have a few more. If you have less, just leave the spaces open. You may fill them in later if you decide to add more fabrics. If you have more, you can always add an extension to your sheet.

STEP SEVEN: Sketch Rough Silhouettes for Your First Group

Now that you have revisited your design inspiration and assembled your fabric boards, you're ready to envision the various pieces for your first group and sketch roughs of your garments. For example, if you are doing a fall sportswear group, you might know that you want to include one coat and one outerwear jacket. You probably have one or two fabrics heavy enough for outerwear, so you already know which fabrics would be used. Now you can look at the various coat and jacket ideas you've collected and start to get an idea of what the silhouettes might look like. Your next fabrics will probably be lighter-weight woolens suitable for tailored jackets and/or trousers, so pull together the images that might influence those pieces. If your inspiration seems lacking, you may want to do more research. Once you get the silhouettes, the details can be worked out when you create your design croquis.

Helpful Hints

1. Think about how many figures you want for your group.
2. Estimate how many pieces each figure might be "wearing." For example, if it is a layered group with five figures, you might want fourteen to eighteen garments. On the other hand, if it is a dress group with five figures, you may only have five to seven garments, assuming you include a couple of two-piece designs.
3. Make a list of the pieces you think you might include in your group.
4. Using your design inspiration and any other ideas you might have collected, sketch out potential silhouettes in flat form over your templates. These do not have to include details. If you feel uncertain about a particular silhouette, sketch some alternative ideas as well. The good news is that nothing is set in stone, so you can make changes later as better ideas occur.

Designer: Alexsandra Del Real

KNITWEAR: WORKING HAND SKETCHES

These designer sketches illustrate an on-the-job process of planning the sweater components of a line. Although the sketches are rough, the details are quite specific, including the yarn type, the fastenings, types of stitches, garment dimensions, and so on.

It may also be helpful to read the job description of an entry-level knitwear job at Jessica Simpson Knitwear, a division of Jones Apparel Group. See the lists on the right.

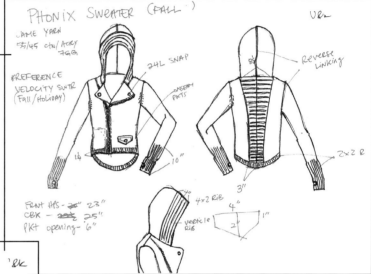

Entry Level Job Requirements

- Sketch in Illustrator
- Develop spec and tech packs
- Develop new embroideries
- Trim and belt development; make comments
- Track samples
- Check in and spec protos
- Hang and steam samples
- Create presentation boards
- Work with PD to prepare bulk wash standards
- Liaison with production
- Check invoices
- File and organize trims, artwork, etc.
- Adjust to changing time and action calendars
- Work against sensitive time lines

- Work with PD to prepare bulk wash standards
- Track samples with overseas vendors
- Communicate with factories regarding tech packs
- Accurate and timely communication of specs with factories
- Provide high level support to designers and senior designers

Qualifications

- 1 to 2 years minimum experience
- Minimum associate degree in fashion or BA in related science
- Must know Illustrator and Photoshop
- Excel, Word, Outlook
- Must be organized
- Excellent written and verbal communication skills
- Interpersonal skills
- Must be a team player
- Ability to adjust to changing priorities

STEP EIGHT: Place Your Favorite Silhouettes on Your Master Sheets

Once you have sketched out your rough silhouette ideas, cut out your favorite flat for each garment and attach it to your rough master sheet with a straight pin or double-stick tape. This will allow you to add and remove your silhouettes as you please without difficulty.

Look at your jackets and see if any look too similar. Imagine you are a buyer who is looking for three or four very different silhouettes that still have a relationship to the group. If any are questionable plan to do some more sketches when you have the time and focus to be creative.

Continue to review your key elements (Concept, Inspiration Images, Season, Customer) to make sure you are happy with your choices and that they blend well. If something looks out of place, then consider replacing it.

STAY FLEXIBLE

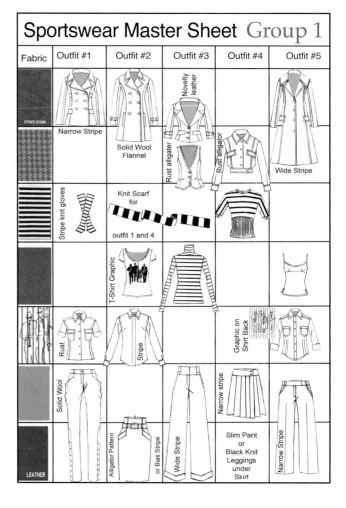

Sportswear Master Sheet Group 1

Helpful Advice

1. If you are doing a group of coats, consider offering a short jacket, a torso or peacoat length, a three-quarter or carcoat length, and a long coat.
2. For jackets, consider including a fitted shape and an easy shape. You can offer one in your solid and one in your novelty or fancy fabric.
3. Decide how many layering pieces you will want. For fall, it could be as many as three or four layers on top: A t-shirt or tank, a shirt or second knit piece, and a sweater over. An outerwear piece could layer over that.
4. For bottom pieces, two skirts and three trousers generally create a good balance. Trends and your customer will dictate whether skirts or trousers are more important.
5. Make sure all your flats are in correct proportion to each other. Avoid shrinking them down to different sizes to fit the grid.
6. For the final master sheet, clean up your presentation and print a clean copy.

Fabric Breakdown

1. Often jackets and trousers are cut from the same cloth if the weight of the fabric allows this.
2. The shirting and knit pieces should offer a solid and a novelty. Balance your pieces between knits and wovens.
3. If you have three trousers, offer two in solids and one in a novelty; with two skirts, offer one solid, one novelty.
4. For Fall II groups, consider offering at least one hand-knit piece.
5. Remember that these are simply loose guidelines to help you achieve good ratios in your groups.

Sportswear Master Sheet

Fabric	Outfit #1	Outfit #2	Outfit #3	Outfit #4	Outfit #5
Jacket weight base cloth May be the same as bottom weight					
novelty jacket weight May be the same as bottom weight					
Hand Knit knit a sample					
Cut and Sew Knit					
shirting Print or Pattern Can be a color road map					
bottom weight can be a base cloth					
Novelty Bottom Weight optional					

STEP NINE: Repeat Steps 5 Through 8 for Your Remaining Groups

Once you have completed the rough master sheet for your first group to your satisfaction, it will be a valuable exercise to go through the same steps for your other groups. Keep reviewing the completed groups as you go, as you are likely to see repetition and imbalance of pieces when you do this. This process will encourage the creation of a pleasing variety in your design groups, and discourage you from falling back on what is easiest and/or comfortable.

NOTE: You do have the option of going on to complete the first group, but chances are, when you do your other groups, you will see the changes you wish you had made. If you plan all your groups, you will be able to focus on each group until it is complete, knowing that the accompanying groups will not compete with it.

STEP TEN: Check the Balance of Pieces Among Your Groups

When you have completed all four or five master sheets, lay them out and do a final review.

Consider

1. Do I have a good balance of pieces in each group?
2. Does each group look different in terms of silhouette, fabrics, and trims?
3. Are the pieces for each group consistent with my concept?
4. Do the pieces look as though my customer would wear them?
5. Do my fabric choices make sense for the look and weight of the garments?
6. Do my fabrics have a good variety of textures, patterns, and color? Does each one support its concept?
7. Is there a good balance of light and dark fabrics? Do I have enough color?
8. Does the master sheet look exciting? What can I add to create a dramatic mood in the group?
9. Are all my flats in proportion to each other?
10. Do I feel confident enough in my choices to move on to the next chapter? If not, why?

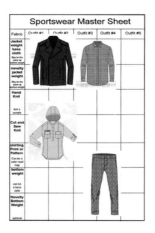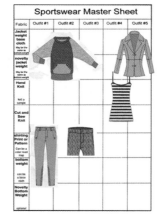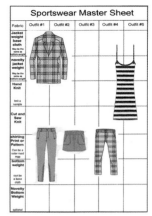

Master sheets help you to keep track of your pieces.

Designer: Alexsandra Del Real

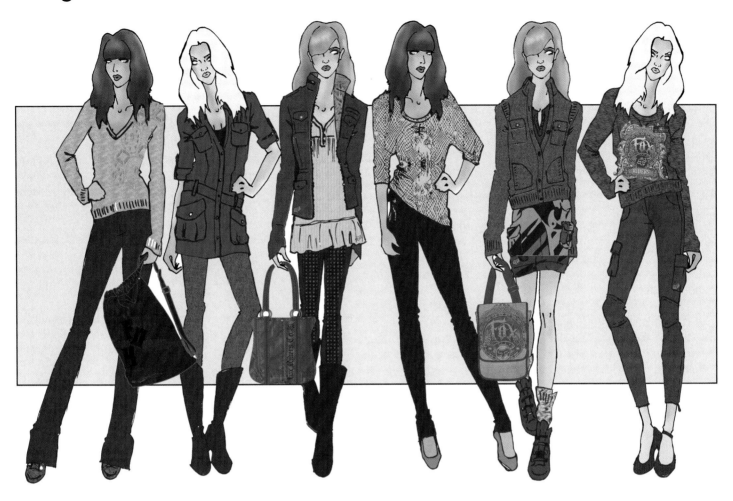

COMPANY: FOX RACING

Alexsandra has worked at Fox Racing for the past two years as a cut-and-sew knits designer and sweater designer. She was recently promoted to design manager, so she now oversees and manages a design team.

As you can see in Alexsandra's great sketches above, the line indicates a lot of sweaters. Note how each style is different from the others to encourage buyers to purchase them all.

We can see that Alexsandra's ability to design and style cool knits has already made her a success and a rising star in her company. She travels to China several times a year to work with the factories where the line is produced, and she brought back this photo of one of the workers adjusting a very large knitting machine.

CHAPTER SUMMARY

Let us learn to appreciate there will be times when the trees will be bare, and look forward to the time when we may pick the fruit.

—Anton Chekhov

Because fabric is so key to the designer's process, it is essential that you spend the necessary time and effort creating effective fabric boards for your portfolio. If you have followed the steps in this chapter, you should be well on your way to having these completed for all your groups. But before you move on to the next chapter, take time to review what these boards must accomplish and determine whether yours are achieving these goals.

1. Have you built at least one or two of your fabric groups around a plaid or print?
2. Do your fabrics reflect and support your concept?
3. Are they appropriate to the targeted customer in terms of aesthetic, quality, and price?
4. Do your boards have a good balance of color, texture, fabric weights, patterns, and so on?
5. Have you chosen fabrics that will provide a good ratio of hard and soft finished garments?
6. Do your fabrics have a pleasant hand? Remember that potential employers will want to feel your choices to see if you understand the importance of tactile effect.
7. Have you considered the various principles of color harmony in choosing and evaluating your colors? Do your color values contribute to the correct mood of your groups?
8. Have you chosen fabrics that are suitable and practical for the customer you are targeting?
9. Have you gathered extra swatches as substitutes in case something does not work out in the design process?
10. Have you collected good trims and fastenings that suit your fabrics and support your concepts?
11. Have you created a variety of exciting treatments that will contribute to good design?
12. Are your boards laid out in a way that adds to the visual appeal of the fabrics and is the mood of the layout suitable to the group?
13. Have you developed organized master sheets for each group?
14. Are your fabric and garment ratios well-balanced? Are you making good use of every fabric you have put on your boards?
15. Are your fabrics suited to the designs for which they have been selected? Employers will be looking beyond just color to the weight and hand of the fabric, as well as the price-point.

Although casually arranged, these fabrics have been carefully chosen by designer Keith Hsieh for his planned menswear group. A variety of distressed denims, shirting, cotton and wool plaids, soft leather, and a cool, exposed zipper all add up to a very masculine, contemporary mix.

References

Marshall, Jackson, Kefgen, Touchie-Specht, and Stanley. *Individuality in Clothing Selection and Personal Appearance*, Sixth Edition. Upper Saddle River, NJ: Prentice Hall, 2004.

Chijiiwa, Hideaki. *Color Harmony: A Guide to Creative Color Combinations*. Rockport, MA: Rockport Publishers, 1987.

TASK LIST

1. Review some textile strategies to stimulate your creative juices.

2. Review all of your concepts and inspiration images. Make any needed changes before you start collecting fabrics.

3. Collect fabric swatches and plenty of trims.

4. Plan and create fabric treatments for your groups. Err on the side of more, because treatments add so much to your book!

5. Build your fabric boards. Consider investing in some great pinking shears if your boards don't look sharp. Explore different formats to find your own style.

6. Make at least four or five copies of the blank master sheet and add your swatches for your first group.

7. Sketch out your silhouettes, trying to find a good balance of lengths and shapes.

8. Add the final versions to your master sheet.

9. Repeat this process for your other groups.

10. Make sure to compare your groups to maintain "big picture" balance and variety throughout your book.

FABRIC SWATCH LAYOUT

Sweaters(formal) — Cut & Sew Knits(casual) — Matte Jersey(formal)

Velvets(formal) — Chiffon (formal)

PRINT OR PLAID

CottonNylon Wovens — Cotton shirtings(casual) — Stripe shirtings

Crepe(formal) — Wool(formal) — Gabardine(formal)

Twill(casual) — Denim(casual) — Corduroy(casual)

Leather(formal) — Suede(formal)

This chart gives a more formal layout sequence for fabric boards. This can be a good starting point to help you organize your fabrics swatches. Note the additional organizing principle that groups dressy with dressy and casual with casual fabrics.

GROUP OR CONCEPT _____

Resource Form:
Source: _____
Fabric: _____
Fiber: _____
Price: _____
Season: _____

Resource Form:
Source: _____
Fabric: _____
Fiber: _____
Price: _____
Season: _____

Resource Form:
Source: _____
Fabric: _____
Fiber: _____
Price: _____
Season: _____

Resource Form:
Source: _____
Fabric: _____
Fiber: _____
Price: _____
Season: _____

Resource Form:
Source: _____
Fabric: _____
Fiber: _____
Price: _____
Season: _____

Resource Form:
Source: _____
Fabric: _____
Fiber: _____
Price: _____
Season: _____

Make a number of copies to take with you to the fabric store to help organize your swatches and trims.

Chapter 4

Create Your Mini-Mockup Portfolio

MOOD IMAGE

Spectacular achievement is always preceded by spectacular preparation.

Robert H. Schuller

Planning Your
Mini-Mockup Portfolio

The goal of this chapter is to help you develop a miniature mock-up of your fashion portfolio that resembles as closely as possible your final outcome, with a minimum of four groups. You will plan and rough out the details of all four groups using templates provided at the end of this chapter. This may seem like extra work, but we promise you that the reward will be a better portfolio. What are the advantages of this exercise?

By putting your groups into portfolio form, you can see how effectively they "flow" from one group to another. Good flow happens through a number of elements:

1. **The fabric colors:** For example, you might start your book with a lighter, more colorful group, play with different neutrals in the next two groups, and end with something darker and more dramatic. However you plan your colors, you want it to be visually stimulating to the viewer.
2. **The mood:** Varying the mood of your groups is also visually stimulating. Even if you have an overall theme, like interior design, you know that different rooms have very different moods. Save your strongest mood groups for the beginning and the "finale."
3. **The variety of looks:** Too much of the same thing, no matter how well done, is never as interesting. Variety can come from seasonal differences, of course, and if you do seasons, you need to arrange the groups accordingly and not jump around. Generally it's better to start with Spring and end with Fall or Resort.
4. **Design differences:** Even a "seasonless" book must have a variety of design details and silhouettes, fabrics, and accessories. How you arrange those differences is important. You need to grab the viewer in the beginning, keep them interested in the middle, and "wow" them in the end.
5. **Your muses:** Which are your most exciting muses? Where should they be in the group order? Save the best for last.

Having to arrange your groups and their components will alert you to any concepts that are too repetitive or that don't mesh in terms of flow.

For example, you may love your group of black cocktail dresses with sequins and lace, but when you try to fit it with your other dress groups visually, you realize it is too "glitzy" and does not mesh with your other more sophisticated concepts. No matter where it is in your mini portfolio, it looks out of place. Or you may simply find that the denim group with stitching treatments just is not interesting enough once you arrange it with your other more visually compelling groups.

Putting together your mini portfolio forces you to decide on issues like group order and layout choices.

Postponing these tough decisions is tempting but will often result in wasted effort because your groups won't work well together in the end. You will see a number of layout choices in this chapter, and the sooner you choose one, the more efficient you will be. Also deciding your group order allows you to focus on each group in the order it will appear in your book, which helps you to stay on track. Assembling each group as you complete it will also prevent last-minute disasters.

TEN STEPS TO A MINI PORTFOLIO

1. Choose your portfolio format.
2. Assemble your group elements.
3. Copy your templates and reduce your elements.
4. Create an outline of your visual plan.
5. Add mood images and fabric boards to your template.
6. Create thumbnail compositions.
7. Create thumbnail flats.
8. Add figure layouts and flats to your template.
9. Seek good critiques.
10. Make necessary changes.

STEP ONE: Choose Your Portfolio Format

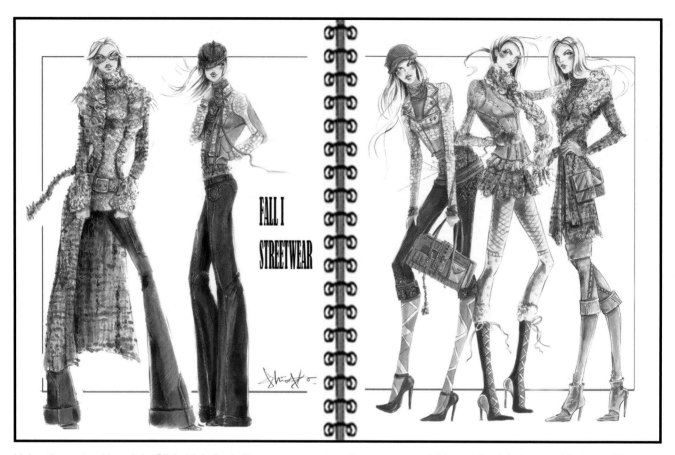

Using the natural break in Olivia Ko's lively figures, we can produce a wonderful layout for this format. Horizontal images allow you to show your figures full size, but they also force you to break up the figures across two pages. Despite the break, the figures can and should still relate to each other. Note how the two "bookend" figures face the center of the page. We could also play with moving the images forward in space so we show cropped views of the outfits.

Designer: Olivia Ko

It's time to make one of the tougher decisions in the portfolio process. Settling on a consistent layout for your book is a big commitment and not one to take lightly. Because some formats are more labor intensive and require careful craftsmanship, you will want to keep your strengths and challenges in mind. For example, if you tend to be messy but really want to do fold-outs, you might enlist a very neat person to help you. But you do need to make a choice so you can move forward.

Things to Keep in Mind

1. **Once you have committed to a layout, you must plan each group in that format** (although you will see that a couple of the variations can be combined). You do not want to force your viewer to turn the book around to see your various groups.
2. **Different layout formats present different advantages and challenges,** so study the examples carefully. If you find your mini layouts are not going well, it is a good time to make a switch.
3. **Plan your mini portfolio so you do not leave any blank pages.** There is always a clever alternative to a blank page that will be more interesting and finished looking.
4. **Make sure to have your actual portfolio by the time you make the format decision.** You may want to experiment with some of your projects in the book to see what format feels right.

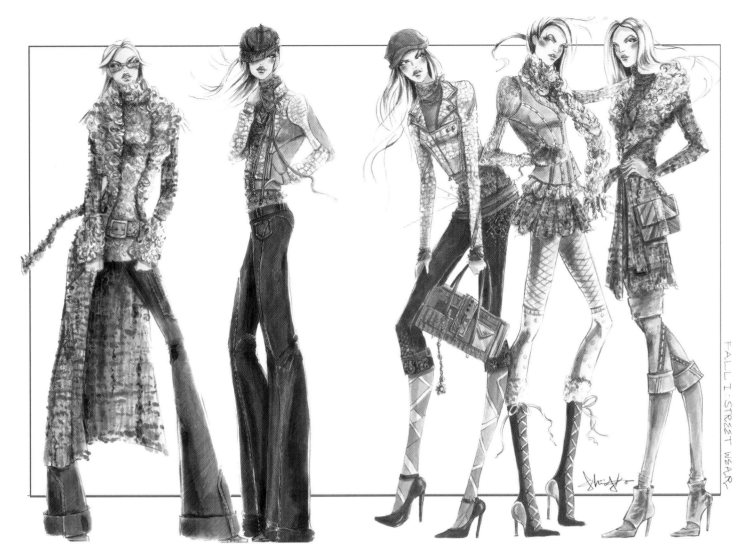

FALL 1 STREET WEAR

YOUNG DESIGNER WOMENSWEAR

FABRICS

Note how the fun styling and colorful, cool accessories make this group work especially well. There are many fashion-forward customers who do like color, so if you can have at least one colorful group in your book to show that you know how to make it work, you will benefit.

Designer Profile

Olivia Ko, Senior Designer at Mattel, currently serves as lead designer for the Barbie core fashion line "Barbie Fashionistas." Specializing in fashion innovation and conceptualization, she consistently delivers fresh and chic styles every season. Drawing upon the latest fashions and accessories, her creations reflect her passion, exhibiting an exceptional level of detail, realism, authenticity, and originality.

 Olivia's family and childhood memories inspired her to pursue her dream of becoming a Fashion Designer. Today, Olivia finds happiness in knowing her creations enable girls to play out their dreams and fantasies.

Vertical Layout Format

Basic Vertical Format

1. This is probably the easiest layout to use, because it's pretty uncomplicated for you to put together, and easy for the viewer to understand.
2. You can have as few as three figures in your group, but we have also seen twelve carefully arranged poses that looked great. That group had six outfits, each one shown with a "jacket on" figure and another figure with the jacket off.
3. Note that the flats should stack very precisely under each figure, which enables the viewer to easily connect one to the other.
4. A recap of fabrics next to flats is nice, since you don't see them next to your figures. You can also add mini figures next to fabrics.
5. You can create variations by breaking up the figures and flats.

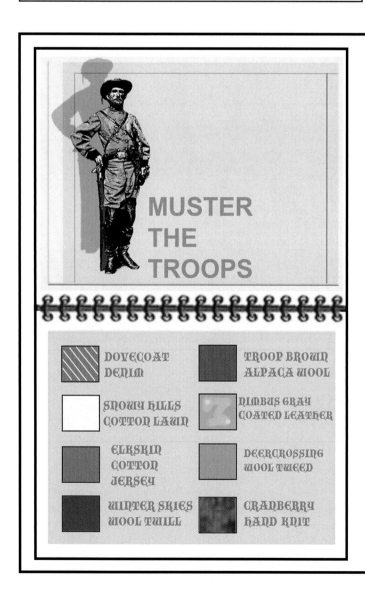

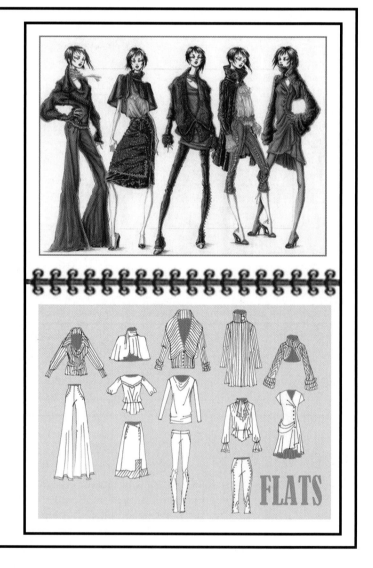

Designer: Barbra Araujo

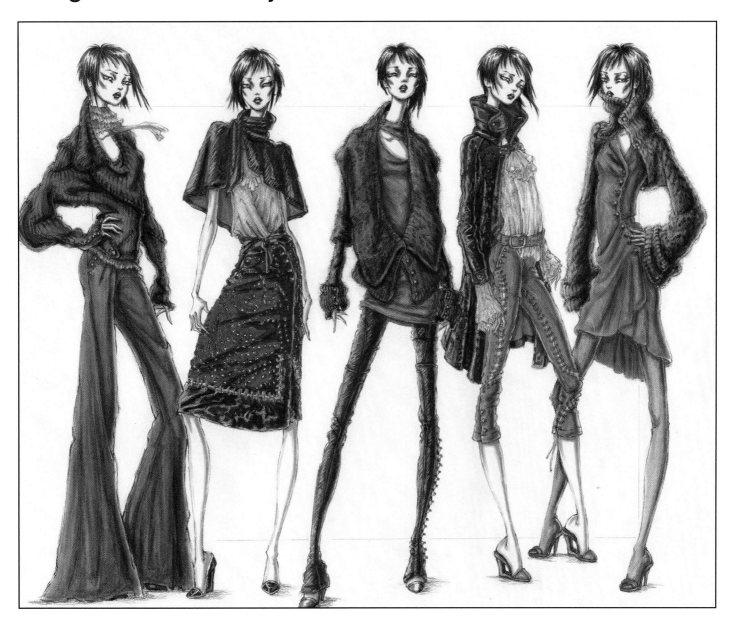

Apparel Category: Contemporary Sportswear

As you can see, this beautifully composed group, designed and illustrated by designer Barbra Araujo, is perfect for a classic vertical portfolio layout. Although it shows five outfits, the figures are placed close enough together to fit well on the page. If you analyze the poses, you can see that Barbra has used only two different figures, but by flipping them and changing the heads and arm poses slightly, she creates the illusion of a great variety. The overlapping of the poses adds visual interest.

Because Barbra has included historical military silhouettes and details in her group, such as the short cape, the cropped pant with buttons up the side, and the high-collared coat, the image of the soldier makes a good mood image. Note that the names of the colors relate to both military and the natural settings in which they might be camped. The flats are stacked in an organized line under each figure, so the viewer can easily connect flats to illustrations. They are always arranged in a tops-to-bottoms order.

Although the group is all fairly dark and in muted tones, the careful rendering encourages us to look at each piece individually. The important details, such as the military buttons and the lace jabot and cuffs, stand out. The attention to the variety of textures also gives each garment a unique look. We can almost feel the soft, fuzzy yarns of the sweaters. Creating tactile visuals is an important part of the design illustration process, which we will discuss more in Chapter 7.

Also note that the shoes are all similar, except Barbra varies the color and adds military-style leggings. The heads are all the same muse in different poses, which Barbra pulls off beautifully. This consistency of *support elements* allows the viewer to focus on the designs. The color in the group is also balanced so that it carries our eye around the page.

Menswear Designer: Keith Hsieh

Apparel Category: Young Mens Contemporary

Menswear designer Keith Hsieh shows us an alternative use of the vertical format with his very cool groups titled *Insignificant Damages.* The mood image is shown above the illustrated group and the next two pages are devoted to the flats. Although the flats are separate from the group, Keith includes the mini versions of his figures next to each flatted outfit. The fabrics fit nicely on the second flat page.

Keith has chosen to use the same walking pose for all his figures, which sends the figures forward toward the viewer, creating a dynamic visual energy. He has placed the lightest color, pale yellow, on his two bookend figures, and the strongest color, rust, on the central figure. The rest of the colors are muted, but the lights and darks are also balanced to keep our eye moving around the page. When this balance is done correctly, it looks easy, but these elements must be carefully placed. We will discuss this more thoroughly in Chapter 6.

Keith has also made good use of his Photoshop skills to add rather abstract backgrounds to both figures and flats. Again, the effect is subtle, but important to the overall mood. As in Barbra Araujo's layout, the accessories and heads all have a similar look, so the focus is completely on the clothes. The youthful, disaffected look of Keith's muse supports the Postmodern theme indicated by the title of the group.

The facing page shows another design group from Keith's portfolio, as well as his statement and some great advice for young designers. You can see how well this group supports the general mood of Keith's cutting-edge aesthetic. Keith is currently the Assistant Product Manager (Assistant Designer) at Armani Exchange in New York.

Designer Statement

I am originally from Taiwan. My family is in the bridal business; they do both design and production. That's what inspired me to study fashion. I have seen so many dresses and lace and flowers since I was a kid, so I wanted to try menswear. The advice I would give grads is to work on digital skill really HARD! Everything is digital now, because everything has to be in emails: tech packs, spec sheets, everything. But hand drawing is also really important. I'm lucky that we still do hand drawn flats and some illustration by hand. They were surprised because my book was kind of digitally done, but I can still draw. And know your fabrics! It helps when they ask you to do research, order fabric, fabric boards, etc. We are really well trained but there will always be people who are better than you. Ask questions, don't pretend you know then mess up stuff. Don't be shy; learn to speak up. Don't be afraid to start from the bottom. I started as an intern; I was cutting fabric, ordering fabric, buying coffee, etc. and then I moved up to drawing flats, doing inspiration and fabric boards, and I ended up designing all the prints for their woman's collection last season!

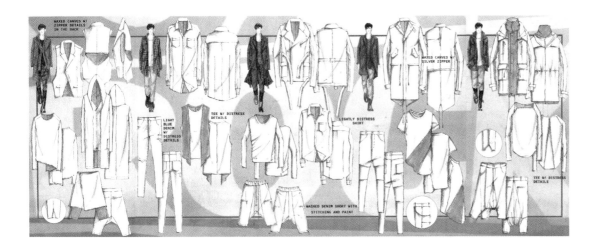

Vertical Format with Extensions

Foldout Pages

The viewer's ability to see all the elements of the group in one visual, thanks to the foldout pages, is an obvious advantage if it is executed correctly. See page 114 for directions on how to construct your fold-out pages so they are sturdy and the edges are clean.

MOOD IMAGE

FABRICS

FLATS · FIGURES · FLATS

Vertical Format with Extensions:

1. This format requires extensions that meet exactly in the middle, so the execution has to be perfect.
2. All the components are shown together, which can create visual impact.
3. The space for flats is somewhat limited.

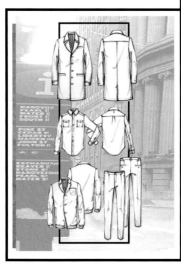

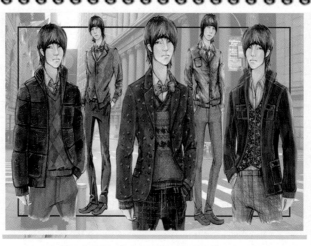

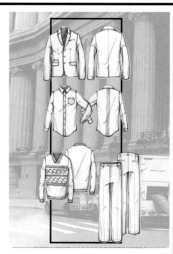

The *mood image* of a venerable school in England supports the concept of this charming Young Collegiate Menswear group by designer Sarah Ahn. The classic menswear fabrics like tweed and wool plaids look great cut in young, slim silhouettes. The use of loose ties and colorful bow ties adds to the whimsical mood of the group. Note Sarah's skillful use of a background to tie together the various elements of her collection.

MEN'S COOL COLLEGIATE LAYOUT

Designer: Sara Ahn

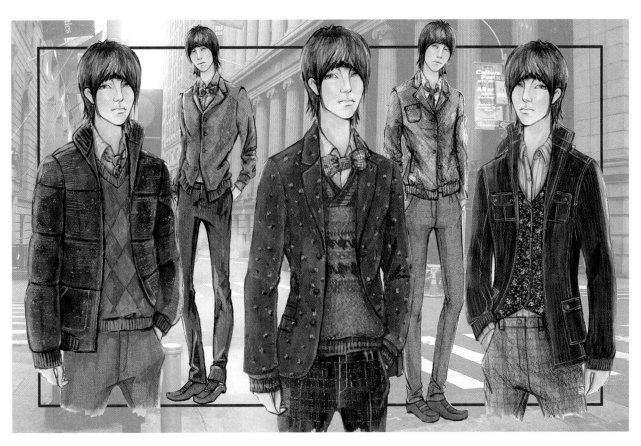

Technical Flats

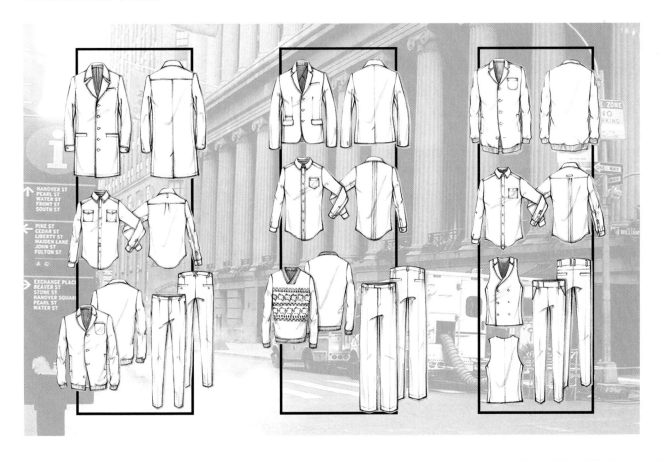

HOW TO CREATE A
FOLDOUT PORTFOLIO PAGE

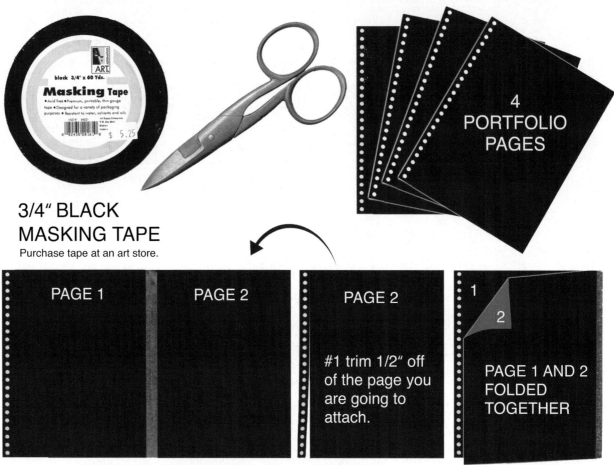

**3/4" BLACK
MASKING TAPE**
Purchase tape at an art store.

4 PORTFOLIO PAGES

PAGE 1 PAGE 2

PAGE 2

#1 trim 1/2" off
of the page you
are going to
attach.

PAGE 1 AND 2
FOLDED
TOGETHER

Trim page two 1/2" removing perforation side
tape two pages together with black masking tape.
Tape both sides of page to fully attach together.

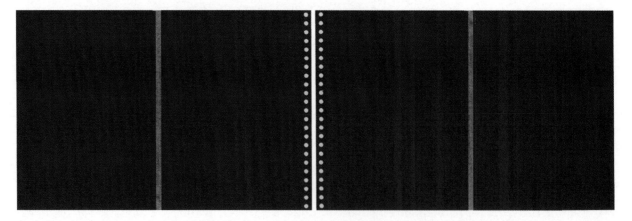

Now that your foldout pages are ready, insert your finished designed pages into a presentation.

Horizontal Layout Format

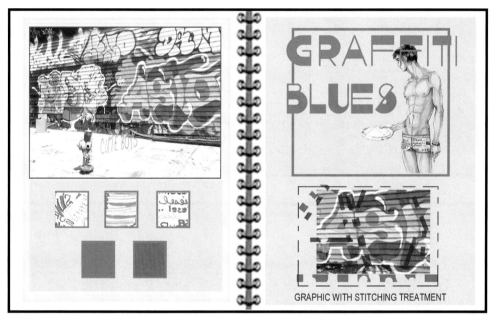

GRAPHIC WITH STITCHING TREATMENT

Basic Horizontal Layout

- This is a very compressed format that can work well if your fabric board and flats are fairly limited.
- Focusing on just one garment like jackets or t-shirts can be a nice change of pace in your book.
- Cropped figures can be hard to compose, but they have a lot of drama. The drawing must be very good, or very graphic and well-designed.

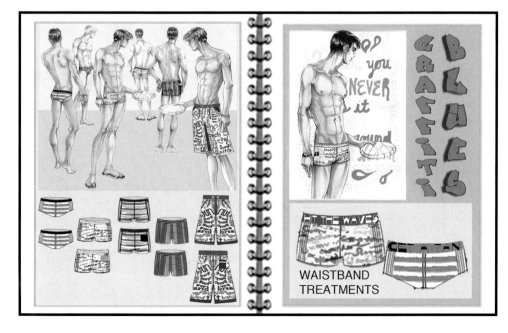

WAISTBAND TREATMENTS

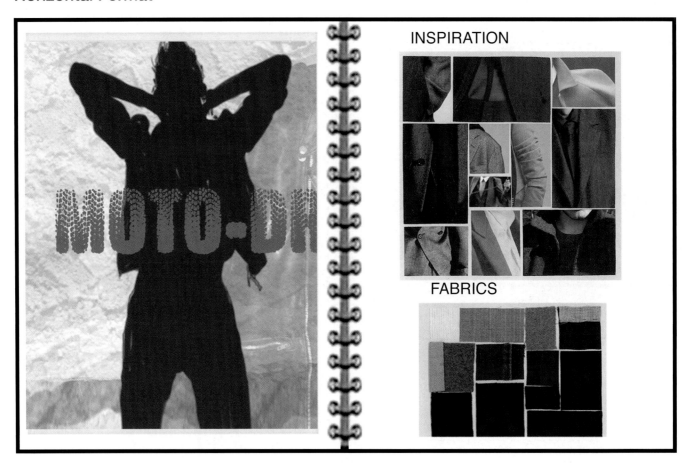

INSPIRATION

FABRICS

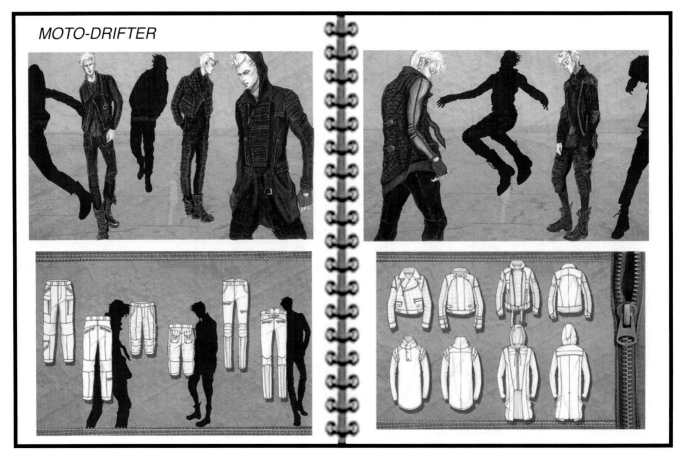

MOTO-DRIFTER

Menswear Designer: Cherise Shikai

Designer Statement

I was born and raised in East Los Angeles and was mentored at O'Neill men's swimwear, Todd Oldham's men's fall sportswear, Sean John menswear, and Bob Mackie gowns. I interned at Hurley International for their menswear division. I also was a member of the H20 intern team that helped develop Hurley's clean water initiative and designed a booth at the U.S. Open of Surfing in Huntington Beach. Currently I am an apparel design apprentice working in men's sport at Reebok in Canton, Massachusetts.

These very cool and visually exciting designs are based on the theme of Motocross Racing. This is a form of motorcycle or all-terrain vehicle racing held on off-road circuits. BMX is a similar sport for nonmotorized dirt bikes. Using inspiration from something that is cutting edge in present-day culture is a great way to add "cool" to your designs.

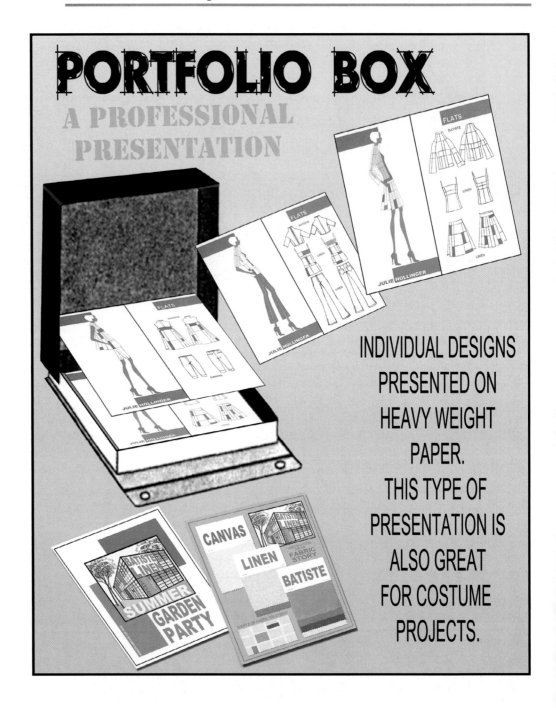

If you really want to stand out from the crowd, you can consider portfolio formats that do not involve the traditional notebook-style portfolio. As you see from these two presentations, the approach can be quite different, and still look visually exciting and professional. Both of these approaches involve the hard box-style portfolio. They do not use the typical plastic sleeves of a notebook style, which is both good and bad. Plastic sleeves tend to get worn after some use and should be replaced. Sometimes students handle their books too much just in making them, and the pages are messed up before they even go on their first interview. With the box formats, you do not have to worry about that issue, but you do have to be aware that your work may get dirty because it has no protection and people will be handling it. We do think these individual cards are great if you want your viewer to focus on individual outfits. They also work externely well for costume presentations because each character can be a separate card.

Accordion Format

This is a very striking presentation method that keeps your groups in good order and is bound to grab a viewer's attention. The down side of this is that you do need some space to display your work, which is not always available in a job interview. Such great presentation skills are valuable in the design field, especially in entry-level jobs.

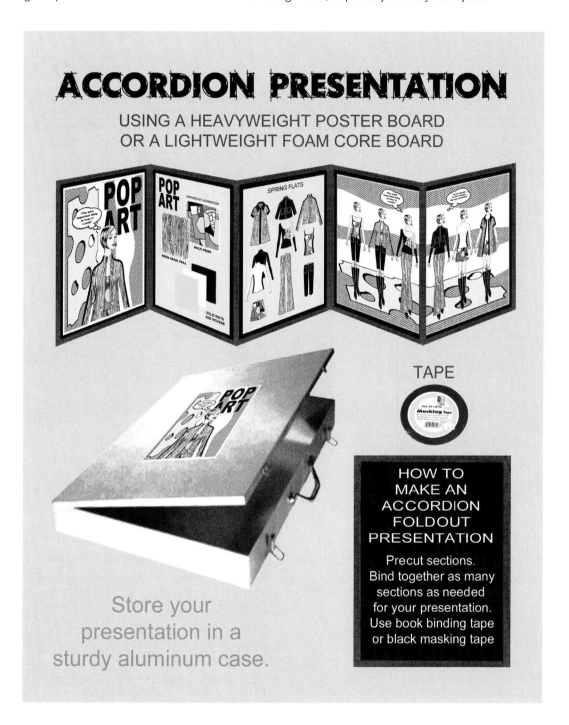

STEP TWO: Assemble Your Group Elements

If you have diligently followed the steps in the first three chapters you should already have all the key components (at least in planning stage) for each group ready to go into your mini portfolio.

These include:

1. Themes/concepts for all four or five groups.
2. Fabric boards for all groups.
3. The season of each group, if you plan to address seasonal changes.
4. The mood of each group and the inspiration image that will convey that mood.
5. The muse for each group that reflects the concept.
6. The general attitude of the figures, and the resulting mood of the poses.
7. Inspiration images for the composition of each group.
8. A master sheet for each group with rough sketches of flats.

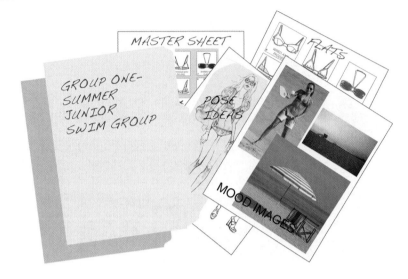

If you feel confident in your choices for these components, you are ready to begin your mock-up. Of course, none of this is "set in stone" yet, and flexibility is an important characteristic of a designer. But at some point we have to commit.

STEP THREE: Copy Your Templates and Reduce Your Elements

TEMPLATE ONE

TEMPLATE TWO

Keep in Mind

1. Templates one and two can be used horizontally or vertically.
2. Copy these templates and enlarge them to the size of an $8\frac{1}{2}$" × 11" sheet of copier paper. You will need about 12 to 15 copies.
3. You can use the gray as your background or collage in a new color before you make copies. You can also scan your template and change it in Photoshop.

Templates with Extensions

TEMPLATE THREE

TEMPLATE FOUR

REDUCE YOUR COMPONENTS TO FIT YOUR TEMPLATES.

REDUCE YOUR ELEMENTS

Once you have your templates copied, copy or scan all the elements you've collected and created, reducing them to fit the proportion of your template page.

STEP FOUR: Create an Outline of Your Visual Plan

As we discussed in our introduction, creating a visual flow with your images and ideas is a priority for an effective book. How you order your groups is key. The following templates show a workable plan using traditional seasons in a simple vertical format. If you chose a fold-out format, all the elements of each group can be shown on just two pages. If your groups are seasonless you can plan your categories like a runway show. Start with more casual designs, and end with a dressier finale group.

NOTE: Four groups is our recommended minimum for a portfolio. A fifth group, especially if it shows additional skills, is ideal. Julie Hollinger's portfolio, which follows Chapter 11 shows all five groups.

Focusing on creating a written outline will encourage you to make those tough decisions about order and seasons. Notice that the descriptions of the groups and the flats show a clear plan to offer variety in the elements of each group. The rendering and flats will be approached differently each time, providing opportunities to show a gamut of skills.

REMEMBER THAT YOU WANT TO GRAB YOUR VIEWERS' INTEREST WITH GROUP 1, MAINTAIN THEIR FOCUS THROUGH GROUPS 2 AND 3, AND WOW THEM WITH YOUR FINALE.

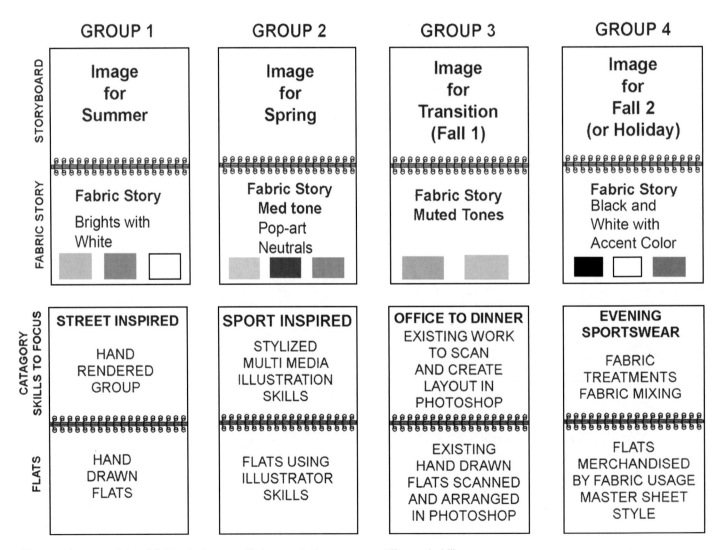

Showcasing a variety of flat techniques will demonstrate your versatility and skill.

Womenswear Designer: Charmaine De Mello

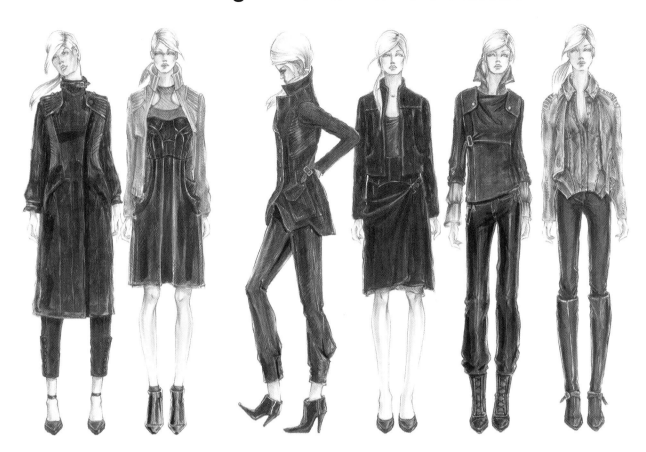

Young Designer: Womenswear

Charmaine de Mello lives in New York City, working for companies such as Calvin Klein and Vivienne Tam. "My advice to anyone starting their career is to take what you have learned and run with it. What you learn in school serves only as guidelines to prepare you to be on your own. There are no rules when it comes to creativity, except this: Be open to change, and do what feels right. Really develop your inner instinct and sharpen your design eye—it will make you a stronger designer. Take some time to figure out your own design philosophy and identity. This may take some years, as it has for me. I'm still slowly discovering my own. But every new job and experience has helped to clarify my design identity: focused, tailored, feminine without being fussy, and always empowering. The next 20 years of my career are unforeseeable, but I will always hold true to this identity."

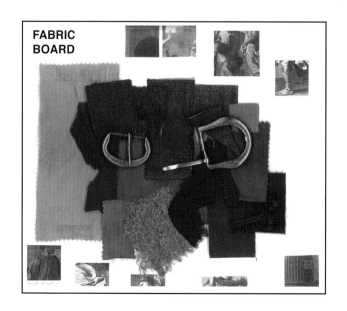

FABRIC BOARD

Fall Separates

Womenswear designer Charmaine de Mello has created a lovely fall separates group for a contemporary customer. Her inspiration image is quite unusual in that she used the famous Nicolas Poussin painting *The Rape of the Sabine Women.* If you check out this marvelous, rather frightening composition, you will see why Charmaine chose it. The beautiful details on the garments of the figures inspired some wonderful designs. We see a definite point of view in the details, especially in the neckline and shoulder treatments and shapes.

Because this group is a somber fall separates group, Charmaine would probably consider adding a more colorful holiday group to show her versatility. You want to consider such issues when you make your visual plan.

STEP FIVE: Add Mood Images and Fabric Boards to Your Template

Once you have committed to a layout plan, you can begin to assemble the first two pages of your mini portfolio. Use your templates to add your sized mood images and fabric boards as you plan to place them in your book. Check to make sure that the mood images support the color direction of your fabric story and that the relationship between the two is clear and visually compelling.

STEP SIX: Create Thumbnail Compositions

If you love to illustrate your designs as we do, you will be happy to reach step six! It is time to use all those cool inspiration photos of groups, plus your own inner vision and even composition ideas you've done in the past, to create some exciting thumbnails of great pose layouts. Take each group separately, sharpen your pencils, grab some tracing paper, spread out all your pose ideas, and start sketching.

NOTE: Templates are provided on the Companion Website (www.myfashionkit.com), which can also give you some good ideas for compositions. If you work first to create your own figures, however, your skills will improve more and your book will develop a more personal style. We will also review pose development in Chapter 6.

Things to Keep in Mind

1. Consider sketching each pose separately, even if you have a group photo. This allows you to move the figures around to try different compositions. Even better, scan them and experiment in Photoshop.
2. Try to come up with several layouts for each group. Chances are your first idea will be the more obvious solution. If you push yourself, you will find your new ideas are probably more interesting.
3. Remember that playing with perspective creates a sense of depth and visual interest. It's easy to move figures back and forward in space in Photoshop. You can also copy each figure in several proportions, then work with those to find different layout ideas.
4. When you sketch new figures, don't put clothes on them. Good figures can be used over and over, and you will be glad to have them, especially when you have been out of school and want to change your portfolio. Your anatomy is likely to be better as well if you draw the figure structure.
5. Remember that you can always draw one good head for your muse, then use it for all the poses of a group. However, if you are good with faces, it is fun to have more than one angle. Of course you can always adapt a photo as well.

Make Thumbnail Layouts of Your Composition Ideas

1

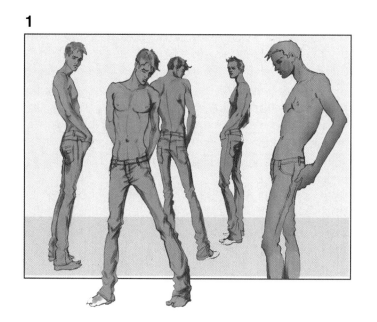

2

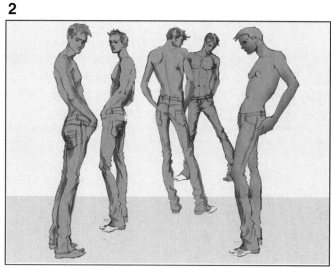

3

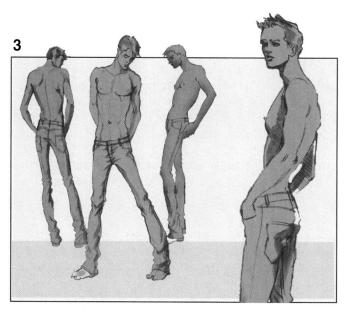

4

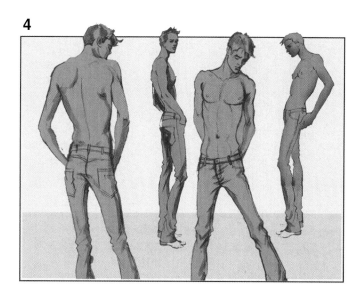

Things to Keep in Mind

1. You can simply sketch different layouts, but scanning or copying your figures to different sizes makes it easy to "play" with different ideas.
2. For a very complex layered group, a simple composition might be the best solution.
3. Note that lighter and darker shades are another way you can visually "push" figures back or forward in space.
4. Cropped figures can add drama and show more detail, but you have to be careful where you make the cut. A general guideline is to crop at mid-thigh or mid-calf.

NOTE: The balance of color and pattern in the actual garments will ultimately dictate the best composition.

STEP SEVEN: Create Thumbnail Flats

Although your master sheets may still be in very rough form, you can pull from them to create thumbnail flats for each of your groups. Doing this will encourage you to think in ever more concrete terms of the silhouettes and details of each concept. It will also give you a real idea of how many flats each group will have, which will allow you to plan how you will arrange them and place them in your portfolio. Layout problems are a common cause of students failing to finish a group on time, so budget your time at this stage.

NOTE: This is also a good time to revisit your visual plan and consider how each group of flats will finally be rendered: using Illustrator, by hand, and so on.

Remember to:

1. Stack your flats from top to bottom, and make sure underpieces will fit comfortably beneath your overgarments.
2. It's easy to add pattern or loose color, especially in Photoshop, which helps you to see the flow in your mini portfolio.

STEP EIGHT: Add Figure Layouts and Flats to Your Template

This step is pretty self-explanatory, and I am sure you are getting the idea as you see your mini portfolio come together. All this preliminary thinking in miniature is creating a true Big Picture plan. When you are ready to start your actual portfolio, you can focus on the all-important design and illustration aspects, knowing that your logistical issues are well in hand. This does not mean that you will stick completely with what you have decided so far. In fact, chances are you will be making changes. But we trust you will feel more confident knowing you have done much of the difficult planning up front.

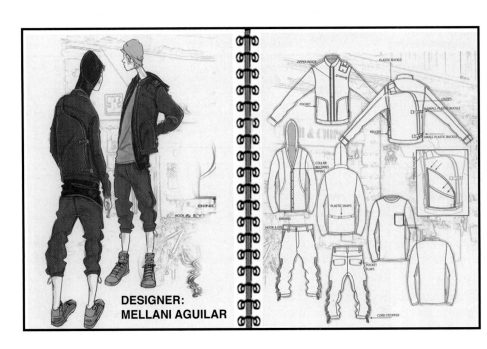

DESIGNER: MELLANI AGUILAR

In a horizontal format, you are inevitably putting the flats next to the figures, rather than lining them up underneath. If you want more than a few figures, you must think first about space, and second about clarity. The space issue can be solved by doing fold-outs. If you're up for this, that's great. Otherwise, you may have to do really small flats, or keep your groups very small. You can enhance clarity by numbering the figures and corresponding flats, or adding tiny figures next to the correct flat row. The rendering of the flats in your final also will help the viewer connect it to the corresponding figure.

Young Men's Designer: Mellani Aguilar

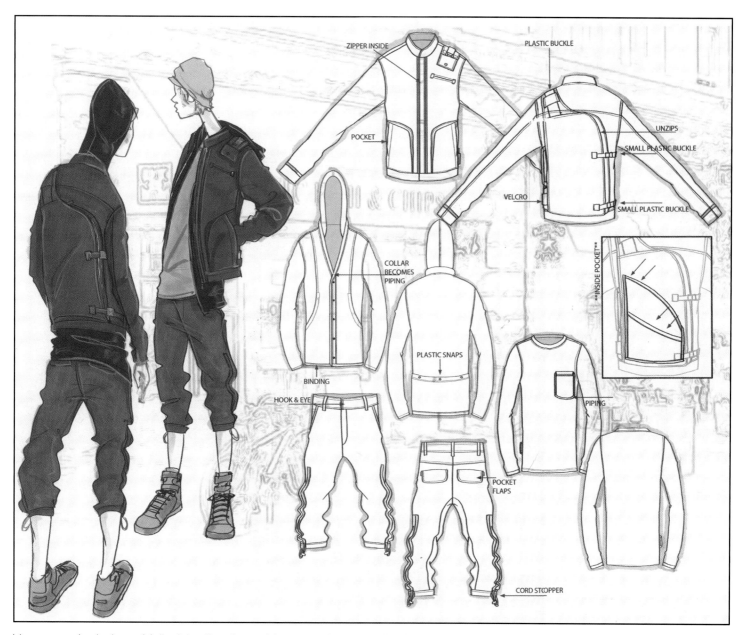

Young men's designer Mellani Aguilar chose this unusual composition because she wanted to feature the functional aspects of her jacket design. By putting the back figure in the foreground she calls attention to the very cool and innovative built-in backpack, which she also carefully details in her flats. When you choose poses, it is wise to think about what in your group you especially want to feature, then make your choices based on that.

Designer Statement

I was born in Quezon City, Philippines. I wanted to be an architect but upon moving to the U.S., I opened my eyes to the possibility of applying my love for design to clothes. I fell in love with menswear and started working as an assistant menswear designer. Because I work in a more activewear-inspired industry, a big portion of my job involves developing computer generated flats and graphics. I have to say that being fully knowledgeable on Photoshop and Illustrator and capable of translating the design and concept in a more detailed manner with a computer is a great skill to have! It has for sure paved the way to where I want to be.

STEP NINE: Seek Good Critiques

Congratulations! The hard work in this chapter is done, and you should have in your hands a completed miniature portfolio that reflects your extensive preparation and dedication to excellence! The other good news is that other people do most of the work on this step. Your job is to simply seek feedback from your instructors, peers, mentors, Mom and Dad, and so on; whoever you think would have a valid opinion that could be helpful. Plan to get the opinions of at least three people but preferably a few more. Make sure to take notes, and write the person's name next to the comments.

We think you will be surprised by how much someone can pick up from even a small version of your portfolio and by the constructive comments that result. Of course, you may get some conflicting opinions, which can be confusing, but that happens in the industry all the time. Do consider the sources and who is the most knowledgeable on the subject. But this is your book and you have to feel confident showing it, so go with your best instincts.

In the end, know that the thinking and planning you have done is the biggest payoff for your future career. You have accumulated a great deal of information involving your process that people can't see just by looking at your rough mini-layout.

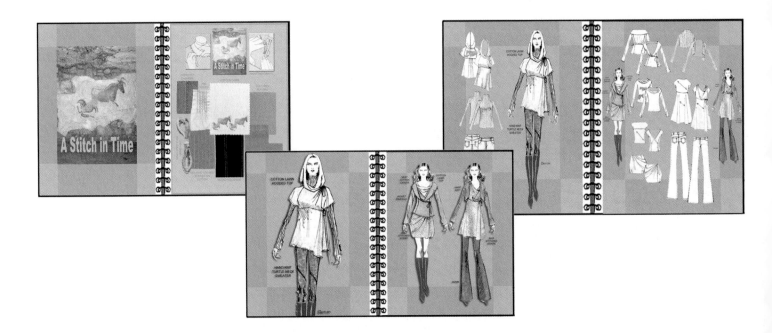

STEP TEN: Make Necessary Changes

Once you have enough feedback, revisit your notes and take some time to decide what if any changes you want to make.

Things to Keep in Mind

1. Even if all your "critics" think your plan is perfect, you still may have received some good ideas from their comments that encourage adjustments. Don't ignore these impulses, but don't get stuck thinking about it either.
2. If you do decide to make changes, you can revisit your "mini" and see how the adjustments flow. But you do not have to re-do if you feel ready to move on. You can start developing your first group with the intended changes in mind and adjust accordingly.
3. This is a good time to revisit your time-management plan and make adjustments there as well. You probably have a clearer picture of which groups will require more time.

CHAPTER SUMMARY

If you have followed the chapter steps carefully, you should be the proud owner of a completed mini portfolio that is an ideal guide to producing your full-sized book. If you have received feedback and made any necessary changes, you are ready to move on to the wonderful process of creating your designs! Since you already have most of the components in place for your groups, like mood boards and fabric stories, you can focus completely on the main course of your book "banquet": the design groups.

Now that you have settled on a layout, you will be able to do rough sketches of how your group might look in its vertical or horizontal format. Again, if nothing looks right to you, you might consider trying a different layout. Some people just find certain compositions suit their work better than others, no matter how they try to do something new.

As we have already pointed out, your mini book is not set in stone. But the discipline to stick with your set course is an important element of success. If you get a different idea that seems more promising, try to discuss it with a faculty member. It is easy to get highly impulsive when you are under pressure, so be careful about embracing a new plan.

TASK LIST

Check these off to make sure you have completed all the steps.

1. Purchase your portfolio case. ☐
2. Choose a portfolio layout. ☐
3. Copy your format template and enlarge to the size of copy paper. ☐
4. Reduce your key elements to an appropriate size. ☐
5. Outline your visual plan including seasons, fabric ideas, flat strategy, and so on. ☐
6. Add mood images to your templates. ☐
7. Make thumbnail layouts. ☐
8. Create thumbnail rough flats. ☐
9. Add layout and flats to your mini template. ☐
10. Continue with all four or five groups. ☐
11. Have several trusted people critique your mini portfolio. ☐
12. Make corrections as needed. ☐

ADDITIONAL ACTIVITIES

1. Research portfolios on the Web and see what students are doing at other schools. Choose one portfolio group and write a paragraph describing what you think are the strengths and weaknesses of the work.
2. Complete a rough draft of your resume and add it to your mini portfolio.
3. Do the same thing for a cover letter, business card, or both.
4. Exchange mini portfolios with another student in your class and talk about them, making constructive suggestions.

Chapter 5
Develop Your Designs

REALM DREAMER

KEITH HSIEH

MOOD BOARD

FABRIC BOARD

Who would not want to see the design group that resulted from this beautiful mood board and fabric story by menswear designer Keith Hsieh? You will later in these pages.

The steps in this chapter are all about how you will develop the designs for your groups and create a beautiful portfolio.

130

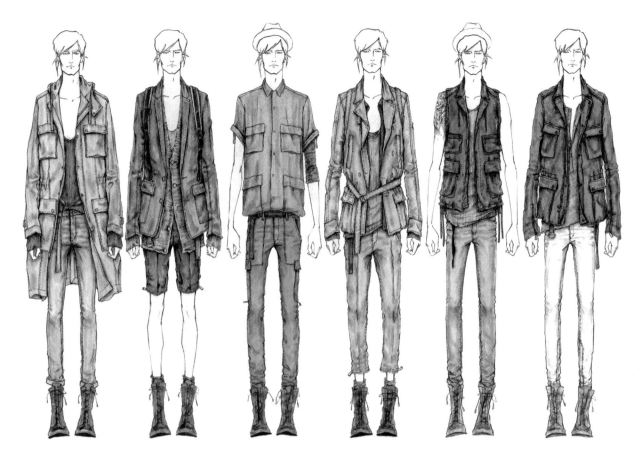

Designer: Marcus LeBlanc

Develop Your Designs

At last! We are ready to create the "heart" of our portfolios: interesting designs that express who we are as creative people. You may have heard the expression, "There are many ways to skin a cat," which simply means there are multiple methods to successfully solve any problem. This is certainly true of fashion design, especially if you want to get beyond simply looking at what other designers do and playing off their creativity. Even if you have developed tried and true methods for creating groups that effectively show your talents, it never hurts to add more elements to your creative toolbox. A fresh approach to design development can make your work more fun and rewarding.

One of the key ways we'll encourage new ideas is to analyze not only traditional clothing design concepts, like proportion and color, but also to examine how successful designers in related disciplines like architecture, fine art, and product design think about their work. You may be surprised to realize that the process of designing a dress can have a lot in common with that of designing a building or a beautiful salad bowl. Good design is good design, and a good designer can probably design anything.

Croquis Format

The chapter will also take you through all the steps needed to thoughtfully develop your designs. Taking the time to create a good croquis format for each group will save you frustration and help you to tackle your design work methodically, as we have been doing in our step-by-step approach. We will also ask you questions to help you think about how you might apply the various theories to your own work.

With that in mind, let's begin to discover that fresh point of view!

TEN STEPS TO GOOD DESIGN

1. Review Elements and Principles of Good Design.
2. Review Principles of Architectural Design.
3. Review Principles of Product Design.
4. Review Principles of Visual Artists.
5. Review Croquis Formats.
6. Consider Sustainability.
7. Create Detailed Flats for Each Group.
8. Draw Your Designs on the Croquis Figure.
9. Make Adjustments to Your Flats As Needed.
10. Check the Balance in Your Final Designs.

STEP ONE: Review Elements and Principles of Good Design

There are several important *elements of design* that can be expressed in one or two words, such as shape, proportion, color, focal point, and contrast. These are so basic to the creative process that they should always be considered, no matter what the project. *Contrast* is a blanket term that involves all the other elements, because we can use any of them to create excitement and surprise. Combining unexpected colors, patterns, proportions, or shapes can all add visual intrigue. On the other hand, designs that lack contrast tend to look more conservative and even boring, so it pays to keep this important tool in mind. Our examples show different ways you can create contrast, but you will undoubtedly come up with some of your own. Don't be afraid to push proportion differences or employ contrasting textures and bold patterns that are more interesting when combined together. Think about subtle differences as well. An all-black outfit that contrasts matte and shine is a sophisticated combination. Create the unexpected and your audience will be intrigued.

Contrast

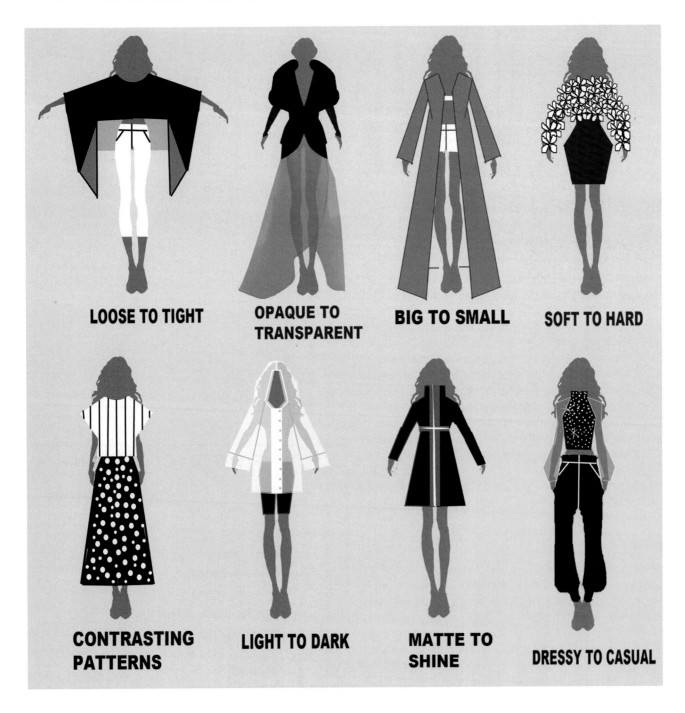

LOOSE TO TIGHT **OPAQUE TO TRANSPARENT** **BIG TO SMALL** **SOFT TO HARD**

CONTRASTING PATTERNS **LIGHT TO DARK** **MATTE TO SHINE** **DRESSY TO CASUAL**

Womenswear Designer: Masami Fukumoto

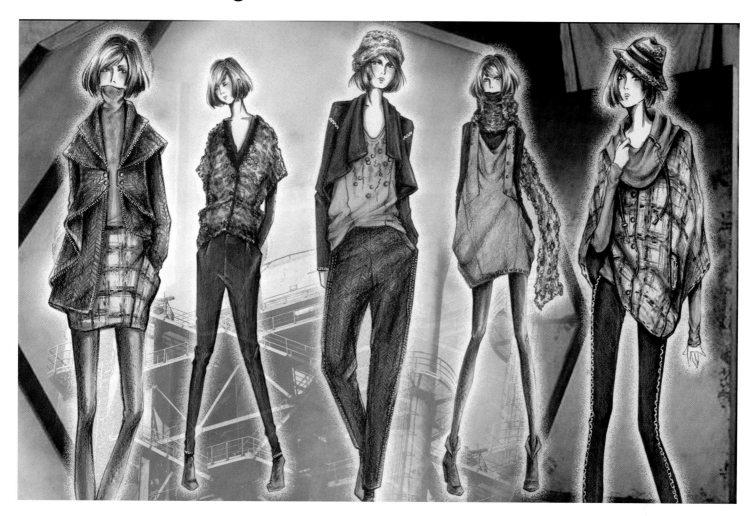

Contrast

Masami Fukumoto's wonderful fall design group provides lessons in subtle *contrast*. Although the group presents a definite design consistency of comfortable but chic garments in soft neutrals with angles created by specific cuts and drape, there is still much contrast to keep the viewer interested. First of all, the contrast in proportions is always well thought out. For example, the first sweater is the longest top, and it is paired with the shortest bottom, a woven plaid mini-skirt. The contrast of texture with pattern is fun, and Masami moves the plaid to the striking loose top in the other "bookend" figure on the right, creating a pleasing visual relationship. The second figure from the left contrasts extreme texture with solid flat knit. The third adds some embellishment and light to dark juxtaposition. The fourth figure adds a cute jumper to the mix, and a scarf that bundles her all the way to her nose! The two loose trousers contrast nicely with the tight, subtly embellished pant on the last figure. Masami keeps her muse looking young with cute accessories and turned-in toes. Her excellent Photoshop skills add an urban background and a glow to all her figures.

Designer Profile

Designer Masami Fukumoto was born in Japan and came to the United States in 2000. Her wonderful skills in both drawing and design landed her a job in 2010 at Juicy Couture as an assistant designer in the fashion sweats department. She currently works at Joie as an Assistant Sweater Designer. She works closely with the Head Designer creating sweater groups and mood boards, interacting with vendors, reviewing lab dips, doing trend research, and, of course, creating tech packs. Masami is inspired by costume design, including Cirque du Soleil, movies, and high-end fashion.

Masami's advice to future designers: Take digital classes seriously! That's what you will be doing all day every day. Keep inspiring yourself, because the days can get redundant.

Designer: Jenna Rodriguez

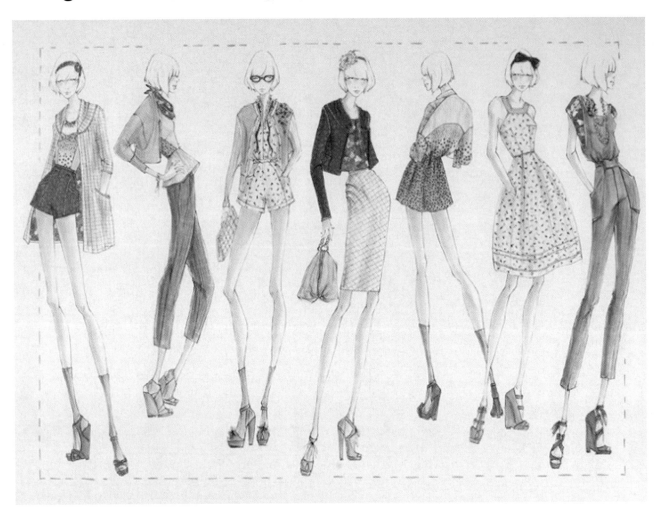

CATEGORY: JUNIOR GIRLS' SPRING

QUIRKY COQUETTE

quirky coquette

MOOD BOARD

Designer Jenna Rodriguez's use of wonderful and quirky inspiration images like cans of paint and cardboard forms has produced this charming junior group that has contrast galore. Identify where you can see:

1. Loose to tight
2. Big to small
3. Contrasting patterns
4. Light to dark
5. Dressy to casual

Note how Jenna places her more intense colors of red and blues in strategic places throughout the group. She also carefully balances her patterns with the easy contrast of solid colors. While Jenna keeps her silhouettes young and fresh, she also gives her customer the choice of some longer skirts and trousers. She can go from casual to career in the same group.

Using Contrast in Design

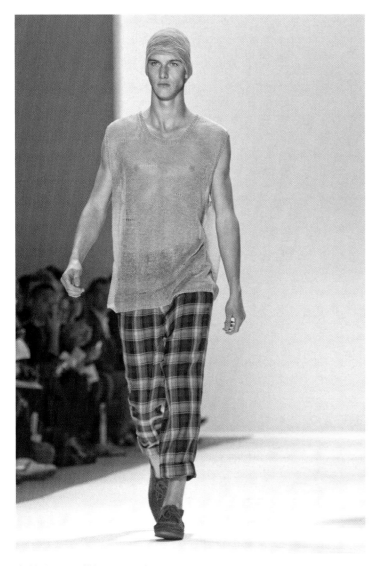

© K2 images/Shutterstock.com

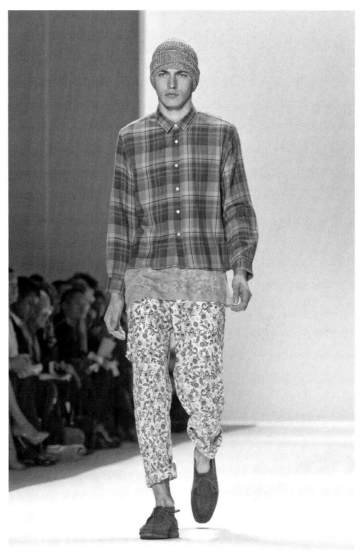

© K2 images/Shutterstock.com

Although the contrast in menswear is usually subtle compared to womenswear, I think it is pretty easy to see a variety of applications of this principle in these two young menswear outfits by designer Duckie Brown for his 2011 Spring/Summer collection. Because Brown's customer is younger and therefore generally more experimental, he is able to use contrast more boldly than are more conservative men's designers.

The first outfit contrasts a lightweight and light-colored transparent fabric with a hefty, dark plaid. The shirt looks rather androgynous, whereas the trousers are made of a classic menswear material. The rolled cuffs undermine the seriousness of the trouser.

The second outfit employs two fabrics with very different moods, a classic plaid and a delicate flower print. The shirt is quite a bit shorter than the norm, and the peach undershirt adds another androgynous element. In contrast to the rather feminine aspects, the shoes are brown and very masculine.

Take the time to look at some of your favorite designer's runway shows and see how they employ contrast in their collections. Looking specifically for that element should make it much clearer for you to identify.

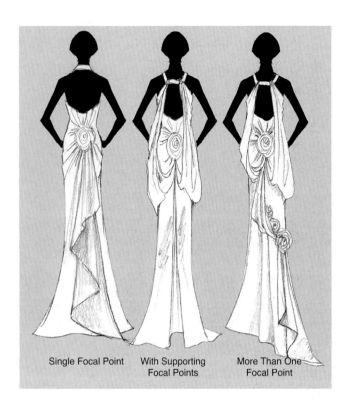

Single Focal Point With Supporting Focal Points More Than One Focal Point

Focal Point

The focal point is the center of interest in a garment. It becomes dominant and draws the viewer's eye to it. Deciding where you want the eye to be directed will help you in your design process. It's important in a group to move the focal point around. This not only creates a more interesting composition, but also encourages good merchandising. Even customers in the same age group want to put emphasis on different areas of the body.

NOTE: Having more than one focal point in a garment can be distracting, but you can have supporting details that lead the eye to the center of focus. This creates "flow," which is desirable in good design.

THINK OF THE BODY AS A LARGE CANVAS

What part of the body are you leading the eye to focus on?

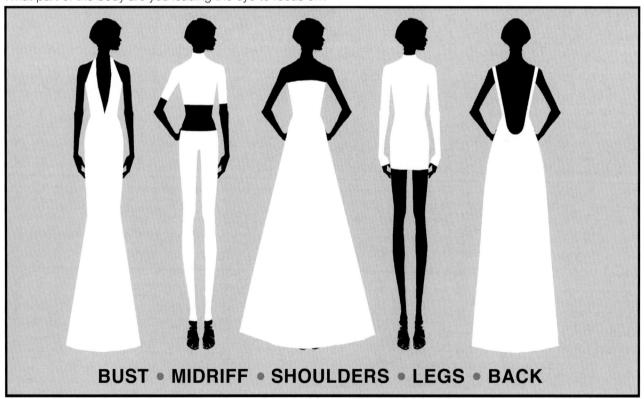

BUST • MIDRIFF • SHOULDERS • LEGS • BACK

Different decades featured different areas of the body. In the 1920s and 1970s, emphasis was on the legs, in the 1930s it was the back, in the 1940s and 1980s the shoulder, in the 1950s the waist, and in the 1960s it was all over the place. The 1990s featured the midriff; today, strapless wedding dresses are the vogue.

Womenswear Designer: Xena Aziminia

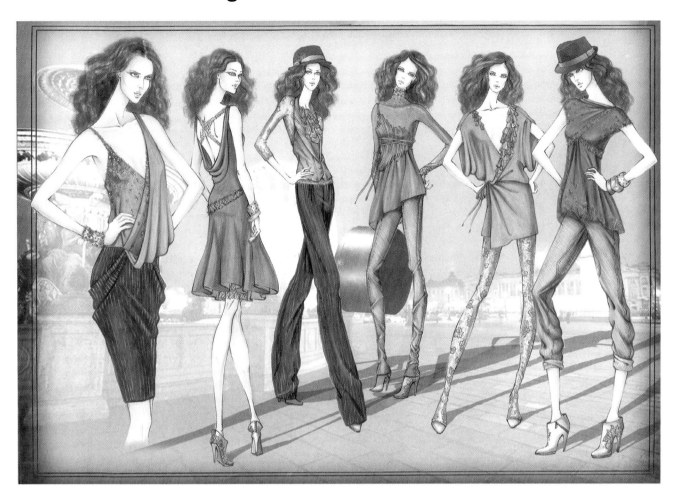

Focal Points and Contrast

In this glamorous day-to-evening contemporary group, designer Xena Aziminia creates clear focal points using exquisite lace, beading, and drape treatments. She also merchandises beautifully, making each piece unique so a buyer would want it all! As you can see from the ovals in the diagram below, most of these focal points are in the bodice area. The back view is the only real exception. Why would Xena focus primarily on this area? When a woman is going out to dinner and/or dancing she is often seen primarily from the waist up, so creating a beautiful bodice is an essential skill for designers in this arena. Featuring the bodice also leads the viewer's eye up to the face, so Xena's glamorous head drawings really complement the look of her group.

Because Xena's muse is very body-conscious, she uses contrast in a more subtle way. The words on each figure in our diagram detail what we see as contrast in each outfit. For example, figure A has a very soft, draped top contrasting with a more structured skirt that, despite the drape details, looks a little "hard." Imagine too if Figure C had trousers that were highly embellished like the top. The viewer would not know where to look first, and the two pieces would compete. As it is, the tiny tailored vest works perfectly to frame the elaborate and feminine lace details.

A B C D E F

SOFT TO HARD

BARE BACK TO COVERED LEG

EMBELLISHED TO CLEAN

LOOSE TO TIGHT

FULL TO SLIM

DRESSY TO CASUAL

Design Elements: Shape and Proportion

You really can't design clothing without thinking about shape and proportion. Fashion as we know it began in the twelfth century when men cut and darted fabric, shaping the original robe into fitted garments. These men became the master tailors of the Renaissance and dressed the wealthy in ever-changing silhouettes. It is the shape or silhouette that continues to define the look today. Think how different the cinched waist and full skirts of the 1950s were from the wide shoulders of the 1980s. But it is also the contrasting proportions of "shape combinations" like the ones you see on these pages that create new styles. Ideal proportion is considered to be about 35/65, meaning the top is about one third of the garment or outfit to two-thirds for the bottom, or vice versa. Try to avoid proportions that are too close to 50/50 as that tends to be visually boring.

NOTE: Geometric shapes have angles and straight lines and have an industrial feel. Organic shapes are curvy and free-form and tend to reflect something in nature. Is the mini-group below more geometric or organic?

If you want crisp shapes, you need crisp fabrics or fabrics with body like wool or cotton. The group below is designed with organza and Jasco cotton and wool jersey in mind.

You will always benefit from adding some historical research to your mix.

Customer: Urban, youthful career girl.
Layers can be mixed and matched.

FABRICS

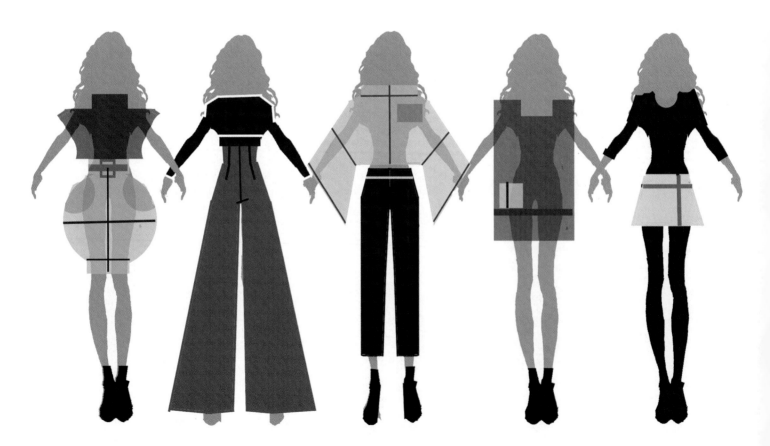

Womenswear Designer: Jenna Rodriguez

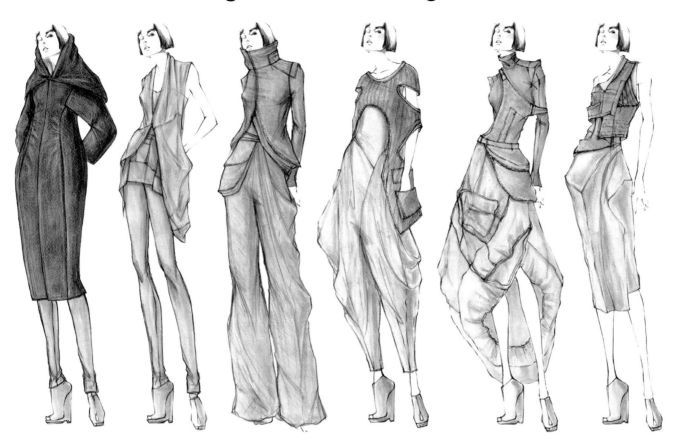

Although each outfit in Jenna Rodriguez's exciting and dramatic portfolio group is unique, you can see a definite consistency of concept and thinking throughout the group. The result is a strong statement about shape, proportion, and structured silhouettes. Note how each outfit pushes the proportion quotient. For example, the length and volume of the long, voluminous coat contrasts beautifully with the peek of slim trousers. The structured, fitted vests in the two right figures work wonderfully with the soft, draped skirts.

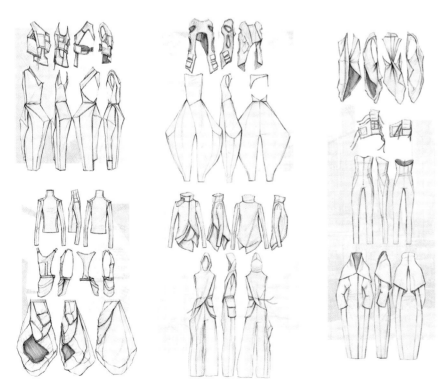

Jenna's beautiful flats show her strong silhouettes even more clearly than her illustrations. Drawn to look three-dimensional, they create a sculptural effect that completely supports the drama of the group. Jenna solved the layout issues by organizing the flats into outfits and using subtle background tones to tie each outfit together.

Methods to Create and Change Shape

One of the most interesting ways to create new silhouettes is through the use of treatments that affect and create shape in your designs. You can use the great variety of existing treatments or develop your own through experimentation and research. If you find an interesting way to use a treatment, you can build that into your collection in different ways and using different fabrics. Look, for example, at the quilted coat in Carina Bilz's lovely collection on the facing page. Because it is designed to be made in a light woven fabric like organza, it has a lot of body and creates a distinctive puffy shape. Imagine the same quilting in soft leather or denim. The look would be very different, but still have a relationship to the group.

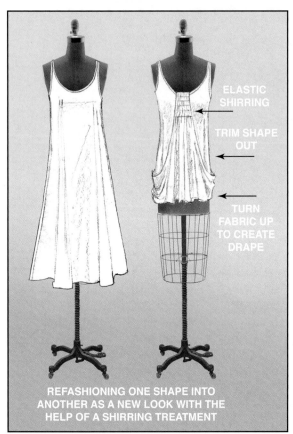

ELASTIC SHIRRING

TRIM SHAPE OUT

TURN FABRIC UP TO CREATE DRAPE

REFASHIONING ONE SHAPE INTO ANOTHER AS A NEW LOOK WITH THE HELP OF A SHIRRING TREATMENT

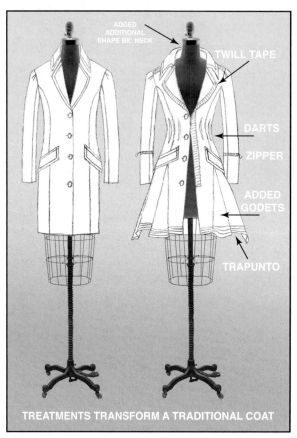

ADDED ADDITIONAL SHAPE BK. NECK

TWILL TAPE

DARTS

ZIPPER

ADDED GODETS

TRAPUNTO

TREATMENTS TRANSFORM A TRADITIONAL COAT

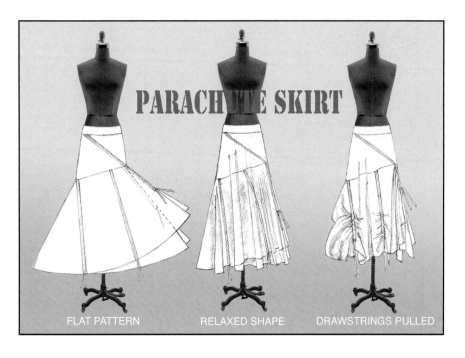

PARACHUTE SKIRT

FLAT PATTERN RELAXED SHAPE DRAWSTRINGS PULLED

Things to Consider

1. These examples show several great ways to recycle existing garments. By making a dress into a draped top we can reuse something that has gone out of style. What are other things you could do with the same dress?

2. Adding darts and additional fabric in the form of godets completely changes the silhouette of the coat in second example above.

3. In the third example at left, pull-strings can make almost any garment both more versatile and more interesting.

Designer: Carina Bilz

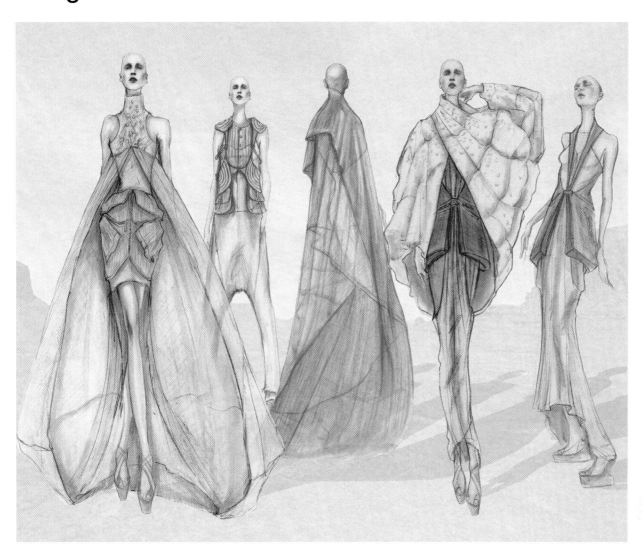

Spring 2010

MOOD BOARD

FLATS

This striking group by designer Carina Bilz (for mentor Isabel Toledo) uses a variety of treatments to create dramatic shapes and strong contrast. Note the use of functional pockets built into the skirt and vests.

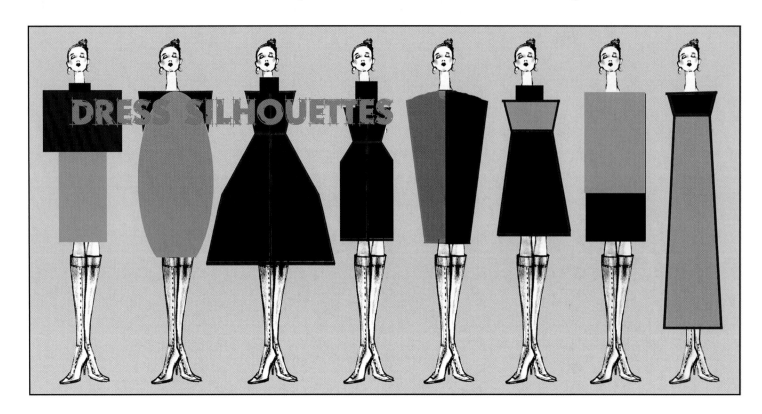

It is the pervading law of all things organic and inorganic, . . . That form ever follows function. This is the law.

Louis Sullivan, Architect, 1896

Form Follows Function

It is easy to see a relationship between the simple silhouettes above and architectural forms. The technical flats that we draw in fashion have a great deal in common with an architect's blueprints. We can all look at beautiful buildings and get inspiration for our designs. By now you are probably familiar with the concept "form follows function," but it may be beneficial to revisit this concept in more detail.

Louis Sullivan, an American architect, was commissioned to design the first Chicago skyscraper. Realizing that the baroque forms of ancient Greece and Rome were not applicable to modern design, he formulated a new way to think about form and space; that *the ways in which a building was intended to function should determine the form.* This may seem rather obvious today, but at the time it revolutionized architectural practice, as well as that of other design disciplines.

How Does "Form Follows Function" Apply to Fashion?

1. Because clothing is always made to be worn, it is by necessity functional, but the level of that functionality varies a great deal.
2. A well-made garment will, at the very least, allow movement, and be comfortable for the wearer. It can also be hoped that it has a correct fit.
3. For some companies like Patagonia, functionality is indeed a law to be strictly observed. A jacket designed to withstand a blizzard is very different from a jacket made to look chic at a cocktail party. Both have a specific function.
4. Understanding the context of your customer's lifestyle and the specific use of the garment you are designing should largely determine your priorities.
5. Thinking very specifically about function can lead you to new ways of creating your designs.
6. If you add details to a garment, you will want to consider if they add to or subtract from the functionality. Superfluous details like buttons that don't function are sometimes considered bad design.

To simplify a dress, I make as few seams as possible, and I am forever standing away and looking at it, asking myself what can I take away from it rather than what can I add to it.

Valentino

Ornament is a Crime

A less familiar concept, "ornament is a crime," was equally influential in this time period. In fact, it formed the basis for the Modernist movement of the last century, and led to the success of famous architects like Le Corbusier, Walter Gropius, and Mies van der Rohe. They saw simple industrial forms, free of ornamentation, as beautiful and functional. They declared this principle, along with "form follows function," to be the moral basis of design integrity.

Current Thinking

Although these principles went hand-in-hand at their inception, recent thinking has put them more into conflict. After all, embellishment can also be functional. For example, if ornamentation on a retail building encourages people to enter and shop, it is serving a practical purpose and fulfills the "form follows function" dictate. So minimizing ornamentation is really an aesthetic preference. Calvin Klein, for example, has made a fortune creating minimalistic, sculptural garments for customers who appreciate ultra-clean design. He would probably consider the beaded ornamentation on this striking wedding dress silhouette unnecessary, even garish (see photo).

But not everyone wants minimalism. So what is a middle ground? We could propose that an ornamental design element is perhaps better design if it both looks good and also functions in some way. For example, a bow that is integrated into a design and actually functions as a closing seems more valid than one that is just "stuck" onto a dress. Even if it is simply altering the form of the garment in an interesting way, the detail has a purpose. That provides us with another principle for thinking about and making design decisions.

How do you feel about ornamentation? Do you tend more toward minimalism (less is more), or do you like more complexity in your designs?

Have you thought about functionality in the past when you have added details to your garments? Do you think your designs might benefit from your being more aware of these principles?

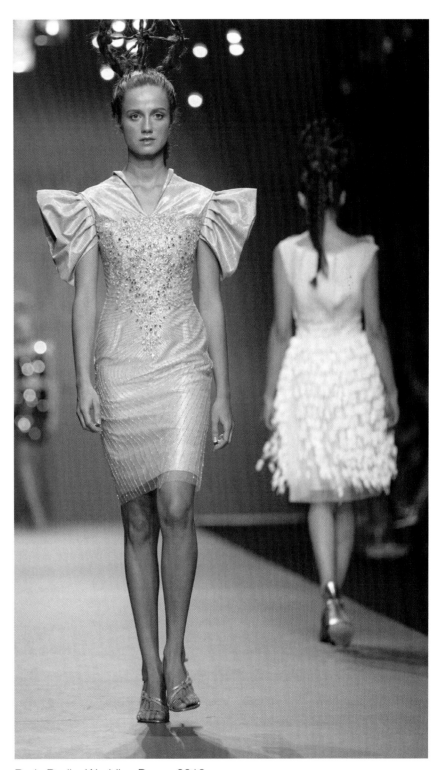

Boris Pavlin, Wedding Dress, 2010
© Gordana Sermek/Shutterstock.com

Menswear Designer: Marcus LeBlanc

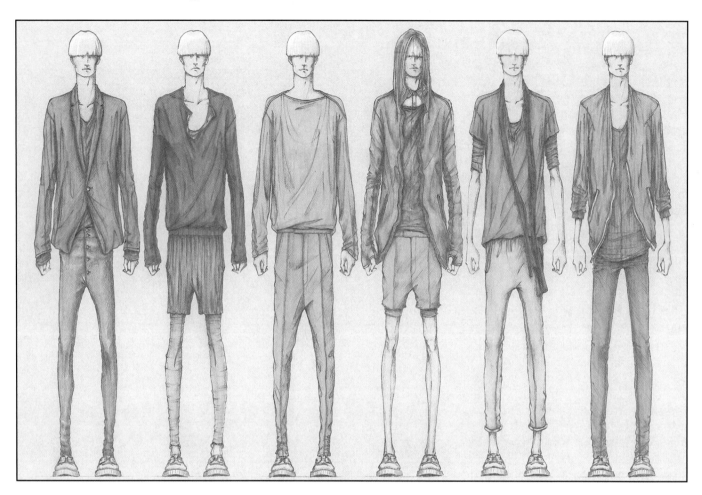

DESIGN GROUP FOR JOHN VARVATOS

Marcus LeBlanc Statement

I was born June 14, 1984, in Oakland, California. I always knew that I wanted to be visually creative. Even as a young kid I was always trying to draw the most beautiful people possible. It wasn't until high school that I decided to be a fashion designer.

I gave a sample of my portfolio to John Varvatos and included a letter that told him how much I admired his work and would love to work for him. One month later, Mr. Varvatos called my cell to invite me to work with him in New York. I moved to New York and spent four years designing for John Varvatos. It was amazing.

Then, feeling like I needed a different point of view and to gain some varied experience, I applied for a job designing menswear at Theory. I got the job, but not before doing two illustration projects for the CEO, the first one being "too John Varvatos" (I guess I was right that I needed some varied experience). I feel the most creative when I find time to add an illustrated group to my portfolio (sometimes I skip the flats and fly straight into the sketches, like dessert before dinner!) Even though I was warned against it at school, I still get attached to my work. I put a lot into these little guys, all the while just imagining where they may take me next!

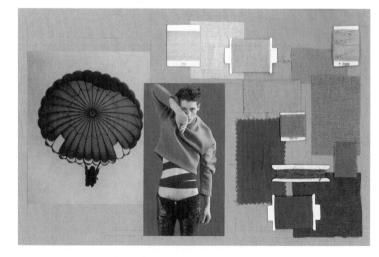

MOOD BOARD AND FABRICS

Note the organized, very clean fabric presentation: straightforward and masculine.

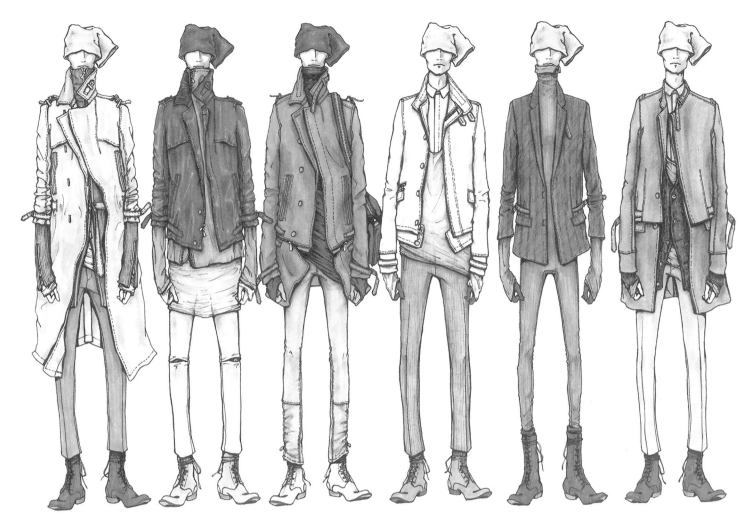

MENSWEAR DESIGNER: MARCUS LEBLANC

"Form Follows Function" and "Ornament Is a Crime"

It is easy to see the application of these important design principles in menswear designer Marcus LeBlanc's minimalist design groups. Every piece in the two examples shown on these pages is functional and based on classic silhouettes. There is no ornamentation, including pattern, and all the details are essentially functional. Yet there is a pleasing variety in terms of proportion and silhouette. Light, medium, and dark tones provide contrast. It is easy to imagine a young architect wearing these clothes, as they would likely suit his aesthetic perfectly.

It is worthwhile to note all the ways that Marcus adds to the functionality of his designs:

- Straps at neck, waist, and cuff allow for loosening or tightening adjustments.
- Extra layers at the shoulder prevent wear from bag or backpack straps.
- Extra pockets provide additional storage opportunities.
- Openings at trouser knees allow freedom of movement
- Pull strings at trouser cuffs allow length adjustment.
- Zip-off additions to jackets allow adjustments in length.
- High necks, hoods, and extra-long sleeves provide extra warmth.
- Zippers at the neck allow for adjustments to changing temperatures.

STEP THREE: Review Principles of Product Design

Dieter Rams's Ten Principles of Good Design

Dieter Rams is a German industrial designer closely associated with the consumer products company Braun and the Functionalist school of industrial design. He formulated these principles for product development, but adds the caveat that "they cannot be set in stone because, just as technology and culture are constantly developing, so are ideas about good design."

1. **Good design is innovative.** Technological development is one of the primary means to achieve true innovation, and this applies to clothing as well. Innovative fibers with fascinating attributes are emerging, and new amazing electronic devices are being built into clothing to serve the wearer in unexpected ways.

2. **Good design makes a product useful.** Clothing is inherently useful, but if something is poorly designed, chances are it will end up in the back of the closet. Adding detail without function adds to cost and generally detracts from performance.

3. **Good design is aesthetic.** Because clothing is such an integral part of our lives and our identity, the aesthetics of dress are doubly important. If we don't like the way something looks, we probably won't wear it. According to Dieter Rams, "Only well-executed objects can be beautiful."

4. **Good design makes a product understandable.** A well-designed garment will not be confusing or hard to put on.

5. **Good design is unobtrusive.** If garments visually overwhelm their wearer, their design quality is questionable. But decorative details and accessories are a personal choice. Some people love "bling."

6. **Good design is honest.** If the price of a garment reflects its true quality and production costs, then it is a well-priced garment. An honest product does not "attempt to manipulate the consumer with promises that cannot be kept."

7. **Good design is long-lasting.** Some people like wild and crazy "fast fashion," but design that is timeless is more difficult to achieve. We call the purchase of such garments "investment dressing."

8. **Good design is thorough down to the last detail.** Well-designed clothing is not random. Respect for the consumer is obvious in good design.

9. **Good design is environmentally friendly.** Sustainable practice in design will be more and more a key issue in the marketplace. You would be wise to make this awareness part of your practice. Try to conserve resources and minimize pollution throughout the life cycle of the product.

10. **Good design is as little design as possible.** Less is more. The jacket on this page, made by Patagonia, a company that takes these ideas seriously, looks very simple. But read about all its functional features and you will be amazed!

PATAGONIA
MEN'S
NANO
STORM
JACKET

PRODUCT INFORMATION

Ice routes in Norway, skiing through Northeasters, and sleet-storm belays In Newfoundland: Where cold and wet go hand-in-hand, so goes our Nano Storm™. It pairs top-notch PrimaLoft® One insulation with a waterproof/breathable H2No® barrier, bonded to the nylon ripstop shell, doing double-duty to keep you warm in even the most drenching and frigid conditions. The fully adjustable, helmet-compatible hood has a laminated visor to help you see through the tempest, the jacket's cuffs seal with self-fabric hook-and-loop closures, and a dual-adjust drawcord hem cinches tight to help keep your heat in. Pockets: two handwarmers, one left chest, one internal (all zippered) and one drop-in. Recyclable through the Common Threads Recycling Program.

Details

- 2.5-layer 100% nylon ripstop with a waterproof/breathable H2No barrier and Deluge DWR (durable water repellent) finish
- Lightweight 60-g PrimaLoft® One polyester insulation provides excellent warmth and compressibility
- Unique quilt pattern holds insulation in place promoting durability and longevity
- Helmet-compatible, fully-adjustable hood with laminated visor for great visibility in bad conditions
- Watertight, coated center-front zipper treated with a Deluge DWR (durable water repellent) finish
- Pockets: two handwarmers, one left chest; one Internal zippered pocket, one drop-in
- Self-fabric hook-and-loop cuff closures seal out the elements and keep you dry; dual-adjust drawcord hem keeps drafts out and warmth in
- Shell: 2.5-layer, 2.6-oz 50-denier 100% nylon ripstop, with a waterproof/breathable H2No® barrier. Insulation: 60-g PrimaLoft® One polyester. Lining: 1.4-oz 22-denier 100% recycled polyester. Shell and lining have a Deluge® DWR (durable water repellent) finish. Recyclable through the Common Threads Recycling Program
- 683 g (24.1 oz)
- Made In Vietnam.

Property of Patagonia, Inc. Used with permission.

Product Design

Photos courtesy of Julie Hollinger.

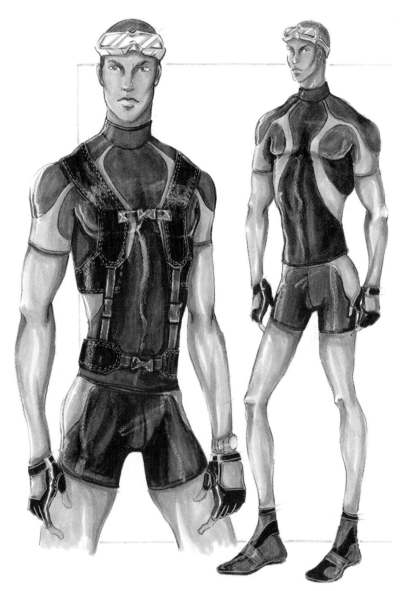

Designer: Cherise Shikai

The Inspiration of Good Design

Although Cherise Shikai's very functional and sleek wetsuit designs were not inspired by these beautiful chrome objects, you could easily find a relationship between them. For example, notice the contrast of black and silver neoprene, the curved seam lines that reflect the curve of the handles, the linear straps relating to all the lines in the chrome, and so on.

Any good designer could probably look at these minimalist functional objects from the 1930s and get inspired by the principles they express. Imagine, for example, how Giorgio Armani might use them as inspiration for a collection of suits, or Vera Wang in beautiful eveningwear.

Good design inspires us all!

Designer: Keith Hsieh

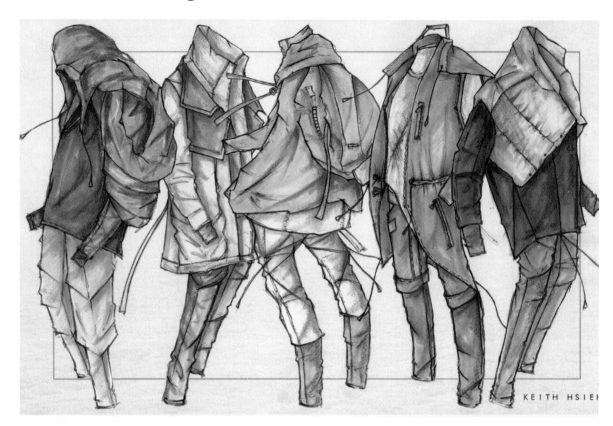

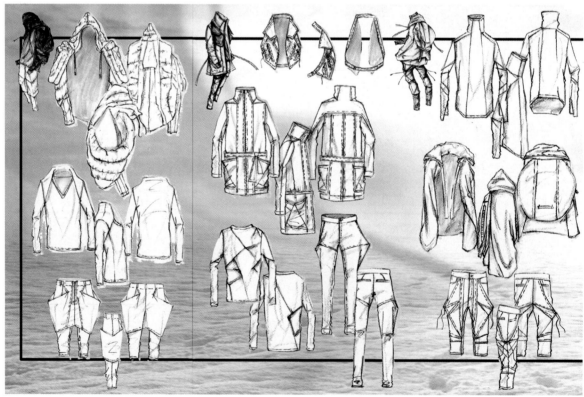

The functionality of these dramatic designs is obvious. Built-in backpacks, pocketed harnesses, and zip and drawstring closures contribute to both the look and the inherent usefulness of these aesthetically pleasing outfits. Keith's use of dynamic "ghost figures" adds to the mood of the collection.

STEP FOUR: Review Principles of Visual Artists

Elizabeth Beeson, in her 2009 article at www.suite101.com titled "The Principles of Visual Art," identified seven visual principles that she applies to fine art composition. We can use these same principles to analyze this dress design inspired by the amazing Rodarte sisters.

1. ***Visual harmony*** is achieved by using similar types of shapes, lines or colors. If a design has a lot of curved seams, for example, a square cut-out would perhaps be out of place. Color will generally be warm or cool, not both. Our example is consistently asymmetrical and employs a lot of diagonals, wrapping of fabric, and distressed edges. The colors are largely cool, but there are accents of warmth which draw our attention to the bodice. (See Variety and Emphasis.)

 Is the design visually harmonious? What would you change?

2. ***Variety*** of shape, color, or details can be used to create a focal point in a design. Combining different ornamentation and proportions creates visual interest. This dress is all about variety: four patterns; numerous textures; braided, wrapped, and distressed fabric treatments; and warm and cool colors.

 Is there too much variety in this dress? What would you edit out?

3. ***Balance*** refers to the way visual weight is placed on a design. Note that even though this dress is asymmetrical, the visual weight of the skirt is evenly distributed, and the bodice and sleeves are fitted and lighter than the skirt. However, balance does not have to be symmetrical.

 Is the balance of visual weight in this dress attractive? What if the skirt went to the knees?

4. ***Movement*** refers to how comfortably the viewer's eye moves around the outfit in a visual loop.

 Do the lines of this dress keep our eyes moving? Are there any visual stops?

5. ***Emphasis*** again refers to the need to create a focal point. You may even throw in that element that is not consistent to draw attention to what you as a designer want to emphasize.

 What elements on this illustration create emphasis? Why?

6. ***Proportion*** refers to the way that the various elements in a garment work together in terms of their size. The proportion of top to bottom is a key factor, as a 50/50 proportion is not very interesting. Generally, contrast of proportion is the goal.

 If the bodice of this dress was fuller, would it look more interesting, or too heavy?

7. ***Rhythm*** refers to the use of visual repetition in a garment or outfit. This repetition can form pattern, texture, and also visual energy.

 Do the repetitive elements in this dress make it more visually interesting?

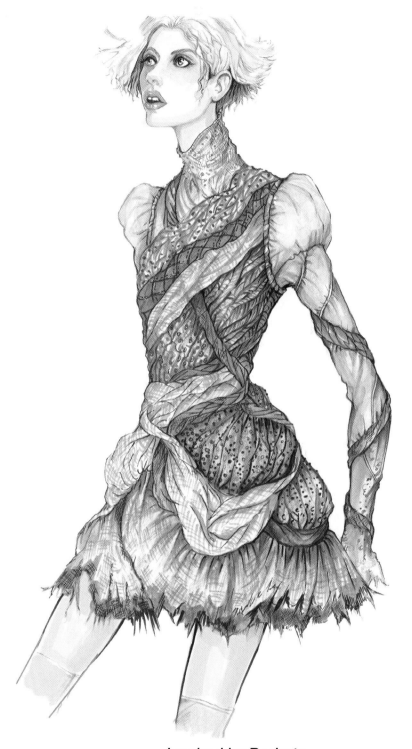

Inspired by Rodarte

Womenswear Designer: Minnie Yeh

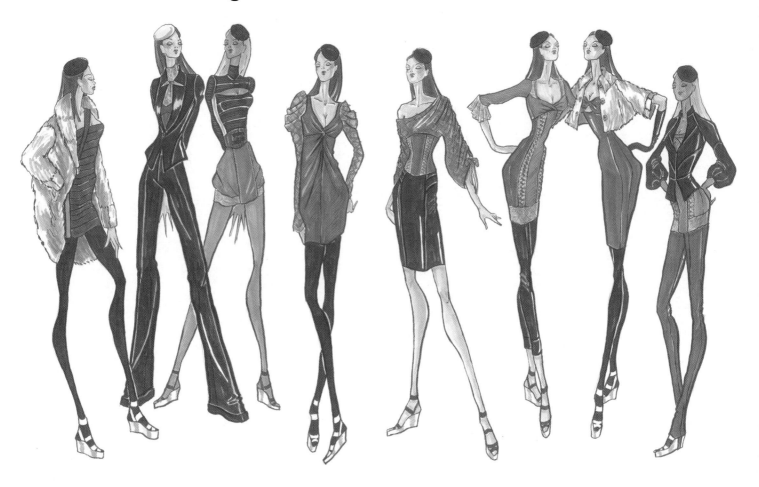

Artistic Principles

Designer Minnie Yeh has done a lot of work for the well-known firm Bebe. She has worked both full-time and freelance with them, so she knows the customer very well. As you can probably tell, Minnie designed this striking group with the Bebe muse in mind. The muse is confident, likes to show off her body, is not afraid to wear color, and likes short skirts and sexy details.

Let's analyze how Minnie used the Principles of Visual Artists described on the preceding page:

1. Visual Harmony: This is reflected in the use of linear patterns and treatments in most of the garments. Some of the patterns are very obvious, some are subtle, and a few garments have no pattern at all. This balance prevents the garments from competing with each other visually.
2. Variety: A variety of necklines is especially apparent in this group, and the neckline is often the desired focal point for this customer. There is also a great variety of hem lengths and textures.
3. Balance: Minnie uses pattern, drape, and texture as well as cutouts to frame the bust. The bust area is also given more visual weight with the fur coat and jacket and the sleeves providing increased volume.
4. Movement: Minnie uses a good balance of color and black to keep our eye moving around the page. Imagine all the black being on the lower garments. The group would be much more static.
5. Emphasis: Minnie has also brought attention to the bodice of her dresses by adding empire seam lines. The cut-out draws our attention, as do the soft, white coat and jacket shapes. The black suit is an unexpected element in a group of dresses that adds visual drama.
6. Proportion: The short skirts create fun contrast with the long, thin legs of Minnie's sensual figures.
7. Rhythm: As in Visual Harmony, the repetition of linear patterns creates movement and visual energy. Each garment is interesting on its own, yet all work well together.

Designer: Davy Yang

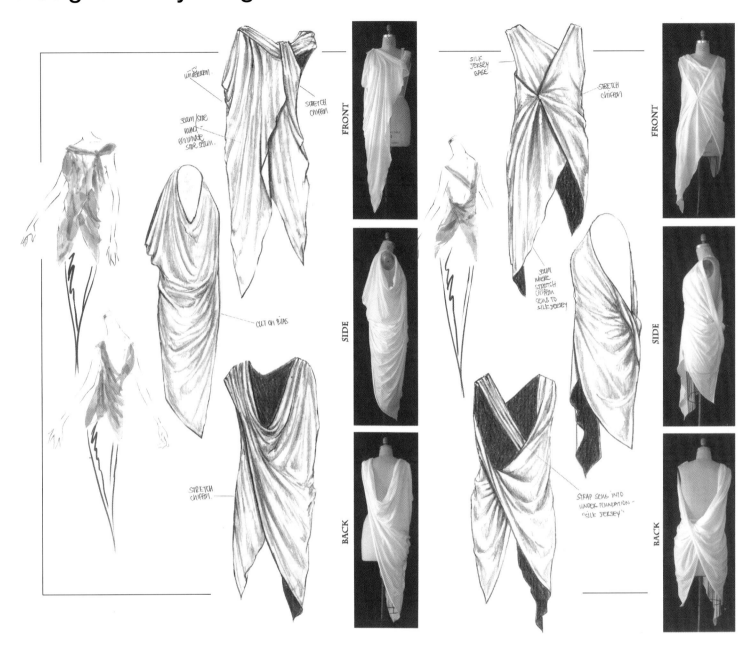

Designer Davy Yang achieves a wonderful sense of Visual Harmony, Movement, and Rhythm by repeating the lovely shapes of swirls and soft drape in these sculptural draped garments. Davy did these as a college senior working on a mentor project with Koi Suwannagate.

Draping is another tool that encourages original design, as so much can be done with a good piece of cloth draped on the dress form. You can create a drape you like, then do different designs based on those general shapes.

After graduation in 2010, Davy worked as an intern for Oscar de la Renta. He was offered a design job by Rod Beattie for his line of elegant swimwear, Bleu. Although Davy enjoyed his New York experience, he is more than happy to return to sunny L.A.

Designer: Koi Suwannagate

Koi Suwannagate is a young designer herself. She is from Thailand and majored in Fine Art. She considers herself an artist using fabric as her medium. Her advice to young designers is that you should do what you're best at. *"Stick with your core, do what you know, and you really can't go wrong. Especially at this time. This is what I've learned."*

STEP FIVE: Review Croquis Format

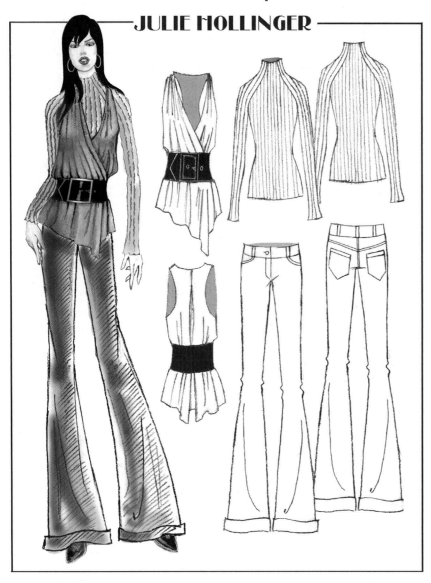

JULIE HOLLINGER

The croquis format includes

1. **Croquis figure or figures.** You can show a design with jacket on and jacket off, but do not put more than one outfit on a page.
2. **Front and back flats stacked in order.** Include side-view flats if necessary to understand the design. Flats must be in proportion to each other and to the clothes on the figure, although it is generally okay to exaggerate the figure proportions more than the flats. This works if they visually convey the same proportion.
3. **Color or pattern indication on flats.** These do not have to be in great detail, but your indication should convey the placement and direction of patterns or prints.
4. **Fabric swatches and trims.**
5. **Fabric treatment samples.** If you are using fabric treatments in your croquis, you should have the samples ready to show.

HAND-DRAWN CROQUIS

Croquis translates as "quick sketch" in French, and that means the croquis process should be a fairly rapid method to get your design ideas down on paper. If you want five outfits for your group, chances are you will do a minimum of fifteen to twenty croquis and edit down to the best five. Ideally you have an instructor helping you choose which ideas to develop further.

In order to speed up the process, looser drawing and quick marker indication of color and pattern for the figure is the norm. You are capturing the "feel" of the look. Your flats, however, should always be well thought out and detailed.

Development Steps

1. Develop a good variety of tops and bottoms that will offer a buyer/customer a well-merchandised group.
2. Decide on key design details that can be repeated in a variety of ways in the group.
3. Keep in mind that some pieces can have more obvious design elements while others should be subtle. Balance in the group is the goal.
4. Keep experimenting on flats until you have solutions you are really excited about. Don't be satisfied if it is "just okay."

Croquis Checklist

- Are your designs current and interesting?
- Is there a sense of current styling, and are the garments wearable?
- Can we see the development of ideas and an organized way of approaching your design work?
- Are the flats and figures in correct proportion to each other?
- Is there content in your designs from all angles, and not just the front?
- Is the color and pattern indication easy to read?

Multiple Figure Croquis Formats

Although these wonderful figures by designers Barbra Araujo and Mellani Aguilar are more finished than your average "quick sketch" croquis, these examples should give you a good idea of the possibilities for multiple figure formats. If you are presenting croquis to an instructor or design mentor, showing multiple views of your favorite designs always looks impressive.

Spending a little more time on your croquis to make them look more polished can be worth the effort. As we have said, some employers are as interested in seeing your design process as they are in seeing finished illustrations. So keep your croquis neat and collect them in a notebook to include when you are ready to go to interviews.

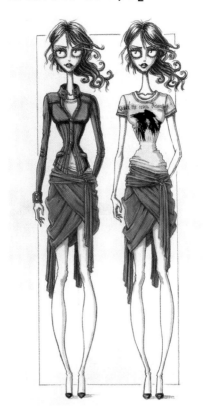

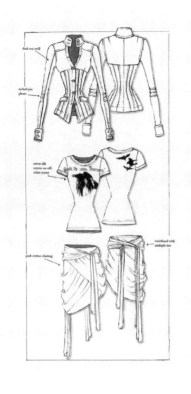

BARBRA ARAUJO

CROQUIS FORMAT: FRONT AND BACK FIGURE, TABLOID SIZE PAPER (11" × 17")

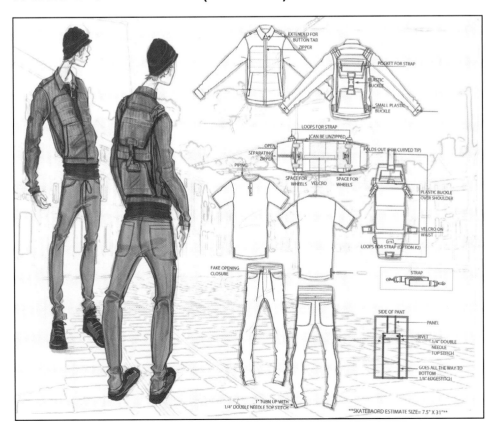

Since we have been discussing functionality in this chapter, pay special attention to the wonderful functional details that Mellani has built into her jacket and trousers, and the precise way she documents those important aspects in her carefully executed flats.

Create a Croquis Figure Suitable for the Group

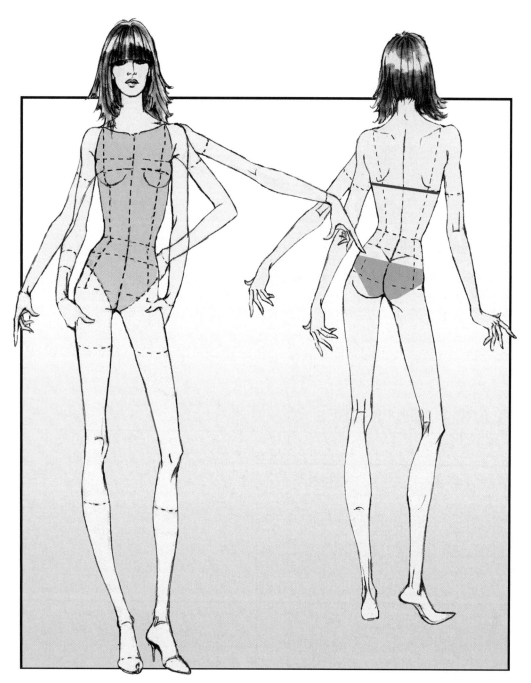

An Effective Croquis Figure

1. Is well-proportioned for the clothes you are designing.
2. Provides some choices for arm positions.
3. Has a front and back that match proportionally.
4. Is in a pose that is not too extreme.
5. Has some space between the legs if you are designing trousers.
6. Is divided into structure lines to facilitate putting the clothes on the figure correctly.

SIDE VIEW FIGURE

Things to Keep in Mind

1. It's easy to get used to designing on front-view figures only, but this does not encourage you to think around the body. If you can think dimensionally, your designs will have better "flow" and your silhouettes will be more interesting.
2. Although an outstretched arm may look a little old-fashioned as a pose, it works well for showing deep arm holes, which always come back into style.
3. A turned-out leg is great for showing inseam details or for full skirts and wide-legged trousers.
4. Learning to draw quickly and accurately over a croquis figure will make you a better artist in general and allow you to get a lot of ideas on paper. Generating many good ideas is the basic job description for designers, so becoming efficient in your process is an important goal.
5. If you can use the same figure for both your croquis and finished illustrations, it will save you a lot of time and headaches. Often proportions are changed or lost in transferring designs to a different figure.

Menswear Designer: Cherise Shikai

These stylish menswear designs, created by Cherise Shikai for her design project for Sean Jean, demonstrate the use of a straightforward but dynamic figure that can function for both croquis sketches and finished illustrations. You may want to create a new figure when you illustrate, but be aware that it is also acceptable to use that same figure a number of times to create your portfolio illustrations. If the garments are drawn and rendered well, the look can still be compelling visually. Cherise's strong design work has landed her a good position at Reebok in Massachusetts.

Note how Cherise has created a mood board with specific colors and military images that set up the viewer for both the group concept and coloration. If your mood board sends contradictory messages, the viewer will be thrown from the start.

MOOD BOARD

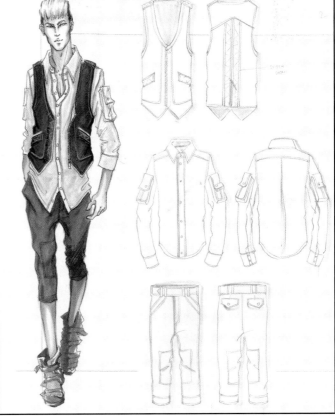

STEP SIX: Consider Sustainability

For the forward-looking in the industry, ethics is the new elegance, and doing things right carries more weight than doing things fast. Having the time and the money to care about where clothes come from is set to be a key feature of 21st-century luxury.

Suzy Menkes, "Sustainability is Back in Fashion," NY Times, March 29, 2009

Another important arena that may influence your design thinking is *sustainable fashion*, also called *eco fashion*. This concept is a part of the design philosophy and trend of *sustainability.* This is a philosophy that is growing in influence because the fate of the planet is in the balance, and environmental problems can be greatly affected by shifts in thinking in an enormous global industry like fashion. Sustainable fashion is also part of the larger trend of sustainable design, in which a product is created with consideration to the environmental and social impact it may have throughout its total life span, including its "carbon footprint." Replacing the more trivial desire for constant new luxuries is a yearning for lasting value and a desire to know where fabrics come from and how garments are produced. Even high-end companies like Barneys are putting their muscle behind environmentally friendly clothing. The company is focusing on organic knits, eco-friendly cottons, grown-to-sewn denim, and even recycled gold jewelry.

While environmentalism originally manifested in the fashion world through financial donations, sustainability-minded fashion designers are becoming more proactive. They are utilizing eco-conscious methods at the source through the use of environmentally friendly materials and socially responsible methods of production. These sustainable technologies use less energy and fewer limited resources, do not deplete natural resources, do not directly or indirectly pollute the environment, and can be reused or recycled at the end of their useful lives. Designers are also creating innovative methods to *upcycle* or create new products from old waste. For example, there are efforts to use industrial waste material to make a variety of accessories. These efforts can influence the behavior of the consumer, which can have long-term positive effects. People are more conscious of the idea that garments can be reinvented rather than just dumped into a landfill. There might be libraries where people could rent special occasion clothing or fibers that would eliminate the need for constant washing of garments.

As a young designer just entering the field, you may want to research this important subject and determine what if any influence this might have in your selection of employers. Your point of view may also affect how you present yourself in job interviews, and in resumes, cover letters, and so on. There are very smart people who believe the future of fashion will be completely grounded in this form of thinking, so it is worth your time to be aware. **If an employer asks you where you stand on this issue of sustainability, you want to be able to reply knowledgeably and with confidence.**

Green Fabrics and Fibers

What distinguishes ethical fashion from the traditional industry?

1. The use of sweatshop-free labor.
2. Energy-efficient processes, alternative energy, and low-impact dyes in manufacturing.
3. Eco-friendly fabrics, which are produced using fewer toxic chemicals, consuming less land and water, and emitting fewer greenhouse gases.

It is not easy to find fabrics that can be produced honoring all three criteria. Tencel is one promising synthetic. It is made by extracting the cellulose from eucalyptus, which is broken down with a non-toxic recycled detergent. The production is a *closed loop system,* which means minimal impact on the environment, and it is a lovely, soft, silky fabric.

The most simple and effective form of green fashion involves the reuse of clothing that already exists. Garments are torn apart and put back together or combined with other garments in new and interesting ways. These recycled objects become one-of-a-kind pieces that offer a unique look for the savvy fashionista. Such efforts can be termed *recyCouture*, as they are generally custom-made, and often involve hand-work and interesting treatments. The re-fashion movement is a direct way to reduce waste and increase the life of beautiful garments.

There are now more educational opportunities for fashion students to study sustainability and how they can apply it in the field. For example, the London College of Fashion offers an MA in the subject called Fashion and the Environment, which, according to their website "introduces the concepts of sustainability and sustainable fashion design and development at a postgraduate level." The program explores design process, while at the same time examining the impact that the practice has on the environment, as well as on social and cultural institutions. Students are expected to pursue sustainable solutions paired with realistic business models.

A growing number of companies are taking a stand on sustainable practices, so graduates can reasonably expect to be employed on the basis of their expertise in this subject.

There are some interesting blogs and other information on sustainability on the Web:

1. zerofabricwastefashion.blogspot.com: Timo Rissanen does a blog on his PhD work which involves green fashion practice.
2. http://www.ecofashionworld.com: Eco Fashion World's guide lists sustainable designer brands and online eco fashion stores.
3. http://uncsustainsfashion.wordpress.com/2010/02/10/why-a-sustainable-fashion-show-you-ask/ Read about a sustainable fashion show at the University of North Carolina.
4. http://www.theuniformproject.com/ Read about a young girl who wears the same little black dress every day for a year, creating different looks with accessories and adding other garments to the mix. You can also download a pattern to make your own little black dress.
5. http://technorati.com/lifestyle/green/article/marci-zaroff-is-poised-for-the/ Read an interview about the history of eco fashion.

DESIGNER: Alejandra Carillo-Munoz

The theme of this lovely group is meant to reflect natural fabrics and sustainable design.

The concept behind this lovely and ethereal group by designer Alejandra Carrillo-Munoz is the use of natural fabrics and sustainable designs. Alejandra is passionate about being an environmentally conscious professional!

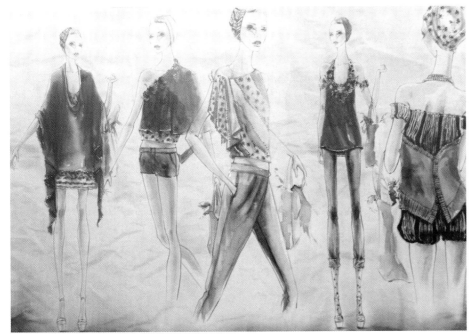

STEP SEVEN: Create Detailed Flats for Each Group

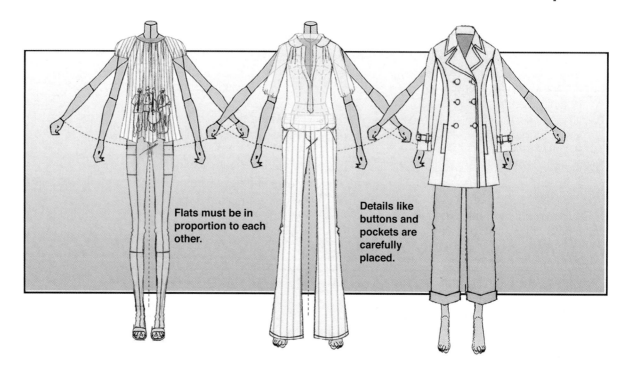

Flats must be in proportion to each other.

Details like buttons and pockets are carefully placed.

CLASSIC HAND-DRAWN FLATS USING A FIGURE TEMPLATE

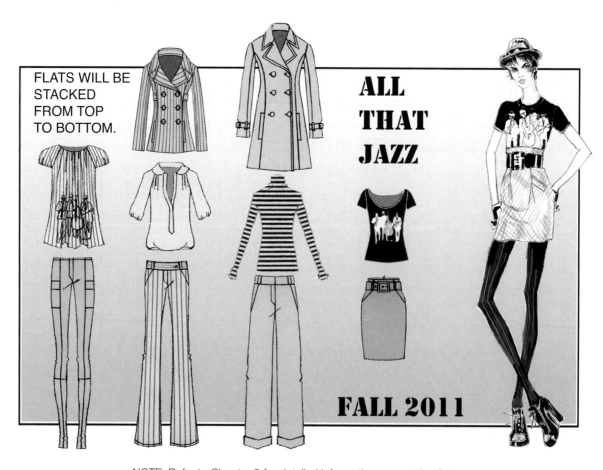

FLATS WILL BE STACKED FROM TOP TO BOTTOM.

ALL THAT JAZZ

FALL 2011

NOTE: Refer to Chapter 8 for detailed information on creating flats.

Womenswear Designer: Barbra Araujo

Design Development and Flats

Analyzing these beautiful design sketches by designer Barbra Araujo, it is easy to see that she takes just as much pride in creating beautiful flats as she does her exquisite illustrations. The flats for this group, created for mentor Behnaz Saraf-pour, are mini art pieces that convey the beauty of the designs. You can also see the consistency of design development as Barbra uses her treatment of controlled pleating to create silhouette and drape. The use of subtle pattern that lends a tribal feel to these sophisticated outfits also brings cohesion to the group. Note how she uses it extensively in some pieces and just in limited areas on others. Her use of proportion contrast and shape is especially striking in the coat paired with a very skinny trouser.

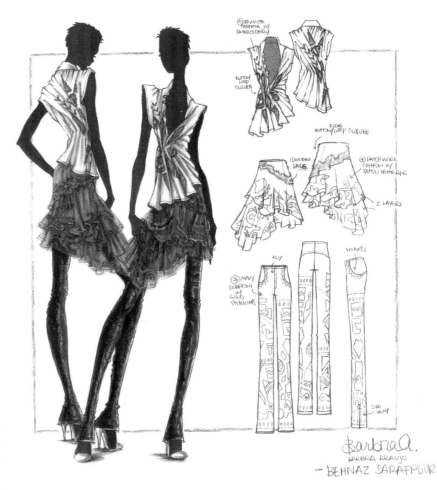

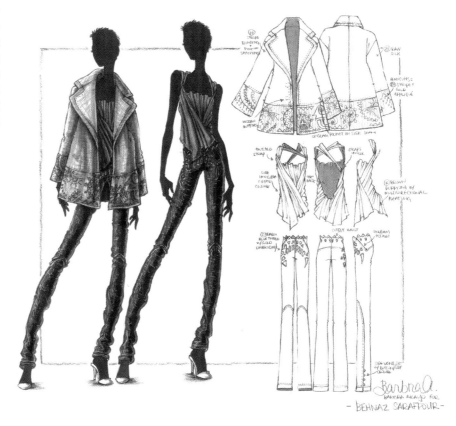

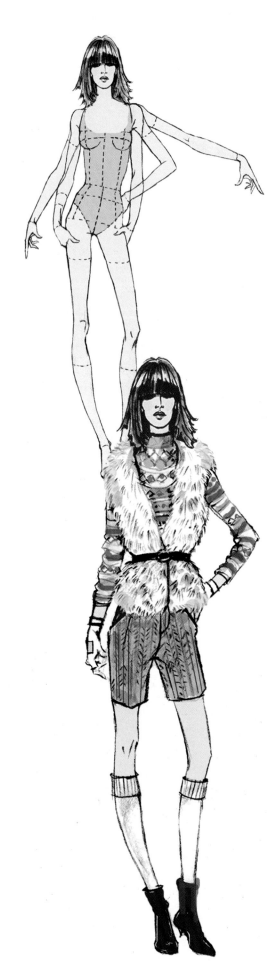

STEP EIGHT: Draw Your Designs on the Croquis Figure

As we have said, the croquis process is an opportunity to experiment with your ideas on the figure and in flat form. If you have someone helping you edit, you may go through several rounds of croquis before you have chosen the final outfits to illustrate. This is a valuable process that will lead to a stronger group, so try to budget your time to do plenty of exploration on the croquis figure. This exploration will lead you to create additional flats as you see the need for different shapes or styles.

Since Chapter 7 is all about putting clothing on the figure, we will not take the time to discuss it here. These are your croquis, not finished illustrations, so they can certainly be more loosely drawn and rendered. But the more accurate you are now, the easier it will probably be to do your finished work.

Things to Keep in Mind

1. Try to put your sketches up on the wall and live with them for a couple days. You'll see what changes should be made before you finalize them.
2. Get feedback from a few people you trust. At this point you do not need a million opinions. You are just likely to become confused and lose momentum and/or confidence.
3. Take time to style the clothes on your croquis. Open up the jackets, put the hands in the pockets. Add the hats, scarves, gloves, and shoes—whatever will capture the look you want. Don't plan on making it look cool later.
4. Do have visual reference when drawing your clothes.
5. Be prepared to draw and redraw until you have the look you want.

Design Development, Step-by-Step

1. Work with tracing paper and good pencils with erasers.
2. Start with flats, but move to the croquis figure when you want to see how the pieces will work together.
3. Develop your ideas. If you have a good idea, **milk** it. In other words, use your idea in a number of different ways. We tend to think of more obvious things first, creatively. Perseverance leads to originality.
4. Consider what fabric you intend to use for each design, and think about its characteristics. This will guide you in what is and isn't possible. For example, chiffon would never hold a voluminous silhouette. Heavy wool won't take fine details.
5. For a separates group, consider designing tops first, especially if they will be the most elaborate pieces. Make sure you have a variety of choices (less fitted, more fitted, longer, shorter, etc.) If the tops are more basic (like T-shirts) and the bottoms (skirts and trousers) more elaborate, then begin with those instead.
6. Build on those pieces with coordinating jackets, vests, more elaborate sweaters, and so on.
7. Keep in mind that if you believe in a detail or a fabric enough to use it once, then you should use it in other garments as well.
8. Layer your designs on top of each other, as you would paper doll clothes. This will allow you to see if they work proportionally together. Does the shirt fit under the jacket? Does the jacket fit under the coat? Does the pant look good with the tops? The more you work out these potential flaws, the better your group will be merchandised.
9. Be especially aware of focal points. If your garments have too many visually strong details, they will compete with each other. For example, who would want to wear a top with ties down the front and a skirt with bows around the hem? There should be one primary focal point in an outfit.

Womenswear Designer: Charmaine de Mello

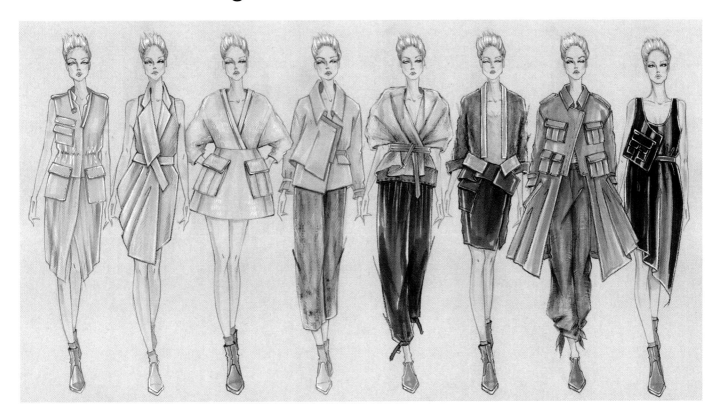

Design Development

The design development in this chic contemporary women's group by designer Charmaine de Mello is quite clear. Charmaine has taken architectural elements like sharp angles and hard pleating and used them in a variety of ways to create a group that is both well merchandised and highly functional. (Note all the roomy pockets.) The variety of pieces that could mix and match, as well as the varied proportions to suit any number of body types, would encourage a discriminating buyer to purchase a number of pieces.

We cannot know the quantity of croquis that it took for Charmaine to get ready to illustrate her group, but we would guess there are many rough sketches behind these accomplished designs. When you work, don't be afraid to use plenty of tracing paper, working over your sketches until you are satisfied.

The flat design illustration by Julie Hollinger shows the use of one good detail in a number of ways. This type of varied use not only takes advantage of an attractive detail, but also lends cohesion to a group. As a designer, you should always be collecting good details and thinking about how many different ways you can use any particular one. This method will help you create more interesting and marketable designs.

MOVING DETAILS AROUND

STEP NINE: Make Adjustments to Your Flats as Needed

This is an important step to make sure that your flats and croquis figures match in terms of proportion. Probably the most common mistake we see in the classroom is a lack of consistency in this area. Employers will want to see that you are very proportion-conscious as even the smallest mistakes can cost a lot of money. Of course, it's equally important that your flats are in proportion to each other. Use the templates below, or others in Chapter 8 to make sure you are on the right track.

FLAT TEMPLATE FIGURE FLAT TEMPLATES

Flat figure templates should be used to create garment templates and to check the proportions of your outfits on the figure.

THIN COPY PAPER OR TRACING TISSUE

JACKET FLAT TEMPLATE

Once you have created a set of flat templates, trace over them to draw similar types of garments. This method is faster and more accurate. Don't use the figure to create every original flat.

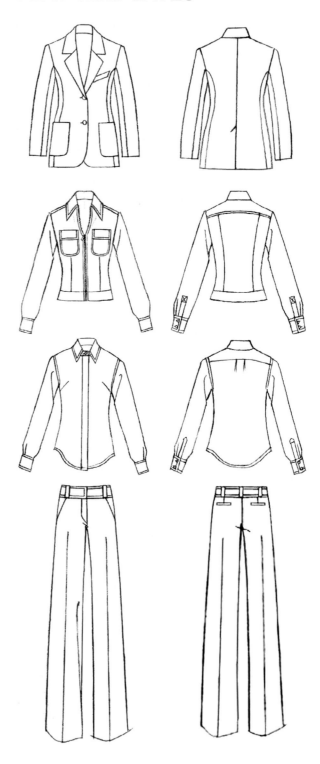

STEP TEN: Check the Balance in Your Final Designs

At this stage you want to be quite critical before you put your group into final illustration form. Probably the easiest way to do this critique, if you've done your croquis by hand, is to copy them and cut out the figures. Arrange them as you would your group, and then do a merchandise analysis.

1. Good balance of garment silhouettes? A variety of lengths and bodies?
2. Pattern and solids?
3. Textured and flat fabrics?
4. All garments look like the customer/muse would want to wear them?
5. Used your details and fabrics more than once?
6. Accessories work well together and don't distract from the clothing?
7. Garments can mix and match?
8. Repetitive elements bring cohesion to the group?
9. Color or tones used to good effect?

DESIGNER: JENNA RODRIGUEZ

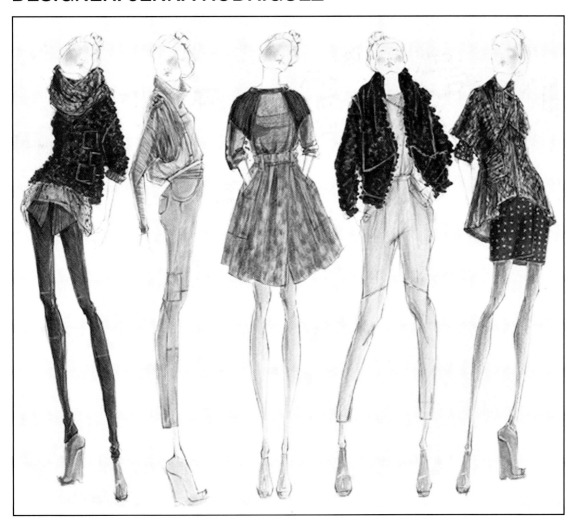

This playful and chic group by Jenna Rodriguez provides a good example of a well-balanced group. The pieces are varied, the color placement provides good contrast, and there is a mixture of textures and flat solids that draws the viewer in.

Talent is cheaper than table salt. What separates the talented individual from the successful one is a lot of hard work.

Stephen King

If you have followed this chapter faithfully, you should have your design work well in hand. Practicing design process and developing your ideas to their full potential will help realize your talent in the field. Also keeping in mind what you bring to the table in terms of your background, interests and passions, areas of special talent, and so on, will keep the work more personal and therefore unique. Of course, recognizing who your customer is will also keep you from straying too far from what is actually saleable to your chosen audience.

We also hope that looking at different ways of thinking about design stimulated some new thoughts about your pro-cess and how it might be deepened in a variety of ways. Research is a key component of any design project. This can mean not only looking at other designers, but also exploring areas outside the "box" of fashion. Taking inspiration from prominent designers in other fields can refresh your point of view and lead to more original output.

We hope this chapter has also made clear that there is a definite process for developing designs that can aid in your success. Approaching design work randomly can often lead to inferior work and/or general chaos. Good ideas are not that easy to come by, so learning to make the best use of them through design development is one key to success. One or two good details or treatments, used in a number of ways throughout a group, can bring cohesion and visual pleasure. If garments and outfits don't appear to be related to each other, the group looks poorly conceived.

Great Fashion Innovators

One thing we have not discussed in detail is fashion designers, living or otherwise, whom we might recommend as great innovators. Generally young designers will seek out and gravitate to their own influences, and that is all to the good. But some students do tend to forget or avoid looking at other designers, possibly because the sheer number of them can be overwhelming. So it may be worthwhile for us to single out a few notables who are great for research and seem to generate ideas that resonate beyond the runway.

This image is a drawing of Peggy Moffitt in a swimsuit design by **Rudi Gernreich**. He is notorious for having created the first topless bathing suit back in the early 1970s when such a thing could still create a scandal. But Gernreich was full of fascinating ideas that were ground-breaking at the time and still have relevance. A noteworthy contemporary of his is the French designer Courreges. Check out also the fashion output of artist Andy Warhol.

Of course, **Vivienne Westwood** lit up the 1980s with her use of punk themes, and her runway shows almost always had some kind of subversive statement as subtext. **Alexander McQueen** is another who must be studied for his outrageous and mesmerizing themes.

Issey Miyake was the first Japanese designer to break into Western fashion and has created some amazing industrial pleating processes. He is followed by avant-garde designer **Rei Kawakubo**, creator of Commes de Garçons.

Martin Margiela and **Viktor & Rolf** are all graduates of the famous Antwerp Royal Academy of Fine Arts. Margiela is especially interesting for his ideas on applying deconstruction to fashion.

DECONSTRUCTION

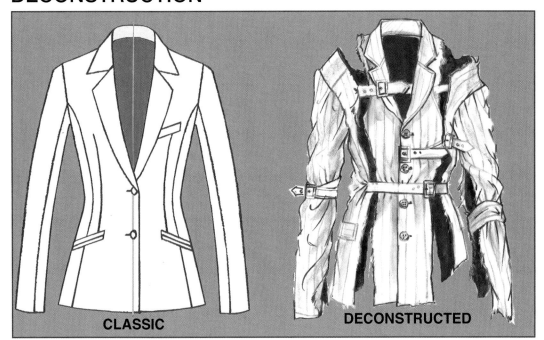

CLASSIC DECONSTRUCTED

Deconstruction is another interesting design principle to explore. The concept actually originated in the literary world, so it has been fascinating to see how different designers interpreted the ideas behind the word. Martin Margiela and Rei Kawakubo were two innovators who first explored it, but most designers have since used the idea in any number of ways in their collections. Do some research and see what interesting approaches you can originate.

TASK LIST

1. List the three most important principles that you learned from the first four steps, and describe several ways you might make use of those ideas in your work.

2. Review your croquis format to see if there are ways you might improve.

3. Adjust your croquis figure if your designs aren't looking as good as you would like. Check that your proportions and pose enhance your work.

4. Review all your flats to make sure silhouettes look as exciting as you pictured them, that details are placed correctly, and that you are taking different approaches for each group in terms of flat "style."

5. Review your design drawings, keeping in mind that this is where you should spend your time to make sure the drawing is correct. Do not count on rendering to make mistakes or poor drawing less obvious. Be willing to redo as needed.

6. Revisit the design principles you listed and see if there is anything you could do to improve the work before you start rendering.

7. Make sure the proportions and details of your designs match the proportions of your flats.

8. Research sustainability and decide where you will draw your line in the sand when it comes to employment.

9. Research deconstruction and see if there is a new way you can take the concept forward in your groups.

10. Check the balance of all your groups in terms of:
 a. Seasons (if you are using a traditional seasonal approach)
 b. Different fabric choices
 c. Interesting muses and a variety of ethnicities
 d. Accessories
 e. Cool compositions
 f. Different ways to approach your flats

11. Get your drawing and rendering tools in order in preparation for the next two chapters!

Chapter 6
Develop Your Pose

Style is an expression of individualism mixed with charisma.
Fashion is something that comes after style.

<div align="right">

—*John Fairchild*

</div>

Introduction

At last we are ready to begin developing exciting fashion figures that will showcase your designs to their best advantage. Like models on a runway, your poses will complement your outfits with their beautiful look, cool attitude, and fashionable accoutrements (all the details of hair, make-up, accessories, and so on). There are, of course, step-by-step methods for creating good poses, and because an effective pose can be adapted to many different uses, it can last a lifetime. Practice makes perfect, so gather your tearsheets and let's draw.

What Do Almost All Fashion Poses Have in Common?

1. Their primary purpose is to show the clothes. This means that the models are not lying down or bending over. Rather, they are in a pose that does not cover up garments.
2. This means that almost all fashion poses will be standing, with arms and legs in positions that do not cover up any key details.
3. They convey a specific attitude. A pose without some kind of attitude (whether it's haughty anger, passive gawkiness, or seductive femininity) is probably a boring pose.
4. The attitude of the pose complements the garment the figure is wearing.
5. Generally, the pose is not too extreme, as this can distort the garments.
6. The proportions are idealized in a way that is attractive to prevailing tastes.
7. The look of the figure reflects the tastes of the target consumer.
8. To get some sense of movement in relatively simple poses, a primary weight-leg pose is used frequently.

Often more than one figure is used to show the garments from different angles, to display a group, or to focus in on details.

Some poses may be "editorial," meaning they are used more for the mood that they set; other poses or flats are used to show the actual garments clearly.

TEN STEPS TO GREAT POSES

1. Review Figure Structure and Anatomy
2. Develop a Proportion Sheet for Your Muse
3. Review Your Thumbnail Layouts and Croquis
4. Determine the Mood of Your Group's Poses
5. Develop Your Fashion Heads
6. Develop Your Structured Pose
7. Add Fashion Heads to Figures
8. Refine Hand and Foot Details
9. Adjust Proportions for Younger Figures
10. Finalize Proportions and Details

STEP ONE: Review Figure Structure and Anatomy

Rib Cage–Pelvis Opposition

Hey, no one said that drawing the human body is easy! But what is more exciting than a beautifully realized depiction of human form? The fashion figure is especially exciting because we exaggerate proportions and movement to add to the impact.

Certain structural principles can help you create more effective figures. It's worthwhile to pay attention to these principles when you create your portfolio poses.

Points to Keep in Mind

1. One of the main characteristics of fashion poses is that the weight is *primarily on one leg.*
2. Weight-leg poses are very versatile, because the "play" leg that is not holding weight can take a variety of poses while the torso remains the same.
3. Weight-leg poses place the rib cage at an angle *opposite to the pelvis.*
4. This also means one shoulder is higher and the opposite hip is also higher.
5. The flexibility comes in the waist area, where one side is compressed and the other side stretched.
6. Many students do not take the time to recognize and make use of this important detail, so their figure poses look awkward or stiff.

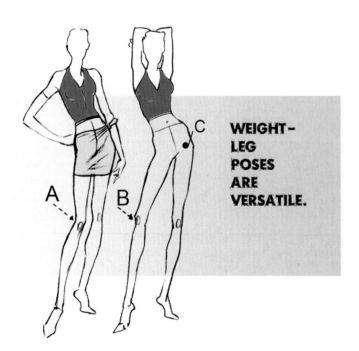

WEIGHT-LEG POSES ARE VERSATILE.

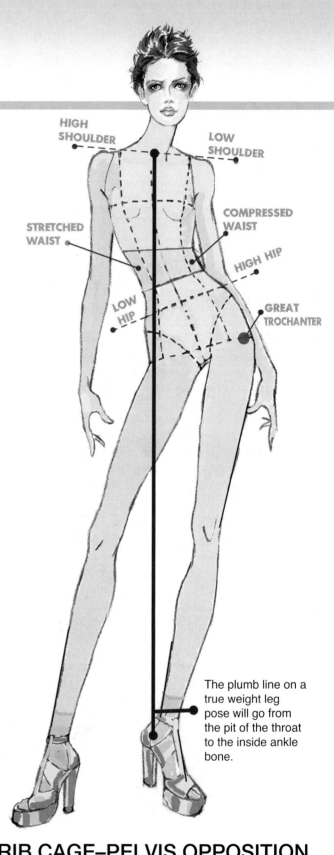

HIGH SHOULDER

LOW SHOULDER

STRETCHED WAIST

COMPRESSED WAIST

HIGH HIP

LOW HIP

GREAT TROCHANTER

The plumb line on a true weight leg pose will go from the pit of the throat to the inside ankle bone.

RIB CAGE–PELVIS OPPOSITION

Female Fashion Legs

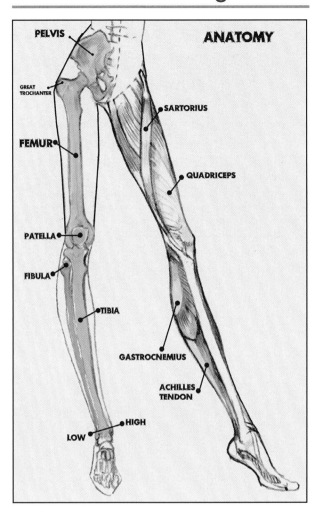

ANATOMY

- PELVIS
- GREAT TROCHANTER
- FEMUR
- SARTORIUS
- QUADRICEPS
- PATELLA
- FIBULA
- TIBIA
- GASTROCNEMIUS
- ACHILLES TENDON
- HIGH
- LOW

BONES MUSCLES

BACK VIEW LEGS *FRONT VIEW LEGS* *SIDE VIEW LEGS*

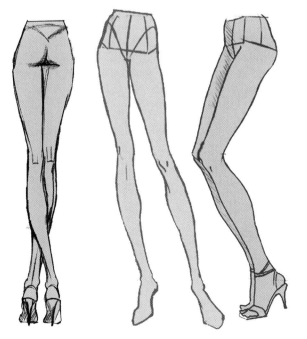

WEIGHT-LEG POSE

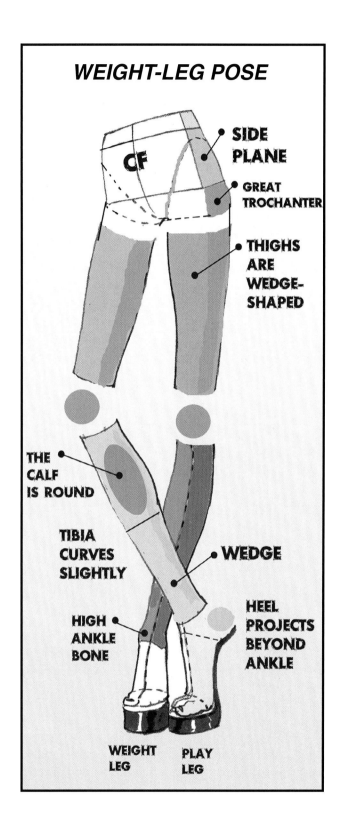

- CF
- SIDE PLANE
- GREAT TROCHANTER
- THIGHS ARE WEDGE-SHAPED
- THE CALF IS ROUND
- TIBIA CURVES SLIGHTLY
- WEDGE
- HIGH ANKLE BONE
- HEEL PROJECTS BEYOND ANKLE
- WEIGHT LEG
- PLAY LEG

Male Structure

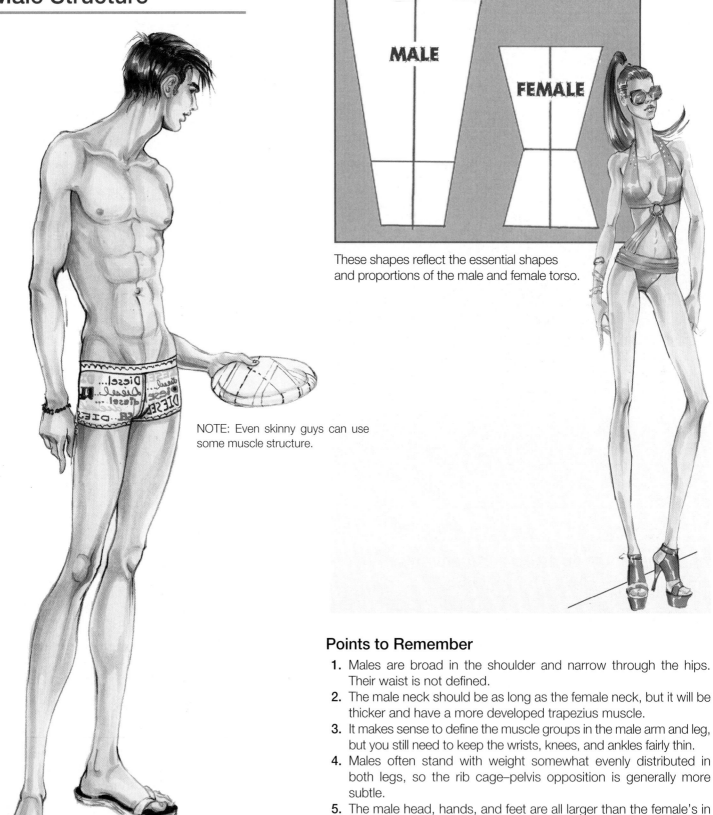

These shapes reflect the essential shapes and proportions of the male and female torso.

NOTE: Even skinny guys can use some muscle structure.

Points to Remember

1. Males are broad in the shoulder and narrow through the hips. Their waist is not defined.
2. The male neck should be as long as the female neck, but it will be thicker and have a more developed trapezius muscle.
3. It makes sense to define the muscle groups in the male arm and leg, but you still need to keep the wrists, knees, and ankles fairly thin.
4. Males often stand with weight somewhat evenly distributed in both legs, so the rib cage–pelvis opposition is generally more subtle.
5. The male head, hands, and feet are all larger than the female's in proportion to their bodies.

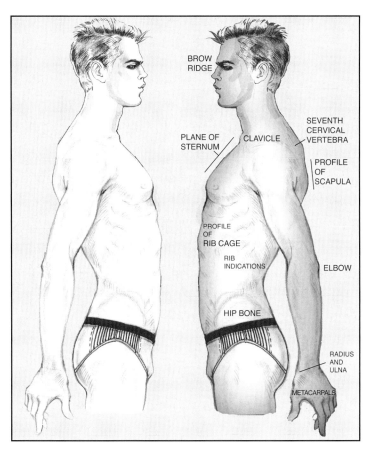

BROW RIDGE

SEVENTH CERVICAL VERTEBRA

PLANE OF STERNUM

CLAVICLE

PROFILE OF SCAPULA

PROFILE OF RIB CAGE

RIB INDICATIONS

ELBOW

HIP BONE

RADIUS AND ULNA

METACARPALS

Male Anatomy

There are many subtle differences between the male and female form. For example, note the side view of the male chest. The pectoral area must be drawn in an angular way so it does not look like breasts. You can also see clearly the larger volume in the male necks, shoulders, and arms, and the narrow, more angular hip. We will discuss the difference in facial structure later in the chapter.

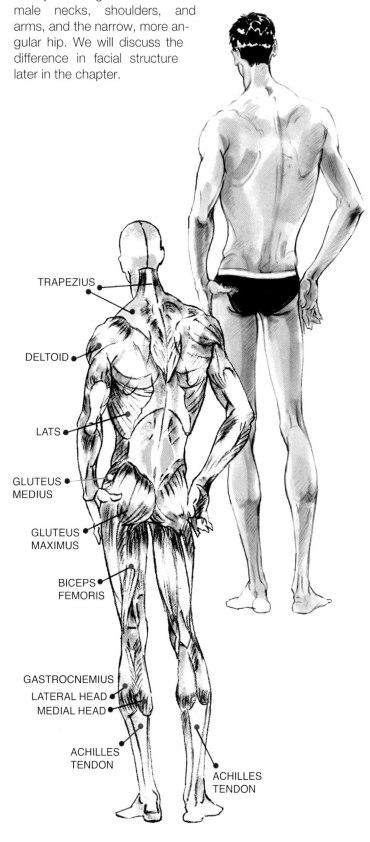

TRAPEZIUS

DELTOID

LATS

GLUTEUS MEDIUS

GLUTEUS MAXIMUS

BICEPS FEMORIS

GASTROCNEMIUS
LATERAL HEAD
MEDIAL HEAD

ACHILLES TENDON

ACHILLES TENDON

Front, Side, and Back Views

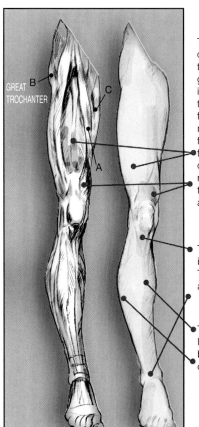

GREAT TROCHANTER

B

C

A

The four-headed quadriceps is the largest muscle group in the leg, and it is one you may want to define for your male figures. It creates the rounded shape on the front of the thigh (rectus femoris) and is also visible on the inside leg (vastus medialis). The outside of the thigh (vastus lateralis) is a more gentle curve.

The head of the tibia (the shin) is easily seen below the knee. The tibia also forms the ridge above the arch of the foot.

The upper inside of the lower leg is a prominent curve formed by the gastrocnemius. The outside contour is one consistent curve.

DESIGNER: ANGELA CHUNG

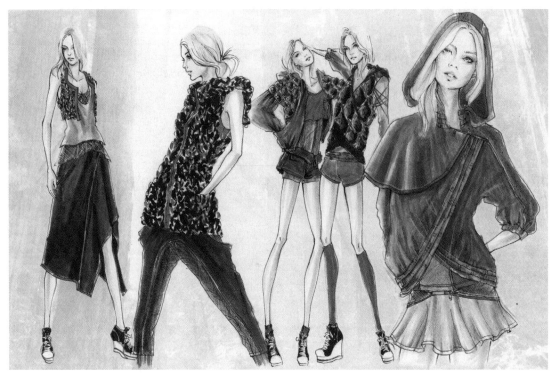

You can see how important an understanding of good anatomy is for both these activewear groups.

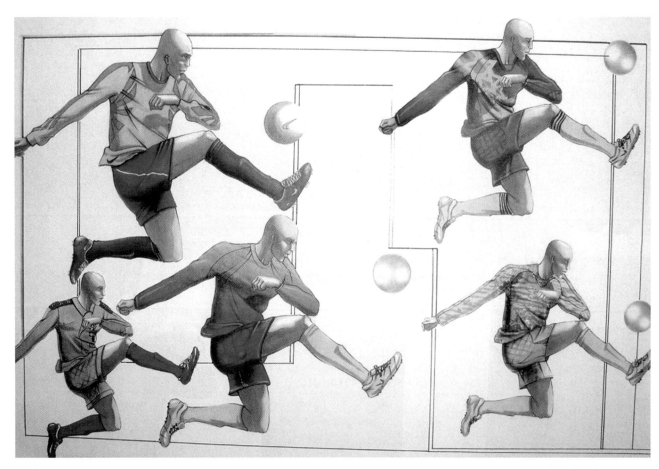

DESIGNER: XENA AZIMINIA

STEP TWO: Develop a Proportion Sheet for Your Muse

As fashions change, so do things like pose styles and figure proportions. Over the years we have used quite different proportions, which, as you see in the following charts, are measured in head lengths. The shortest adult figure has been about nine heads; the tallest, usually for evening wear, has been as many as fifteen heads tall. A realistic human figure is rarely more than seven to eight heads.

Although figures have reached extravagant lengths in the past, recent trends seem to be toward a more realistic figure, especially for more sporty clothing and younger looks. As usual there is no one right answer to any problem, so do not take these charts too literally. They are a starting point for you to develop your own look.

You may find it helpful to copy the chart that applies to your groups, then enlarge it to several different sizes so you can make comparisons as you draw.

Things to Keep in Mind

1. Proportion is a key element of good design, and the proportion of your figures can also make or break an outfit.
2. Chances are you will want to use fairly similar proportions throughout your book, but that is not a hard and fast rule. Some groups may be very stylized and others more realistic. Or you may have an evening group as the finale of your book, and decide to use a longer, more elegant figure. If it works, it works.
3. So long as your book flows well visually, you can break all kinds of rules.
4. But one rule we do follow is having consistency of figure proportion within each group. You do not want to have a tall girl standing with her shorter friends.
5. If you move some figures back in space, you will of course have a variation in size but it will be proportionate.

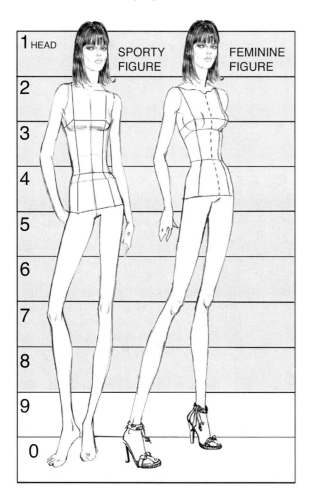

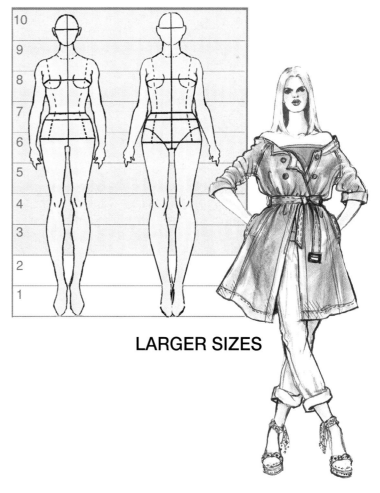

LARGER SIZES

STEP THREE: Review Your Thumbnail Layouts and Croquis

It's time now to start making concrete decisions. You will want to have all your information and preparation in mind when you do. Let's begin by asking some key questions:

1. **Does the mood of my thumbnail layout reflect my concept?** Put words to your concept image. Is it quiet or loud, aggressive or subtle, elegant or funky? When you have chosen the words that fit, keep applying them to your other choices to make sure you are supporting the chosen mood.

2. **Which kind of pose would best showcase my garments?**
 a. If your clothes are flowing and romantic, you may want to show movement with walking poses. You can also show sporty separates with walking poses that have a lot of cheeky attitude, or very dynamic menswear.
 b. If your designs are elegant, with lots of subtle detail and/or embellishment, you probably want simple poses with most of the attitude in the look of the head.
 c. Complex layered outfits also call for simple, subtle poses.
 d. Humor is always a crowd-pleaser. If you are doing amusing childrenswear, then of course you want poses with some attitude and humor.
 e. Even young men's wear can be quite humorous and fashionably "nerdy," and no one is more unselfconsciously funny than a vain teenage girl. We had one student who illustrated her evening gowns on the cartoon character Marge Simpson, and it actually worked very well.

3. **What are the pose needs that my croquis dictate?**
 a. If you have wide trousers, you will want a pose with legs apart and possibly hands in the pockets.
 b. If you have pencil skirts, you will need some "legs together" poses as well.
 c. If you are designing swimwear, you may need to spend extra time with your anatomy book, making sure your poses are well structured and look relaxed. Note that overlapping poses can add interest to the group.
 d. If you are doing junior girls or guys, make sure you have reference from that age group. Young teens have a body language that is all their own.

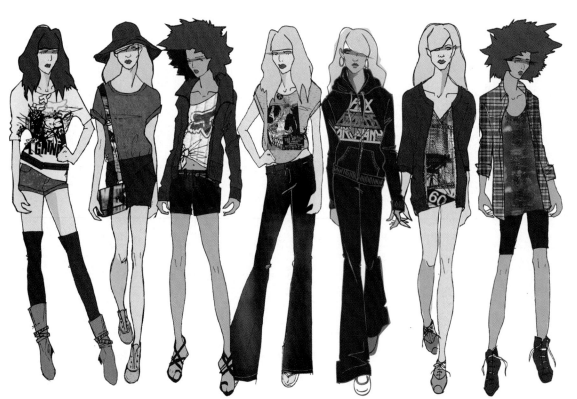

ALEXSANDRA DEL REAL

These poses perfectly fit the mood of this customer, who is young and hip. Alexsandra used only two poses, but by flipping them and changing the arms and hairdos, she gave them a great variety of looks.

STEP FOUR: Determine the Mood of Your Group's Poses

You should be ready now to make a final decision on poses for your first group. Of course, your decision may be influenced by the figures that you already have in hand that have worked for you in the past. Using what you have can save a lot of time and effort, and there are many ways to make an old pose look fresh.

But if your group calls for something new and bold, we hope you can find the time to try some new approaches and make use of your illustration inspiration to create the perfect muse for your group.

This does not have to mean a great time investment. For example, the casual sporty pose (A) shown here can work for both tight skirts and big pants, so it's very versatile. You can just change the arm positions for some variety if you are pressed for time. Example B, though active and fun, still could serve for dressy cocktail separates or something more casual as well. But keep in mind that whatever poses you choose should show the best aspects of the outfit. In other words, if you use side views, you need to have something interesting to show from that view. It's quite discouraging when students design something beautiful, then don't use a pose that actually shows their cool detail.

Military influence has always been important, and if your group is all about that, you have it made in terms of poses! Just develop one straightforward figure and use it multiple times so your group looks like it's in military formation (Example C). Of course, you could always throw in a back view for a fun visual surprise! Remember, a new pose or two can really freshen your group, so let's get to work!

A. CASUAL SPORTY

B. ACTIVE DRESSY

C. MILITARY FORMATION

FUNNY KIDS

Even without a face, this kid has a lot of attitude.

NERDY COOL

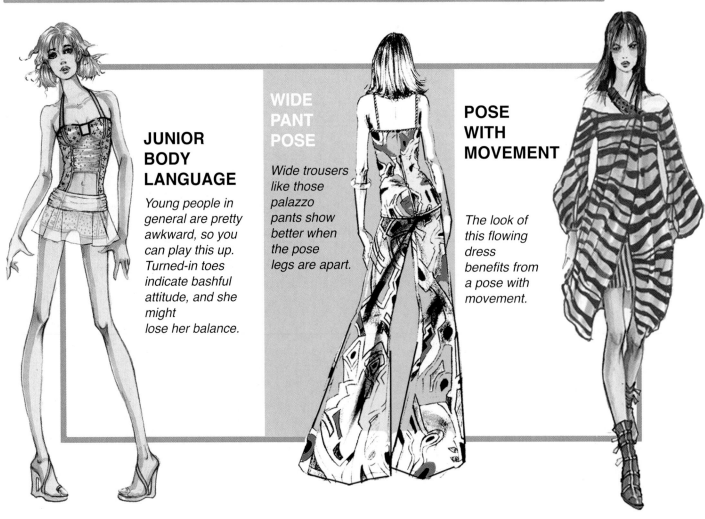

JUNIOR BODY LANGUAGE

Young people in general are pretty awkward, so you can play this up. Turned-in toes indicate bashful attitude, and she might lose her balance.

WIDE PANT POSE

Wide trousers like those palazzo pants show better when the pose legs are apart.

POSE WITH MOVEMENT

The look of this flowing dress benefits from a pose with movement.

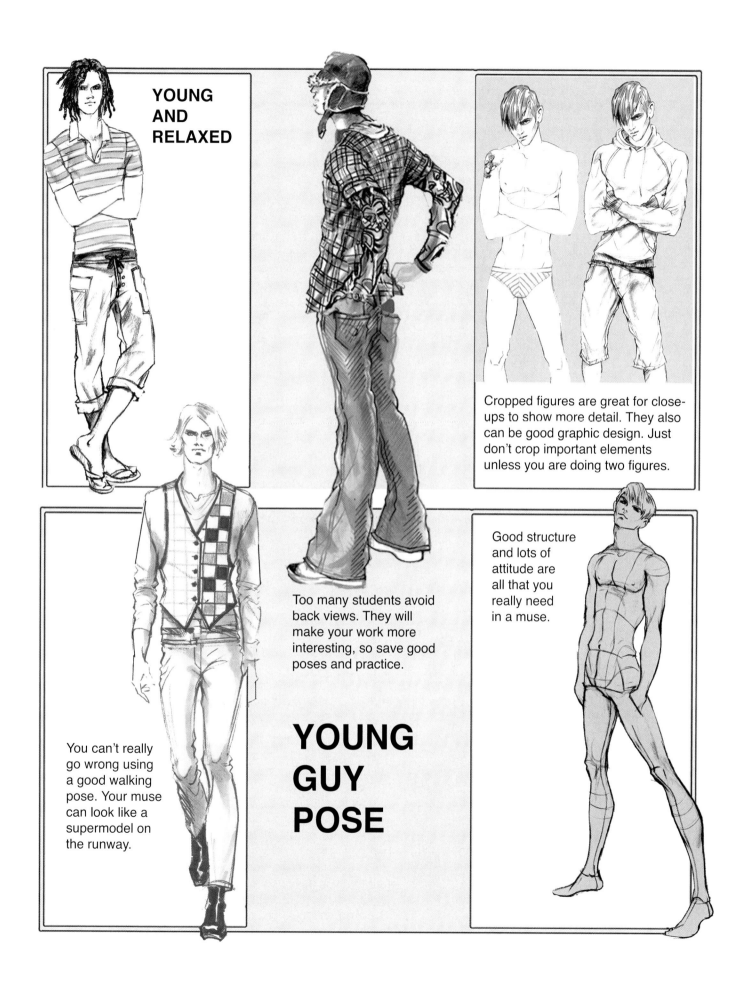

**YOUNG
AND
RELAXED**

Cropped figures are great for close-ups to show more detail. They also can be good graphic design. Just don't crop important elements unless you are doing two figures.

Too many students avoid back views. They will make your work more interesting, so save good poses and practice.

Good structure and lots of attitude are all that you really need in a muse.

**YOUNG
GUY
POSE**

You can't really go wrong using a good walking pose. Your muse can look like a supermodel on the runway.

Designer: Xena Aziminia

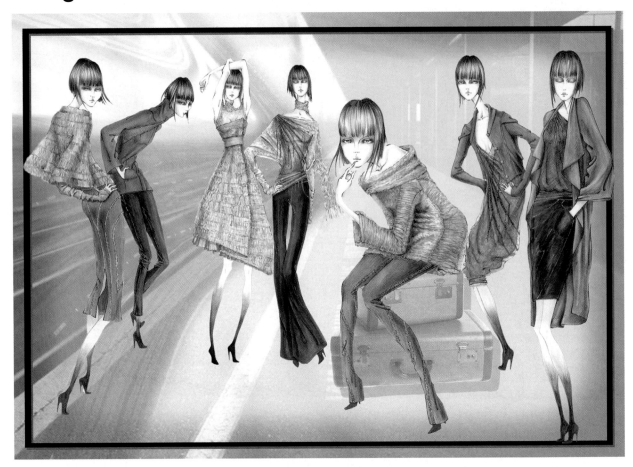

Xena Aziminia created this wonderful group called simply "Purple" for her portfolio. Xena's impressive illustration talents imbue these figures with so much personality and sense of fun. Yet the design concept of sophisticated outfits that mix and match and travel well (note the suitcases and the highway) is completely clear and consistent. She makes it all look effortless!

Mood Poses

These poses that have so much expression are what we would call "mood poses." This means they are perhaps more successful at projecting a certain attitude than in showing the specific outfit. Xena's other poses in the group are more straightforward, which creates a nice balance, but the composition would not be as fun if these weren't a part of the group.

If you use mood poses, it is important that you have very clear flats so the viewer can see the details more clearly. The drop shadows are another fun way to enhance the look.

STEP FIVE: Develop Your Fashion Heads

The look of your muse is key to the success of your group. The hair, make-up, face, and attitude either enhance your look or undermine it. You are almost better off with a minimal, graphic face than one that distracts. If you have trouble drawing faces, don't give up, but know there are many solutions to the problem, so be realistic about your skills.

Chances are you have developed a style for drawing heads already, but trying some new approaches can lead to something interesting and fresh.

Things to Keep in Mind

1. We are not doing portraits. A head that is too literal or over-rendered distracts from the designs.
2. Having a balance of ethnicities makes your book more current and global and shows you have a broad point of view.
3. Photo heads can be adapted for illustrations and work quite well. This technique can save time and stress. But you need to stylize and render the photos so they are not too recognizable and blend with the rest of your illustration.
4. There is no excuse for poor structure in fashion heads because you can trace your muse to get correct placement of the features.
5. It is often helpful to create larger fashion head drawings, scan, print and render them, then shrink them down for use with your figures. The heightened detail makes the extra steps worth it!
6. In general, you want to emphasize the eyes and the mouth of your fashion heads. The nose is less important, and can be distracting, so keep it minimal.
7. Sometimes the most simple faces are the most striking. If they add to the mood, you have succeeded.
8. Even if you have a head that you are happy with, you might want to draw several alternatives, or experiment with stylizations. The first solution is not often the most interesting.
9. Try to find different views of your muse head so you are not limited to one angle.
10. Make sure your reference is current. You can have great looking designs, but if your muse looks out of date, you have potentially ruined your group.

DRAWING FROM FASHION LAYOUTS

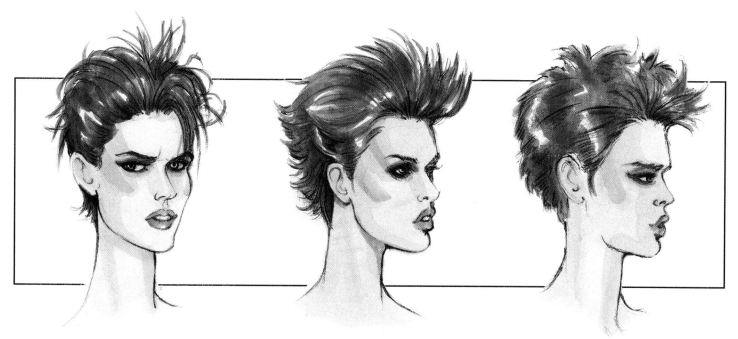

These three heads were drawn from a photo fashion layout that was all the same model. This approach allows you to draw the same pretty person from several different angles and use it in your group, so you have a variety of views but maintain a consistent muse.

Who Is Your Muse?

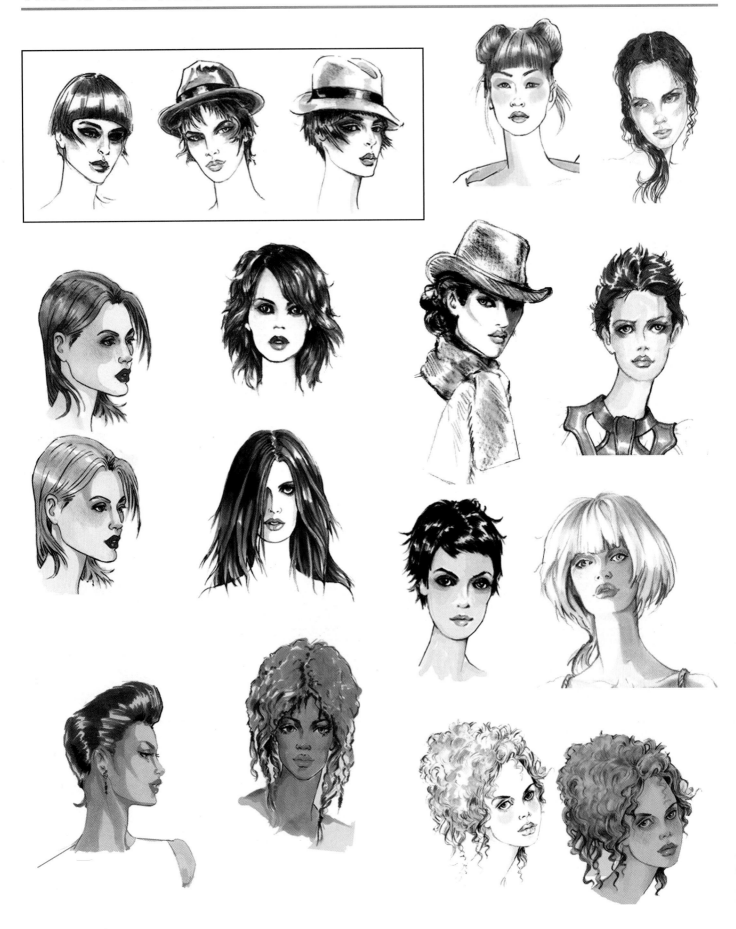

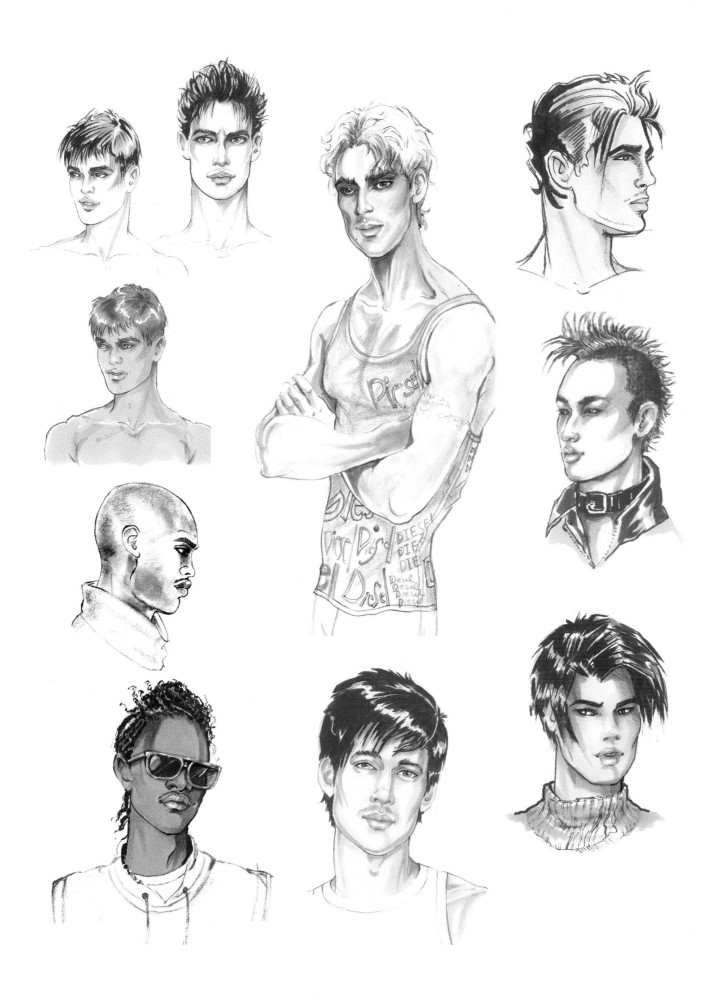

STEP SIX: Develop Your Structured Pose

You are now ready to develop your finished poses for your first group. That is exciting, because soon you can see your croquis designs on figures in a finished group and your portfolio will begin to take shape.

When developing figures, especially from photos, it is easy to be involved mainly with outline contour, head, and proportions. These are important elements, but unless you also consider structural information, your pose will probably not measure up. It's hard to get the full effect of a stance unless you capture the rib cage–pelvis contrast, no matter how subtle you think it is.

Just as for all the other processes described in this book, we suggest a step-by-step method for developing your pose. Too often students rush this important task.

The other big advantage, as you will see, to placing structure lines on your figures is it is much easier to draw your designs accurately!

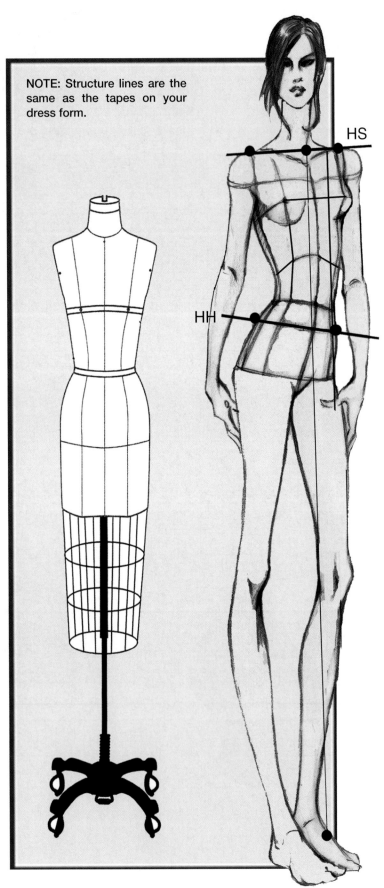

NOTE: Structure lines are the same as the tapes on your dress form.

HS

HH

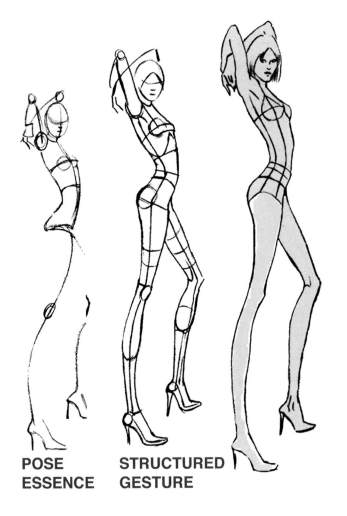

POSE ESSENCE

STRUCTURED GESTURE

Develop Your Pose, Step by Step

1. Start with a loose gesture sketch that has the mood you want. This is a pretty subtle walking pose with legs close together so it is ideal for dresses, but there is still a sense of movement.

2. Add the bust, volume, and structure lines to your pose. Make sure you are aware of what leg is carrying the most weight. In this pose, the right hip is higher so the weight is primarily on that leg.

3. Start adding your details, like shoes and a feeling of the head. Sketch a sample garment to see how well the pose is functioning. Sometimes a well-drawn pose will still not be flattering to the designs, because the proportion isn't working, so we always "test-drive" a pose before finalizing anything. Note that both the dress and hair swing toward the high hip.

4. Add shadows to the figure and garments to see if the proportions still work. If you are happy with the look, then finalize your details.

Develop Your Back View Pose, Step by Step

1. We began with a photo of a model in a back view pose. We traced the photo, adding structure lines to the figure. This provides us with an accurate gesture in a very short time.

2. We stretched out the structured pose and began adding details to see if it had the right mood.

3. The final pose is a little taller and the features are refined.

4. You can see our "test-drive" to the right. This pose works well to show a pretty back detail.

STEP SEVEN: Add Fashion Heads to Figures

Finding the Perfect Muse

Which muse best complements the designs?

Points to Consider

1. Different faces and hairstyles create a variety of moods.
2. If you can develop several rendered heads and sketch your designs on your figures, it allows you to try different looks before you make a final decision.
3. You can simply trace your head drawings and render them, but it makes it especially easy to try different looks if you scan all your elements into Photoshop, as we have done here. The two lower heads take a simple graphic approach that keeps the viewer's attention on the designs.

Designer: Summer Spanton

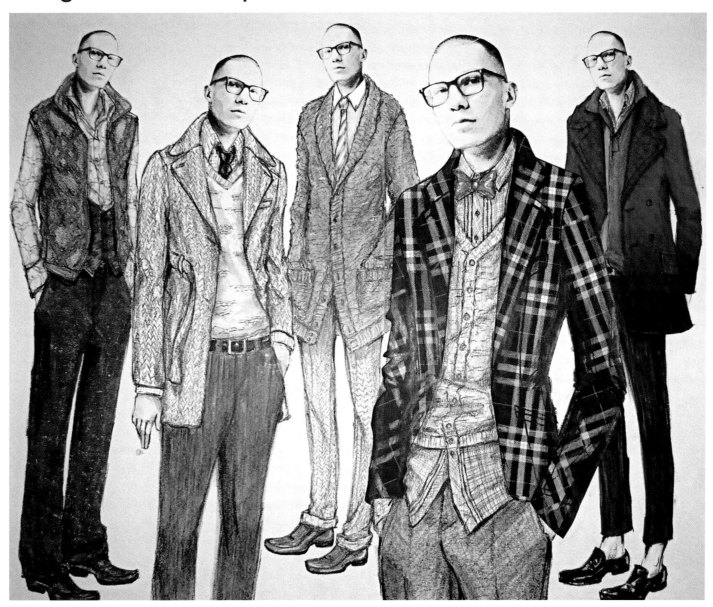

MOOD BOARD

Summer Spanton does a wonderful job of utilizing a photo-based head to contrast with and complement her highly rendered designs. Summer did this "cool nerd" group for her menswear portfolio while she was still a student.

STEP EIGHT: Refine Hand and Foot Details

Male Hands

1. Male hands are more angular and generally larger than female hands.
2. They will have square nails and tips, while the female's fingers will be more slender and "pointy."
3. The male wrist will be wider and more angular.
4. Guys rest their hands on their hip, not their waist.
5. A natural looking walking pose will often have one hand swinging back and one coming forward.
6. Guys look great with their hands in their pockets, so that can really save some time. But don't do that with all your figures or it will start to look weird.

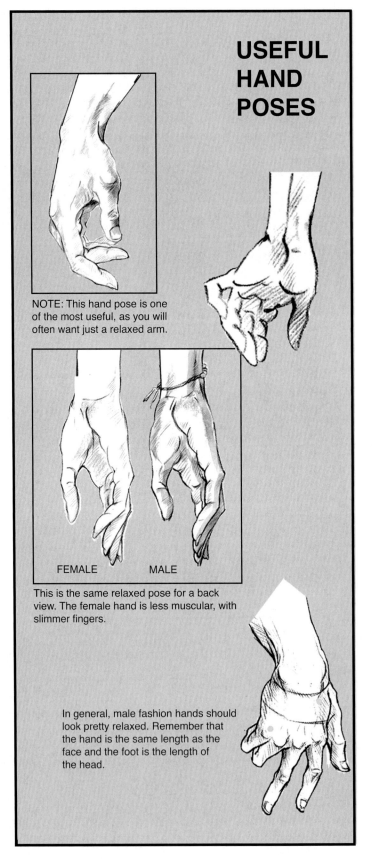

USEFUL HAND POSES

NOTE: This hand pose is one of the most useful, as you will often want just a relaxed arm.

FEMALE MALE

This is the same relaxed pose for a back view. The female hand is less muscular, with slimmer fingers.

In general, male fashion hands should look pretty relaxed. Remember that the hand is the same length as the face and the foot is the length of the head.

Study the arcs that the finger joints and tips follow. Getting the proportion of the thumb and the correct finger bend are keys to hand success

HAND GESTURE AND FINISHED DRAWING

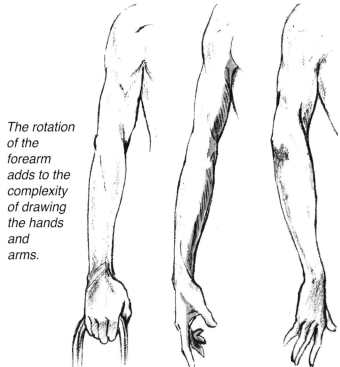

The rotation of the forearm adds to the complexity of drawing the hands and arms.

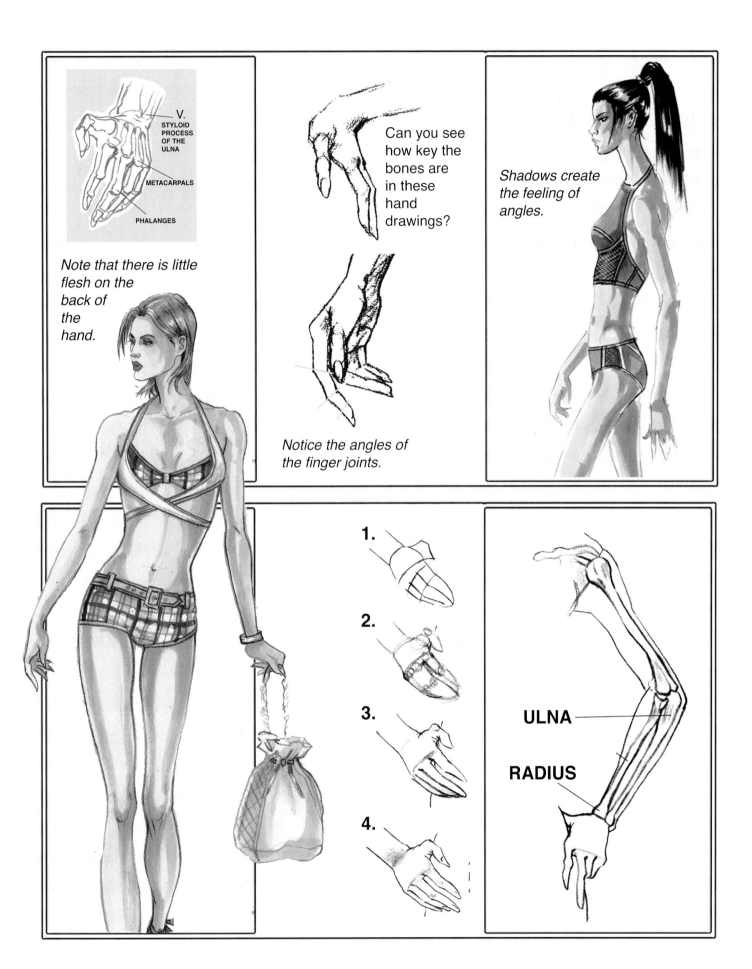

V.
STYLOID
PROCESS
OF THE
ULNA

METACARPALS

PHALANGES

Note that there is little flesh on the back of the hand.

Can you see how key the bones are in these hand drawings?

Notice the angles of the finger joints.

Shadows create the feeling of angles.

1.

2.

3.

4.

ULNA

RADIUS

Feet and Shoes

Everyone knows that the wrong pair of shoes can ruin an outfit! Feet and shoes are challenging but critical. Take the time to find just the right shoes for your look and make the effort to draw them correctly! If you still aren't satisfied, then consider scanning shoes and collaging them into your drawings.

Things to Keep in Mind

1. Whether the shoe is flat or high-heeled, it is helpful to think of the foot in three parts: the heel, the arch, and the toes.
2. The more foreshortened the angle, the more extreme the contour of the foot will be. Of course, with flats, we do not have to deal with the under-plane of the foot.
3. All the toes turn toward the second toe.
4. The ends of the toes create a plane.
5. Note the fleshy part of the foot behind the toes.
6. The toes, like the fingers, form an arc.

Drawing shoes can be fun if you choose shoes that turn you on.

STRUCTURE OF THE FEET

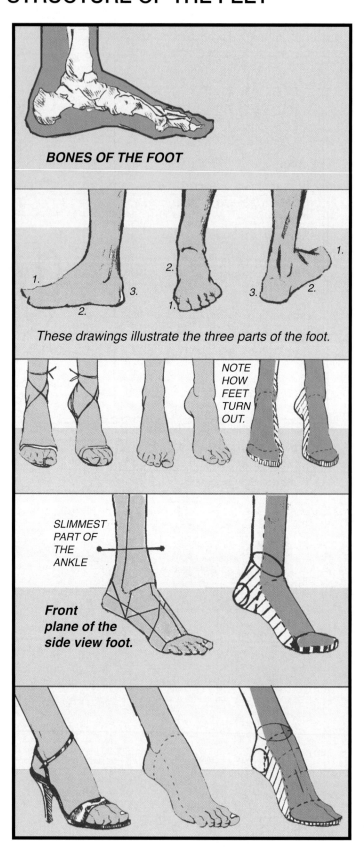

BONES OF THE FOOT

These drawings illustrate the three parts of the foot.

NOTE HOW FEET TURN OUT.

SLIMMEST PART OF THE ANKLE

Front plane of the side view foot.

In walking poses, shoes have to reflect the foreshortening and movement of the feet.

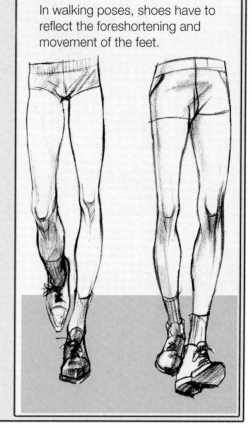

Back Views

1. The top of the heel (under the foot) always turns up.
2. The heel of the shoe will be longer than the toe of the shoe, because of the foreshortened viewpoint.
3. The style of the heel changes from season to season, just like clothing. Observe and make use of the trends.

PATENT LEATHER BOOTS

There are all sorts of wonderfully eccentric shoes and you should take full advantage of that in your work. But make sure that your designs dominate, rather than the shoes or any other accessories.

Note that the toes turn up!

Little Girls

KID PROPORTIONS

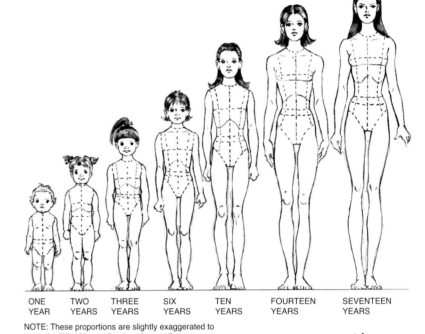

| ONE YEAR | TWO YEARS | THREE YEARS | SIX YEARS | TEN YEARS | FOURTEEN YEARS | SEVENTEEN YEARS |

NOTE: These proportions are slightly exaggerated to make the little kids smaller than they really are.

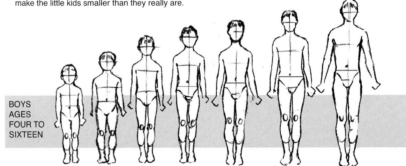

BOYS AGES FOUR TO SIXTEEN

Things to Consider

1. Even older kids still have some trouble with balance, so they tend to stand solidly on two feet or be in motion.
2. Kids have big heads, small necks, big eyes for the proportion of their heads, big feet, straight torsos (not much waist) and a layer of baby fat that keeps their shapes soft and not overly developed.
3. Kids' hair should generally be soft and a little messy.
4. Girls especially are often very "touchy-feely." They hold hands or connect in some other way.
5. Kids can be very funny and that includes drawings of them. Check out a book on cartooning for some good ideas.

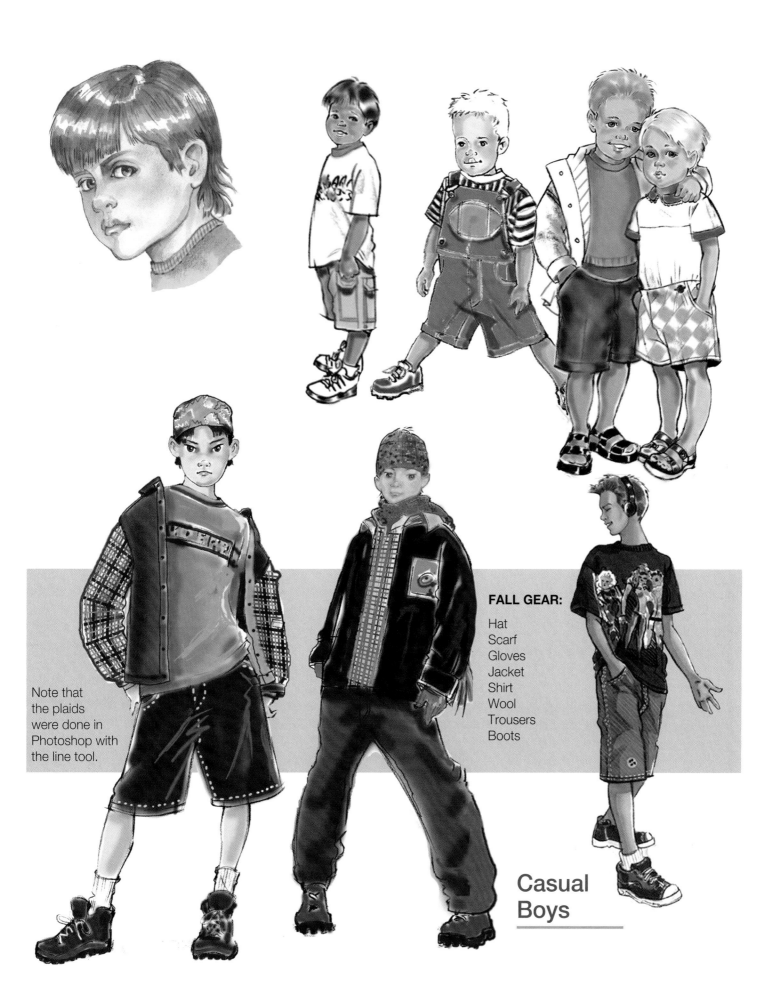

Note that
the plaids
were done in
Photoshop with
the line tool.

FALL GEAR:

Hat
Scarf
Gloves
Jacket
Shirt
Wool
Trousers
Boots

Casual
Boys

Womenswear Designer: Minnie Yeh

Womenswear Designer: Barbra Araujo

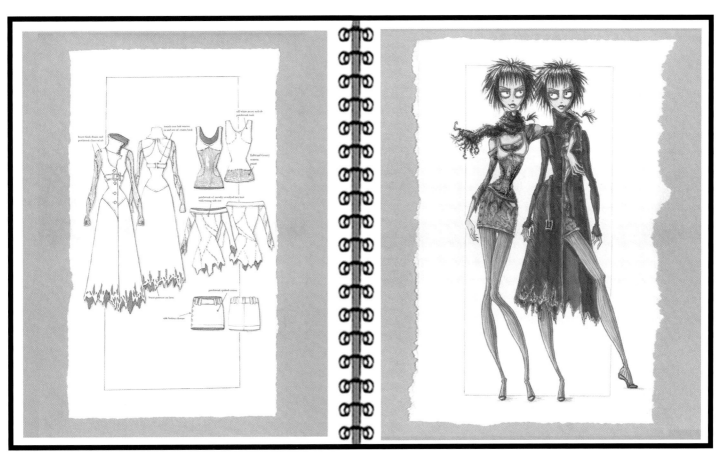

Figures for Junior Swimwear Group

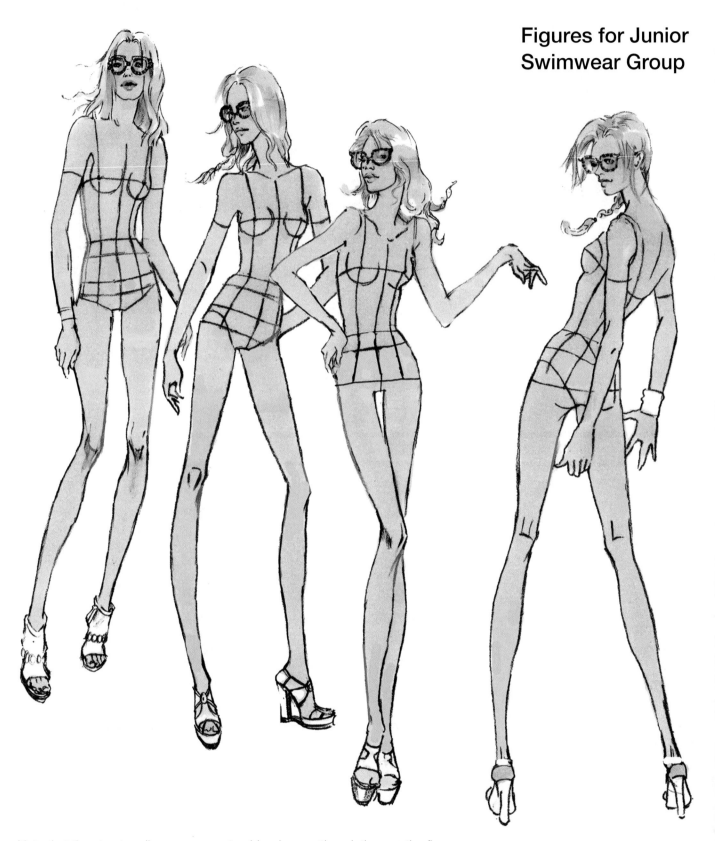

Note that the structure lines are a great guide when putting clothes on the figure.

Five-Figure Composition with Overlapping Figures

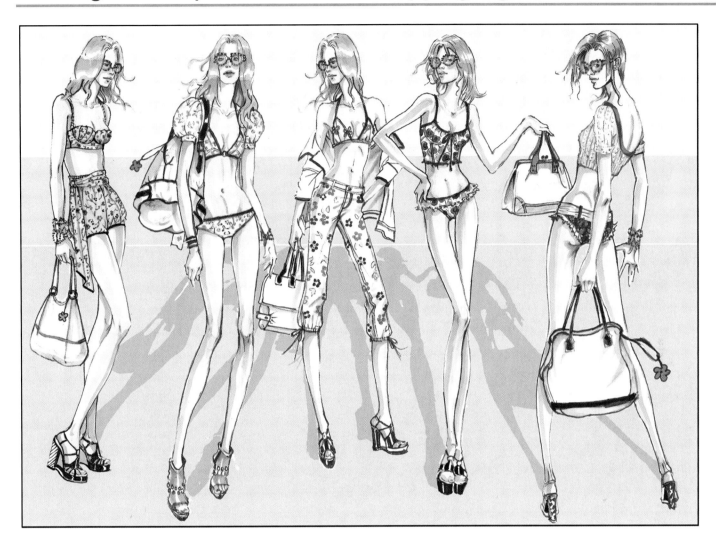

Complex Composition

This complex composition is especially unusual in that a back-view figure (5) is dominant. This happens because the figure is larger, the stance is aggressive, and the head is turned toward the viewer. Figure 2 is the secondary figure, while figure 1 is the sole bookend. The two middle figures are frontal so they do not recede even though they are smaller. The cropped pant, with its graphic pattern, also pulls our eye to figure 3.

The accessory bags help to unite the figures visually, as does the overlap of poses, which creates a sense of movement and connectivity. The shadows also connect the figures and create depth. The moving strands of hair support the beach background, which was created in Photoshop.

Five-Figure Composition with Cropped Figure

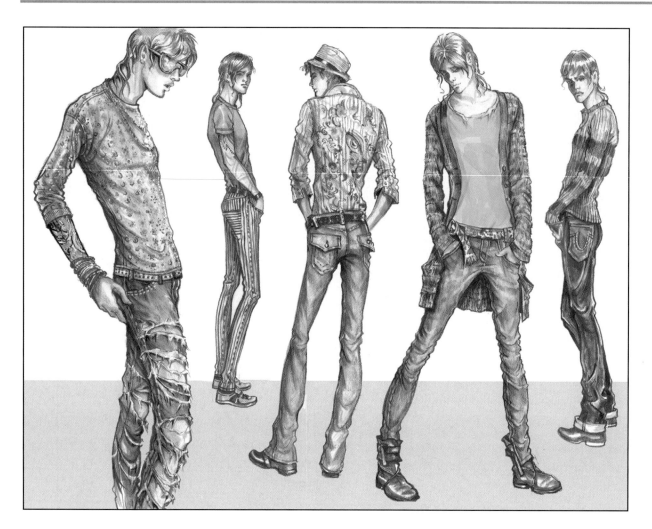

Figures are numbered in order of their dominance in the composition.

Figures generally have a place in the visual "pecking order" of a composition. They will dominate based on a number of factors including size, color saturation, detail and "drama" of clothing, accessories, facial expression, and so on.

Composition Analysis

1. Primary figure: A cropped and enlarged figure in the foreground will dominate a composition. The pattern, intense hot colors, and exaggerated detail also pull our eye to this figure, which is great for showcasing cool details.
2. Secondary figure: This figure would also work well as a primary figure because he is facing forward and has a strong stance. A direct gaze toward the viewer would be more powerful. The color of the tee also attracts attention. A graphic would increase the impact.
3. Although this figure is placed back in space and turned sideways, which is less imposing, he takes third place because he is looking directly at the viewer. The red stripes are also strong graphically.
4. This figure has a strong stance, but he is turned away from the viewer. The pattern of the shirt does draw our attention.
5. This figure is pushed way back in space, so he is the least dominant. He is also rendered in cooler tones, which helps keep him back in space visually.

Make it Your Own

Although you can use the poses you find on the web or that we provide to illustrate your groups, the more you assert yourself in the development process, the more individualized your poses will be. It is never too late to work on your drawing skills, which come in handy in the industry. For example, if you are in a meeting and your boss asks you to quickly sketch an idea, you want to feel confident that you can pull off a decent drawing. You will also find yourself changing jobs periodically, and being able to draw and design a special "killer" group for your targeted company will certainly get your foot in the door.

However, if it is still a real struggle to come up with a great pose, then we would encourage you to start with one of our figures as a base for your pose. Then you can refine it to your taste and make it your own. After all, you are being trained as a designer, not an illustrator, although drawing well can certainly bring in extra income.

Do spend time on your drawings and don't be satisfied until you feel they are right. Live a couple days with them to make sure you are still happy. It's amazing how much more you see when a little time has passed.

TASK LIST

Revisit the chapter topics to make sure you have achieved your goals

1. **Reconnect with the structure of figures.** Many times we fall into bad habits over time and something like well-used poses can get distorted or simply poorly drawn. Take the time to create something new that reflects your mature viewpoint. If your work is just so-so, consider ways to make it great. Consult with your instructors. After all, this is your portfolio, so you want it to be your best effort!
2. **Proportions are everything when it comes to design.** Again, get feedback to see if others feel your proportions are working. We do tend to be blind to our own work. Try new proportions and see if your clothes look better. Let great illustrators inspire you to stylize your work.
3. **Sometimes your best ideas lie in small, spontaneous sketches.** Don't discount the value of the things you do quickly, because they often reflect your vision most accurately. You just have to do the hard work to make them portfolio-ready.
4. **Mood is key to creating successful design groups.** If your group looks generic and does not reflect your passion for design it will be a "snooze" for the viewer as well.
5. **The head, or heads, you use for your muse can make or break your group.** So take the time to make it right. If you struggle, start with a photo. You can trace and render the photo, posterize it, use Photoshop filters, and so on to make it your own.
6. **Remember: Some of the best poses are the most simple.** But they do need to project attitude through both body language and expression. Structure lines will keep your figures "honest" and help you put on clothes correctly.
7. **Make sure your fashion head looks comfortable on the figure.** The "stiff-neck" look is not attractive.
8. **Make your hands and feet/shoes count.** They are an important aspect of the whole look. If you have trouble with hands, trace some from this book. Don't hide them all the time. And don't draw generic shoes. That is boring and unimaginative.
9. **A designer must be detail-oriented!** Pay attention to the little things.
10. **Have fun with composition.** Take the time to try different things.

We love Lolly's figures because they are so uniquely her own, and because they have humor that always pulls the viewer in.

LOLLY ZHONG

Chapter 7
Draw and Render Your Designs

Clothes make the man. Naked people have little or no influence on society.

Mark Twain

Introduction

Now that you have planned your composition and created beautiful fashion poses, you are ready to finalize your designs on the figure and render them in your chosen fabrics. Even if you have a high skill level, this can be a bit scary, especially for the first group, but following the key steps in this chapter can help to reduce the stress and achieve great results. We have tried to provide numerous reference images so you can make sure your design details are accurate as well as examples of the various garments that can help you with your drawing. It is critical that you have the correct supplies for rendering your fabrics. This is not the time to skimp on markers if you have unusual colors that are hard to match.

As usual, preparation is an important aspect of the step-by-step process, and the willingness to redraw and rerender until you have what you want is absolutely key. On the other hand, demanding an unrealistic level of perfection is also to be avoided. If you can use Photoshop and Illustrator, it becomes much easier to make quick changes (see Chapter 9). Keep in mind that deadlines are all important, and additional changes can be made after you graduate.

Things to Keep in Mind

1. The great variety of fabrics and silhouettes can be categorized with words like stretchy, embellished, crisp, and so on. When you choose a fabric to draw, think of descriptions like "crisp and light," "heavy and textured," "shiny and delicate." Do the same with your garments. Use words like "fitted and sexy" or "loose and casual." These words can help you to stay on track.
2. Think about what quality of line will best convey the characteristics you choose. A delicate fabric will naturally require a more delicate line.
3. Even if you are experienced at drawing clothes, your drawing will improve if you use good reference. Take the time to pull out the right tearsheets for the project. It can also be more helpful to look at actual drawing, so do make use of the examples in this and other books.
4. Learning to edit visual information in reference photos is also key. You do not want to spend hours capturing every nuance. One light source is sufficient, even if your reference has more. Make the photo adapt to your style, not the other way around.
5. Do not start rendering until you are happy with your drawing. Small unresolved issues will cause tedious and sometimes disastrous delays.
6. Approach rendering logically, step by step. Practice before you tackle your final drawing.
7. If you are heavy-handed, use a Verithin pencil instead of a Prismapencil to do your drawings. You can also clean up drawings in Photoshop.
8. If you are messy, keep a paper towel under your hand as you work.
9. If you feel bored by your work, something is wrong. Find the excitement in whatever you are doing. Then your audience will be excited as well.
10. Each fabric is its own drawing and rendering problem. Try different and less obvious solutions, so your work has a variety of textures and styles. Don't fall into old routines.

TEN STEPS TO SUCCESS

1. Review basic principles of drawing clothes on the figure.
2. Draw your outfits loosely on your figures.
3. Put loose color and pattern on your figures and check the balance.
4. Make adjustments to your drawings, adding or editing elements as needed. Change poses if necessary.
5. Draw over each outfit, refining the line, silhouettes, and details.
6. Scan your final drawings and print them out separately or as a group, ready to render.
7. Review principles of good rendering.
8. Render your entire group.
9. Complete your flats in correct proportion to the garments.
10. Put your work up and live with it for a few days.

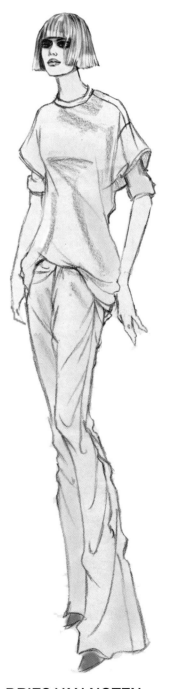

DRIES VAN NOTEN

STEP ONE: Review Basic Principles of Drawing Clothes on the Figure

Although you are likely already in the field or a graduating senior, it never hurts to review basic principles. They also come in handy when you need to redo a group to get that next great job. It's easy to forget the basics when you're under stressful time pressure. So let's look at some good examples and see what we can glean.

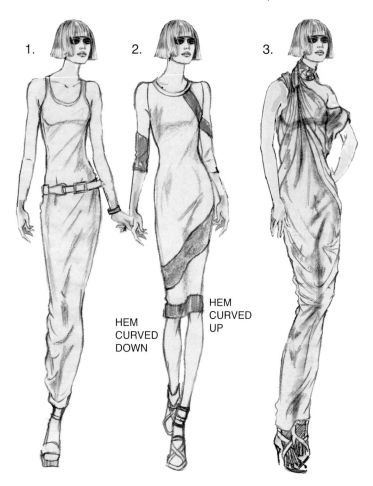

1.

2.

HEM
CURVED
DOWN

HEM
CURVED
UP

3.

Principle 1: Unless you are drawing Superman in spandex, give your clothes some ease. Swimsuits and exercise wear are the exceptions to this rule

1. This is a clingy knit dress, but folds indicate where the body is and how it is moving. The leg extended back creates specific folds. Good visual reference really helps in drawing such details. Small folds also help the viewer know that the belt is separate from the dress and cinched snugly.

 NOTE: A shadow defines the plane of the breasts, but that is as much as we want to show unless we are drawing for video games.

2. Again, this dress clings to the body, but she has enough room to walk with ease, and folds at the elbows show the subtle bend of the arm. The shadow indicates the leg coming forward.

3. This is a chic evening dress by Lanvin, and it is made more elegant by the use of beautiful drape and folds. Such detailing will show expensive fabrics to advantage in a way that a skin-tight garment would not.

 NOTE: The contours of the dresses follow the shape of the body.

This collar looks more relaxed and interesting if drawn open with straps hanging. It would look uncomfortable all zipped up.

Principle 2: Draw and style clothes the way you would wear them. If everything is too neat and pressed and buttoned up, your designs will look stiff and unnatural

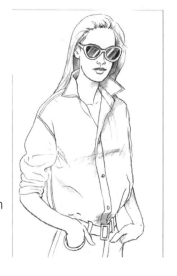

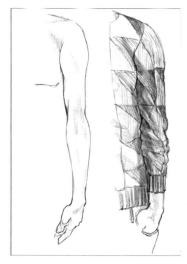

Notice the open collar and pushed-up sleeves.

Principle 3: Don't be afraid to create volume. Many designs lack drama because they are drawn too conservatively

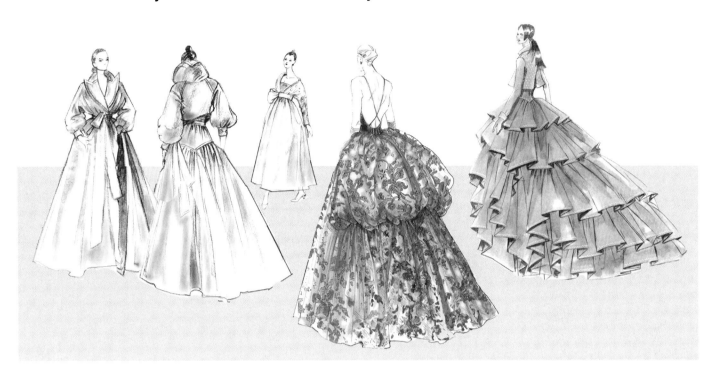

Principle 4: The magic is in the details, no matter how subtle

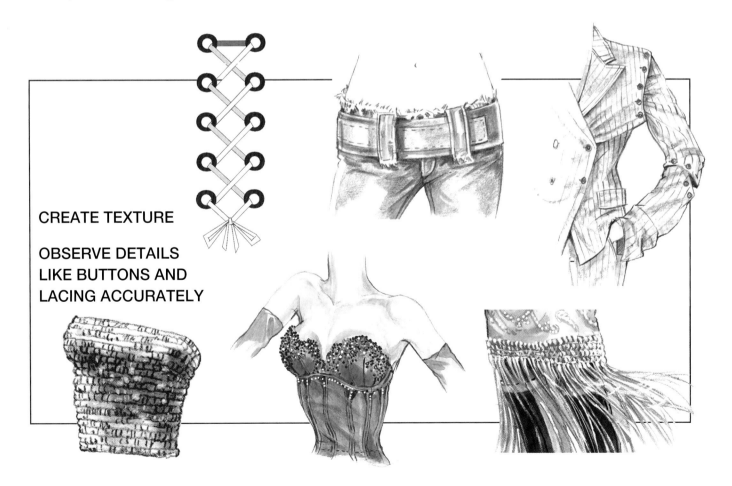

CREATE TEXTURE

OBSERVE DETAILS
LIKE BUTTONS AND
LACING ACCURATELY

STEP TWO: Draw Your Outfits Loosely on Your Figures

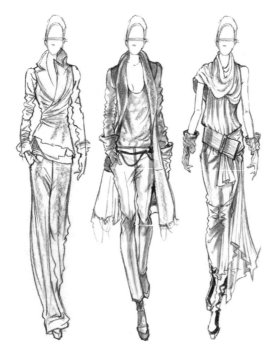

Things to Keep in Mind

1. Use the contours on your figure to ensure that the clothes go around the form. Straight lines will flatten everything out.
2. Draw with tracing paper over your figures. Be prepared to redraw several times to get the right proportion and look.
3. Make sure your clothes look relaxed and are styled as you would want them to be worn.

Designs by Haider Ackermann

STEP THREE: Put Loose Color and Pattern on Your Figures and Check the Balance

Things to Keep in Mind

1. Make sure no one figure completely dominates.
2. Note how the patterns keep your eye moving around the three figures. Don't have all the pattern on just the tops or the bottoms.
3. Do your figures look like they belong together? For example, do you think the figure in the middle is too sporty compared to the other two figures? Or is the dress out of place with the layered outfits?
4. Do your accessories go well together? Perhaps the shoes on the middle figure need to be more tailored.
5. Even for a small group like this one, you need to have a balance of pieces. Would this group work well to mix and match?

NOTE: These figures were rendered in Photoshop. This is a quick way to do a practice rendering.

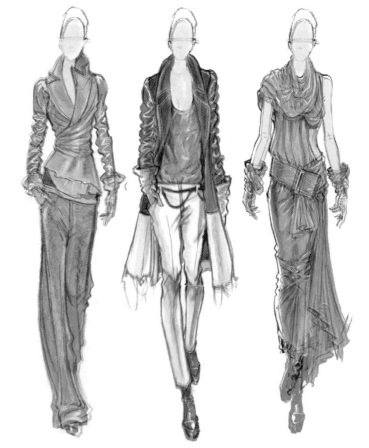

Designs by Haider Ackermann

BALANCING COLOR

Balancing the color in your group is important because it allows your designs to be visually interesting. The use of color placement will help your presentation have a sense of movement and energy. This group combines warm and cool colors.

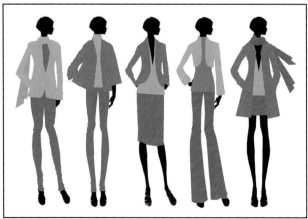

This example with all the bottoms in the same color shows how stagnant and visually boring this approach can be.

STEP FOUR: Make Adjustments to Your Drawings, Adding or Editing Elements as Needed and Changing Poses If Necessary

ADD WRAP

CHANGE SHOES

DESIGN MAKEOVER

Things to Keep in Mind

1. This is the time to make changes, before you start your detailed drawing and rendering. The tendency is to avoid change and to hope it just works out, but it's much more frustrating to have to start over when you have wasted a great deal more time.
2. Remember to put your work up on the wall and live with it for a few hours, or even better, a few days.
3. If you add a garment, no matter how simple, you need to also add a flat to the group.

STEP FIVE: Draw Over Each Outfit, Refining the Line, Silhouettes, and Details

Consider drawing each garment separately so you can scan it. This technique may save you time later.

Final Drawing Checklist

1. Buttons are correct size and evenly spaced. Make sure that you have a realistic number of buttons for the garment.
2. You have added specific topstitching as needed. Don't wait to plan this after you render.
3. You have considered the style of pockets and added them to drawings and flats. Most quality garments have some kind of pocket.
4. Your line quality varies according to the fabrics. Your chiffon should not look the same as your wool, even in the drawing.
5. All your key layers are clearly seen. Do you need to add a second figure with the jacket off?
6. You are happy with all the other elements of your drawings including faces, hair, accessories, and so on.

STEP SIX: Scan Your Final Drawings and Print Them Out Separately or as a Group, Ready to Render

Things to Consider

1. You can render your original drawings, but if you "mess up," you will have to redraw and that takes valuable time. It is more efficient to scan your drawings, arrange them in Photoshop, then print out a few copies just in case.
2. Your rendering will still be "hand-done" if that is desirable. Or you can render the individual figures and scan those. This technique allows you to do your final composition after the figures are rendered, and makes it easier to add backgrounds, text, etc.
3. If you have a larger group, you will probably have to go to a professional to have it printed on large scale paper, or you may have such equipment at school.

STEP SEVEN: Review Principles of Good Rendering

General Thoughts

1. If you have spent enough time on your finished drawing, your rendering should go fairly quickly and smoothly.
2. If you are spending too much time (hours and hours) on one figure, you are possibly overworking it. Take a break and get some perspective.
3. Practicing tough renderings ahead of time can save a lot of frustration when you are doing the "real thing." Make sure you have accurate color renderings as well. If you need specific tools, go buy them.
4. Keep your tools organized. It will save you time and aggravation when you are working under pressure.
5. If you make a mistake on one garment and you want only hand-rendering (no Photoshop), you can rerender and collage that garment in with a good glue that won't peel off later.

Fashion Heads

1. A beautiful outfit will not distract from a poorly drawn or rendered head. If you cannot pull one off (some of us just struggle with fashion heads) try a silhouette figure or adapt a photograph. This can work extremely well and look very current. It's especially great when you have several views of the same head.
2. It does not make sense to render the head last, because if you mess that up, you will probably want to do the whole thing over. We suggest starting with the head.
3. For beautiful detail on your fashion heads, render a larger head and then reduce and add to your figures in Photoshop.
4. Pay attention to what is happening in make-up, especially on the runways. Using current techniques will make your figures look more hip.
5. In a pinch, you can cut out a poorly drawn or rendered head with an exacto knife and paste a new head from behind the page.
6. You can be bold with hair color because that is happening in the salons. But don't let your muse overwhelm your designs with too much color. Choose colors that reflect the outfit.

Fabrics, Color Matching, and Details

1. If your rendering looks boring, revisit your fabrics. You may need to add a strong color accent, or more contrast in texture and/or pattern.
2. Every fabric has its own quality, depending on how it was produced and what fibers make up the mix. Having a little yardage of the fabric you are rendering is helpful and is better than working from a tiny swatch. You can also see how the fabric drapes and catches, reflects, or absorbs light.
3. Remember to use words to define your fabric and keep revisiting them as you render. If a fabric is soft and drapey and your rendering starts to look stiff or heavy, you need to stop and rethink your approach.
4. You can match a lot of subtle fabric colors using neutral markers with Prismapencils in brighter colors. The coat rendering on this page, for example, has a warm gray base in marker with pencil colors added on top. Some blending of the pencils with the marker helps to integrate the various shades.
5. Adding texture with Prismacolor pencils is easy. (Use the side of the tip.) For heavier textures like tweeds, use gouache and pen as well.
6. Note that the leather on the coat, which is smooth and shiny, has only blended color. White gouache adds the shine.
7. For rendering very bright, intense colors you probably need a specific marker that closely matches the color. Too much layering of color doesn't always work and may end up looking muddy.
8. Do not shade bright, cheerful colors with gray. Instead, use a darker version of the same color. You can also add Prismapencil and blend.
9. Adding touches of what we would call Patina colors can really add richness to your renderings. These are the warmer neutrals like bronze, terra cotta, sepia, etc. Note the rust color on the coat.
10. Our favorite tools for pulling out subtle details are white gouache or Bleedproof White, which adds highlights (use a #00 brush), and a black micropen, which can add emphasis to the tiniest elements like buttons and zippers. Don't be satisfied if your important details disappear.

1 2 3

E31 T3 TERRA COTTA PP

WHITE COAT WITH GRAY SHADOWS

Because I wanted my beige coat to stay very neutral in tone, I chose to use gray shadows rather than a darker version of the beige. The Terra Cotta Prismapencil adds some warmth and helps the warm and cool tones to blend.

Basic Rendering, Step by Step

Basic rendering generally follows the same three or four steps.

1. We lay in the *base coat* of our garment. This is generally the color you see when you squint at a fabric swatch to see the essential shade. Because we already have some shadow, and marker is semi-transparent, we can see the shadows coming through.

2. Step 2 is generally the shadow tones, although some artists begin with shadow, which is okay as well. My light source is coming from the right, so approximately one-third of the left side of the coat is shadowed. There are also cast shadows on the right from the sleeve.

3. When the shadows are rendered to your satisfaction, Step 3 involves any finishes you do to emphasize design details or to add texture, distressing, highlights, etc. White gouache enhances the metal snaps and buckles, and Prismapencil adds some texture and contrast.

NOTE: The examples to the left show base coats applied in Photoshop with Color Overlay and Pattern Overlay. Both of these tools are found under Adjustments, a subcategory of Images. Once you apply the layer to your drawing, you can adjust the opacity to effectively show your design details.

COLOR OVERLAY WITH MARKER SHADING **PATTERN OVERLAY**

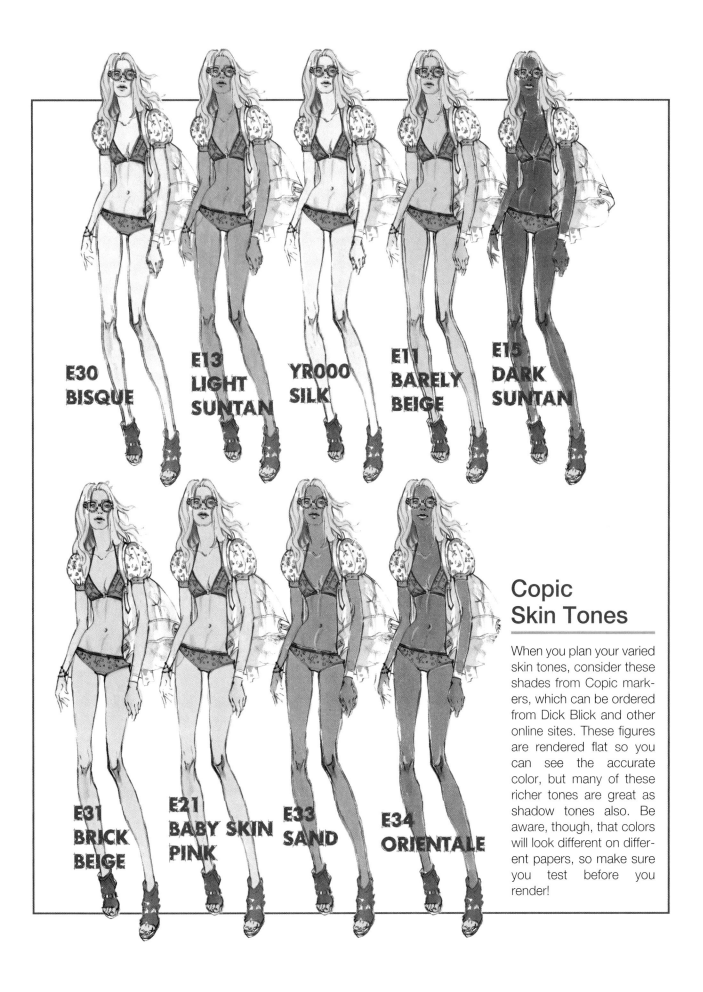

E30
BISQUE

E13
LIGHT
SUNTAN

YR000
SILK

E11
BARELY
BEIGE

E15
DARK
SUNTAN

E31
BRICK
BEIGE

E21
BABY SKIN
PINK

E33
SAND

E34
ORIENTALE

Copic Skin Tones

When you plan your varied skin tones, consider these shades from Copic markers, which can be ordered from Dick Blick and other online sites. These figures are rendered flat so you can see the accurate color, but many of these richer tones are great as shadow tones also. Be aware, though, that colors will look different on different papers, so make sure you test before you render!

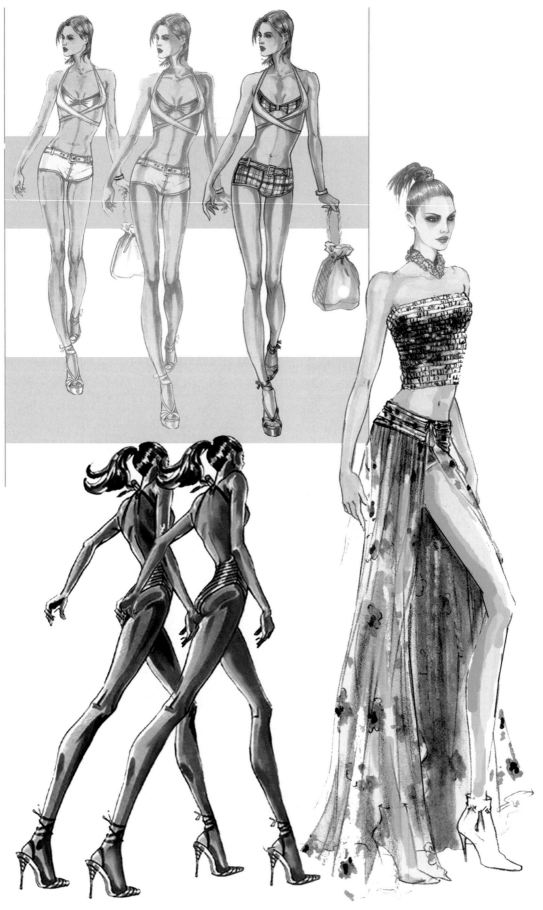

Applying Skin Tones

1. Be methodical.
2. Know your light source direction.
3. Start with a base coat.
4. Choose a compatible shade (or the same shade if you want very subtle contrast) and add soft shadows over about one-third of the figure.
5. Use a darker compatible shade (or blended Prismapencil) to add the darkest shadows in select areas.
6. Try to leave a little light between your skin tone and your contour lines, at least in some spots. This allows your line to stand out on its own.
7. Be bold in your choice of skin tones. Using the same one all the time shows a lack of imagination and/or global perspective. As you can see on these pages, the choices are numerous.
8. If your group is very warm in color, don't use a cool skin tone, and vice versa.
9. The best way to indicate transparency is to have the skin tone show through from underneath.
10. Do not overwork your skin tones, as they will get muddy and leatherlike. Applying them with a Q-tip allows you to lay the tone in quickly. It pays to buy the refills of the colors you use the most anyway.

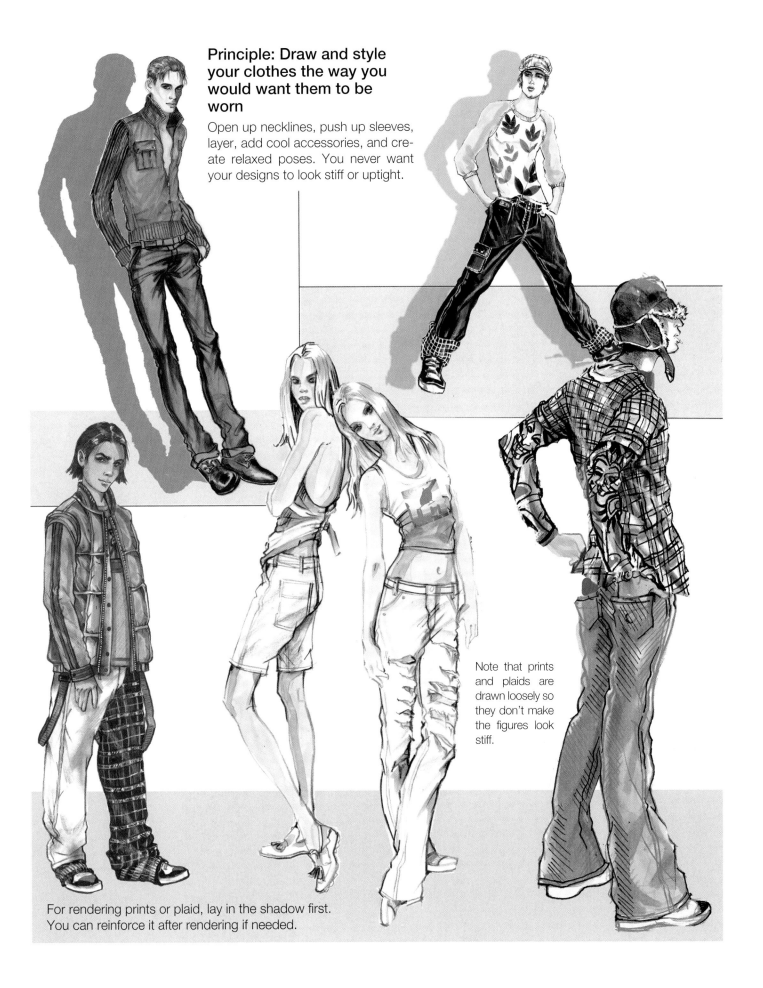

Principle: Draw and style your clothes the way you would want them to be worn

Open up necklines, push up sleeves, layer, add cool accessories, and create relaxed poses. You never want your designs to look stiff or uptight.

Note that prints and plaids are drawn loosely so they don't make the figures look stiff.

For rendering prints or plaid, lay in the shadow first. You can reinforce it after rendering if needed.

Fall Textures

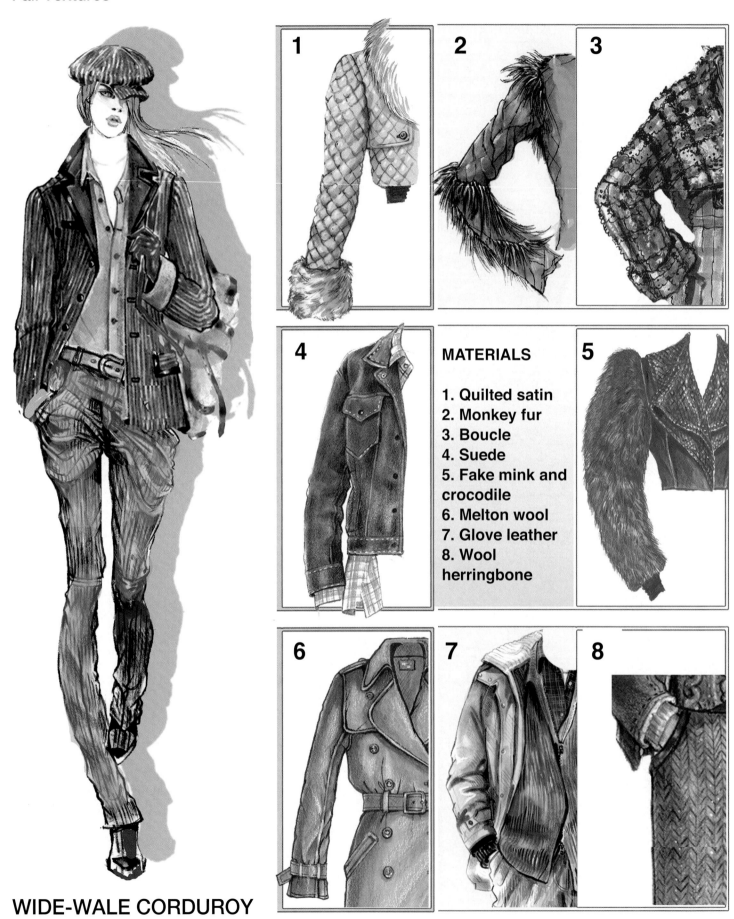

MATERIALS

1. Quilted satin
2. Monkey fur
3. Boucle
4. Suede
5. Fake mink and crocodile
6. Melton wool
7. Glove leather
8. Wool herringbone

WIDE-WALE CORDUROY

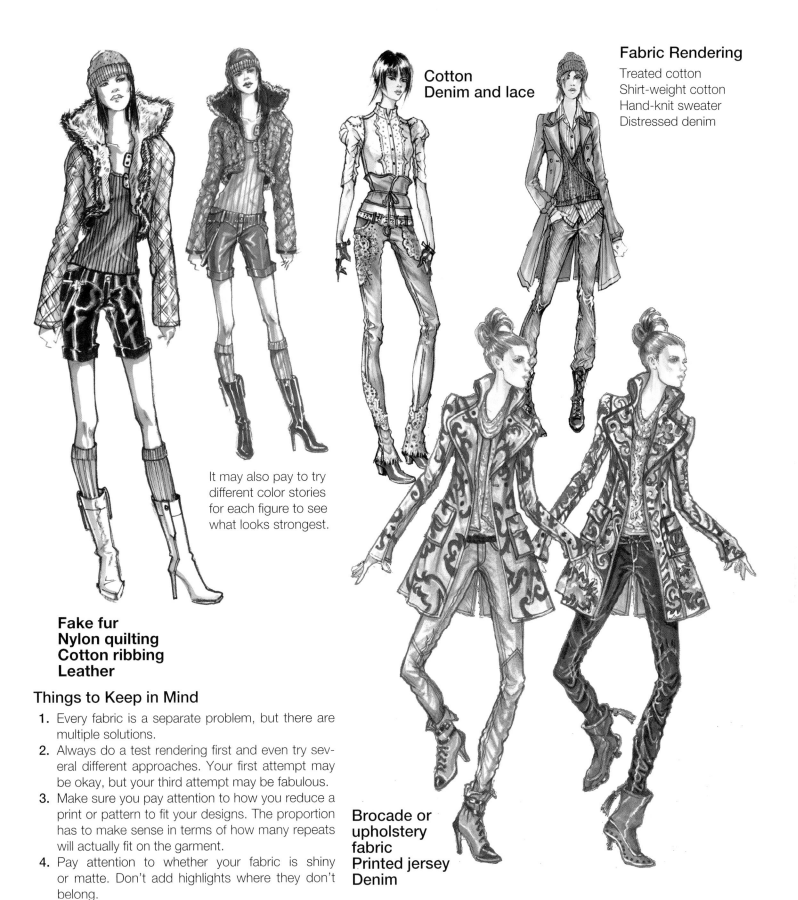

**Cotton
Denim and lace**

Fabric Rendering

Treated cotton
Shirt-weight cotton
Hand-knit sweater
Distressed denim

It may also pay to try
different color stories
for each figure to see
what looks strongest.

**Fake fur
Nylon quilting
Cotton ribbing
Leather**

Things to Keep in Mind

1. Every fabric is a separate problem, but there are
 multiple solutions.
2. Always do a test rendering first and even try sev-
 eral different approaches. Your first attempt may
 be okay, but your third attempt may be fabulous.
3. Make sure you pay attention to how you reduce a
 print or pattern to fit your designs. The proportion
 has to make sense in terms of how many repeats
 will actually fit on the garment.
4. Pay attention to whether your fabric is shiny
 or matte. Don't add highlights where they don't
 belong.
5. Be specific about fabrics. They are your bread and
 butter, and you need to show you know what you
 are doing.

**Brocade or
upholstery
fabric
Printed jersey
Denim**

Rendering Eveningwear

1. As with other types of garments, spend your time making the drawing correct. Don't leave any details in an abstract form. Know where your drape is coming from and how it should hang based on the fabric used. Ideally, you can buy a half yard or so and drape it so you can see exactly how it hangs.
2. Dimension is created through strong lights and darks. Knowing where the light will hit (based on a consistent light source) and where you'll have shadow will produce convincing drapes and folds.
3. The three metallic-looking dresses (Example 1) were rendered with normal markers. Metallic markers should be used only on small details.
4. Note that the shiny area follows the princess line of a garment. I have a primary shine on one side and a secondary, more subtle shine on the other.

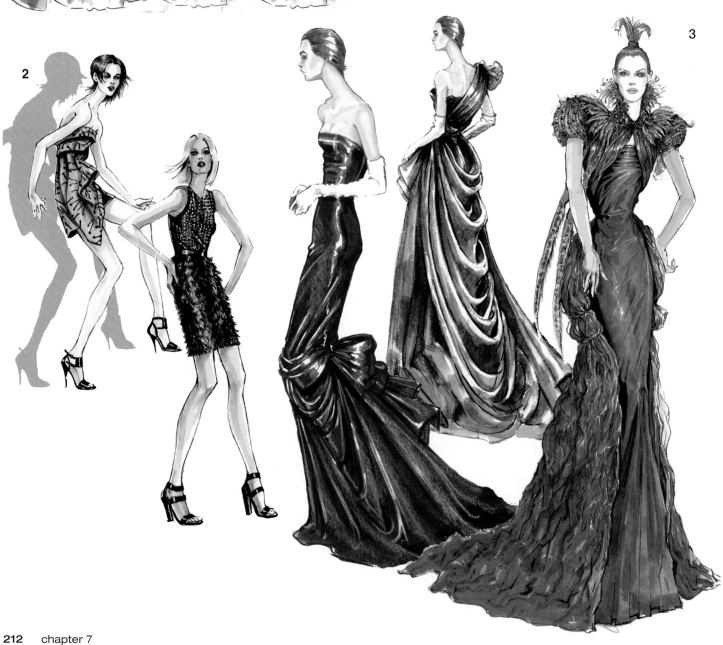

Review Principles of Good Rendering

It can be helpful to look at rendered figures and analyze what makes them work or not work. Be observant, and if you like something figure out why.

Feathers can go in different directions. They may also cross over each other.

Tweed has a lot of texture. Exaggerate it a bit so your viewer does not miss it.

Fur is hair. It goes in one direction.

Note how the shadow on the stockings makes the coat seem more dimensional.

Casual shoes and brightly colored tights make the clothes look less serious and younger.

Exaggerate fun details like beading so they don't get lost.

The skirt's lace pattern is drawn loosely, but the flowers do sit on diagonals.

Leave a highlight to separate the sides from the top of the shoe.

Integrate your colors throughout the sketch. Note how the colors of the clothes are reflected in the hair.

Note the balance of warm and cool colors and the contrast of textures with flat tones.

If you are designing sophisticated clothing, use a neutral rather than an overly peachy skin tone.

The trousers are lightweight wool. Because the fabric is flat or has only a subtle nap, the lights and shadows are not that strong. Using Prismapencil on its side adds a soft texture.

Use shadows to define the curve of the leg inside the full trouser.

CREATING DIMENSION

You can see from these examples how adding light with white Prismapencils and gouache and shadows with marker and pencil can create a very convincing sense of dimension. This is especially important in Fall renderings of heavier fabrics and knits.

STEP EIGHT: Render Your Entire Group

As we have mentioned, you have several choices in this step:

1. **Labor intensive:** You can trace all your figures onto one page and render. If you are very confident, this is a fine way to go, and your group will be entirely hand-rendered.
2. **Cover your bases:** You can scan your finished composition into Photoshop and print out several copies with a wide-scale printer on your chosen paper. This allows you to do a practice rendering, and be secure in the knowledge that if you need to start over, you at least have your drawing ready to go. You can also arrange your figures in Photoshop if you desire.
3. **Cover your bases 2:** You can print out each figure separately and render it. It's easy to reprint until you are satisfied. Then scan your figures, arrange in Photoshop, and print. You can still add touches of handwork afterwards.
4. **All Photoshop:** Some of you may be good enough in Photoshop to do your final rendering using your computer only. After you print out your group, you can always add a few touches of handwork, which will increase the depth and help to pull out any less obvious details.

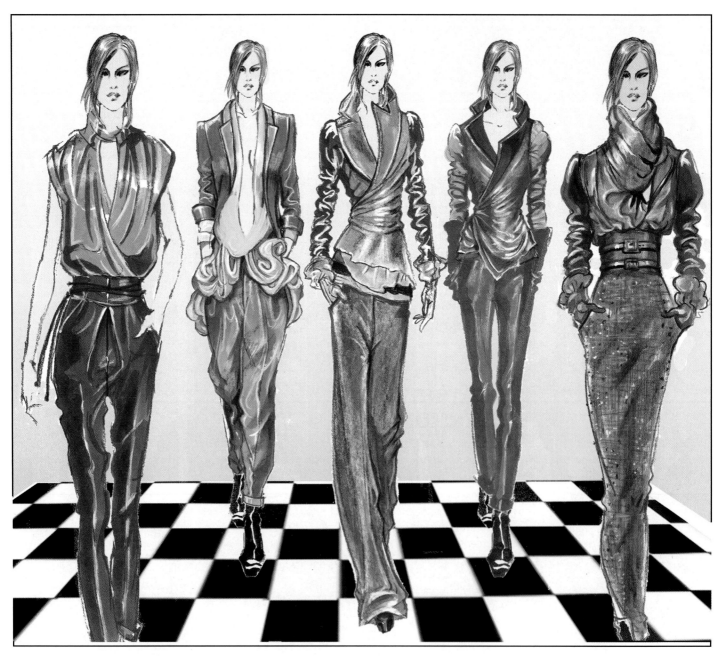

Haider Ackermann Designs for Fall 2011

This outfit was sketched from Haider Ackermann's inspiring 2011 Fall Collection.

1. **Descriptive Words:** *Dramatic, sophisticated, moody, serious,* and *edgy.*
2. **Muse:** Contemporary. The muse cannot be overly feminine or junior.
3. **Pose:** The clothes are quite complex, so the pose should be relatively simple. Walking poses generally support a dramatic mood.
4. Turning the collar up adds to the drama.
5. This collection is about the contrast of subtle textures. Each layer must have its own quality.
6. The leather of the sleeves is very shiny, so the light and dark contrast is fairly extreme.
7. The bodice has a muted shine. The white was added first with Prismapencil, then touches of white gouache were added.
8. The trouser is in panne silk velvet, so it has texture and sheen. Using the side of your Prismapencil over the marker adds soft texture. Note that using several subtle but compatible colors adds an iridescence to the rendering.
9. Be careful with strong colors. Many sophisticated garments have a strong gray undertone.

STEP ONE:
Review principles for good fashion drawing.

STEP TWO:
Do a loose sketch of your designs on the chosen figures.

STEP THREE:
Render your designs loosely, showing color, texture, and pattern.

STEP FOUR:
Analyze the group for balance of color and composition.

STEP FIVE:
Make any needed corrections, and refine your drawing.

STEP SIX:
Scan your drawings and print to render.

STEP SEVEN:
Review good principles for rendering.

STEP EIGHT:
Render your outfits, making sure that details do not get lost.

Couture: Haider Ackermann

STEP NINE: Complete Your Flats in Correct Proportion to the Garments

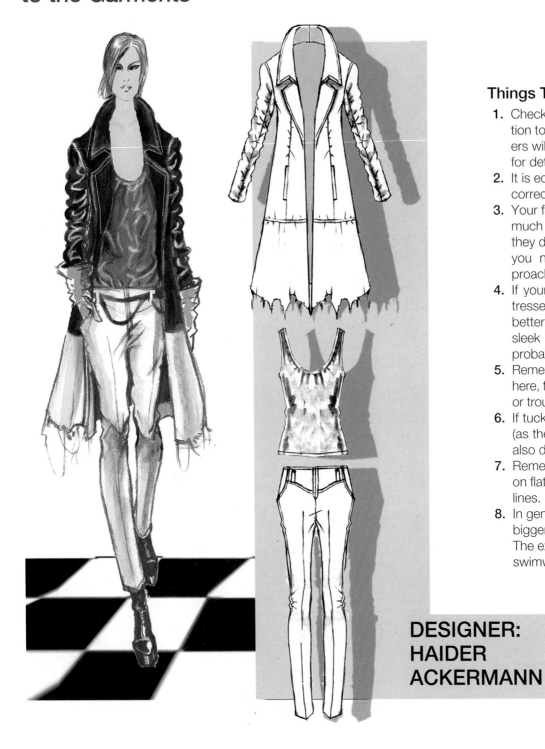

DESIGNER: HAIDER ACKERMANN

Things To Keep in Mind

1. Check and recheck flat-to-figure proportion to make sure it is consistent. Employers will notice if you have an accurate eye for detail.
2. It is equally important that your flats are in correct proportion to each other.
3. Your flats need to sell your clothes just as much or more than your illustrations. If they don't convey the mood of the group, you need to rethink how you are approaching them.
4. If your group is very organic and/or distressed, a hand-drawn style might suit better. On the other hand, if they are more sleek or high-tech, Illustrator flats are probably a better choice.
5. Remember to "stack" your flats as shown here, from the top layer to the bottom layer or trouser.
6. If tucks or folds are built into the garment (as they are in this coat sleeve), you must also draw them on the flat.
7. Remember that your outside contour line on flats should be stronger than the inside lines.
8. In general you will not make your flats any bigger than the garment on the figure. The exceptions to this could be lingerie or swimwear and infant and childrenswear.

STEP TEN: Put Your Work Up and Live with It for a Few Days

CHAPTER SUMMARY

If you have followed the steps in this chapter carefully, your designs should be sparkling and beautiful, due to your careful and accurate rendering. The first impression of each group should be clear and easy to understand, and fit well with all your supporting materials. By putting the work up for a few days after it's finished, you give your critical self the opportunity to see any flaws or confusing elements. Don't overcorrect; if you have time later, you can always rerender, but wait until the end if possible to stay on schedule.

Rendering Review

1. Solve all your problems and clarify in the drawing stage, not with rendering.
2. Have a consistent light source.

3. If you have any rendering problems, some of these can be solved in Photoshop, or you can cut out the offending element with a mat knife, rerender, and collage the new garment into place. You can also attach a clean piece of paper to the back of your rendering, which will show through where you made the cut, and rerender on that.
4. In a more complex sportswear outfit, try to render some garments more loosely and some very precisely. If they are all too much one way or the other, your outfit will either look stiff or chaotic.
5. Add highlights with gouache or gel pens to buttons, edges of collars, stitching details, belt buckles, tucks, edges of french seams, tops of pockets, and so on. This is of course especially true for shiny garments. You can also use a white Prismapencil if you want a more subtle highlight.

TASK LIST

1. Review basic principles of drawing clothing. Don't allow yourself to fall into bad habits that have developed over time. Start fresh with a new viewpoint.
2. Start with loose drawings of your garments, so you can do them quickly and move on to practice rendering. You will probably get a better look if you start more loosely as well.
3. Render your outfits loosely as you think you will want to place the fabrics. It is much better to see the whole group this way than to spend time doing detailed rendering and realize later you have to redo. Make sure you have balance of color, fabric usage, details, accessories, and so on.
4. Once you are happy with your fabric placement, go back and check details to make sure your ideas are consistent with the fabric choices.
5. Polish your drawings until you are completely satisfied with the look, the line quality, the fit, and the proportions. This is the stage that calls for real patience to get everything right. If you don't, it will probably cost you much more time later.
6. At this point, we recommend scanning your drawings. Even if you want to do a completely hand-rendered group, you still can print out your drawings for practice rendering. This will save you a lot of time. Even better, scan your figures and place your garments on them in Photoshop. You can also add tiny prints, complex plaids, and so on.
7. Review principles of rendering. It might also be helpful to watch some of the rendering demos (by Kathryn Hagen and others) on YouTube before you start. So many resources are available to inspire and instruct you! Pay special attention to your skin tone choices. Don't just use the same one for everything.
8. Now you render! Take your time, but don't overwork.
9. Complete and polish your flats. Remember that there is a whole reference chapter on flats and figures. (See Chapter 8.)
10. We hope you are now in the habit of putting up your work and allowing yourself to look at it for several days. You'll be amazed at how different it may look when you get some "distance."

Chapter 8
Garment and Technical Flats

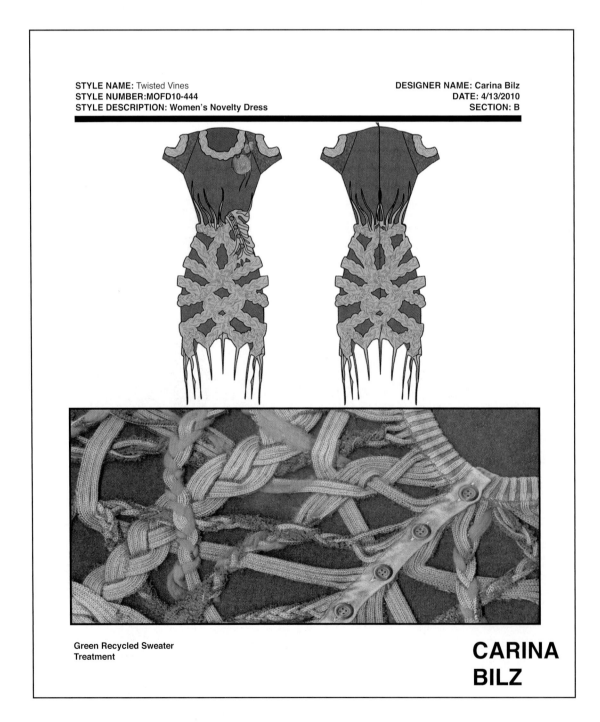

STYLE NAME: Twisted Vines
STYLE NUMBER:MOFD10-444
STYLE DESCRIPTION: Women's Novelty Dress

DESIGNER NAME: Carina Bilz
DATE: 4/13/2010
SECTION: B

Green Recycled Sweater
Treatment

CARINA BILZ

Introduction

We have already related to you the importance of flats to a designer and certainly to the companies they serve. This chapter will help you to realize the many ways you can create flats and also to understand the multiple uses they have in the industry. Depicting the content of your designs (and other designers' ideas as well) through flats is probably the second most important skill you will acquire. (Good design process is the first.) As an entry-level designer, you will almost certainly be expected to draw flats in Illustrator and also by hand, at least when the occasion demands it. So if you are still insecure about the quality of your flats, now is the time to resolve that issue.

TEN STEPS TO GREAT GARMENT AND TECHNICAL FLATS

1. Collect Figure Templates in Proportion to Your Groups
2. Collect Garment Templates in the Silhouettes of Your Groups
3. Practice Your Hand-Drawn Flats
4. Add Dimension to Your Hand-Drawn Flats
5. Practice Basic Illustrator Flats
6. Create a Collection in Illustrator Flats
7. Compare Figure and Flat Proportions
8. Consider Different Layouts for Flats
9. Create Tech Packs for Your Portfolio
10. Look at Professional Line Sheets and Lookbooks

Designer Nurit Yeshurun created these beautiful hand-drawn flats for her job as Menswear Designer for John Varvatos in New York. Note how technically precise and yet artistic they are, and how Nurit uses her wonderful figures to enhance the presentation. You can see she knows how to make full use of the fact that she is a very accomplished artist as well as a talented designer.

STEP ONE: Collect Figure Templates in Proportion to Your Groups

In the next few pages we have provided a set of what we consider good basic flat proportions. Of course, "good proportions" vary from student to student, designer to designer, and company to company. If you need different proportions, you can adapt these basic templates by stretching or shortening them in Photoshop. Although we feel that drawing over actual garment templates will save time and provide greater accuracy, there are those who excel at drawing flats just using these figures. But this illustration shows what is perhaps the best use of these figures: stacking your finished flats on the figure to see if the proportions work well together.

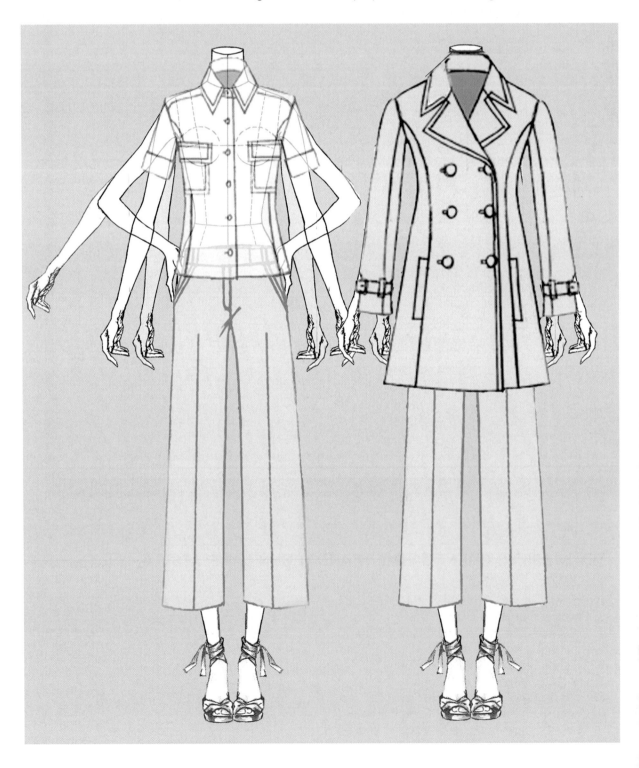

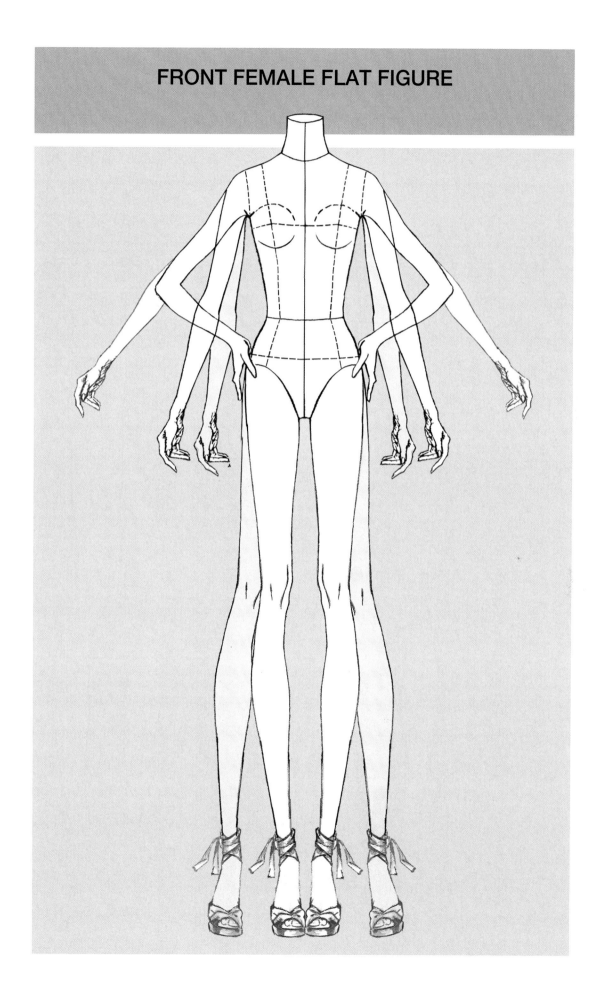

FEMALE BACK AND SIDE FLAT FIGURE

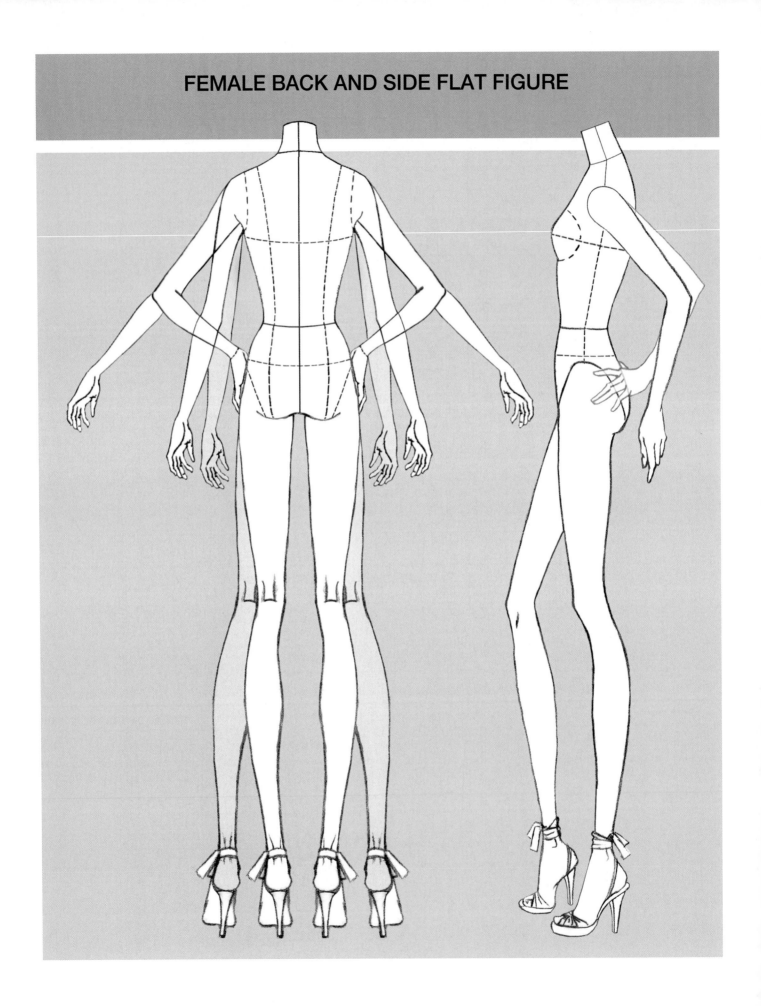

COSTUME/REALISTIC FLAT FIGURE

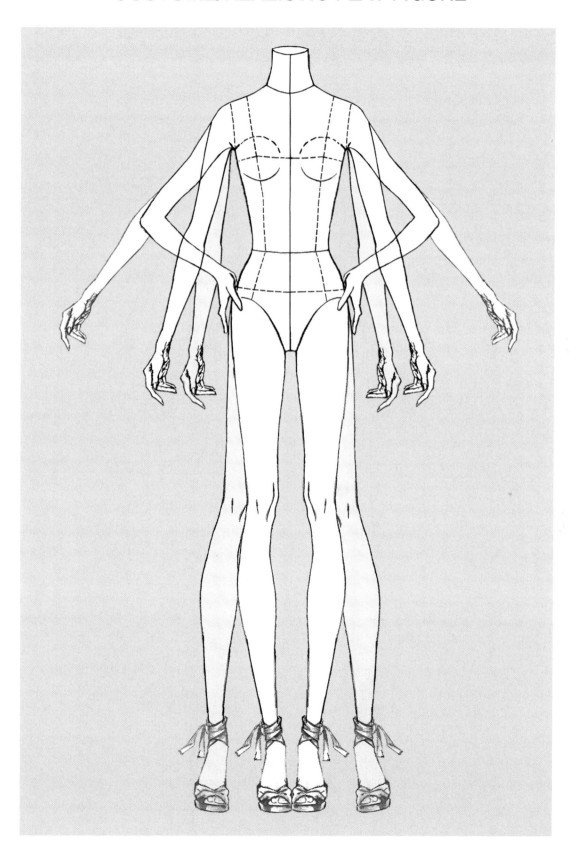

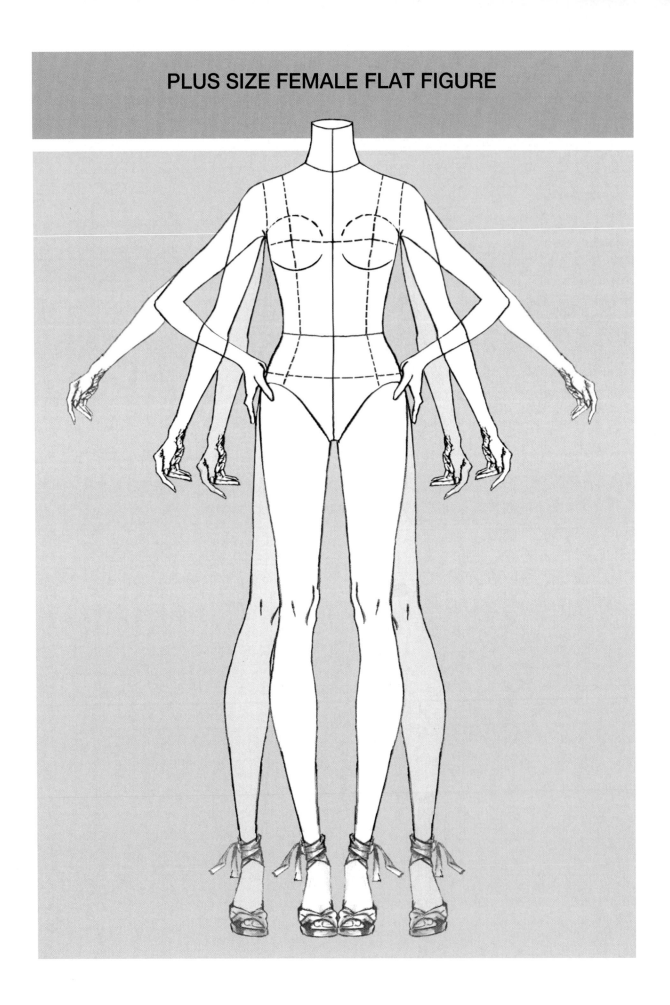

EVENINGWEAR TEMPLATE

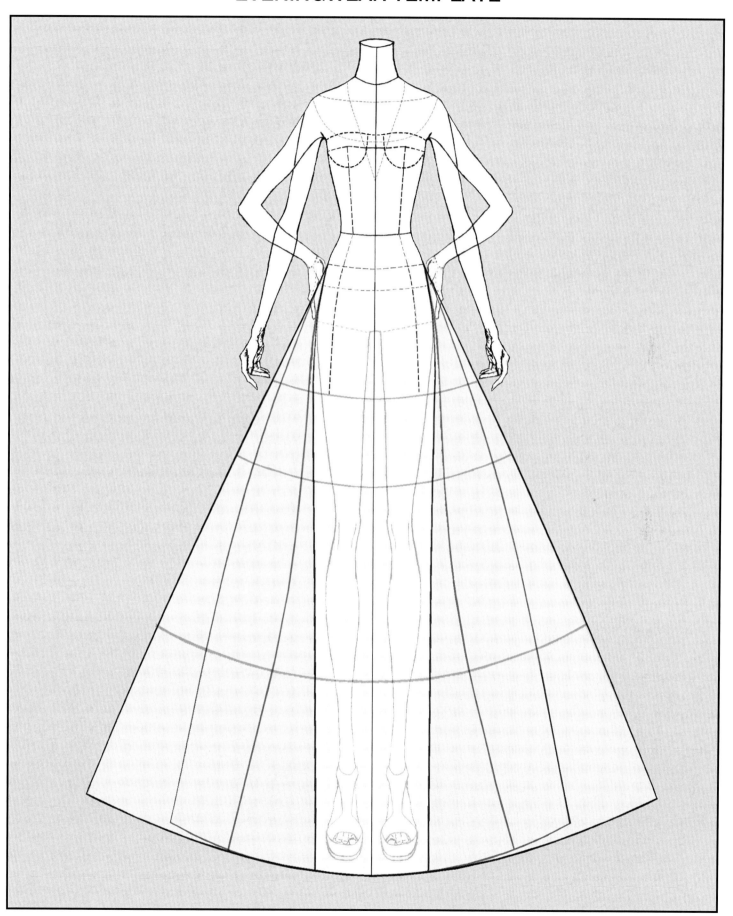

SWIMWEAR FLAT TEMPLATES

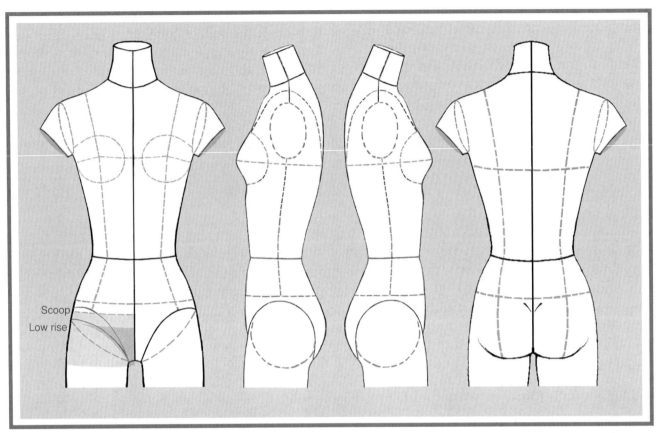

Scoop

Low rise

When designing swimwear, incorporate a variety of leg openings, such as low rise, string, boy short, scoop, and so on.

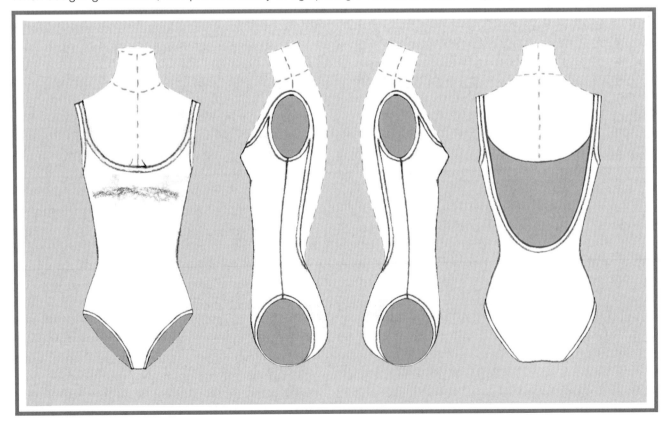

These templates will help you think "around the body" when you are designing swimwear.

LINGERIE FLAT TEMPLATES

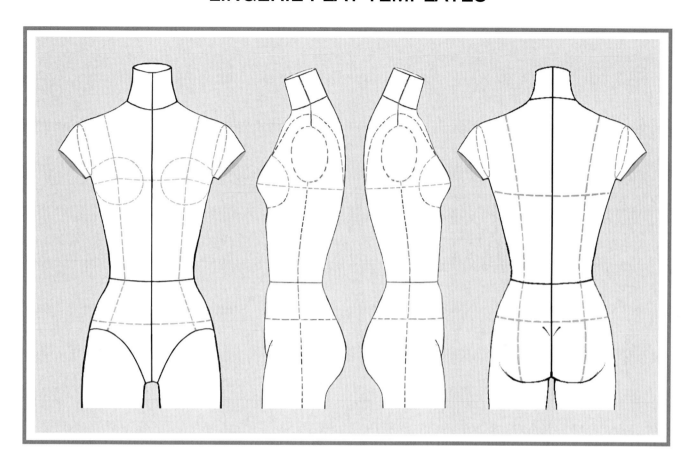

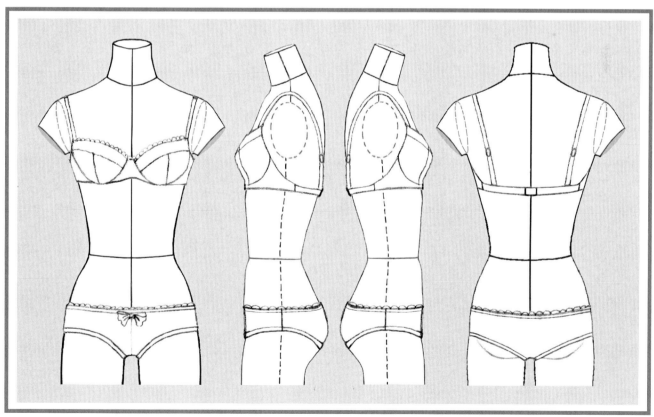

These templates will help you think "around the body" when you are designing lingerie.

PRE-TEEN FLAT FIGURE

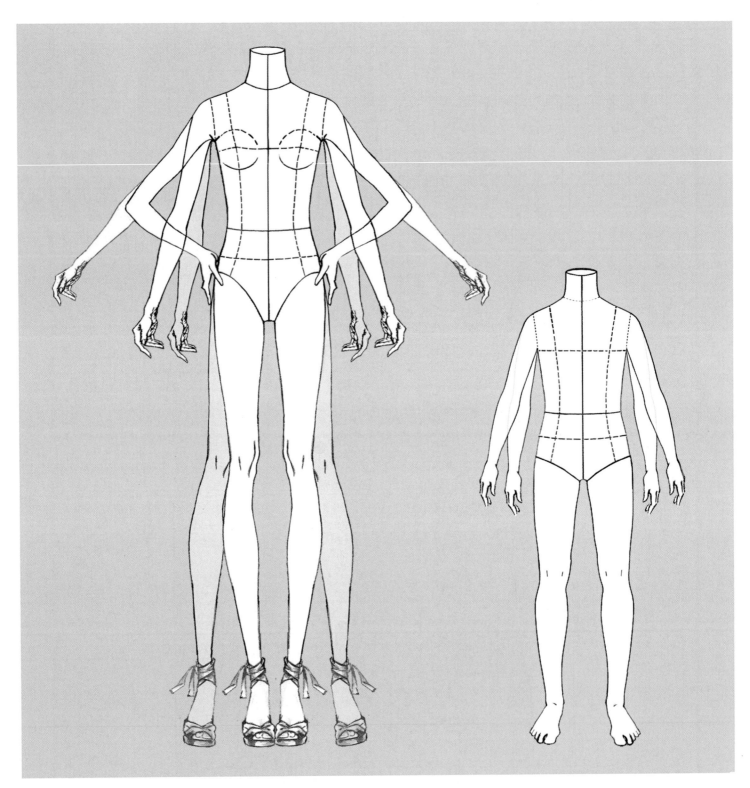

CHILDREN 4–6X

FRONT

REALISTIC MALE FLAT TEMPLATE

FRONT

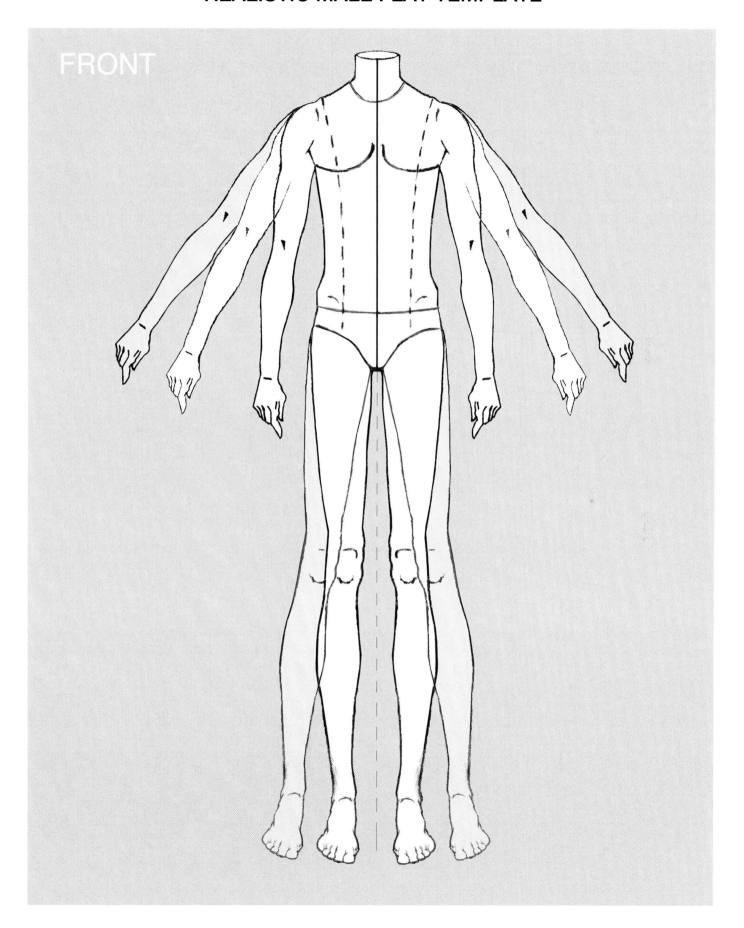

REALISTIC MALE BACK AND SIDE FLAT TEMPLATES

BACK

SIDE

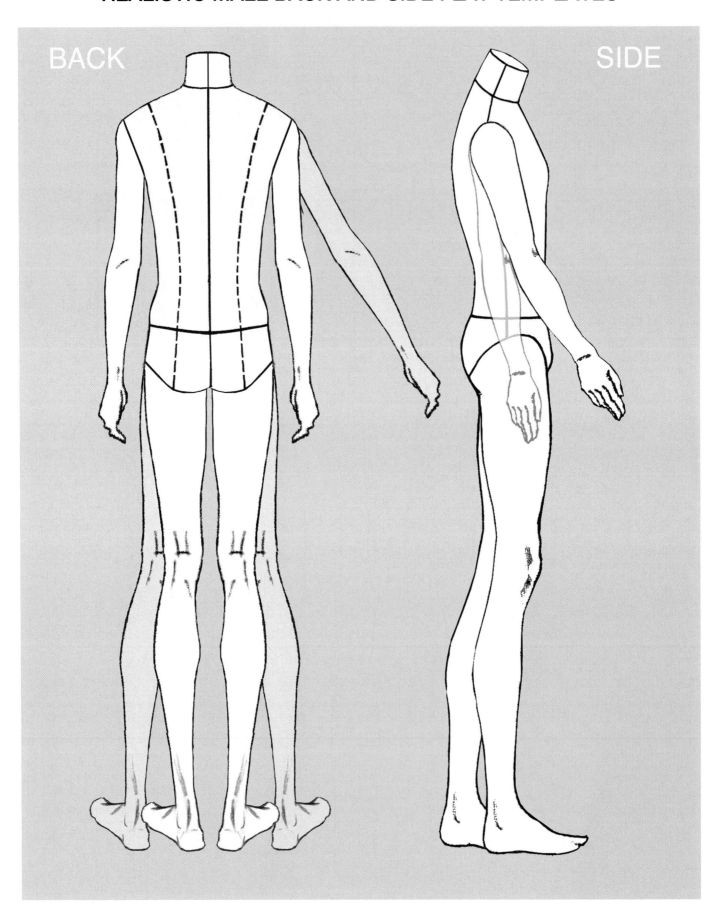

MEN'S SWIMWEAR TEMPLATE

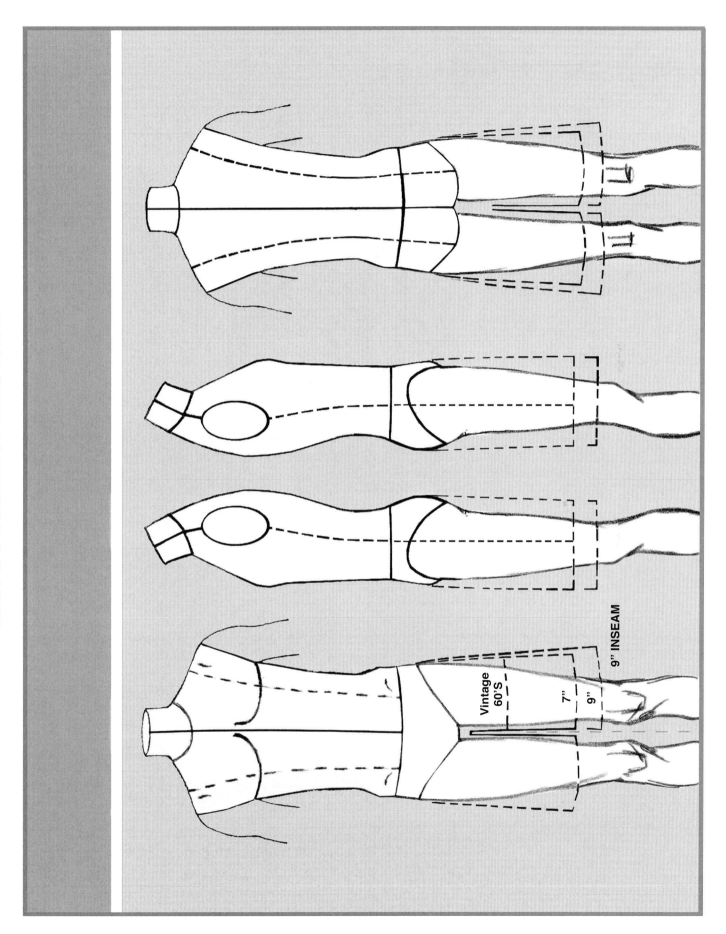

Vintage 60'S

7"

9"

9" INSEAM

STEP TWO: Collect Garment Templates in the Silhouettes of Your Groups

FEMALE FLAT TEMPLATES

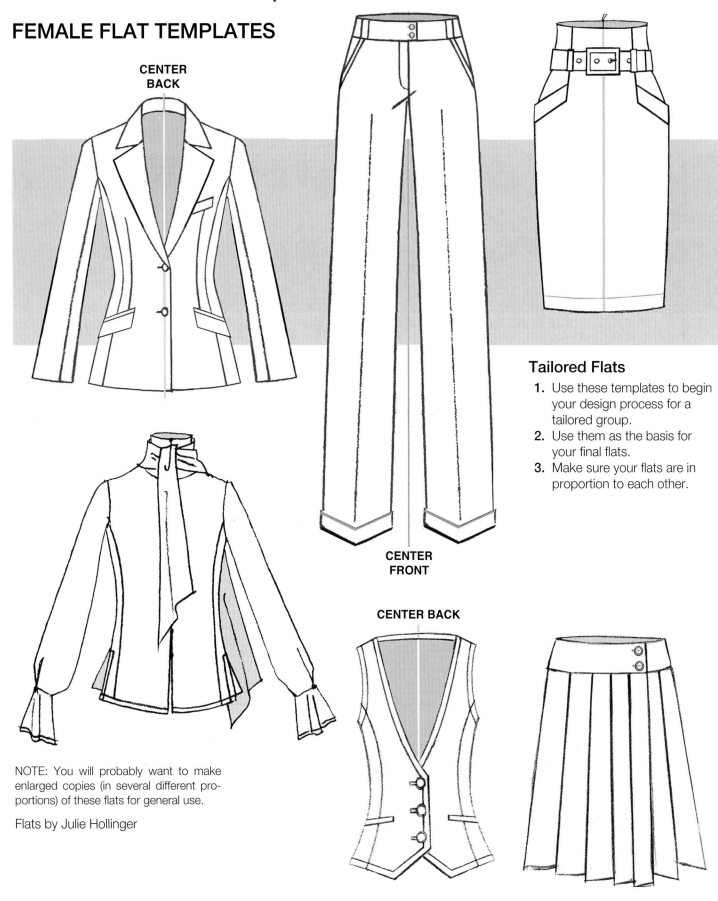

CENTER
BACK

CENTER
FRONT

CENTER BACK

Tailored Flats

1. Use these templates to begin your design process for a tailored group.
2. Use them as the basis for your final flats.
3. Make sure your flats are in proportion to each other.

NOTE: You will probably want to make enlarged copies (in several different proportions) of these flats for general use.

Flats by Julie Hollinger

WOMEN'S FLAT TEMPLATES

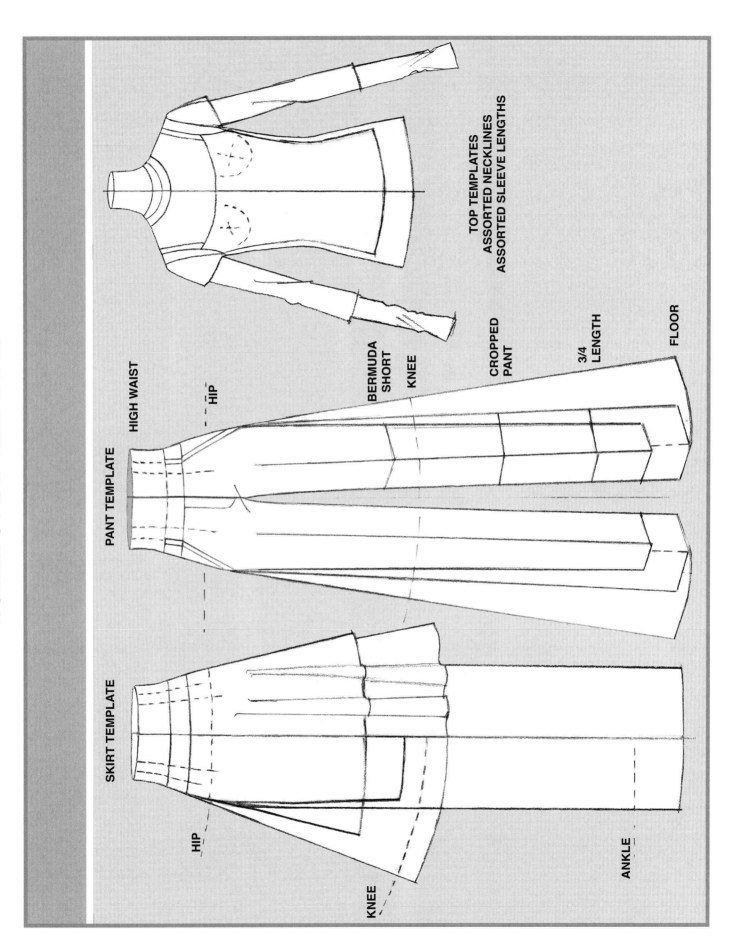

TOP TEMPLATES
ASSORTED NECKLINES
ASSORTED SLEEVE LENGTHS

PANT TEMPLATE

HIGH WAIST

HIP

BERMUDA SHORT

KNEE

CROPPED PANT

3/4 LENGTH

FLOOR

SKIRT TEMPLATE

HIP

KNEE

ANKLE

FEMALE JACKET TEMPLATES

MALE FLAT TEMPLATES

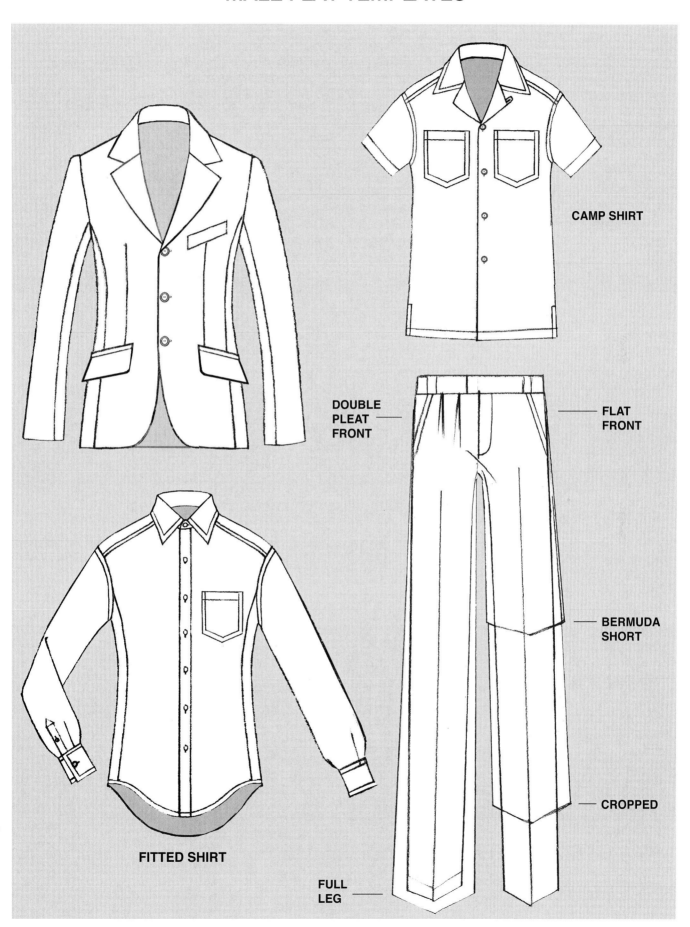

CAMP SHIRT

DOUBLE
PLEAT
FRONT

FLAT
FRONT

BERMUDA
SHORT

CROPPED

FITTED SHIRT

FULL
LEG

STEP THREE: Practice Your Hand-Drawn Flats

Using a garment template is easy and helpful if you are used to drawing flats freehand.

1. Select the template that is closest to what you are drawing from your collection of flat templates.
2. Lay the garment as flat as you can to draw it. Make sure there is no distortion in the way it is laid out.
3. Do a quick visual analysis of how the template is different from the garment you are flatting.
4. Put tracing paper over the template, then rough out one half of the silhouette of the garment. If the garment is very simple, or you are quite experienced, you can probably skip this step.
5. Use another tracing paper to draw a more precise flat, making sure your outside contour line is the strongest line. All the interior lines should be lighter and more delicate.
6. Compare all the sizes of sleeve to hem, width of cuff to hem, and so on. Once you are happy with your flat, fold your tracing paper in half and trace the other side. Perfect your flat and add any texture or color to achieve the effect you want.

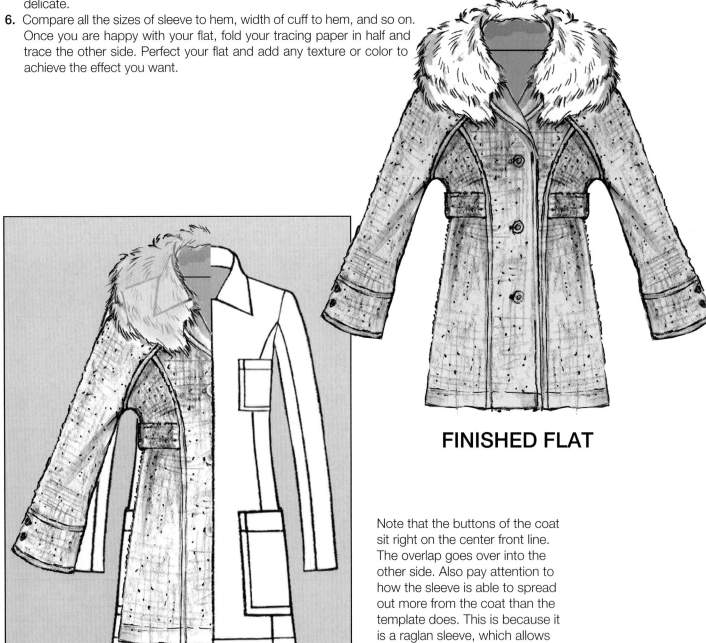

FINISHED FLAT

USING A GARMENT TEMPLATE

Note that the buttons of the coat sit right on the center front line. The overlap goes over into the other side. Also pay attention to how the sleeve is able to spread out more from the coat than the template does. This is because it is a raglan sleeve, which allows more ease under the arm.

WASHED GARMENT FLATS

Learning to create flats that look as though they have been washed and/or distressed can help you give your book more personality and also make it look more current. In order to learn this technique, the best exercise is to draw a flat from a garment that has these characteristics. You will see all the little extra touches that create this effect. Elaborately rendered flats work especially well if you want to do a group just with flats. This makes them into little art pieces, and is easy to do with markers, Prismapencils, and touches of white gouache.

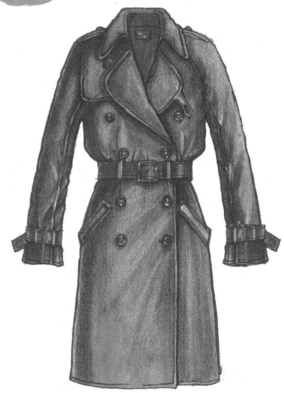

Original trenchcoat flat by Michelle Lucas.

RENDERED FLATS

STEP FOUR: Add Dimension to Your Hand-Drawn Flats

You can add dimension to your flats in a number of ways. For a detail like the quilting in our first example, dimension is really vital to understanding the look of the garment. Of course, not all flats need to be rendered this way, but you want to be able to add those extra touches when it suits your group. As for what we could call 3-D flats like the men's activewear garments shown below, these really serve double duty as both flats and also showing how the garment would look on the figure. You can create templates like these for any group and show the whole thing in this "three-dimensional" format.

ADDING PATTERN IN PHOTOSHOP

Laying plaid over our quilted vest and turning down the opacity allows the drawing to show through. The same thing can be done with markers, as they also are semitransparent.

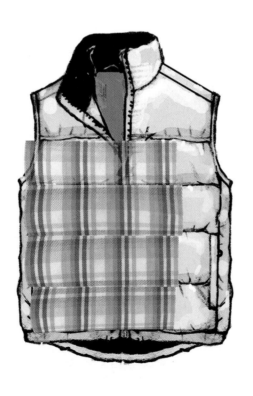

By placing each of the sections of plaid separately and using the Warp tool under Edit/Transform, we can manipulate the plaid to curve with the form of the quilting. It is easy to get duplicate plaid "pieces" by using the *Copy* and *Paste* tools under *Edit*. You can create the same effect by hand, of course, if you are skilled at rendering plaids.

STEP FIVE: Practice Basic Illustrator Flats

Begin with a very simple project like this T-shirt. Being able to add rows of topstitching to flats with such precision is one of the best features of computer-aided design. The template figures are from Sandra Burke's book *Fashion Computing*.

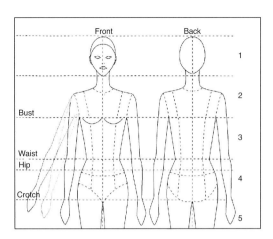

Once you have completed your flat in Illustrator, you can Save it to your desktop and open it in Photoshop. It is easy then to go to Fill under Edit and select the Custom option. You can use the program's pattern library or add your own scanned patterns.

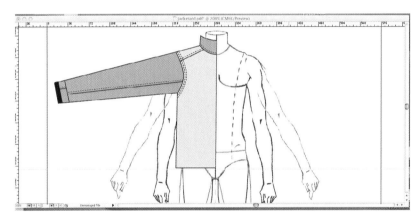

We scanned our own male figure template to act as a basis for this outerwear flat.

If you have not done Illustrator flats before, you will want to take a class or at least get a good book on the subject to help you get started. Sandra Burke has written a book called *Fashion Computing* (Burke Publishing) that we have found quite helpful. It provides a step-by-step method with projects that start out very basic and build to greater complexity as you improve your skills. The book also includes templates of figures that you can scan and use as proportion guides as you work. There is also an e-book titled *Adobe Illustrator for the Fashion Industry* that you can download at a reasonable price.

Go to http://www.designersnexus.com/free-fashion-flats/flat-fashion-sketch for free Illustrator flat downloads. You can build your template collection with these, though the jacket silhouettes are a little strange. They also offer a library of details that could be very helpful. Also www.youtube.com/watch?v=hcVJ5ylipYs and *FashionHustler.com* offer various tutorials on creating Illustrator flats. You can also find tutorials on our website at www.pearsoned.com/hagen. There are many other resources you can find with the click of a button on the Web. Check it out. Once you get started in Illustrator, you will find it's a lot of fun and the results can really enhance your portfolio and make you look like a pro.

STEP SIX: Create a Collection in Illustrator Flats

Designer Lynn Quan shows us how to create an exciting menswear collection of rendered Illustrator flats that showcase both her design and technical skills. As you can see, she scanned in her patterns and placed them on the garments in the correct proportion. All the garments are consistent in their proportions as well. Balancing some color with neutrals makes this a very saleable little group.

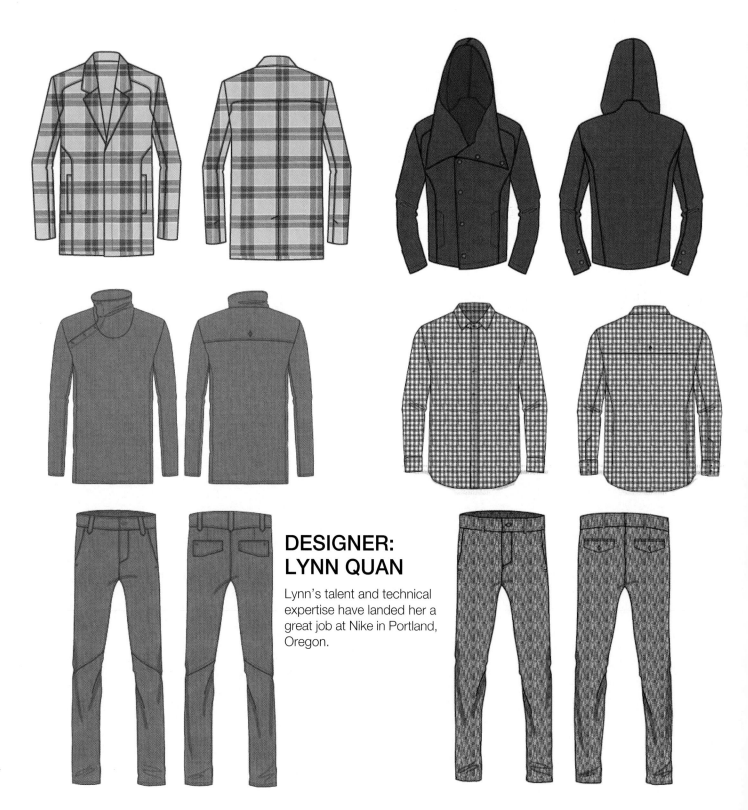

DESIGNER: LYNN QUAN

Lynn's talent and technical expertise have landed her a great job at Nike in Portland, Oregon.

STEP SEVEN: Compare Figure and Flat Proportions

Many students do a great job in getting their flats all in proportion to each other, but when they put the flats next to the outfit on the figure the proportions no longer match. Keep in mind that the flats in your portfolio do not have to be "specs"; these completely realistic flats would look strange next to your exaggerated fashion figure. Try to create a proportion that is visually convincing with the figure, but perhaps a bit closer to the truth. Of course, when you are working for a company, their standards may be very different, so stay flexible!

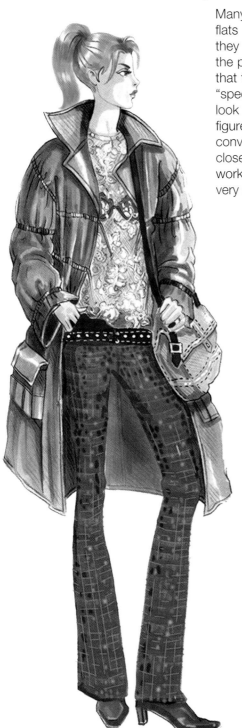

Although these flats look in proportion to each other, the coat is much too short to match the proportion on the figure.

WRONG

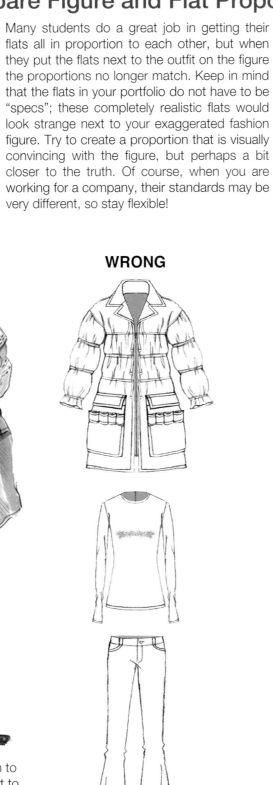

RIGHT

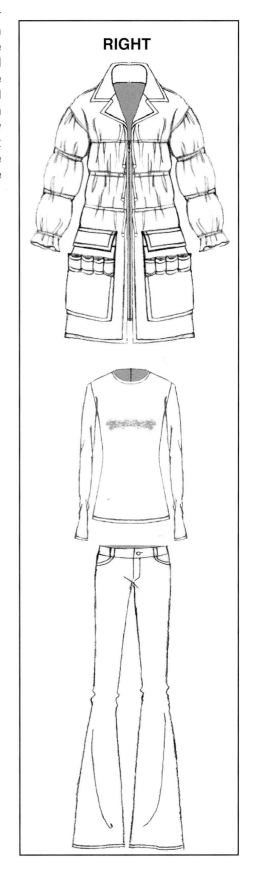

STEP EIGHT: Consider Different Layouts for Flats

If you are doing flats for a dress group like designer Courtney Chiang's, your job is fairly easy. Most viewers can visually connect flat to figure quite easily. On the other hand, if you are creating a complex separates group like designer Renata Marchand's (below) you need to arrange your flats very carefully to maintain maximum clarity. As we have said, stacking the flats as they would be worn from top to bottom is critical. But the strong graphic presentation with light flats against a pattern background is visually striking, and the strong graphic elements just add to the fun!

DESIGNER: COURTNEY CHIANG

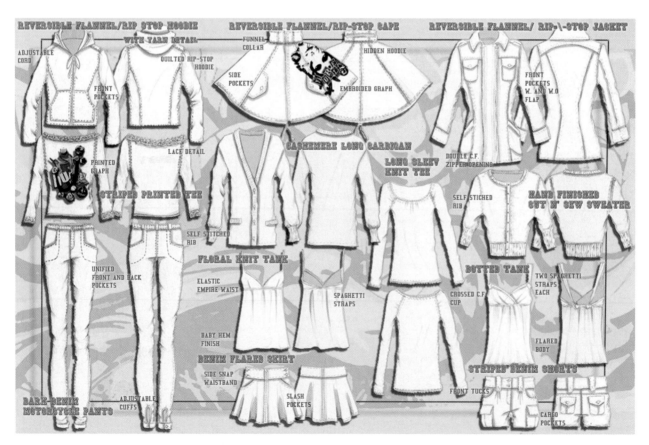

DESIGNER: RENATA MARCHAND

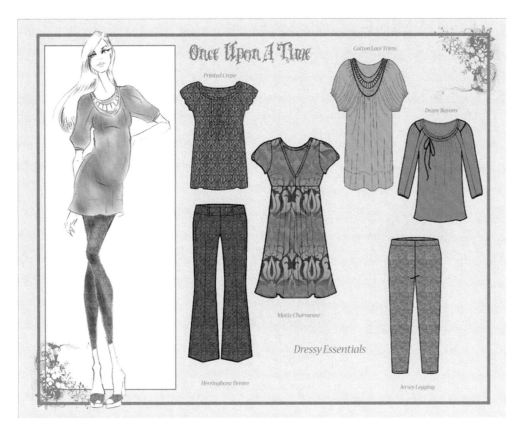

DESIGNER: SELINA EUGENIO

Designer Selina Eugenio has created a charming maternity group that is also a "time saver," as she shows only one figure with a collection of rendered flats. Her flats are so clear and clean, it is easy for the viewer to imagine them on the figure.

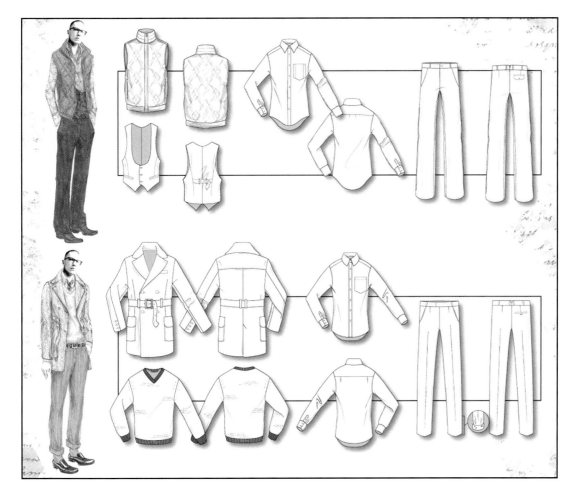

DESIGNER: SUMMER SPANTON

Designer Summer Spanton makes good use of her charming figures to remind the viewer which flats belong to which outfit. She has also arranged them horizontally instead of vertically and it works because it is still very clear.

STEP NINE: Create Tech Packs for Your Portfolio

Understanding how to create great tech packs can be an excellent entry to a job. Designer Summer Spanton displays her skill as a Technical Assistant Designer. Also check out http://www.youtube.com/watch?v=JJCXsOYWAvI for a detailed tutorial on tech packs on YouTube.

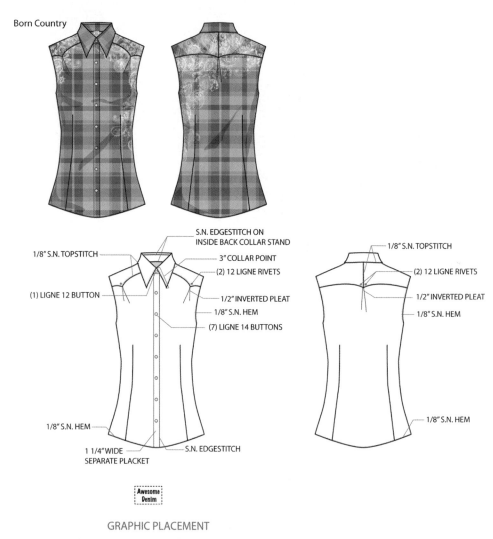

Born Country

S.N. EDGESTITCH ON INSIDE BACK COLLAR STAND

1/8" S.N. TOPSTITCH

3" COLLAR POINT

(2) 12 LIGNE RIVETS

(1) LIGNE 12 BUTTON

1/2" INVERTED PLEAT

1/8" S.N. HEM

(7) LIGNE 14 BUTTONS

1/8" S.N. HEM

1 1/4" WIDE SEPARATE PLACKET

S.N. EDGESTITCH

1/8" S.N. TOPSTITCH

(2) 12 LIGNE RIVETS

1/2" INVERTED PLEAT

1/8" S.N. HEM

1/8" S.N. HEM

Awesome Denim

GRAPHIC PLACEMENT

DISCHARGE FOLLOWED BY WHITE WATER-BASED S.P.

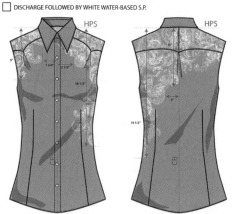

HPS

HPS

SEE "BORN COUNTRY" ARTWORK FILE FOR ACTUAL SIZE ART

Tech pack by Summer Stanton.

Men's Shirting Designer Danh Tran

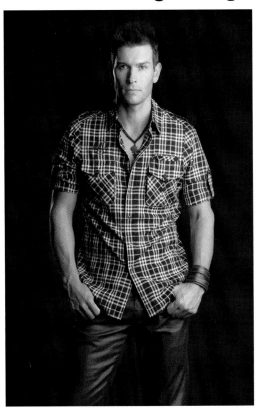

Photos of the finished product on a model can go into a lookbook or it can be used for sales on the company website.

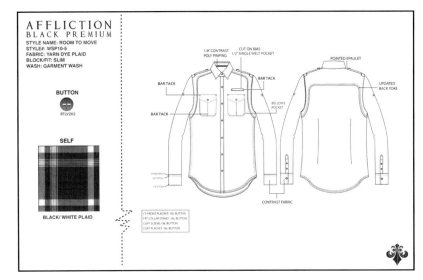

TECH PACK

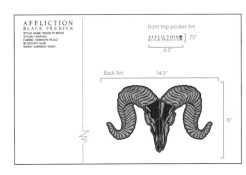

The full tech pack of this cutting-edge men's shirt by designer Danh Tran is shown, which includes the line flat, the flat with fabric added, the button style, trim details (including the very specific added notes), a technical layout of the graphic, and a photo showing the finished sample (with sleeves rolled) on a model.

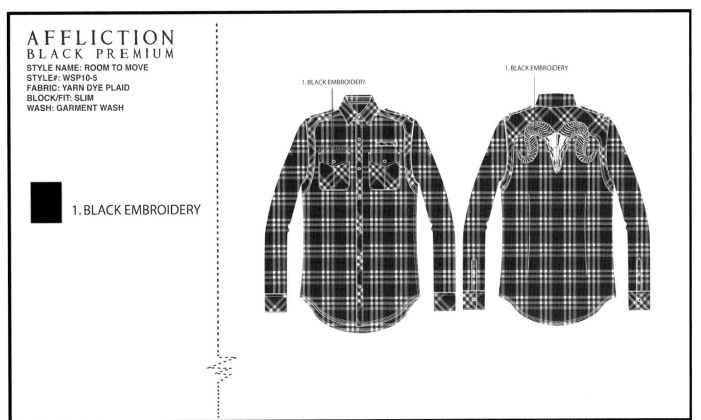

AFFLICTION
BLACK PREMIUM

STYLE NAME: ROOM TO MOVE
STYLE#: WSP10-5
FABRIC: YARN DYE PLAID
BLOCK/FIT: SLIM
WASH: GARMENT WASH

1. BLACK EMBROIDERY

Complex Tech Packs for Overseas Samples

DATE: 8/28/11 BODY: CE21 DESCRIPTION: Short-sleeve T BODY FABRIC: 100% Cotton FINISH: Wash none THREAD COLOR: BLACK	SIZE L STYLE # SIZE XL STYLE # SIZE XXL STYLE #	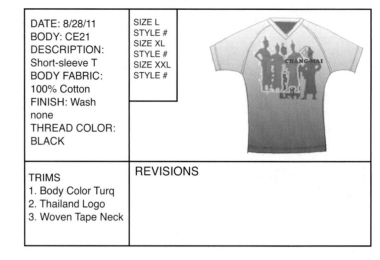
TRIMS 1. Body Color Gray 2. Thailand Logo 3. Woven Tape Neck	REVISIONS NOTE: This space is used if the sample comes back and needs corrections. You hope you don't have to use it!	

1. FIRST COLORWAY

DATE: 8/28/11 BODY: CE21 DESCRIPTION: Short-sleeve T BODY FABRIC: 100% Cotton FINISH: Wash none THREAD COLOR: BLACK	SIZE L STYLE # SIZE XL STYLE # SIZE XXL STYLE #	
TRIMS 1. Body Color Turq 2. Thailand Logo 3. Woven Tape Neck	REVISIONS	

2. SECOND COLORWAY

12"

10"

CHANG-MAI

3. SIZE OF GRAPHIC

8"

14"

CF BETWEEN TWO RIGHT HAND FIGURES

CHANG-MAI

4. PLACEMENT OF GRAPHIC MEASURED

3/4" RIB, 1/4" OVERLOCK

1" HEM

1" HEM

5. DETAILS OF ALL TRIMS AND STITCHING, F AND B

If you are sending information overseas to have samples made from "scratch," your tech packs will need to be much more detailed than if you were simply buying a basic T-shirt and having it screen-printed. Everything must be spelled out and to exact measurements, because a lot of time and money can be lost if the samples come back with something done incorrectly. The company you work for will probably have specific templates that they use for every garment, but to create your own tech packs for your portfolio you can find templates online or create your own. You simply need to convey to potential employers that you understand the concept and the information that is involved in the tech pack process.

NOTE: If you have a lot of colorways, that will add pages, because each one must be separately documented.

	S	M	L	XL	XXL	XXXL
NECK	8 1/2	8 3/4	8/58	8 7/8	9 1/4	9/5/8
SLEEVE	7 1/4	7 5/8	7 7/8	8 1/4	8 3/8	8 3/4
HEM	1/1/4	1 2/3	1 7/8	2 1/4	2 1/2	2 3/4
SHOULDER	5 1/2	5 2/3	5 7/8	6 1/2	6 3/4	7 1/4

6. SPEC SHEET: EXACT MEASUREMENTS FOR ALL SIZES

THAI INDUSTRIES WOVEN LABEL

SPECIFICATIONS

1 1/2	3 1/4	1 1/4

FOLDED AND TOPSTITCHED

ACTUAL SIZE

7. LABEL INFORMATION

THAI INDUSTRIES PEEL-OFF STICKER HANG TAG

PEEL-OFF #2156

THAI INDUSTRIES

SIZE XL

8. HANG TAG SPECIFICATIONS

BLANK PAGE TO STAPLE FABRIC SWATCHES AND TRIMS.

9. FABRIC SWATCHES

W89

W89

WG40

CG31

CER25

10. PANTONE COLORS

Other items of information you might need to include (and each one could be another segment) are:
1. *Folding method* if your garment will be shipped in a bag.
2. *Care label*.
3. Actual *care instructions*.
4. *Hang-tag placement*.

Thanks to FashionHustler.com for this informative tutorial.

Look at Professional Spec Sheets

The term *spec sheets* is short for specification sheets, which are used in many manufacturing businesses, including construction. Just as you need exact measurements to build a house, a factory in China or India needs your desired measurements and details to construct a sample garment that is exactly what you as the designer want and expect.

Specs are typically used when you are first developing a sample. Once you have sketched the flat of the new design, you can take your measurements from a similar garment and make adjustments based on any differences. These measurements are recorded on the spec sheet that is used to produce the sample, and then to make the pattern and eventually for production purposes, so it's critical that everything is accurate.

Things to Keep in Mind

1. Any details unique to the garment are detailed on its spec sheet.
2. The measurements may be given "on the half" (from one side of the garment to the other), "total" (both front and back measurements added together), or "front and back" (front and back measurements given separately).
3. A spec sheet also includes the season, designer, collection, production number, size, fabric content, and trims.
4. A correct spec sheet ensures a good fit.

Key Measurement Points

1. HPS (High Point Shoulder): The HPS is a key reference point that is meaured at the highest point of the shoulder, where the shoulder seam or natural fold meets the neckline seam. Details such as pockets and yokes are most often placed in relation to this key point.
2. HPB/Top Bra: The "Highest Point of Bra" is used when styles like tank tops or bustiers do not have an HPS.
3. Center Front (CF): The center front is always located at the exact center of a garment, so don't be confused by plackets on double-breasted garments. Regular button placement (as opposed to an asymmetrical style) and zippers are typically located at CF.
4. Center Back (CB): A line that may or may not be a seam running vertically down the center of the back of a garment.

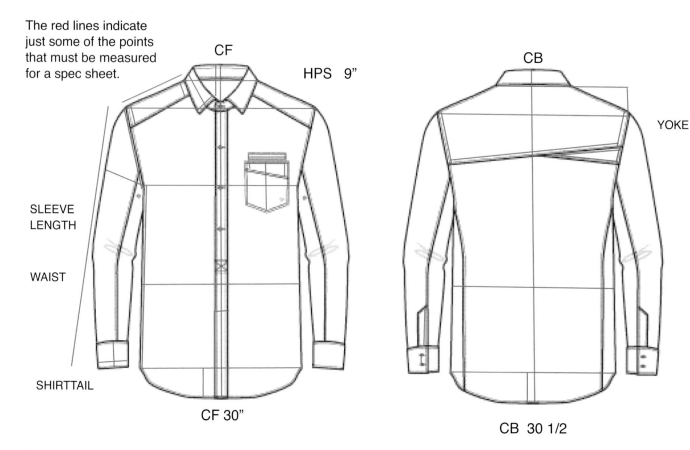

The red lines indicate just some of the points that must be measured for a spec sheet.

CF

HPS 9"

CB

YOKE

SLEEVE LENGTH

WAIST

SHIRTTAIL

CF 30"

CB 30 1/2

Shirt flat by Lynn Quan

Our example shows just a few of the required measurements for a woven top. Others include side seams (SS), body length, across shoulder, shoulder drop, across front, across back, across chest, waist, bottom sweep, shirttail, sleeve length, bicep, sleeve opening, armhole (curved or straight), neck opening, front neck drop, back neck drop, collar stand height, placket width, collar point, collar length, point to point, collar height at CB, cuff height, pocket flap length and width, belt length and width, placket length, and lining length, among others. Anything that needs to be specific must be measured. This may sound like a lot of numbers, but chances are you will be creating a lot of these spec sheets in an entry-level position, and taking these measurements will soon become second nature to you.

Additional Hints

1. Anything not covered in the spec sheet should be explicitly written or illustrated on the flat sketch. You may need to do blow-ups of complex details. Use words, arrows, anything you need to convey the information.
2. Always spread garments out on a smooth, flat surface (not on a hanger or dress form) when measuring them. Make sure there is as little distortion as possible.
3. Button distances should be measured from button center to button center.
4. For areas that are compressed by elastic or smocking, provide both the original measurement and the "compressed measurement."
5. Make sure all your numbers or notes are legible. You can show specific elements in additional copies of your flat sketch.
6. You will need a book on specs or specific templates detailing all the measurements you need for each garment.

MISSY-JUNIOR PANTS TECH PACK

SEASON	Fall 2009	DATE	4/25/09	FABRICATION	Stretch Cotton
STYLE #	PNT-1528	DESIGNER	KR	FABRIC DESIGN	Charcoal Stripe # 235
DESCRIPTION	Low Rise Flare Leg Dress Pants				

SAMPLE REQUEST FORM

MEASUREMENTS	M	1ST FIT	APPRVD SPEC	SKETCH
UPPER WAIST ***	32			
LOWER WAIST ***	34			
UPPER HIP 5" BLW TOP WB AT SEAM ***	39			
LOWER HIP 3" UP FROM CROTCH ***	41			
THIGH (1" BELOW CROTCH ***	25			
KNEE 12" BELOW CROTCH ***	19			
LEG OPENING ***	22			
FRONT RISE	9			
BACK RISE	14			
INSEAM	33			
WAISTBAND HEIGHT	1 1/2			
ZIPPER FLY STITCH (TO TOP WB)	5 3/4			
POCKET LENGTH (BACK)	3/8			
POCKET WIDTH(BACK)	4 3/4			
POCKET PLACEMENT FROM CB	2 1/2			
PCKT PLCMNT FROM TOP WB (BACK)	4			
				HARDWARE & TRIM: 1PC 5 1/2"L DTM BTODY NYLON ZIPPER (FLY) #3; 2PCS GUNMETAL SKIRT HOOKS (SMALL); 1PC DTM BODY 2 HOLE PLASTIC BUTTON 26L; 2 PCS DTM BODY 4 HOLE PLASTIC BUTTONS W/RIM 26L
				COLORS: CHARCOAL GREY STRIPE, BLACK STRIPE, BLACK SOLID; LIGHT GREY SOLID

COMMENTS:	***TOTAL CIRCUMFERENCE MEASUREMENT

NOTE: GRADE SHEETS REMAIN HIDDEN UNTIL FINAL SPECS ARE APPROVED! To unhide, select FORMAT>SHEET>UNHIDE from the top menu and select desired grade sheet.

SAMPLE SPEC SHEET

This is another example of an industry-style spec sheet. This sample is from the e-book *How to Spec a Garment for the Fashion Industry* available at www.designersnexus.com

STEP TEN: Look at Professional Line Sheets and Lookbooks

Gaining an understanding of how flats are used in the industry is a smart move. The more informed you are about the business of fashion, the more employable you will be. Entry-level jobs especially tend to involve a great deal of work with flats. Of course tech packs are one of the main uses for flats, but line sheets are also very important and serve multiple functions.

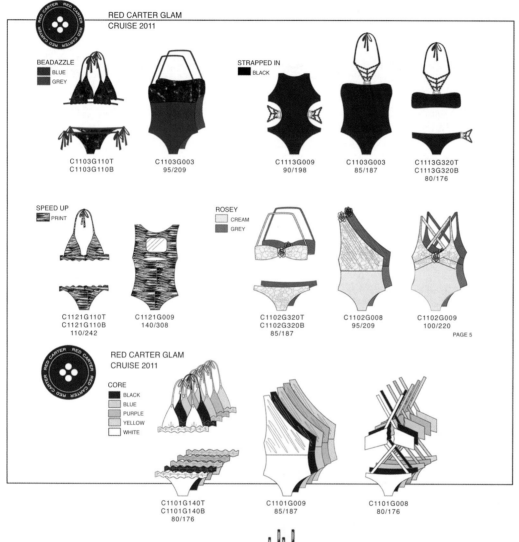

Swimwear designer Red Carter has had a successful swimwear line in Miami for over ten years. His suits are known for their sexy and innovative styles. Read more about Red's star power in Chapter 10.

DESIGNER: RED CARTER LINE SHEETS

These technical flats are used by the designer, the production people, the sales force, and potential buyers to keep track of the seasonal lines.

Lookbooks and Line Sheets

A lookbook is a marketing tool that can include photographs and colored drawings. If you go to websites for companies like BCBG or Anthropologie, they not only have individual styles for you to purchase, but they also show you how to put the clothes together and even discuss or call out trends. This encourages insecure buyers to purchase several pieces so they can duplicate the ready-made "looks."

A line sheet is different. It is an official document of sketches, generally flats, of a particular line for a particular season. Sometimes the flats are just in black and white, but they can also show color, as seen in our Red Carter example on the facing page.

In-house marketing, sales, and production people also use line sheets to keep track of the various styles. Although many designs may get "sampled," the line sheet tells them what actually made it into production.

Line sheets usually have the following essential elements:

1. Styles and style numbers: The styles are almost always in flat form. Occasionally there may be photos. If the back has important details, it should be shown as well. The styles can have both names and numbers, but style numbers are generally easier to remember.
2. Prices: What does each style cost wholesale? You can also include suggested retail prices.
3. Color and fabric information: Show the actual colors, not just names of colors. If you have different colorways you also show this on your line sheet.
4. Season: Indicate the season of the line.
5. Delivery dates and order cutoff dates: When will you start shipping the line and when will you stop?
6. Order minimums: Most companies will have both a minimum order per style and a minimum order overall.
7. Company and/or sales rep contact information: This is handy for all concerned.

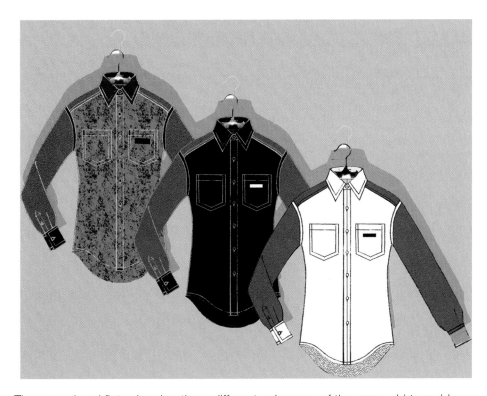

These rendered flats showing three different colorways of the same shirt would work well in a lookbook.

Sales Rep Name		Phone:	212-888-5555 ext 222	Delivery:		**COMPANY NAME**
Company Name		Fax:	212-444-5555	Order By:		
Address 1		Email:	salesrep@company.com	Minimum:		
Address 2		Website:	www.collectionname.com	Sizes:		

COLLECTION NAME				**SEASON: SPRING 2010**		

Sty:	Price:	Sty:	Price:	Sty:	Price:	Sty:	Price:	Sty:	Price:
Description:		Description:		Description:		Description:		Description:	
v									
Fabric:		Fabric:		Fabric:		Fabric:		Fabric:	
Colors:		Colors:		Colors:		Colors:		Colors:	

Sty:	Price:	Sty:	Price:	Sty:	Price:	Sty:	Price:	Sty:	Price:
Description:		Description:		Description:		Description:		Description:	
Fabric:		Fabric:		Fabric:		Fabric:		Fabric:	
Colors:		Colors:		Colors:		Colors:		Colors:	

LINE SHEET TEMPLATE

This line sheet template is borrowed from the e-book *How to Spec a Garment,* which has a lot of good information and illustrations. It can be downloaded instantly from www.designersnexus.com for a modest fee.

Sales Rep Name		Phone:	212-888-5555 ext 222	Delivery:		**KUAI SWIMWEAR**
KUAI SWIMWEAR		Fax:	212-444-5555	Order By:	6/22/12	
782 Los Angeles, LA, CA		Email:	salesrep@company.com	Minimum:	60 pieces	
Address 2		Website:	www.collectionname.com	Sizes:	2-12	

SURF CITY				**SEASON.: HOLIDAY, 2012**		

Sty: B112	Price: 32.50	Sty: B113	Price: 35.50	Sty: B114	Price: 38.50	Sty: B115	Price: 26.50	Sty: B116	Price: 25.50
Description: triangle top		Description:		Description:		Description:		Description:	
v									
Fabric: lycra		Fabric:		Fabric:		Fabric:		Fabric:	
Colors: turq, cherry, lime		Colors:		Colors:		Colors:		Colors:	

Sty: B117	Price: 32.50	Sty: B118	Price: 27.50	Sty: B119	Price: 24.50	Sty: B121	Price: 36.50	Sty: B122	Price: 25.00
Description:		Description:		Description:		Description:		Description:	
Fabric:		Fabric:		Fabric:		Fabric:		Fabric:	
Colors:		Colors:		Colors:		Colors:		Colors:	

CHAPTER SUMMARY

Many students resist the idea of flats in the beginning, because they want to do only what they consider more creative, less technical exercises. But the fact that clothing must work on a body and also that the fashion business is very complex (especially with the global operations of today) means that our "blueprints" are just as important to our industry as an architect's are to him or her. Also, a designer who is not good at things like flats and tech packs may have a tough time finding a job, and those who are skilled at these tasks may become technical designers with job security and a lucrative paycheck. The bottom line is we cannot escape flats, so we must embrace and master them!

The good news is that flats can be beautiful, fun to draw, and also express a designer's ideas with a clarity that a figure may have difficulty matching. If you still feel flat-challenged, we hope that seeing all the different styles and methods for creating flats has stimulated your desire to do them well. If you still struggle, you may want to take an extra course or buy any of several helpful books online. Study the tech pack demonstrations we have mentioned, and consider investing in some templates so you can practice this aspect of your craft with a real-world approach.

TASK LIST

1. Print out the figure templates we provide that are applicable to your portfolio. Consider creating some larger and smaller sizes so you have a variety to choose from when creating your groups.
2. You should have a folder full of garment templates at this point; if you don't, start seeking them out. You do not want to be slowed down by your lack of helpful templates.
3. Evaluate your hand-drawn flats. If they are weak, consult with an instructor as to how you can improve them.
4. Print out some good flats and practice rendering them with a variety of media. It may be helpful to have some real garments to practice rendering the actual fabrics.
5. Evaluate your Illustrator flats. You must be good at this, or you will really hold yourself back in the industry. If you are not up to par, consult an instructor or seek help in online resources.
6. Make sure you have at least one set of good rendered Illustrator flats in your book. This adds variety and is a great skill to have. It is also wise to mix the techniques of using scanned fabrics in Illustrator and rendering with your Photoshop tools.
7. The biggest mistakes students make are not paying close attention to proportions from flat to figure and to just drawing flats in general. These mistakes can cost you your job, so make sure you are realistic about your accuracy in this area and take steps to correct deficiencies.
8. Make sure you do not follow the same formula for all your flat layouts in your book. If you have not planned a variety of approaches, rethink your flats now.

ADDITIONAL EXERCISES

1. If you need to improve your skills, try drawing flats of several garments from your closet by hand and also in Illustrator. Compare the two methods and see if your proportions and skill level match. You can also use these same garments to do a practice tech pack.
2. Research flats, spec sheets, and tech packs online. There is a wealth of good information and inexpensive or free resources that can really inform and add to your key files.
3. Practice doing hand flats with some different media, including Verithin pencils, micropens, and #3 and #5 mechanical pencils. Sometimes a different method or medium can make our work come alive or gain clarity.
4. Check out *CorelDraw* and *Freehand,* which are alternative software programs that may be used in a company you want to work for. If you understand Illustrator, you should find it fairly easy to adapt to these programs as well.
5. Download *Dropbox* or similar sharing programs and practice sharing files with your friends. This is an important skill when you get into the industry.

Chapter 9
Digital Portfolios

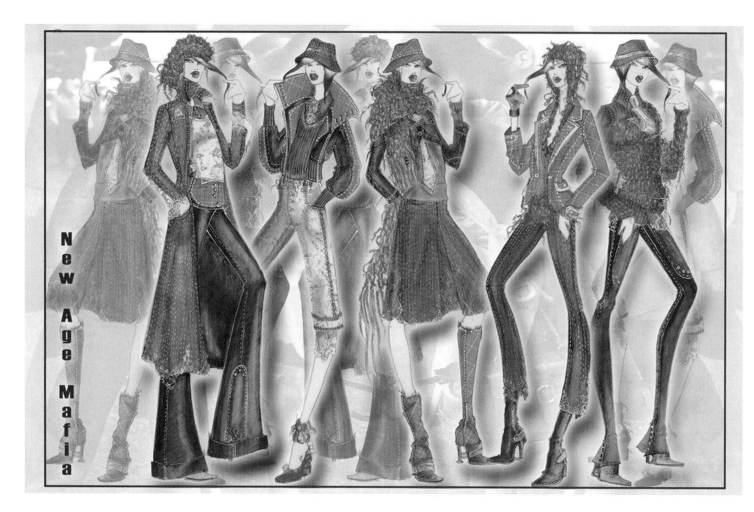

Designer: Selina Eugenio

How can you use digital tools to create amazing Web portfolios and other great materials that will help you get a job?

The wonderful group "New Age Mafia" by designer Selina Eugenio displays Selina's amazing design talent, wonderful illustration skills, and her grasp of complex digital techniques.

Introduction to Digital Portfolios

Because your portfolio is your key marketing tool, you will want to consider all the forms your portfolio can take that may reach different audiences and help potential employers understand all the skills you have acquired. The hard work you put into creating your wonderful groups and amazing flats should be fully exploited, especially as you are competing with people who will no doubt take advantage of all the tools. To avoid being left behind, make sure you understand all your cutting-edge options. The goal of this chapter is to help you explore these tools and the various ways they can be applied to help you "brand" yourself as a designer.

What does this mean? Imagine that when you go on an interview you have not only a great portfolio in hand, but also other materials like an elegant resume and business card that feature your distinctive personal logo. The cover of the DVD displaying your work in a Powerpoint presentation also has your logo and the link to your Web portfolio. Such a consistent, organized presentation shows an employer you are savvy about industry professional practice and that you are not shy about marketing what you have to offer. This is a desirable quality for a designer. It indicates a strong belief in yourself and the will to invest the time and effort to attain your goals.

Computer-Aided Design

Computers bring a vast array of tools to our design process in the fashion industry. Applications include computerized pattern making, page design, Web presentations, and mind-blowing mood images, to name just a few. We trust that, at this point in your education, you are already familiar with the computer and have some knowledge of the key Adobe software programs Photoshop and Illustrator. It is likely you already have decided whether you are essentially a Mac person or lean toward PCs. Both have their pros and cons, so it really is a matter of personal preference and also the depth of your pocketbook. In general, PCs are quite a bit more economical than Macs. Whichever you favor, you are likely to be spending a good deal of time sitting at a computer to do your work creating flats and tech packs, designing treatments and graphics, and so on. Most manufacturers work with overseas factories and they transmit key information digitally, so the designer becomes the conduit through which this information passes. There are companies that are exceptions to this, but they are becoming more and more rare.

As usual, we have broken the chapter down into ten easy steps that you can move through in order, or you can pick and choose the ones that are most relevant to you in the time you have to devote to these cutting-edge professional tools.

TEN EASY STEPS TO DIGITAL SAVVY

1. Explore the advantages of creating a digital portfolio.
2. Study a sample digital portfolio by Alejandra Carrillo-Munoz.
3. Look at options for creating your own website.
4. Explore techniques for creating beautiful mood boards for your digital portfolios.
5. Explore Photoshop strategies, filter techniques, and special effects to enhance your illustrations.
6. Explore techniques to enhance your fabric boards in Photoshop.
7. Explore techniques to create a digital leave-behind CD or DVD and other supporting materials.
8. Consider ways to create beautiful invitations and announcements for your fashion events.
9. Explore various ideas for creating your own logo and other branding elements.
10. Create finished presentations using hand and computer tools.

STEP ONE: Explore the Advantages of Creating a Digital Portfolio

Things to Consider

1. Digital portfolios adapt well to different situations. If you keep your work organized you can easily customize presentations in an amazingly short time. This gives you a big advantage over people who are not so efficient and computer-savvy.

2. There is no right or wrong format for a digital portfolio. You can really make it your own, so long as the work stands out and is easy to read and understand. But know whom you are targeting, and customize with them in mind.

3. CDs and DVDs can be created at a much higher resolution than websites, so details are easy to see. You do need a computer or DVD player to view them, but you don't need the Internet. They are compact and easy to store, so an employer can file a CD until a position opens up.

4. A laptop is a compact way to transport a lot of work, and it does allow you to do more complicated presentations in Powerpoint or other similar formats. However, this is not a common interview tool.

5. An online portfolio is convenient because employers can view it on their own computers at their leisure. If they like what they see, they can invite you for an interview. If they don't, it spares both of you from wasting time.

6. You can actually send a mini sample of your digital work in an e-mail attachment. This is a low-tech way to send individual employers a sample of what you do. But if you don't include a cover letter, it may be interpreted as spam.

7. Websites are by far the most popular digital portfolio medium. A personal site creates an avenue for creative expression, is constantly available, and, through linking, can bring you to the attention of prospective clients or employers that you would be hard-pressed to reach otherwise.

8. The disadvantage of a website is that it does not allow you to adjust your tone, emphasis, and pacing the way you can easily do face-to-face.

9. Although software programs can be extremely user-friendly, there is a specific craft involved in whatever program you use, and it is helpful to be familiar with the technical "rules." Read the instructions before you start.

10. You should be in the habit of scanning all your hand work and keeping everything in organized files along with anything you do digitally. This allows you to send material or examples at the touch of a button. This is important because most technologically savvy people aren't willing to wait.

11. It also pays if you can afford to use the latest software. When you get a job, you don't really want to be struggling to use a newer version of Photoshop or InDesign.

12. Mixing hand work with digital work shows your versatility and creates a book that benefits from the key visual element of *contrast*. If you do your whole book by hand, you may look "behind the times" and generate an impression of a lack of computer knowledge. If your book is all digital, it will probably look a little flat and generate doubt that your drawing and rendering skills are adequate.

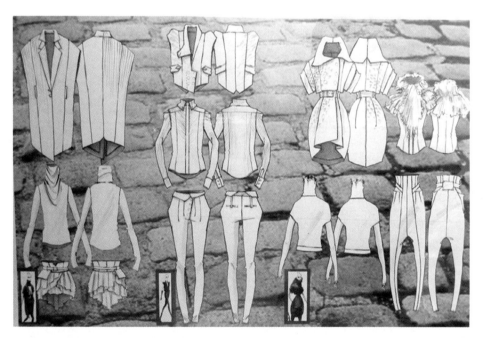

On the following pages you will see the work of Alejandra Carrillo-Munoz, who created a fabulous website for herself using a program called Wix. If you visit her website, you will see it opens up to moving images that create a sense of dynamism, and her graceful figures echo that movement.

Flats for the group "Vie di Firenze" by Alejandra Carrillo-Munoz.

DESIGNER: ALEJANDRA CARRILLO-MUNOZ

STEP TWO: Study a Sample Digital Portfolio

On the next few pages you will see some of the work from the digital portfolio of designer Alejandra Carrillo-Munoz. Alejandra did all the work herself, from finding her choice of host website to putting her work into the format. She photographed all her groups and wrote statements to go with each one. We think she did a beautiful job and thank her for allowing us to show some of her groups in this book. Please view the entire portfolio at http://www.wix.com/acarrillomunoz/portfolio

Designer Statement: Alejandra Carrillo-Munoz

1. I know many people use sites such as Coroflot.com and others, but I really wanted to invest my time in being able to present the work more professionally and that way reflect the effort that had already gone into the portfolio work itself. Also, through the vast benefits of the cyber world, it's easier to get your name out there in the world of fashion when you're just starting to look for a job.

2. I tried different websites (such as Coroflot) but they were very limiting as to the aesthetic choices I had in regards to building the website. I tried Viewbook, and it seemed clean and presentable but it was too complex. I found all of these websites by searching Google for Eportfolio sites. I finally chose Wix.com. My experience was as follows:

 a. I loved that Wix has templates to begin and yet one is able to transform it and develop it in a very specific and personal manner.

 b. Also, it was free, which was great for a recent graduate with no money. :) You have a choice to upgrade and pay but really it is not necessary since the basic services are so great!

 c. The site itself took about three weeks of dedication beginning with photographing my work, which I did because I was lacking an Epson scanner.

 d. In the end I preferred taking my own images because the angles and emphasis on certain images were all under my control.

 e. I had no help on the website so learning it on my own also took time but it was definitely worth it. It was more of a perfecting process.

 f. Also the writing I incorporated took time because I felt that when someone saw my page, not only did I want them to meet my work and my potential but also, through my writing, understand my perspective and my intentions for each group and for my direction in general.

 g. All in all, it was three weeks of really personalizing the page but I can't say it was extremely challenging. It was just an extension of presenting my work and the hard part had already been the portfolio work itself so the website I honestly enjoyed creating.

Designer: Alejandra Carrillo-Munoz

Alejandra created her Web portfolio so that she can direct potential employers to see her beautiful work at their leisure. Alejandra also includes statements about her work that help to give a feeling of who she is and what she cares about. It's a perfect showcase for a passionate young designer!

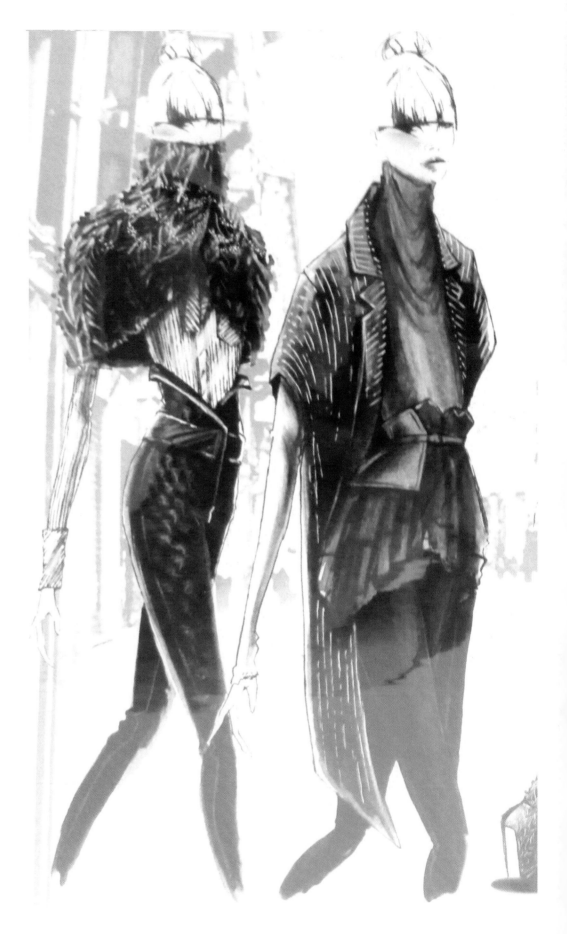

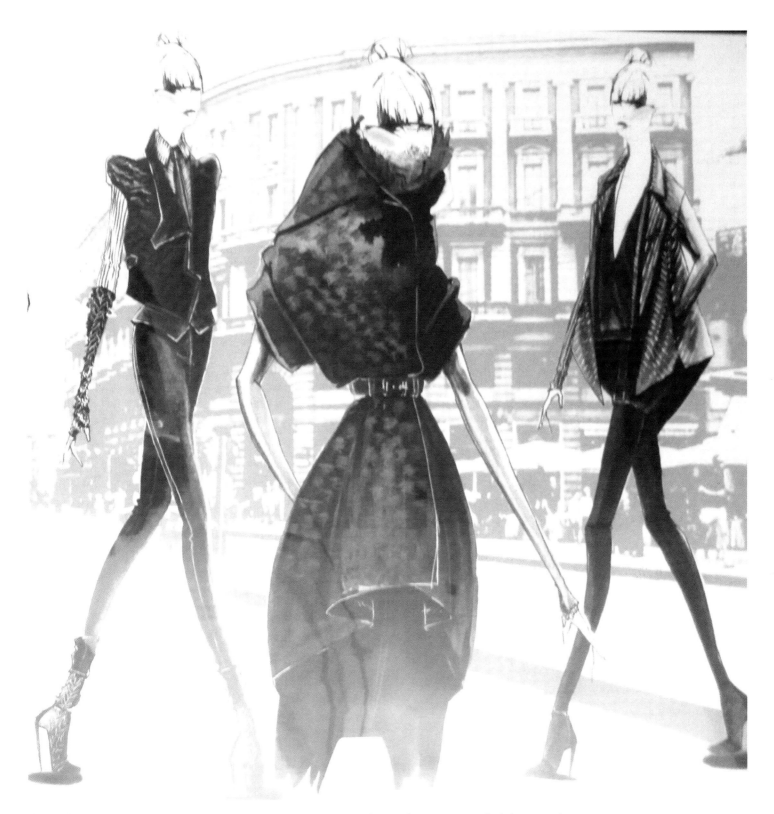

Notice how the sense of the figures moving through space adds to the great mood of the group!

FABRICS

Alejandra's fabric treatments give these swatches a sense of history. They also look quite industrial and ephemeral, as though they are disintegrating before our eyes. The figures are simple and straightforward, yet they feel contemporary with a Postmodern mood.
Designer: Alejandra Carrillo-Munoz

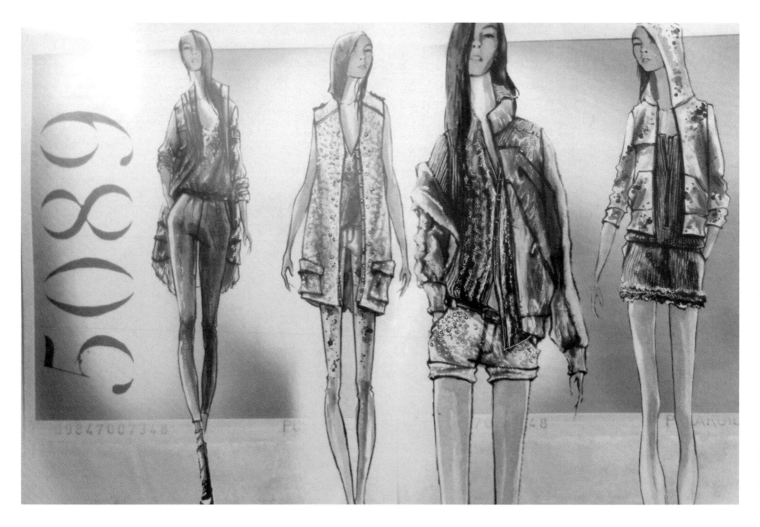

The theme of this lovely group is meant to reflect natural fabrics and *sustainable design*.

Designer: Alejandra Carrillo-Munoz

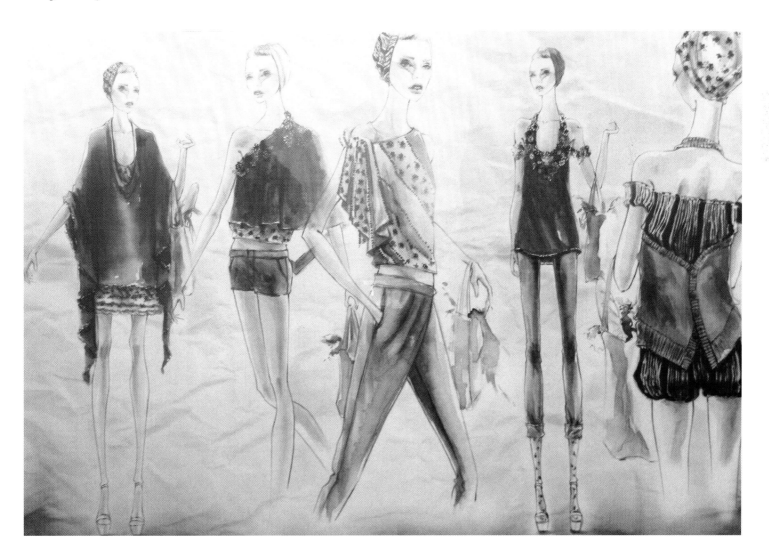

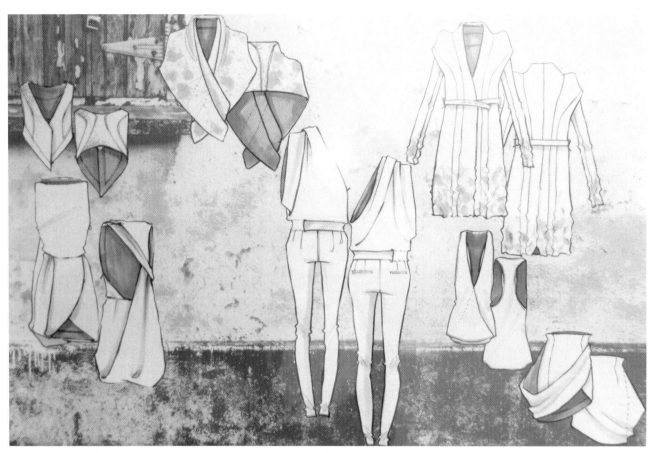

Designer: Alejandra Carrillo-Munoz

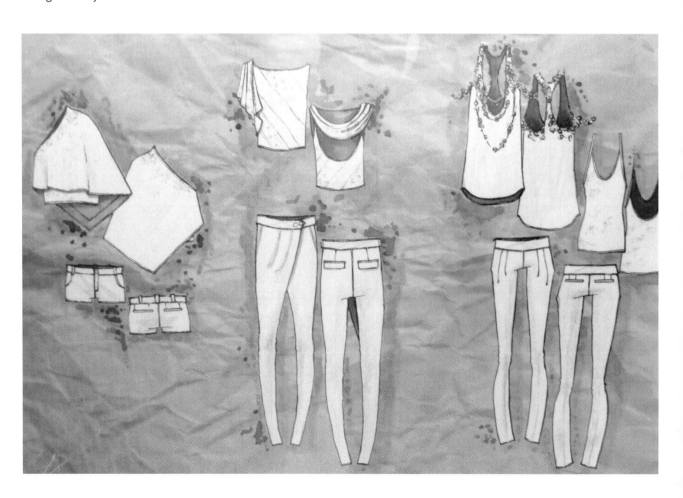

STEP THREE: Look at Options for Creating Your Own Website

Creating a digital portfolio is a wise move, and you don't have to do everything yourself. Web design can be a very time-consuming venture, especially if your computer skills are limited. There are plenty of companies and individuals out there who would love to build your website for a price. The cost will depend on a number of factors, the first being whether you want to be able to talk to a web designer in person about your ideas or you're willing to hire someone via the Internet.

On the other hand, understanding web design is a wonderful asset, so if you are ambitious in that arena, don't hesitate to explore the many program options. In the past, web design was so highly technical that you had to count on a pro who could write code, but that is no longer the case. Software like Dreamweaver, Intuit, and Web Easy 8 are geared to doing it yourself.

You can also find a seemingly endless number of free website hosts that are apparently gambling that a certain percentage of customers will eventually upgrade to get more services or features. One of the most popular is iPage, and it lists its features as:

1. **Unlimited disk space:** You can keep adding to your site, seemingly forever.
2. **Unlimited bandwidth:** The rate at which you can transfer data.
3. **Unlimited domains:** You can create as many websites as you want.
4. **Unlimited gigabyte transfer:** You can upload as many images and text as your ambition dictates.
5. **Free SiteLock security suite:** This prevents anyone from altering or erasing anything on your website.
6. **Free site builder:** You have access to their materials and templates for free.
7. **Unlimited email accounts:** You can connect unlimited email accounts to your website.
8. **E-commerce:** You can conduct business on your website.
9. **24/7 chat, email, and phone:** You can offer these features to your web visitors if you are able to provide them.
10. **Customer support:** Someone will help you if you have a problem.

It does seem amazing that you can get all that for free! If all you need is a site to show your work, one of the freebies is probably more than sufficient. However, if you want more bells and whistles, or if you are ready to set up a business, purchased software offers more features. Let's look at a review (from www.webhostingfreereviews.com) of Intuit, an award-winning program and one of the most popular.

1. Offers an intuitive, user-friendly interface and the most templates of any application that was reviewed.
2. Easy and fast for even inexperienced programmers. Intuit users can choose from more than 2,000 professional templates in a wide array of themed categories and 250,000 royalty-free stock photos, which can be re-sized without distortion. Additionally, the software provides dozens of features and tools to allow you to tailor the site to your particular business or field.
3. Drag-and-drop functionality and step-by-step product instructions.
4. Intuit Website Creator offers one of the simplest and most streamlined approaches to website creation available, reducing the complex process to three simple steps.
 a. You begin by selecting a unique domain name, which is supported by Intuit.
 b. You choose a site template to begin building your custom five-page site. (Larger sites cost more.)
 c. Begin adding images and/or text.
5. You can make changes or alterations at any time and as often as needed.
6. It has automatic file backup to ensure you never lose any of your work or site changes.
7. The software allows you to incorporate various types of media including flash, video, animation, audio, and even QuickTime clips. You can also incorporate a blog.
8. Operational tools include complete website tracking and statistics, so you can keep track of your visitors and sales.
9. 100MB of storage and 5GB per month of bandwidth usage.
10. E-commerce capabilities including a shopping cart, secure checkout, and full integration with PayPal.

We list these features simply to give you a feeling of what you might expect when you are ready to tackle your Web needs. Of course there are books on the subject and taking a class is never a bad idea. Now let's look at other ways you can utilize your digital skills.

STEP FOUR: Explore Techniques for Creating Beautiful Mood Boards for Your Digital Portfolios

1. BACKGROUND

Find yourself an interesting background that will blend nicely with your other images.

2. IMAGE + COLOR LAYER

Choose your primary image that will stand out from your background.

3.

If you are doing colorways, add each of your color chips separately. This technique will enable you to make changes more easily.

4.

Add a compatible transparent color to separate your text from your other images.

5.

Add some evocative text that will show you are a thinking designer who can talk effectively about your work.

6. FINISHED BOARD

Davy Yang

During his recent internship at Oscar de la Renta in New York, designer **Davy Yang** was asked to create mood boards with specific themes. The board on this page is fairly straightforward (background plus images), but the arrangement makes a beautiful, complex-looking composition. As you will see, the board on the facing page is much more layered and the result is subtle and amazing.

Of course, in creating such a complex layering effect, each succeeding layer must be carefully adjusted so the reduced opacity allows us to see the underlying colors and images.

Saving the work in layers also gives you flexibility to make changes as needed.

Designer: Davy Yang

1

This image provides the underlying pattern that ties the whole thing together.

2

This image, though subtle, evokes some kind of wild animal. The color builds up with greens and blues.

3

This image is simple, but it adds another layer of transparent color. The tree disappears and the moon stays.

4

This pattern adds a stronger line in white that complements the moon.

Organic Lattice Color Page

As you can tell from the multiple layers of color and pattern, this board took a lot of experimentation before Davy achieved the look he was after. If you want boards that really stand out and showcase your Photoshop skills to full advantage, taking the time to find unusual images and experimenting with them in layers can really pay off. Many sites offer all kinds of images for free, for a credit only, or for a small fee.

5

6

It's amazing how much more interesting these two images look in layers than by themselves. The feathered eye becomes much more mysterious laid over the pattern, and the moon image really stands out against the darker background.

The Payoff

Davy's work ethic, beautiful designs, and sophisticated aesthetic caught the eye of swimwear designer Rod Beattie, who is launching a new swimwear line called Bleu/Rod Beattie in Los Angeles. Rod offered Davy a design position in his new company, and Davy started there in Spring 2011.

STEP FIVE: Explore Photoshop Strategies, Filter Techniques, and Special Effects to Enhance Your Illustrations

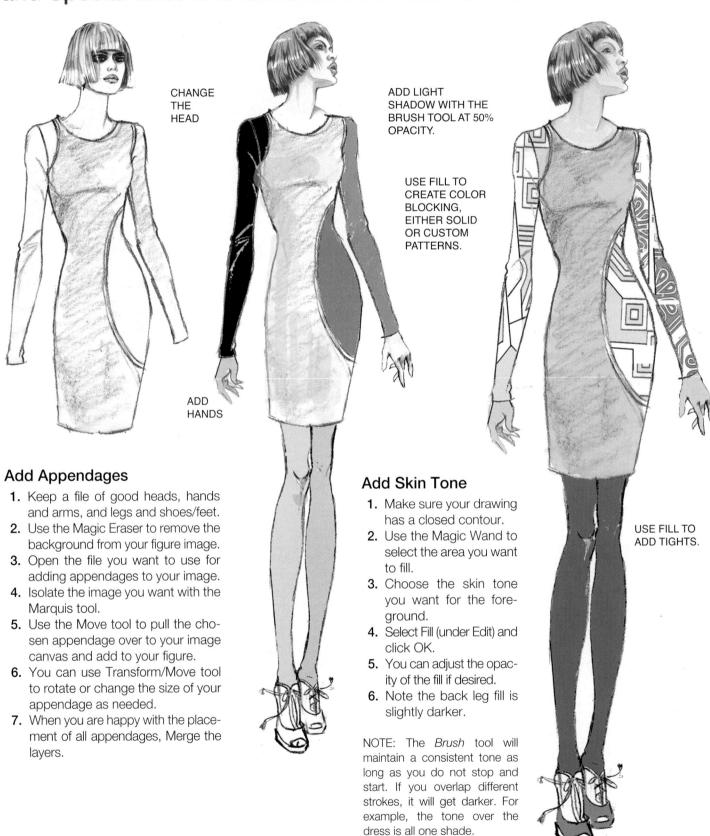

CHANGE THE HEAD

ADD HANDS

ADD LIGHT SHADOW WITH THE BRUSH TOOL AT 50% OPACITY.

USE FILL TO CREATE COLOR BLOCKING, EITHER SOLID OR CUSTOM PATTERNS.

USE FILL TO ADD TIGHTS.

Add Appendages

1. Keep a file of good heads, hands and arms, and legs and shoes/feet.
2. Use the Magic Eraser to remove the background from your figure image.
3. Open the file you want to use for adding appendages to your image.
4. Isolate the image you want with the Marquis tool.
5. Use the Move tool to pull the chosen appendage over to your image canvas and add to your figure.
6. You can use Transform/Move tool to rotate or change the size of your appendage as needed.
7. When you are happy with the placement of all appendages, Merge the layers.

Add Skin Tone

1. Make sure your drawing has a closed contour.
2. Use the Magic Wand to select the area you want to fill.
3. Choose the skin tone you want for the foreground.
4. Select Fill (under Edit) and click OK.
5. You can adjust the opacity of the fill if desired.
6. Note the back leg fill is slightly darker.

NOTE: The *Brush* tool will maintain a consistent tone as long as you do not stop and start. If you overlap different strokes, it will get darker. For example, the tone over the dress is all one shade.

Designer: Renata Marchand

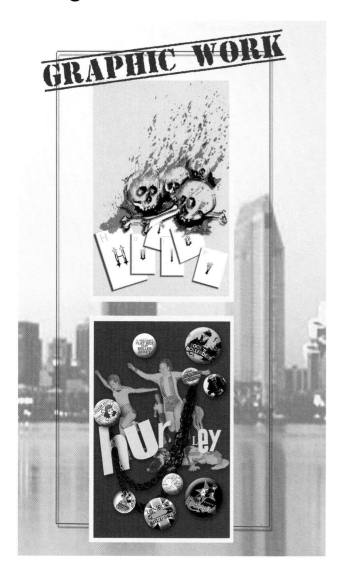

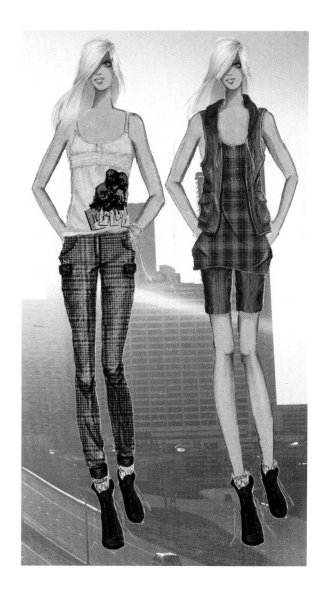

Designer Renata Marchand, whose exciting portfolio won her a great job working for Hurley, used her Photoshop skills to create cool graphics, evocative backgrounds that speak of a restless desire to travel, highly creative font combinations, and a wonderful collage-style mood board of travel photos and souvenir buttons. She also scanned her complex plaids and placed those on her garments, saving herself a lot of time and headaches.

Menswear Designer: Summer Spanton

Note how designer Summer Spanton used her Photoshop skills to add a great photo-based muse with a lot of attitude, flipping the image for a variety of angles. She also placed her patterns, graphics, and treatments, and a subtle but lively background showing her music-based theme.

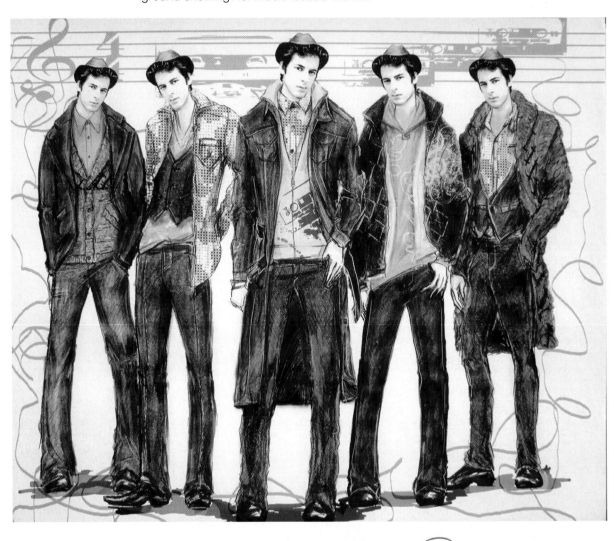

Image Adjustments and Filters

There are so many options in Photoshop that we tend to use a few favorites and forget all the rest, but that can be limiting. The examples below go through the many options offered under Image/Adjustments (upper tool bar) and some of the many filter options (under Filter). Be aware that each one of these tools can create an endless number of different effects. Also keep in mind that what can be done to a head drawing or figure can also be interesting when applied to a flat or a background image. I hope having these as a reference will encourage you to experiment with your images for cool results.

Image Adjustments

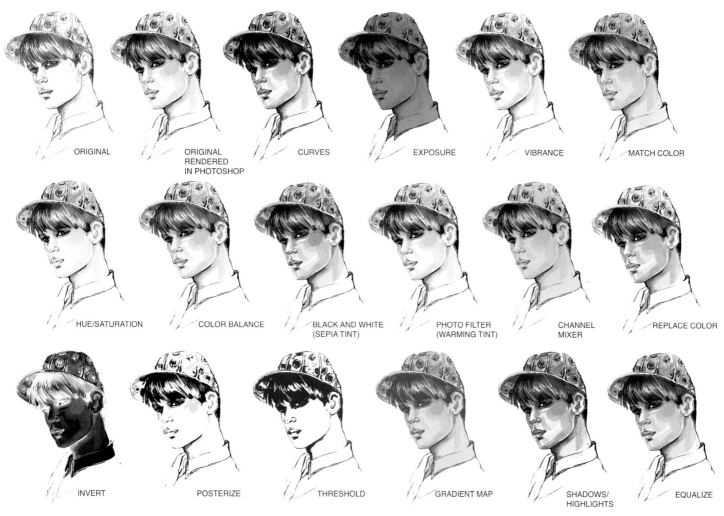

ORIGINAL ORIGINAL RENDERED IN PHOTOSHOP CURVES EXPOSURE VIBRANCE MATCH COLOR

HUE/SATURATION COLOR BALANCE BLACK AND WHITE (SEPIA TINT) PHOTO FILTER (WARMING TINT) CHANNEL MIXER REPLACE COLOR

INVERT POSTERIZE THRESHOLD GRADIENT MAP SHADOWS/HIGHLIGHTS EQUALIZE

Filters

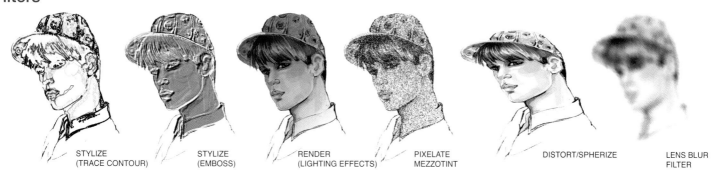

STYLIZE (TRACE CONTOUR) STYLIZE (EMBOSS) RENDER (LIGHTING EFFECTS) PIXELATE MEZZOTINT DISTORT/SPHERIZE LENS BLUR FILTER

Adding a Drop Shadow in Photoshop

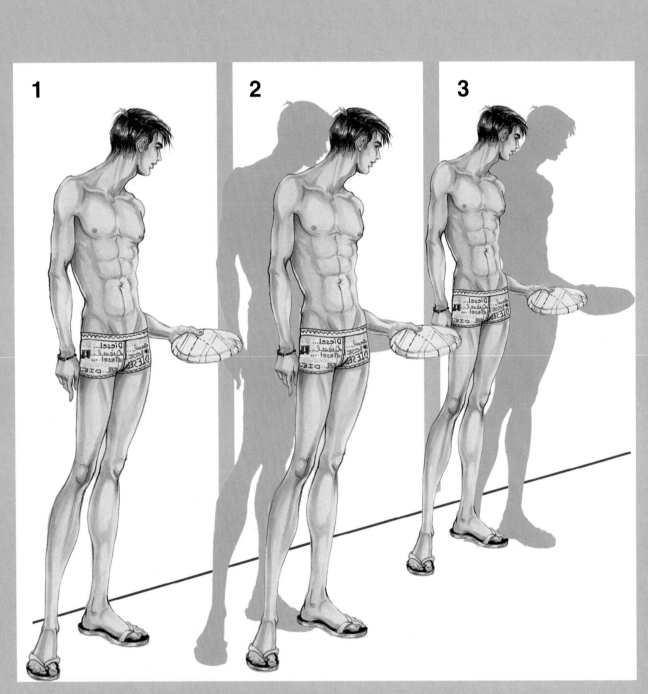

1. Make sure that your figure contour has no gaps, then remove the background with the Magic Eraser.
2. Click on Layer, Layer Style, then Drop Shadow. You can adjust the shadow with the tools provided (it's easy to figure out) or simply use your cursor to move the shadow around. You can also add texture with Noise.
3. This figure shows the shadow on the other side of the figure. I also used Color Balance to make the figure/shadow more blue, which helps to push it back in space.

NOTE: The shadow is not permanent until you flatten the image.

Group Shadows: Step by Step

1. Clean up your figures and remove all background with the Magic Eraser.

2. Go to Layer Styles under Layer, then select Color Overlay. Choose the color that you want (a warm gray for daytime shadows), then click OK.

3. Select Transform under Edit, then select Perspective. By moving the top edge toward the center on both sides, you make your figures go into this flattened perspective. You could also take the shape more to one side if you want to change the direction of your shadows.

4. Use your Move Tool (with Transform Controls activated) to compress the shadow shape from the top. Remove the background with the Magic Eraser.

5. Add a ground to your composition on a separate layer. Use the Move Tool to pull the shadow image into your composition. Reduce the opacity as needed.

6. Add more background if desired. Merge layers. You may want to also save your shadows separately.

Special Effects

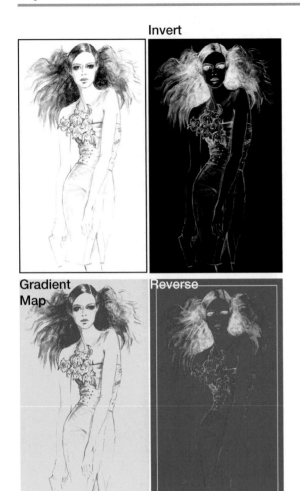

Invert

Gradient Map

Reverse

LAYER STYLE: OUTER GLOW

RETRICULATION FILTER

GRAPHIC PEN FILTER

INNER GLOW WITH A DROP SHADOW

Designer: Xena Aziminia

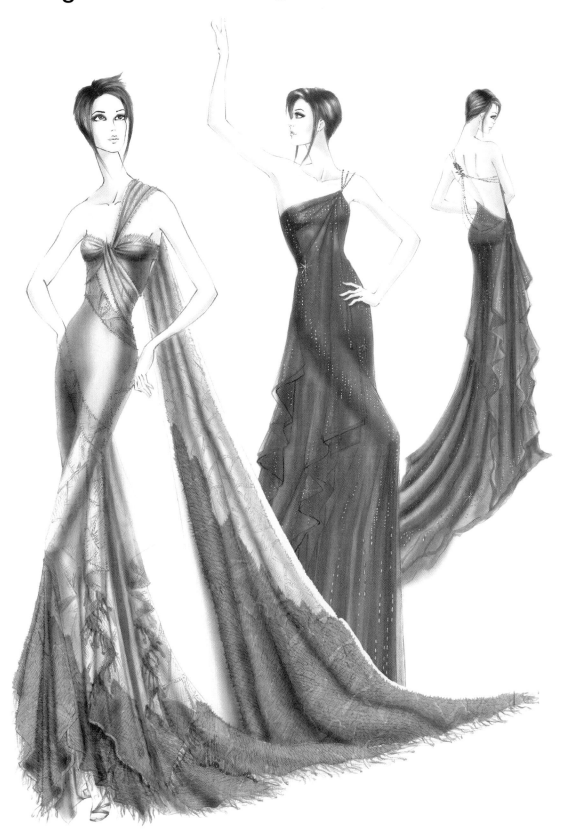

Designer Xena Aziminia taught herself to render these beautiful illustrations in Photoshop, creating a wonderful sense of form, light and shadow, texture, shine, pattern going in and out of folds, and completely convincing transparency. Such mastery takes time and practice, but we see it was worth all her effort!

STEP SIX: Explore Techniques to Enhance Your Fabric Boards in Photoshop

Incorporate a drawing into your fabric board in Photoshop.

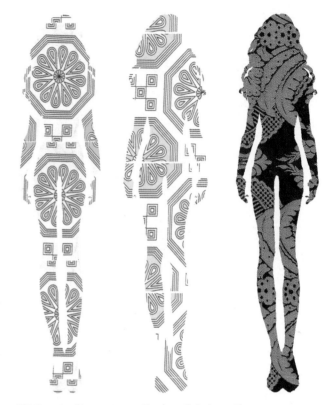

Fill figure silhouettes with your fabric patterns.

Create custom graphics and add them to your fabric boards.
Graphic by Danh Tran. (See more of his work at the end of this chapter.)

Adapt your mood board to become a part of your fabric presentation.

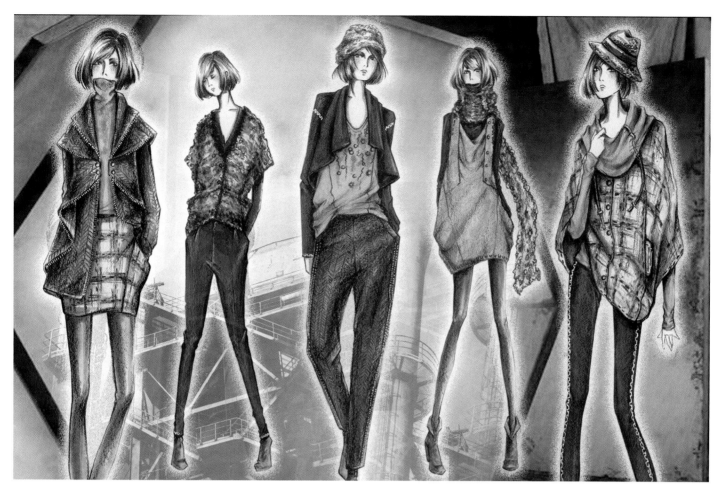

MASAMI FUKUMOTO

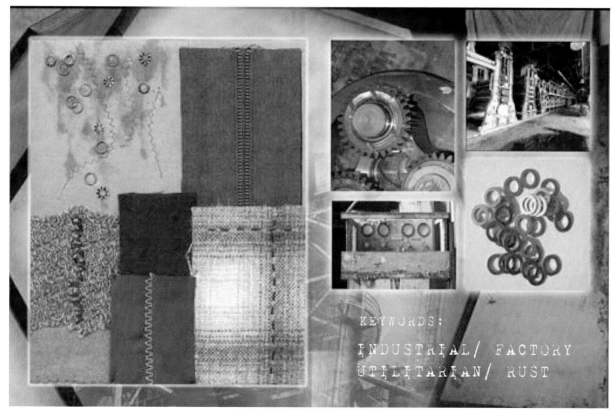

KEYWORDS:
INDUSTRIAL/ FACTORY
UTILITARIAN/ RUST

Designer Masami Fukumoto used Photoshop tools to add interesting backgrounds and inspiration images to her figure and fabric boards.

STEP SEVEN: Explore Techniques to Create a Digital Leave-Behind CD or DVD and Other Supporting Materials

Because it is such an inexpensive and convenient format, a digital portfolio that you can send to or leave with potential employers is worth creating. You can also have just a few key items on the disc to remind them of what they saw or liked in your interview.

CD COVER

CD COVER OR INSIDE PIECE

LEAVE-BEHIND PIECE

CD OR DVD OF YOUR DESIGN WORK

To keep your work from landing in a pile of anonymous digital items, add your art and information to the materials as shown. Software programs will print stick-on labels for your discs, or you can get a special printer and put your label directly on the CD or DVD, which may not be a bad investment.

STEP EIGHT: Consider Ways to Create Beautiful Invitations and Announcements for Your Fashion Events

Designer: Jared Gold

Designer Jared Gold is a master at putting together amazing presentation materials for the many shows and events he has held over the years of his impressive career. The images he creates always hold us visually and make us look closer to see all the wonderful detail and often a humorous subtext.

STEP NINE: Explore Various Ideas for Creating Your Own Logo and Other Branding Elements

Branding Yourself

Having a logo that identifies and connects all your business materials—your resume, business cards, digital portfolios, and so on—is a well-proven business practice.

1. Start by creating an image that will reflect the look of the product, if you have one, and/or yourself. If you (or the product) are sporty, feminine, street, and so on, try to create a logo that reflects these aesthetics.

2. For example, Julie likes modern design, so she chose a Japanese design system called Hanko Stamps. They are used for a person's signature for important documents and art. Julie would design a graphic placement with her initials, inspired by the look of these beautiful stamps. Inverting an image creates its color opposite. You may find that version even more interesting.

3. Julie also likes the simplicity of the BMW logo and others that have a very Americana look. She designed this hang tag with that purpose in mind, and used Carmen Ruiz as a fictional name. She would use the same graphic but change the size and proportion to create different items such as business cards, labels, and so on.

4. If you can think of an object or symbol that connects to your name in some way, that can be a good place to start. The same can be said for your profession. Try to connect your logo to your lifestyle in some way. For example, as a designer, a dress form relates directly to what you do. That shape could be built into your name or initials.

5. Is one of your names a word or part of a word? That could lead to an interesting symbol. For example your name may be Ralph Starret. Part of your name is *star*, so you could use that to create a logo.

6. Consider what happens when you use cursive or other interesting fonts for the letters in your name.

KATHRYN HAGEN **KATHRYN HAGEN**

Kathryn Hagen *Kathryn Hagen* Kathryn Hagen

More About Logos

Things to Consider

1. When you start to design your logo, consider how you want it to function. What is the product it will represent? Is it just you as a brand, or do you already have a product with an aesthetic that you want the logo to convey?

2. Put words to your logo design process that resonate with you and/or your product; for example, "young and chic," "active and dynamic," or "classic and elegant." Use these words to narrow your focus.

3. As part of your logo, you can also use words that describe your aesthetic or your product. For example, Victoria's Secret uses just the word *PINK* written a specific way as the logo/brand name for one of their lines.

4. Pay attention to how other people describe you. This may give you ideas as to what your logo should represent.

5. Review the lists you made in Chapter 1. Something in the lists of favorite artists, hobbies, films, etc., might suggest a good visual representation of you. For example, if you named Lichtenstein as your favorite artist, you might have a comic-book feeling to your logo, or it might even be in a sound bubble. If you love the German Bauhaus sense of design, that could be reflected in the style of your brand.

6. Do rough sketches or collect photos that resonate. Study your visuals and see what comes to mind.

7. Consider the different ways this logo will be used. Is it too complicated, too simple, too big, too small? Make sure it suits your needs.

8. Less is generally more in logos. Keep paring it down.

9. Once you have one or several good ideas, seek out other opinions. How people react to your logo is important, as you are trying to create a certain image. If no one is getting that message, you need to rethink.

10. Try your logo in different situations. Print it out on your resume, build a hang tag around it (as Julie did on the facing page), and do a mock business card. In other words, test your design in as many ways as make sense for you.

These rough sketch ideas demonstrate that playing with Photoshop's *Transform* tools, like *Perspective* or *Skew* (under the *Edit* menu), allows you to create a lot of different effects.

STEP TEN: Create Finished Presentations Using Hand and Computer Tools

Design Presentation with Rendered Flats

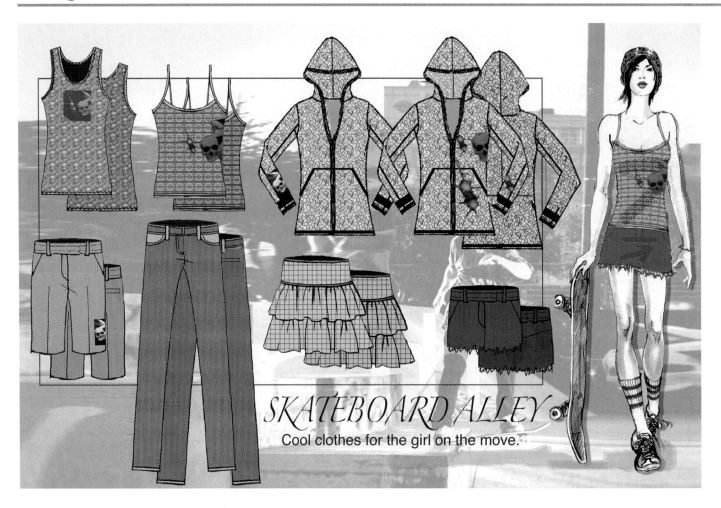

SKATEBOARD ALLEY
Cool clothes for the girl on the move.

Creating Your Presentation, Step by Step

1. Determine the concept of your group, and try to put words to that concept, as shown here in the title and subtitle.
2. Create flats for the group in Adobe Illustrator, or draw them by hand and scan them.
3. Find a photo background (or take one yourself) that supports the theme of your group. We used *Black/White* (under *Image/Adjustments*) to de-saturate the photo, then added a reddish tint. The photo was also stretched with the *Transform* tool to fill the whole space.
4. Arrange your flats on the photo background as shown: tops above, bottoms below. Leave space for a figure if you intend to add one.
5. Use *Edit/Fill* to add color or custom patterns to your flats.
6. We created a separate graphic with several elements and colorways that could be used in different areas on the garments. If you use graphics, make sure they support your concept or theme.
7. Use the *Move* tool to size and place graphics on your figures. You can also use *Warp* under *Edit/Transform* to shape the graphics to your garments. This tool is very useful, so do familiarize yourself with it.
8. Keep the top and bottom flats separate so you can arrange them for the best layout. Make sure that they are in correct proportion to each other. If you overlap them, be sure that the key details on the back still show. On this example, we also darkened the back slightly with *Contrast/Brightness* under *Image/Adjustment*.
9. Create an illustration figure that fits your concept, and dress her in an outfit from your group. You can fill the garments just as you did with the flats. Add shadows over the patterns to indicate a body inside the clothes.
10. Add borders and graphic lines using *Marquis* and *Stroke*.
11. Choose appropriate fonts for your text, and add with the *Text* tool.

CHAPTER SUMMARY

After viewing all the examples in this chapter, you should understand that your digital images are a great asset. They can help you create a personal brand and assemble impressive Web materials that can lead to good jobs. To not participate in the digital "revolution" is to be left behind in too many ways. You may have wonderful talents, but if you are being compared to others with equal talent and technical skills as well, you are likely to lose the game. If you don't feel confident in technical areas, take a class or hire a professional to help you put together a good website and other digital materials. Be organized and focused about your branding of all your materials, and use them whenever you get a chance to network. Business people will appreciate your professional approach.

We hope you have also realized that every image you create might eventually be used in some interesting way, so it pays to scan and organize everything so you can find things when you need them. Saving important work in layers is also a smart thing to do, even if you have to purchase an external hard drive to store them. Save your hard copies as well, including sketches and practice renderings. Some employers want to see your process, and these materials can create a presentation that will impress.

If you are still a student, see that your instructors return your work. If they insist on keeping it, then make sure you get a scan or photocopy. Remember, they are probably saving your best work. Try to get copies of any freelance work you do also, but make sure you understand your clients' policies. Some companies are secretive, so be careful that you don't break any rules and spoil your chances to work there again.

Remember that using images requires certain techniques in order to keep your visuals sharp and clear. When someone looks at your website, you don't want them wondering why your images are messy, too large or small, or too blurred to see well. For best results, scan your images at a higher resolution. We scan everything at 300 dpi or better, and save in TIFF form. If your image does not look clean, remove the background with your Magic Eraser, then go to *Stroke,* under Layer Styles. This will immediately make clear all the extra marks and dust that is creating a fuzzy look. Once you have cleaned up your image, then remove Stroke and flatten your background.

There are many other tricks for creating good digital files. You may benefit from reading a good book about digital skills, or check out the free demonstrations and information on the Web. Resources abound, so do take advantage!

TASK LIST

1. Digital skills are an ongoing study because the tools are constantly changing. Create a personal plan to update your software and stay up to speed on new developments.
2. Look at other designer websites and see what is being done now. You may learn what you do and do not like about existing work.
3. Research potential digital portfolio websites and even take a test run (start placing some images and check out the tools) with the ones that look interesting. You can probably tell pretty quickly if the set-up works for you intuitively.
4. Make sure that at least one or two of your mood boards in your digital portfolio display your more complex digital skills. Experiment with images and text until you have a unique effect that suits your concept.
5. Before you translate your hard copies into digital form, consider all the ways you might use Photoshop or Illustrator to improve their impact. Remember that images look different on a screen, so don't hesitate to make adjustments or remove work that doesn't hold up.
6. Experiment with the special effects if you have not done so before. They can really add drama and visual pizzazz!
7. Use one of your images to experiment with the various filters in Photoshop. You will undoubtedly learn some useful techniques.
8. If you have never added shadows to your work, or created silhouettes, this is a good time to practice the skills. Start with one figure, then try a group as well.
9. Scan one of your more complex illustrations (line only) and try rendering in Photoshop. You may surprise yourself with how well it turns out!
10. Analyze your fabric boards and see if they are visually as exciting as they could be, especially as they will appear on screen. If not, take the time to enhance them with your digital skills.
11. Create your own CD and DVD covers that say something about you and your work. Make sure they look professional and clean.
12. Create an invitation for a fashion show that you might have in the future. Keep your other branding tools in mind.
13. Create a personal logo for yourself. Even better, do a number of samples and then get feedback as to which is most effective.
14. Make sure one of your digital groups consists of flats rendered in Photoshop or Illustrator. This will show potential employers you can do great flats and create an exciting group presentation.

DESIGNER: DANH TRAN

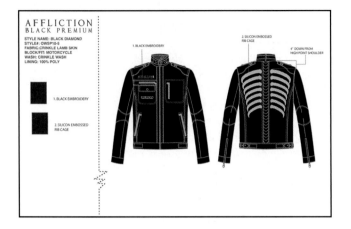

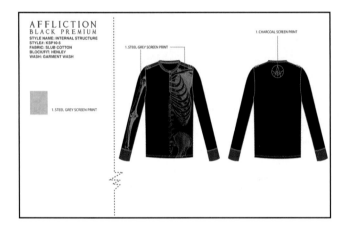

You can see how effectively menswear designer Danh Tran uses all the tools to create clear, clean, yet visually striking flats and great photos of his finished product. Anyone looking at these materials on the Web or in a portfolio can recognize them as the work of a talented professional.

software	description
Microsoft Office includes: Word, Excel, PowerPoint, Publisher	**Microsoft Word** (word processing) - creates text documents, spec sheets **Excel** – creates spreadsheets, use for spec sheets where tables and flats are required **PowerPoint** - creates presentations for screen (slide show/video/web/email attachments) **Publisher** - basic publishing, good starting point for introduction to graphics.
Drawing Software: Illustrator, CorelDRAW, Freehand	Powerful graphics drawing programs - excellent for drawing lines and shapes to create flats/working drawings and technical drawings for specification sheets, including fashion illustrations and presentation work (import images e.g. photos, scans etc.).
Image Editing Software: Photoshop	Industry standard software for image editing, a powerful paint and photo editing program - import, edit and manipulate scanned/digital images, or create images from the initial concept. Images created in drawing packages can be brought into Photoshop to create impressive fashion and fabric presentations for printing and the Web.
Page Layout: QuarkXpress, In-Design (Adobe)	Industry standard for advertising and publishing to produce quality page layout - create dynamic layouts for magazines, brochures, promotional material, marketing etc. (*Fashion Computing's* cover was designed using Photoshop and QuarkXpress, and the content created using InDesign.)
Web Design: Dreamweaver (Fireworks, Flash), Front Page , Image Ready (Photoshop)	Dreamweaver - powerful software for web design (Flash - excellent for creating animations for a more dynamic website. Fireworks for web graphics - also part of the Freehand, Dreamweaver, Flash package) Image Ready (Photoshop) - create and optimize web graphics
Adobe Acrobat	Excellent for converting large image files into PDFs to send as email attachments - on receipt the PDF can be edited, notes attached etc., and emailed back or forwarded. Acrobat Reader (free download) for on screen reading of PDFs.
Winzip (Windows), **Stuffit** (Mac)	Excellent for compressing files ('zip' or 'stuff'), then send the files as email attachments - the receiver must have Winzip or Stuffit to open the files.
Creative Suites: Adobe, CorelDRAW, Macromedia	Graphics Suites (include Drawing, Image Editing, Page Layout and Web Design Software) are less expensive compared to purchasing each package individually.
CAD Suites: Primavision (Lectra), Artworks (Gerber)	Software Suites designed to meet the specific needs of the Apparel and Textile Industry - used primarily in fashion companies, with long production runs, for fashion and textile design, pattern making, grading, manufacturing, labeling, etc.
Fashion Specific: Fashion Studio, Guided Image, Speedstep etc.	There are several Fashion and Textile design-specific packages available for fashion design and presentation work which are less expensive than the more powerful CAD specialist suites - check compatibility with in-house systems, outside printers and service bureaus.

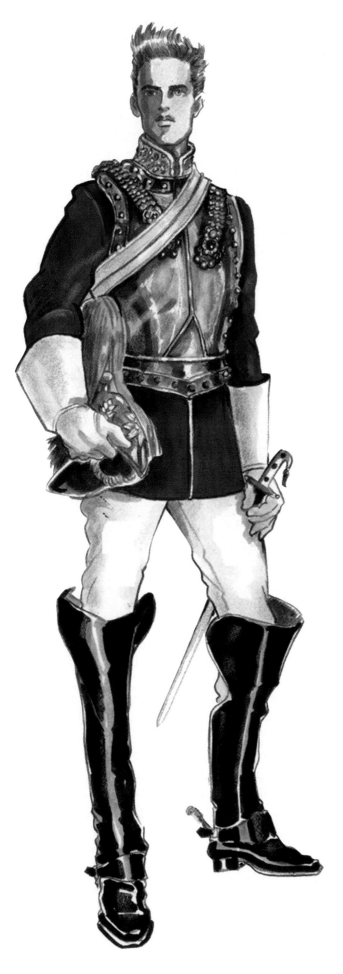

Chapter 10

Additional Categories

Costume

Fashion and Visual Merchandising

Product and Accessory Design

Swimwear and Activewear

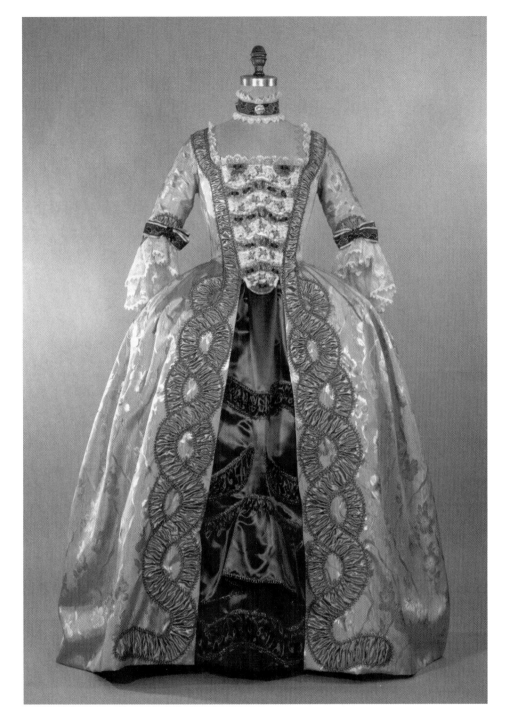

This beautiful eighteenth-century re-creation is the work of historic costume designer Maxwell Barr, who has given extensive lectures on the history and clothing of that period at the Getty Museum in Los Angeles. Maxwell also teaches costume construction at Woodbury University in Burbank, California.

This dress is a wonderful example of the effective use of pattern and texture to create a rich, luxurious feeling in the garment. Analyze all the different elements that were added to create the many areas of contrast. The distinctive shape is created by authentic undergarments of the period that Mr. Barr also constructed with great care.

Source: James Seidelman/Maxwell Barr

Introduction

Although we as authors would love to have the space and time to do separate chapters on all the wonderful categories that come under the umbrella of fashion design, it is not possible or practical in this text. But we do want to at least provide a little guidance and some good examples that might be helpful for those pursuing these interesting avenues. The good news is that the previous chapters and the steps that formulate them can really apply to any visual portfolio. How one researches, gathers tools, creates roughs and finished drawings, and organizes information and images is fairly standard, even though many imaginative variations exist within this classic formula. We trust these steps have been helpful if you have followed them with adjustments to your particular subject matter.

In this chapter, we have focused on the category of costume design because the approach to these books can be quite different and because we have so many wonderful costume designers to feature. We were also fortunate to obtain some great images of visual merchandising from Stylesight that we trust will be a source of inspiration. Further research on the Internet will reveal a wealth of additional resources in all this chapter's categories!

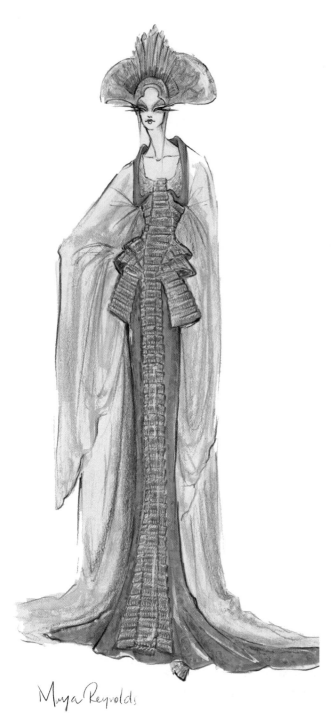

Maya Reynolds

DESIGNER: MAYA REYNOLDS

Maya Reynolds created this beautiful sketch for the Asian Princess project under the mentorship of venerable costume designer Bob Mackie. She was inspired by drawings of Samurai armor from ancient Japan.

COSTUME

Costume Portfolio: Preparing to be a Costume Designer

Many design students dream of applying their creative skills to costume design for theater or film. Good drawing skills are the perfect tool to get a foot in that competitive door because the majority of designers working in that arena do not have those sketching and rendering talents. Therefore, they love to hire assistant designers who can put their ideas on paper effectively.

If you are serious about pursuing costume as a career, consider designing your portfolio in ways that demonstrate you understand the challenges of working on a production, either theater or film. You can do this by relating your groups directly to one or more existing scripts.

The criteria and skill requirements for a costume book might include:

- **Ability to draw figures in more realistic proportions:** Extreme exaggeration is not desirable in the costume world. The need for efficiency and speed, and a realistic understanding of how a garment will actually look, make closer-to-real proportions (eight and one-half heads for a leading actor) a must.
- **Ability to idealize actors (but still make the drawing look like them):** Actors still want to be drawn in such a way that they look their best. A little taller, thinner, and more beautiful—or handsome—is definitely desirable. They expect their costume designer to make them look good, both in the wardrobe room and on paper.
- **Ability to create or depict specific character traits:** Costume designers must use clothing to help define who a character is. This is taking the idea of "customer" to a higher level and creating a specific identity and character development through costume changes. Naturally, the accessories are every bit as important as the clothes, and this attention to detail must be reflected in your drawings.
- **Ability to draw specific expressions:** In thinking of character you will also want to practice and show different expressions and looks. You will not want your villain and your hero to have the same expression.
- **Ability to draw different body types:** You cannot count on every actor having a fashion physique. If a key element of the character is being slightly overweight (think *Bridget Jones's Diary*) or very petite, you need to be able to draw the look that that physicality entails.
- **Great fabric renderings:** Because specific fabrics are an important character indication (Does she wear sleazy rayon or expensive wool challis?), good fabric rendering is a key skill. Include a variety of renderings in your book.

How to Begin

Probably the best way to demonstrate your talents is to choose a play or film with a variety of characters to work with. It might be beneficial to find one that most people will recognize, so they will immediately understand what you have changed or adapted. Choose the characters that interest you. Draw and render your own costume designs for those parts. This enables you to create for and dress specific folk that your audience can understand and relate to.

Other Ideas

Recast a play: It might help you to think of more current actors in the roles you re-costume. For example, think of *The Wizard of Oz* with Keira Knightley as Dorothy and Samuel Jackson as the Tin Man.

Create new current costumes: Design character-driven costumes that still reflect more current fashions.

Add a character: Use your imagination to add someone new to a familiar play (for example, Stanley Kowalski's ex-wife in *A Streetcar Named Desire).* Design outfits that effectively define and reveal the character.

Demonstrate versatility: A complete portfolio might include several characters from two different productions. Your choices should demonstrate your ability to create for very different kinds of situations and environments.

Consider your audience: If you are especially interested in theater design, then gear your character choices to be more extreme or theatrical, and to demonstrate your orientation toward costume history.

Film: For film, include more contemporary and relatively normal-looking people. A mixture of these two approaches would probably work well for either film or theater.

COSTUME DESIGNER: EDDIE BLEDSOE

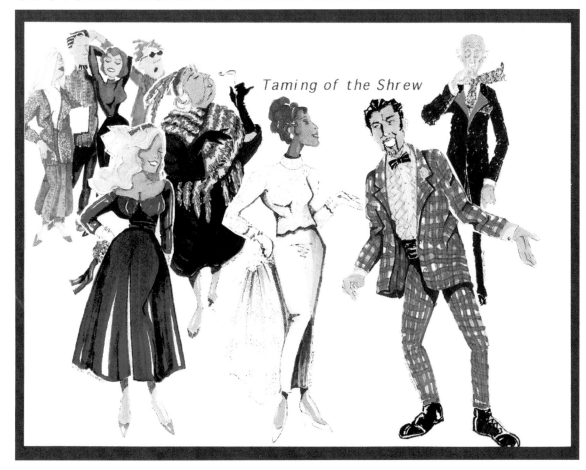

Taming of the Shrew

This lively illustration shows how award-winning costume designer Eddie Bledsoe created a modern version of the Shakespeare classic *The Taming of the Shrew.* The fun way Eddie depicts his characters and the wonderful and distinctive variety of looks immediately pulls the viewer into the sketch.

Costume Designer: Eddie Bledsoe

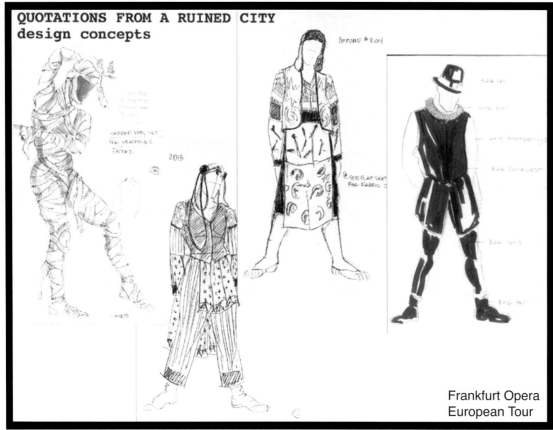

QUOTATIONS FROM A RUINED CITY
design concepts

2013

Frankfurt Opera
European Tour

Although these illustrations are working sketches, note how specific they are in terms of proportion, pattern, accessories, and so on.

Eddie Bledsoe has been the costume director at Los Angeles City College's theater program for many years. He also designed esteemed director Reza Abdoh's last production, *A Story of Infamy*, for the Frankfurt Opera. His film projects are many, including *The General's Daughter, Rough Riders, Batman Forever,* and *Alive.* Eddie also designs the "DaVinci" retro shirts featured in *Two and a Half Men* and *The Truman Show,* to name just a few. For the USC School of Theatre he designed *Ring 'Round the Moon* and *How to Succeed in Business Without Really Trying.* He has also designed costumes for many productions at the LACC Theatre Academy. Eddie was recently named one of the entertainment industry's "Ten Leaders in Learning" by *Variety* and he has contributed as a fashion historian to several periodicals, including the *New York Times, The Wall Street Journal, Real Simple, Los Angeles Times,* and *Women's Wear Daily.* His recent media appearances include a filmed interview on Audrey Hepburn in the Paramount Studio's 50th anniversary DVD release of *Sabrina,* "Fashion Groundbreakers" for the Biography Channel, and *C* Magazine. Eddie was recently recognized for achievement in scenic design in educational theatre by the Kennedy Center/American College Theatre Festival, April 2010, in Washington, D.C., for the LACC's production of *Anton's Uncles,* which also won top honors at the Edinburgh Fringe Festival 2011.

Designer:
Cynthia Johnson

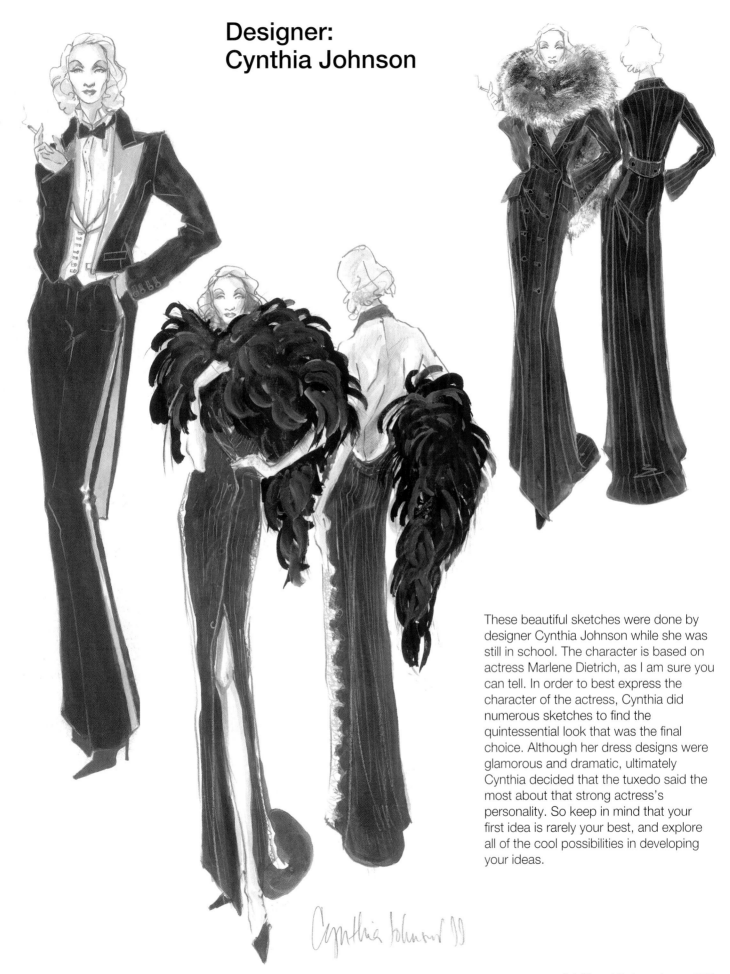

These beautiful sketches were done by designer Cynthia Johnson while she was still in school. The character is based on actress Marlene Dietrich, as I am sure you can tell. In order to best express the character of the actress, Cynthia did numerous sketches to find the quintessential look that was the final choice. Although her dress designs were glamorous and dramatic, ultimately Cynthia decided that the tuxedo said the most about that strong actress's personality. So keep in mind that your first idea is rarely your best, and explore all of the cool possibilities in developing your ideas.

Choosing Fabric Swatches

Things to Consider

1. When you are swatching fabrics for your portfolio, your first consideration is finding fabrics that will produce the desired visual effects of the costume.
2. How a fabric moves can be more important than its color, which can always be changed.
3. The visual effect of a fabric is often more important than the historical accuracy. A realistic play requires greater attention to historically accurate fabrics. A more stylized production allows a lot of room for interpretation.
4. Fabrics can enhance characterizations. For example, a light, floaty fabric might better express a shallow character, while a heavy, dark fabric supports a darker mood.
5. You can always line a fabric if it needs more weight, or soften it by washing. Cutting on the bias can also soften a stiff fabric, although that technique may create the wrong look for the time frame.
6. Texture can be seen sometimes better than pattern. Texture can also add a feeling of richness and suggest a variety of personality characteristics. Small patterns disappear on a big stage, so do consider the scale of the venue.
7. Layers of sheer fabric can be more interesting and colorful than a single layer.
8. If a character needs a specific color, you may need to dye your fabric to reach the desired shade.
9. Beware of synthetic fabrics, which may reflect stage lights differently, creating a harsh effect.

Costume Designer: May Routh

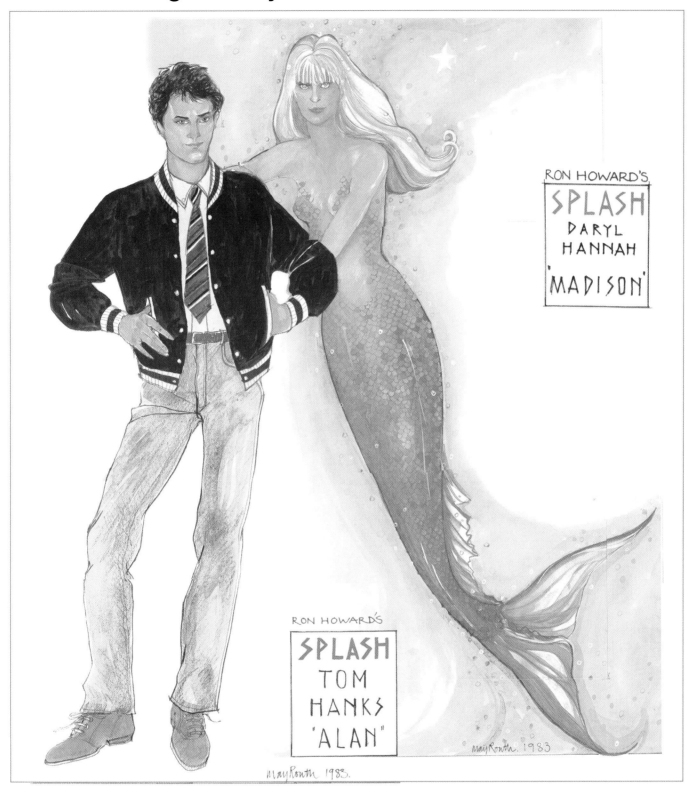

RON HOWARD'S
SPLASH
DARYL HANNAH
'MADISON'

RON HOWARD'S
SPLASH
TOM HANKS
"ALAN"

May Routh was born in India. She graduated from St. Martin's College of Art in London and worked as a fashion illustrator for *Vogue* and *Elle* in Europe. Her first film as a costume designer was with David Bowie in *The Man Who Fell to Earth*, which was followed by *Being There, My Favorite Year*, and *Splash.* She worked with John Frankenheimer on his last six projects, including the Emmy-nominated *Andersonville.* She received the Lifetime Achievement Award of Excellence in Costume Design from the Costume Society of America in 2008. May has been an adjunct professor at Woodbury University in Los Angeles since 2006.

Designer: Bao Tranchi

Costume designer Bao Tranchi has had a fascinating journey in her relatively young life. She was born in Saigon, Vietnam, into a world turned upside down by war. Her family of twelve left the country as a part of the Boat People Exodus. Surviving the seas, starvation, and even pirates, the Tranchi family was sponsored by a Methodist church in Culver City to completely rebuild their lives. Growing up, Bao sewed alongside her mother, a garment worker in LA sweatshops, and she drew with her father who worked as a mechanical draftsman. Knowing she would be a designer, Bao went straight to design school at seventeen. After graduation she sought alternatives to the corporate fashion industry route. Serendipitously, job offers from the film community came to her and she worked on *Beat*, starring Kiefer Sutherland and Courtney Love. Her career took off, and it is a tribute to Bao's independent spirit that she has thrived in such a tough industry.

Here is her history:

1. Approached by Academy Award–nominated costume designer and Madonna's stylist Arianne Phillips to work on all the concept costumes for the film *Queen of the Damned.* Bao became the youngest member ever of the Costume Designer's Guild.
2. Worked on other major productions, such as *Charlie's Angels, Hedwig and the Angry Inch,* and the *Madonna Drowned World Tour.*
3. Did music video styling for Janet Jackson, Destiny's Child, and numerous TV commercials.
4. Dressed such stars as Winona Ryder, Aimee Mann, and Courtney Love for the Academy Awards.
5. In 2001, Bao took over as head designer and creative director of one of the most elite retail stores in Los Angeles.
6. In 2003, The Bao Tranchi Label launched, garnering immediate attention from such magazines as *Vogue, W, Flaunt, Clear, Urb,* and *Massiv,* as well as music and movie stars.
7. Bao premiered her debut fashion show at Smashbox Fashion Week Los Angeles for Spring 2004. "Some things you have to see to believe, and Tranchi's premiere could be one of those. Her rising-star status clearly fits," raved *Women's Wear Daily.*
8. In 2004, legendary Aerosmith singer Steven Tyler and Best Female Rap nominee and VH1 hip hop legend MC Lyte hit the Grammys stage in Bao Tranchi outfits. Bao's clothes have also been worn by Kristen Stewart, James McAvoy, Naomi Watts, Salma Hayek, Paris Hilton, and Jessica Alba, to name a few.
9. In 2005 Bao spent five months in Vietnam and Thailand, designing costumes for director Ham Tran's *Journey from the Fall.* Having escaped Vietnam as a baby, Bao had not only creative passion to do the film, but also a debt to her own heritage to give a voice to the Vietnamese story. The movie has won numerous awards from film festivals around the world.
10. Bao then went on to work with Grammy award winning artist Kelly Clarkson on music videos, red carpet events, concert wardrobe, etc. Her designs can be seen in Kelly Clarkson's hit video "Behind These Hazel Eyes."
11. Bao has been in front of the camera, featured for her fashion expertise. In 2010 Bao was a guest designer on the *Antonio Treatment* show, which airs on the HGTV network. Bao was also one of the judges for the reality show *Faking It,* and a guest judge on *America's Next Top Model Cycle 7.*

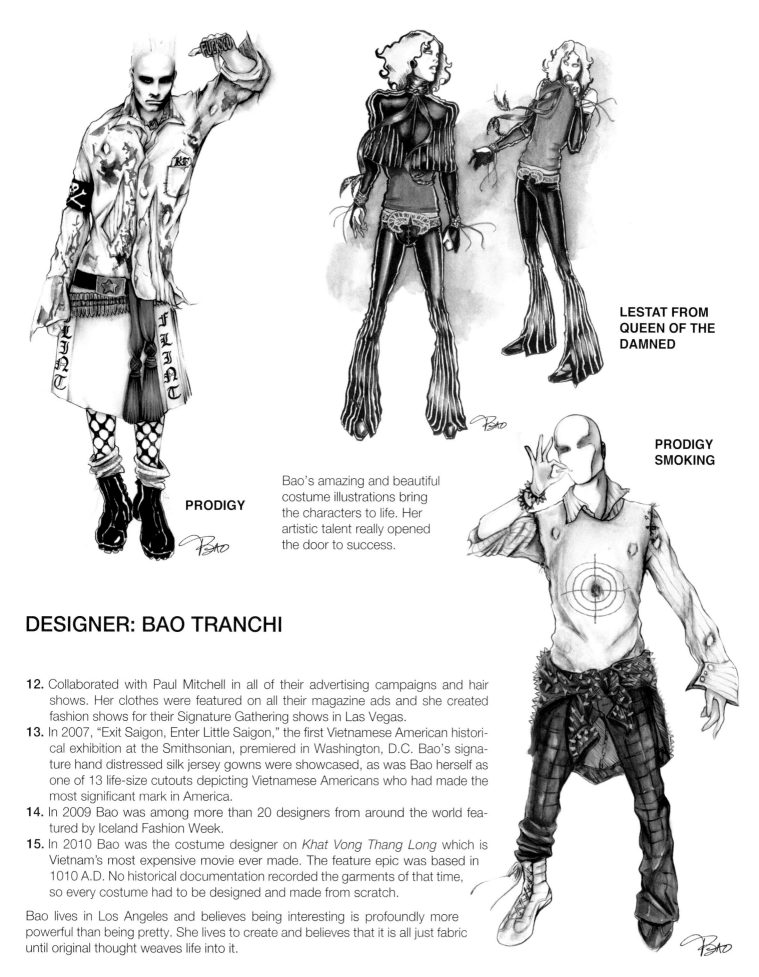

LESTAT FROM QUEEN OF THE DAMNED

Bao's amazing and beautiful costume illustrations bring the characters to life. Her artistic talent really opened the door to success.

PRODIGY SMOKING

PRODIGY

DESIGNER: BAO TRANCHI

12. Collaborated with Paul Mitchell in all of their advertising campaigns and hair shows. Her clothes were featured on all their magazine ads and she created fashion shows for their Signature Gathering shows in Las Vegas.

13. In 2007, "Exit Saigon, Enter Little Saigon," the first Vietnamese American historical exhibition at the Smithsonian, premiered in Washington, D.C. Bao's signature hand distressed silk jersey gowns were showcased, as was Bao herself as one of 13 life-size cutouts depicting Vietnamese Americans who had made the most significant mark in America.

14. In 2009 Bao was among more than 20 designers from around the world featured by Iceland Fashion Week.

15. In 2010 Bao was the costume designer on *Khat Vong Thang Long* which is Vietnam's most expensive movie ever made. The feature epic was based in 1010 A.D. No historical documentation recorded the garments of that time, so every costume had to be designed and made from scratch.

Bao lives in Los Angeles and believes being interesting is profoundly more powerful than being pretty. She lives to create and believes that it is all just fabric until original thought weaves life into it.

QUEEN NGHI LAN

ASSASSINS

DESIGNER: BAO TRANCHI

LY CONG UAN / LONG DINH
BATTLE SOLDIER

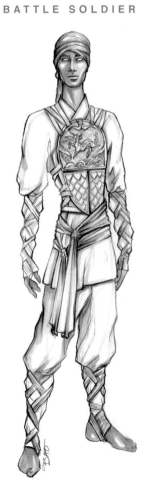

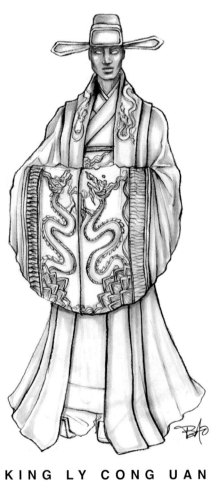

KING LE DAI HANH

KING LY CONG UAN

Developing Character Concepts

Once you have chosen your fabrics, it is time to create your designs. If you are dealing with a script or an existing play or film for your portfolio, developing your ideas for the character will be key to the design process. If your experience is limited, you may feel lost when you sit down to sketch, but making good use of the script will serve you well. You will want to understand your characters well enough to write a statement describing each one in detail. This should include ideas about what you specifically want to project to the audience with your designs.

Ask Yourself

1. Who is this person? What are the primary qualities that I want the audience to understand quickly, through their dress? How do I project that clearly? Or do I want the character to be a mystery, and therefore try to create a more ambiguous message?
2. What is this character's financial situation? How does that situation affect the clothes? A poor character should not be wearing expensive fabrics, unless they look threadbare.
3. Where are the characters going and what are they doing in the story? What clothing decisions are they making based on these circumstances?
4. How does the time period affect their dress? How closely will you want to follow the traditional mode of the time?
5. What, if anything, would they be carrying? What would they have in their pockets?
6. What will their shoes say about them? How should they walk?
7. Is there some symbolism about the character that could be shown through pattern or accessories? For example, a childish woman might wear a pink "Hello Kitty" patterned t-shirt. Look at all the pattern and symbolic elements on the various characters on the facing page. Bao is using these visual symbols to tell us who they are.
8. How will the clothing fit? Before the advent of ready-to-wear clothing, it was a luxury to have good tailoring.
9. How do I want the characters to look next to each other in a scene? Consider the big picture as well.
10. Are my choices consistent with the character? All elements of dress have cultural associations. Every decision you make should be analyzed for its implications.

Expressing Character Traits in Costume Features (Subject to Period)

FEATURE	LOVING	SENSUOUS	INNOCENT	EVIL	MISERLY	SEVERE
Cut	Open, flowing, modest	Full cut, open, lavish	Full cut, modest	Tight, straight cut	Tight, straight cut	Tight, straight cut
Fit	Body revealing	Body revealing	Body concealing	Body revealing	Body revealing	Body revealing
Texture	Soft, fuzzy	Soft, shiny, smooth	Soft, fine	Harsh, rough, hard, shiny	Hard, rough, or medium	Hard, rough
Hair	Soft, generous volume	Elegant, generous volume, or severe, sexy	Soft, loose	Severe or frazzled	Severe or frazzled	Severe, tight style
Colors	Warm, medium intensity, high or low values	Warm, medium intensity, high or low values	Cool, medium intensity, high value	Warm, high or low intensity, low value	Cool, medium or low intensity, medium to low values	Medium low intensity, medium to low values
Silhouette	Round or oval shapes	Round or oval shapes	Round or oval	Straight shapes	Straight shapes	Straight shapes
Line	Wide curves, soft edged	Undulating lines	Gently curved lines	Hard, straight or zigzag lines	Hard, straight lines	Hard, straight or zigzag lines

Reprinted from *The Magic Garment: Principles of Costume Design,* by Rebecca Cunningham (1989), Waveland Press.

Designer: Barbra Araujo

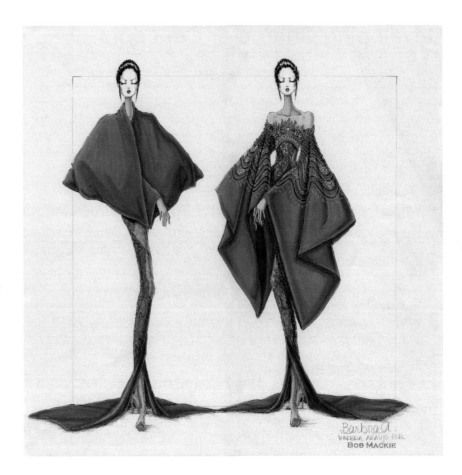

Though Barbra works now for Thomas Wylde as a womenswear designer, it is obvious from these beautiful sketches that she could also move into costume design if the opportunity arose and she had the desire to do so. Barbra did these beautiful sketches while still in school, working under the mentorship of costume designer Bob Mackie. The theme was Asian princesses, and these amazing figures certainly capture a sense of royalty. Barbra's feeling for rich fabrics and color made her a stand-out on the project.

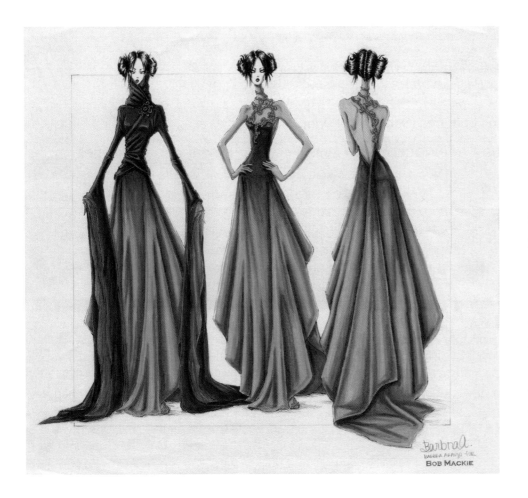

FABRIC BOARD

Designer: Barbra Araujo

Barbra did these wonderful drawings in her junior year in design school for a CFDA project. Again, note her use of texture and color to create visually exciting contrast. Her wonderful instincts for these techniques would work beautifully on the stage. You can imagine Tim Burton hiring Barbra to design his next film!

Iconic department store Harrods embraced the festive spirit with an entirely lavish, eye-catching Christmas window scheme. Elegantly posed mannequins draped in silky jewel-toned eveningwear and striking glitzy cocktail dresses were styled against subdued shimmering backdrops, invoking visions of icy night skies and dreamy wintry surroundings. Elements of glamorous gift-giving were present throughout the displays, with a scattering of champagne bottles and luxurious products intermingled with the mannequins, offering inspiration to all Christmas shoppers looking to purchase the perfect gift.

Source: Stylesight

VISUAL MERCHANDISING AT HARRODS

Images provided by Stylesight.com

Fashion Merchandising Portfolio

As with any portfolio, your goal for a merchandising portfolio is to demonstrate that you have the skills your target employer is interested in and needs to maximize the business. Researching your potential employers will help you to plan your book with an organized and focused structure. The resulting book will be a great tool to convince your "dream" companies that you are the one for the job.

Establishing a Personal Brand

A fashion merchandising portfolio will be your calling card on job interviews and the place to establish your personal brand as a potential hire. Having a book with a consistent and clear aesthetic will identify you as someone who has confidence in your point of view and who could effectively present work in a retail environment. A *personal brand* will also reflect your areas of expertise. Play on your strengths by showing your best work. This may include sketches of store displays that reflect your target employer's merchandise and several advertising campaigns that you have created. Include a variety of materials like ads, flyers, and posters. These can be specific to the potential employer's store or to one that has a similar retail "profile." If you already have some job experience, include photo examples of work you have done in a retail environment. Also plan to include images that show your expertise in a variety of CAD programs so they know you are "cutting-edge" and technology-savvy.

Market Research

You may also want to include a trend report demonstrating research you have put together of a specific customer demographic or area. You can take photos to show what the potential shoppers are wearing and then provide research as to what is actually in the stores where they shop. Your reasoned analysis of this information will be especially important to show that you can reach conclusions based on market research and react in a constructive way to address any potential problems.

Make It Look Good

Because you are presenting yourself as someone who has great taste and current knowledge of the field, your book must reflect those qualities. Careful workmanship and effective use of color and design are essential to create a good impression. An organized approach to presenting your information as well as images will help to demonstrate that you could handle the complexities of a retail environment.

Although there is nothing wrong with showing some range in what you can do, try not to water down the overall impression of what makes your vision creative and unique. A strong "portfolio personality" will help you stand out from all the other applicants. An employer who responds to your vision is likely to provide a rewarding working environment that suits your skills and aesthetic.

Fashion Merchandising: Create a Trend Report

You probably already have experience in creating trend reports and boards, but we have included a list of the elements that you might want to include. Good research, thoughtful choice and editing of images and text, and exciting layout skills will lead to a successful effort.

INSPIRATION AND TREND BOARD

LAYERED MIX AND MATCH

YOUNG AND FRESH

GEOMETRIC PATTERN, INTERESTING CUTS

Abigail Brazilian wears it to the movie premier and her new TV series, Flying Low.

It's the tween version of Prada meets JCrew.

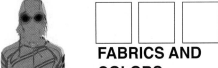

FABRICS AND COLORS

KEY DETAILS?

KEY PROPORTIONS?

GEOMETRIC CUTS

KEY SILHOUETTES, SPRING, 2012

Give it a label and a look

1. What is the look? Give it a name or title like Russian Avant-Garde or Fitness Fusion. Find cool images that express the look accurately.
2. What is the mood of the trend? Is it geared to youth, cutting-edge fashionistas, or something else?
3. What celebrities are wearing it? Check online and pull images of them in the right look.
4. What lifestyle does it serve? The fitness craze or weekend relaxation? Youth club scene or career dressing? Show us visually.
5. What brands reflect this trend? Don't include too many. Feature the key players.
6. What is the concept of the trend? Casual Weekend, Board Room Power Dressing, Young Junior Mix and Match?
7. What inspired the trend? A film, a TV show, an event? Find images that illustrate your choices.
8. What are the key fabrics? Include swatches.
9. What colors are hot for this look? Show accurate color chips.
10. What are the key silhouettes?
11. Key details?
12. Key proportions?

Things to Consider

1. You can also create trend maps showing a number of trends and their overall impact. This will show a potential employer that you see the big picture.
2. Connecting your trend board to a cultural happening or important film shows that you are aware of what is happening outside of fashion.
3. Themes are a vital part of your communication process. Take the time to find original themes that reflect your thinking.
4. Everything on your board must reflect your theme. It ties all your images and text together.
5. Trend boards become concept boards. Create both to show you understand the difference.

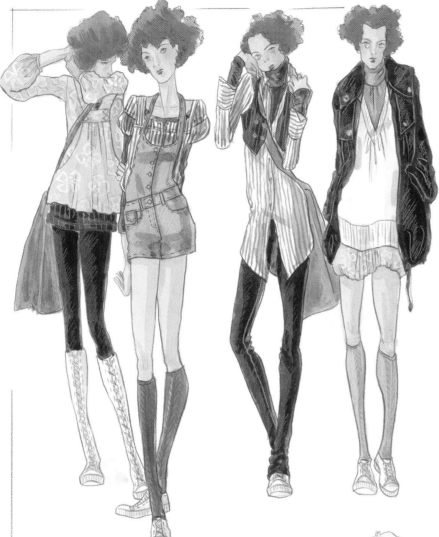

Designer: Minnie Yeh

These charming illustrations by designer Minnie Yeh would look great in any portfolio. Although they are of course Minnie's own designs, a talented merchandiser could illustrate existing pieces that are already in the marketplace.

If you are a strong illustrator you can:

1. Illustrate what you think are the most important designs happening in the field.
2. Illustrate the kind of clothing you would like to deal with in a job.
3. Illustrate the clothing from the company you want to work for.
4. Illustrate your own designs to show your creativity and great taste.
5. Do an analysis of the customer in great detail.
6. Do an analysis of the customer's lifestyle and why the garments suit him or her.
7. Do a breakdown of the group that you illustrate, explaining the balance of pieces, fabrics, etc.
8. Talk about the pricing of the group and why you consider it a good investment.

9. Illustrate manniquins, showing how you would create a display.
10. Use illustrations to create visuals for a trend report.
11. Ilustrate different kinds of customers, and write about how you would address the needs of each group differently.

While Minnie uses some unconventional fashion poses, she creates a very appealing mood with these interesting choices. The addition of a little sleeping dog adds to the fun mood and helps to define the customer.

Visual Merchandising Portfolio

Visual merchandising is the creation of any visual display that promotes and enhances the sale of goods in a retail environment. It is a key element of the retail business and a viable career in the fashion industry. The increasing importance of this branch of retail is apparent in the fact that whole teams of people, including senior management, architects, merchandising managers, buyers, the visual merchandising director, industrial designers, and staff will likely be involved in the process for a major store.

The goals of a good visual merchandiser are:

- To make the shopping experience more stimulating visually.
- To help the shopper easily locate the desired merchandise.
- To help shoppers find elements, including accessories, that work well together so they will purchase more items and be able to "self-select."
- To educate the consumer about recent trends by featuring them at strategic locations throughout the store. This encourages shoppers to seek newer merchandise rather than sticking to the sales racks.
- To create an independent identity for the store based on the exciting and unique displays.

Step One: Choose One or More Retail Environments

The actual design of the store itself is where visual merchandising begins. A well-designed retail environment reflects the mood and qualities of the products it will sell. In creating your portfolio, you may want to choose an actual existing space that displays the kind of merchandise that you would want to work with. This will give your book a real-world structure that would likely appeal to a practical employer. You could choose a different store for each group, or show how you would make the same space exciting and appealing (but still reflecting a consistent aesthetic) over a period of time. Just make sure your concept is consistent, and explain why you have made specific choices.

Step Two: Take Photos of the Actual Spaces

Take clear, well-lit photos of the interior space and the display windows of any store you want to "dress."

Step Three: Create your Displays

You likely already have displays that you have created in school. Hopefully you have had a retail space in mind when you were planning your projects and now you can make use of that planning. If you feel your displays do not really suit the retail space you had in mind, take the time now to find a better solution. A poor "visual marriage" will only undermine your book.

Step Four: Revisit Potential Tools

When creating your portfolio, we would suggest revisiting your display work to make sure that you have taken advantage of all the cool elements that can go into visual merchandising, such as striking color stories, dramatic lighting, cool accessories, and interesting text that provides product information. You can also add detailed descriptions of how you might use sensory input elements such as music or contrasting textures, as well as cutting-edge technologies like digital displays and interactive installations.

Step Five: Add Your Images in Photoshop

Upload your store photos into Photoshop and substitute your own displays. Remember that you can crop your images if you want to show more detail.

Step Six: Create *Planograms* for Your Chosen Stores

You can exhibit your understanding of the more technical aspects of visual merchandising by creating one or more planograms for your display groups. Your diagrams should show specific fixtures for in-store displays and strategic plans for how you would enhance an entire retail space and support sales by organizing merchandise according to style, size, price points, and so on.

These fun and creative windows featuring Designer Barbies and Lanvin boxes would certainly attract the viewer's attention. Using unexpected elements, especially when they are iconic like Barbie, is a great strategy for any display.

Images provided by Stylesight.com

Add interest by designing the background matting.

Source: Images provided by Stylesight.com

PRODUCT AND ACCESSORY DESIGN

The field of accessory design offers many opportunities, whether you want to work for one of the big companies like Nine West or Gucci or start your own company from your living room. According to an article at StyleCareers.com (http://www.stylecareer.com/accessory_designer.shtml), doing your own accessory line makes good business sense because "the starting capital is exceptionally low, the production cost is also very low, so you will be able to make huge profits (at least 1,000%)." Having a website is not that expensive, as we have already discussed in Chapter 9. You can also sell your work on consignment in stores, have your own kiosk at the mall, hold parties to sell and promote your designs, or sell by word of mouth to friends of friends and colleagues.

Although we have shown examples of only a few accessories, there are many categories to choose from. Jewelry, hats, scarves, shoes, handbags, hair accessories, eyewear, watches, and belts are some of the more common categories. It will pay to do some research before you start even a small business, to see what your competition is selling and for how much. You do not want to undersell your product, nor do you want to price yourself out of business.

DESIGNER: KIRK VON HEIFNER
COOL LEATHER AND CANVAS BAGS

Accessory Designer: Doug Hinds

Designer Statement

I design style-driven soft goods product from the concept phase all the way to a finished manufactured good. It starts with a design brief or rough idea that outlines all or some of the needs and wants for a particular product or line of products to be sold at retail. I digest this information and start off by making concept boards that visually communicate a particular set of attributes and ideas that highlight design themes and trends and also identify a consumer. This foundation helps propel the actual design work and keeps it focused, and sets up potential marketing materials towards the end of the process. Next comes the sketch work, which is roughly anywhere from five to fifty black and white line drawings that illustrate potential design ideas. These are not technical drawings even though they are computer generated. They are used purely to project a design sensibility and to provoke a reaction from those who view and select them for development. After a few of the sketches are picked, they then get turned into technical spec packs, which highlight every conceivable detail regarding the product including materials, colors, hardware, dimensions, etc. These spec packs get sent off to a factory for development and in roughly two to three weeks a first sample is returned. The sample is then evaluated based on the initial spec and changes are made. This step is repeated several times until the sample is considered "golden" and ready to be manufactured.

Aside from the standard project cycle above, I also spend a lot of time just coming up with ideas and collecting data on the apparel and accessories market in general. I am a huge trend and concept buff, so I enjoy spending a lot of my down time researching new design ideas and product stories to use in future projects. I also travel to Asia roughly twice a year to work on finalizing designs for production and also to generally speed up timelines when things get cut short. I have also traveled extensively around the U.S., Europe, and Canada for product testing, fabric shows, retail trips, and sales meetings.

DESIGNER: KIRK VON HEIFNER

Cool Shoes
and Boots

SHOE TEMPLATES

HIGH
HEELS

CONVERSE
SNEAKERS

SWIMWEAR AND ACTIVEWEAR
Designer Profile: Red Carter

Known for sophisticated swimwear with a sense of edge, renowned designer Red Carter lends his contagious charm, unique design outlook, and years of industry experience to the wildly popular brand that bears his name.

Make no mistake: this is no overnight success story. Red's story is one of determination, hard work, and creative vision.

Red's drive and ambition have long informed his character, beginning during his youth in Southern California. As a competitive athlete, Red was an accomplished swimmer, diver, and water polo player. When not in the water, Red further indulged his need to ham it up by dabbling in the entertainment industry. Gracing both the big and small screens, Red showed he was set on stardom from the start.

Upon graduation from design school, he got his feet wet designing junior sportswear and activewear for Esprit before putting his creative talent to work at Guess Jeans, Rampage, Mossimo, Victoria's Secret, and Oscar de la Renta. After years of tutelage from some of the best in the business, Red was ready to capitalize on his hard work, his way.

After moving to Miami in 2003, Red quickly became inspired by his new surroundings and motivated by the ever-present energy and bold, Art Deco style. Noting that buildings rose and fell as frequently as the tides, and local artists were as transient as tourists, Red established his brand in Miami to reflect and enhance the city's burgeoning creative spirit.

Since launching his eponymous swimwear in 2004, designer Red Carter has taken the resort industry by storm. Red Carter LLC utilizes its vertical design, development, production, and distribution capability to support its labels Red Carter Glam, Red Carter, and Sandy Bottoms. Red Carter LLC holds the swimwear license for Jessica Simpson and produces private label products for retailers nationwide. Red Carter lines are sold by leading retailers including Barneys, Neiman Marcus, Saks, Intermix, Bloomingdale's, Macy's, Dillard's, Victoria's Secret, and Everything But Water. Red Carter designs have appeared in *Vogue, Elle, Lucky, Marie Claire*, and *Sports Illustrated*. Celebrity following includes Rihanna, Kim and Kourtney Kardashian, Penelope Cruz, Demi Moore, and Jennifer Aniston.

The company also established and operates Salon9, its New York City–based showroom, which has quickly gained a reputation with buyers and editors for representing the industry's leading swim and resort lifestyle brands.

DESIGNER: RED CARTER

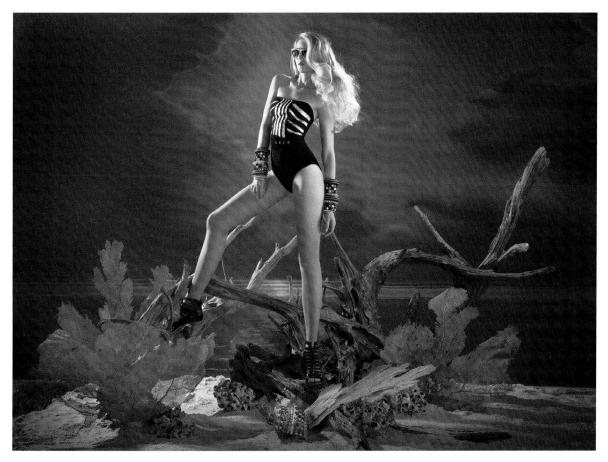

Designer: Red Carter

The compelling text on page 310 is taken from Red Carter's own press release. As you see, he creates an exciting story about himself that helps to involve readers in his career. It is all part of his professional branding, which he does so well.

You can also see a very clear concept running through these designs from Red Carter's 2011 collection. All the pieces are in neutrals, mostly black and white, and they are wonderful combinations of straps and cut-outs that look rather futuristic, sexy, and cutting edge. His customer would need to be bold and confident to wear such attention-grabbing suits!

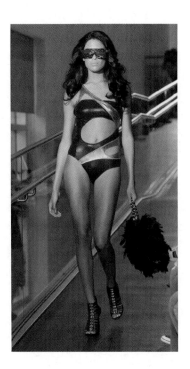

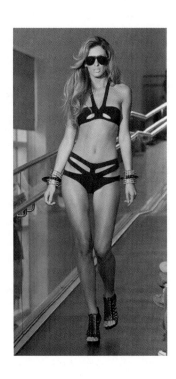

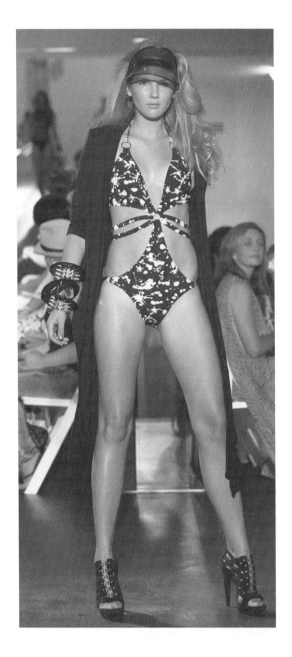

Designer Red Carter taking a bow.

Activewear

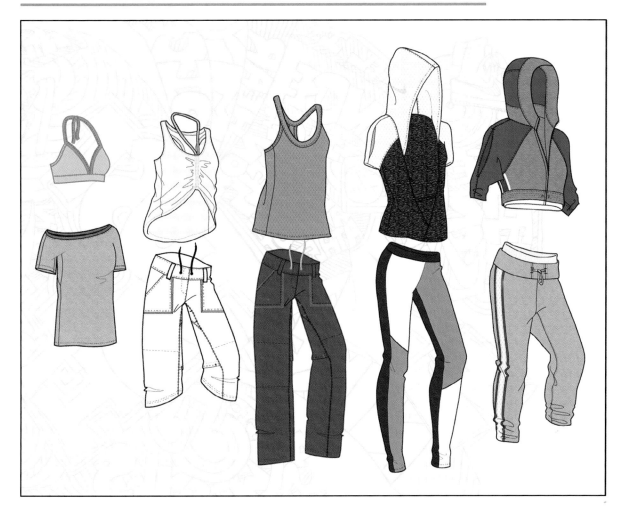

Michelle Kwak has created these fun and colorful 3-D flats for her design position at activewear giant Nike.

ACTIVEWEAR DESIGNER: MICHELLE KWAK (for Nike)

Activewear is a booming area of the industry. The largest companies like Nike and Adidas are global giants, but many smaller companies serve specific niches of the various sports and exercise needs. There are numerous opportunities for students interested in this fun and functional approach to design.

How to Begin

1. Make a list of the active sports with which you have had experience as an observer, fan, or participant.
2. Decide which of those are most interesting to you, or choose a sport that you would like to know more about.
3. Once you are ready to focus on a particular sport, check out the magazines that relate to those athletes and games. There are periodicals for almost every sport imaginable, from kick boxing to weight lifting.
4. Search the Internet for your subject. Your hardest task will be to choose the best websites for your agenda, which is researching the social trends, fashion requirements, and any technical aspects of your sport. Save gear photos for reference by clicking Print. You will see an option to save as PDFs, which will open in Photoshop.
5. You will also find a lot of sport photo sites, and you should be able to download some photos for free. Print out the good ones for figure reference.
6. It is also helpful to go to a store that sells the kind of garments you are designing. Seeing the actual fabrics and how the garments are merchandised is invaluable.
7. Once you have all your research in place, you can collect fabric swatches and begin developing figures. Finding good tech fabrics at retail may be tough, so you may need to order online.
8. Develop front and back figures for your illustrations, as graphics are important for both views.
9. You may want to develop faces that look like one of the more famous athletes in your sport, like Beckham for soccer.
10. Collect accessory ideas as well, and practice drawing different caps, helmets, gloves, and so on.
11. Consider developing your designs in flat form first because placing graphics is easier and generally more effective.

DESIGNER: BARBRA ARAUJO

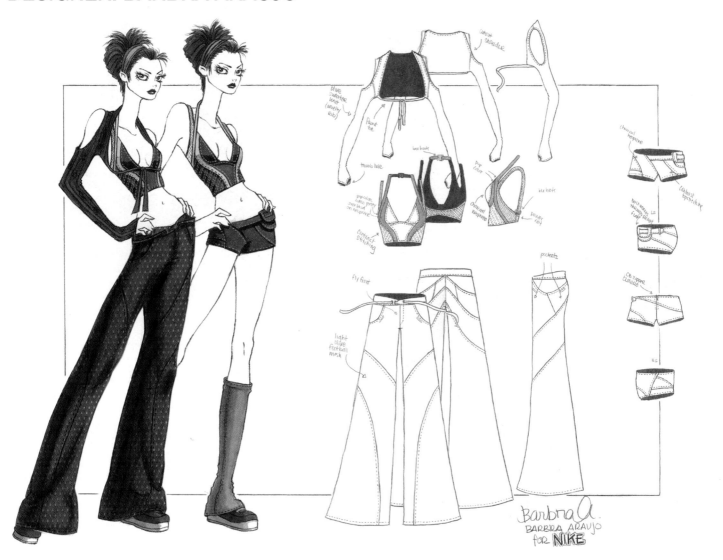

More on Activewear

Things to Consider

1. Shawn Boyer, designer at Anatomie, suggests bringing a sports mentality to the design process. He started his own activewear line because he could not find what he wanted for his own sport, and learned the business by doing it. The more you know about your sport, the more likely you are to please the people who would buy your clothes.

2. If you want to start your own business, there are design consultants who can guide you through the process. Finding good contractors and following all federal labeling standards are just two of the challenges a new designer faces.

3. Getting feedback about the functionality of your designs is a critical part of the process. Find a way to establish a relationship with your customers. For example, Baby Boomers are a large and fairly active group of individuals, but being older means they have different body types and priorities. Connecting with people who represent that population can open up a whole new market for your designs.

4. Your clothing needs to be both comfortable and functional. Consider both issues when you create your designs.

5. Research fabrics and stay on top of new materials. The high-tech sports person is always looking for the next great thing. For example, designer Dee Burton recommends Supplex as a great new activewear fabric, because it wicks away sweat, dries quickly, and maintains both its shape and color through many washings.

DESIGNER: MELLANI AGUILAR

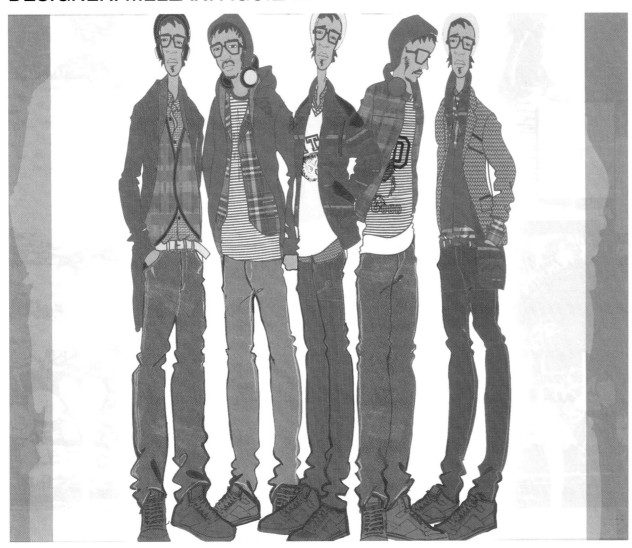

CHAPTER SUMMARY

Whatever category you choose to focus on in your portfolio, the basic principles of our preceding chapters can largely apply. Even in a merchandising portfolio you can break your portfolio into different groups that you focus on to create illustrations, ad campaigns, branding materials, trend analyses, and so on. The same goes for visual merchandising, accessories, swimwear, and so on. A costume portfolio might require a slightly different approach, such as dividing it into characters rather than groups, depending on how you choose to approach it.

The illustrated group shown above by designer Mellani Aguilar is a great example for all the principles we have explored. The illustration style is very individual, the fun mood suits the targeted youthful customer, and the variety of layered tees, shirts, and jackets is well-merchandised and saleable yet has a very fashion-forward look. Mellani uses accessories, humorous expressions, and subtle but amusing poses to enhance the look. She also demonstrates her digital skills by placing her figures in an interesting graphic space that hints at the theme of her group. I think any viewer would be drawn to this visual and want to look carefully at the clothing and also any subsequent groups.

In other words, Mellani does a great job: She pulls us in and fulfills the promise of her visuals by paying close attention to detail and displaying a clear understanding of her market. This is the ultimate goal of all portfolio pieces, and we hope your portfolio is meeting these same demanding but critical criteria!

Chapter 11
Getting and Keeping the Job

DESIGNER: DAVY YANG

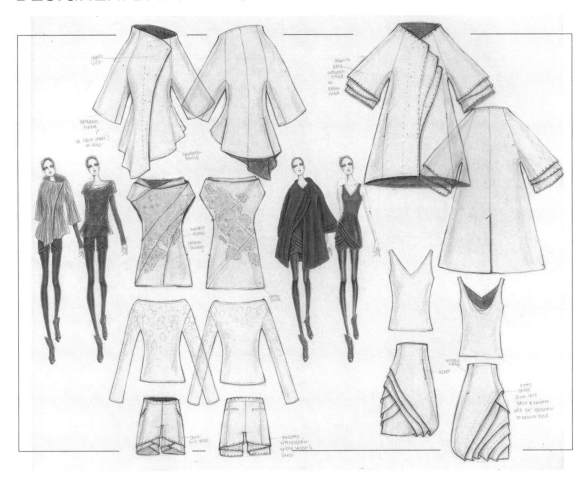

Good visual and design skills like these plus a practical business sense is a promising combination!

Introduction

This text has emphasized various methods of presenting yourself to potential employers. A professional and impressive portfolio is key, and it is supported by other materials such as your resume and cover letter. This chapter summarizes these materials and expands on topics such as interview techniques to help you when you are ready to take the plunge into the industry.

What happens after you get a job? Think about your approach to your career and how you want to conduct yourself on the job now, before you are immersed in what can be a stressful or demanding situation. Techniques for making yourself valuable and keeping your job until you are ready to leave are worth studying and applying, as the competition for positions in the fashion industry can be fierce.

If you choose to leave a job, there are also good and bad ways to do so. Not burning bridges is a wise goal, no matter what the circumstances. For example, a good friend of mine was a designer who had a job with a large womenswear firm. She did a great job for them, but was rather underpaid, so when another firm offered her more money, she jumped at it. However, she gave plenty of notice and left on good terms with the company. It was not a year later that the first firm called to offer her double the salary she had been making, as well as a company car and other perks. Of course, she went back and thrived there, because they now really appreciated what she had to contribute. If she'd left under less ideal circumstances, they probably would have moved on to someone else.

Good business practices are essentially common sense, yet people often fail to follow them, especially when emotions take over. We hope this chapter will be helpful in providing guidance in such circumstances.

Designer: Jared Gold

Jared Gold created the Black Chandelier line of clothing and accessories, which was sold in wonderful retail stores like the one shown. Both the interior and exterior displays reflected the wildly creative aesthetic of the merchandise. Jared also mixed other kinds of artistic objects in with the clothes to create a fun shopping experience. Chances are you will not have your own store right away, but working for other people will provide valuable experience so you are ready when the opportunity arises.

Creating Your Brand

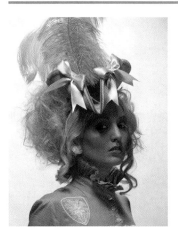

Jared adds to the unique vibe of his designs through his mastery of screen printing and his use of fantastic gothic imagery.

Jared also is able to use his own unique look and dress to promote his ideas. He is seemingly fearless!

"I deny the existence of a mold; it helps you feel much more free when designing. I am inspired by books, perfume, car rides, scents from this wild town as I drive through at night."

Designer Jared Gold has always had a talent for creating an image for himself that people who meet him do not forget. His fantastic shows, beautiful screen prints, imaginative retail spaces, and unique designs all support his position as a respected force in the Los Angeles design industry.

The way Jared started in the field reveals his entrepreneurial spirit. Through his talent for self-promotion and daring design sense he generated a brand new customer base in generally conservative Utah that clamored to buy his fantastic and edgy Rave costumes.

Not everyone has the desire or "chutzpah" to accomplish such an amazing feat, but we all can identify and produce materials that reflect who we are and what we have to offer so industry people have a good sense of our aesthetic identity. Because designers are expected to demonstrate their wonderful taste in whatever they do, your choices in visual materials are critical.

The following pages provide some ideas for how you can approach this key phase of your preparation to enter the field.

Designer: Olivia Ko

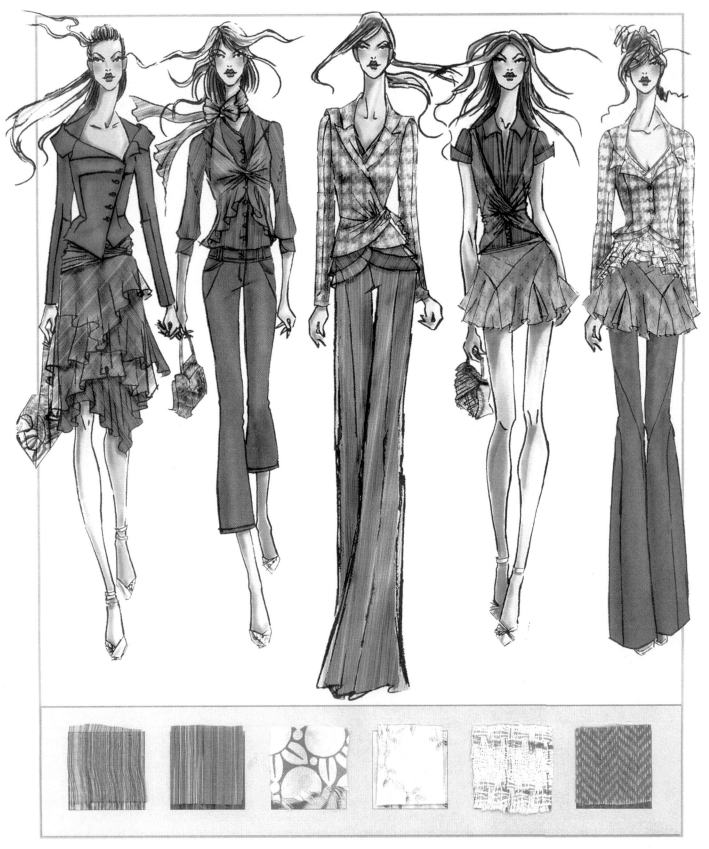

Beautiful work is always a great branding tool. Discriminating people will remember striking presentations with great drawing and techniques. These are skills that are always valued. Olivia shows in this group her bold use of color and her ability to put a great group of fabrics together and use them well in her designs.

Ways to Create a Personal Brand

How can you become more visible?

Think about what you do best and identify what you feel is your expertise. If you can write well, you can start putting it out to a larger audience.

- Create websites, blogs, specialized Facebook pages, and so on. Demonstrate and discuss your interests, passions, and expertise on multiple platforms. But take care with your words and images, as visibility can be a two-edged sword.
- Make it easy for people to contact you to ask questions. You can do this through email, Twitter, Skype, Internet messaging, replying to comments on your website or blog, etc.
- Give advice to other industry people about what you do. Be willing to help them get started and they will likely be a good resource for you down the road.
- Generate opinions that inspire conversation. Make sure you really believe what you are saying, however, as you want to be able to defend it honestly.
- Follow other people in your industry and lend your support to their ventures.
- Don't be afraid to ask people to follow you. Make them a part of your "adventure."
- Don't spread yourself too thin. Stay with the websites and communities that most apply to your work and goals.
- Don't be too shy or modest. Let your professional successes be known so people can share in your progress.
- Join your community organizations and participate in the conversations. Reach out to others who might want to join forces.
- LinkedIn and other similar websites are an increasingly popular networking tools. Join and start connecting!
- Consider the virtual world potential. You may want to create a cool avatar that reflects your brand and explore future retail possibilities at sites such as Second Life.
- Share cool exhibitions, articles, shows, and industry events. This is helpful and will make people check out your pages more often.

Creating Alternative Websites

Websites do not have to be just for your portfolio. You can also use the format to generate your ideas and publicize your "brand."

- Using your area of expertise, set up a website that allows people to ask you, the "expert," questions. Just be prepared to maintain it in a reasonable manner. Don't make promises you don't intend to keep.
- You can set up discussions about your field and focus on what you know best. Again, be prepared to stay with it or you will disappoint your constituency.
- Offer a few online tools that people will appreciate having, such as "How to Create a Tech Pack" or "How to Render Lace." It's amazing to see the number of people who will take advantage of your knowledge and probably remember your name.

Blogging

If you are willing to put the work into creating and maintaining a regular blog, you will have a good chance of attracting followers. Of course, you must have the ideas and material to back it up. Since the fashion industry is so visual, it is probably desirable to include plenty of images as well as your thoughts and opinions. Sharing visual information is a valuable exercise that can lead to all kinds of connections.

- Use a title or name that reflects your brand. Keeping all your materials consistent contributes to the clarity of your image.
- Syndicate your blog in brand-related sites and networks that relate to the fashion industry.
- List your blog in pertinent website, blog, and RSS directories.
- Show your expertise as much as possible.
- Publicize your brand-related successes and achievements.
- Put your personal brand name before the blog comments and include links to your Facebook page or other key networking sites.

Social Media

Everyone is doing it: Social media is a powerful tool for business and even global influence. We would be foolish to ignore its value.

- Choose the sites that will have the optimum benefit and develop them to reflect your personal brand. Again, don't spread yourself too thin. You cannot replace your actual work with full-time branding.
- Use Twitter to share information and make connections. But be careful what you put out there, and keep a professional attitude in what you say.
- Have your biography posted on Wikipedia.
- Separate your professional Facebook page from your social page. Ask people to follow you. Keep it interesting.
- Check out FriendFeed to tie all your resources together into one easy source.

More

If you still have time to do more branding there are additional options and tools to raise your profile.

- You can produce podcasts for YouTube, but make sure you have real content and quality, or you could become the latest "joke" video.
- Start a newsletter about your specialty and keep it going. Invite others to participate.
- Conduct webinars that others will find useful and keep track of those who join. This list can become part of your database of contacts.
- Create products that you can publicize and sell on the web.
- Promote others' products that you think are worthwhile.
- Create interviews of noteworthy industry personalities. Post them with a clear connection to your brand.
- Have someone interview you and post that as well. Make sure you have something to say.
- Create your own trend reports and become an expert in the field.
- Distribute samples of your work in relevant venues.
- Participate in events or conferences where you can speak or at least can be introduced in a way that enhances your brand.
- Do radio interviews or try to become a judge on one of the fashion reality shows.
- Participate in job fairs and share your expertise.
- Organize your own events. These can be panels, lectures, specialty classes, etc. Get to know the movers and shakers in your specific area of expertise!
- Be as generous as possible without giving away the time you need to do good work.

LEAVE-BEHIND PIECE

juliehollingerpascal@gmail.com 123-555-1212

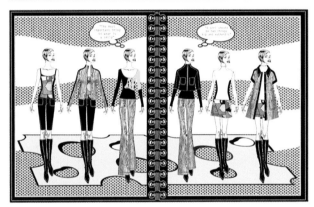

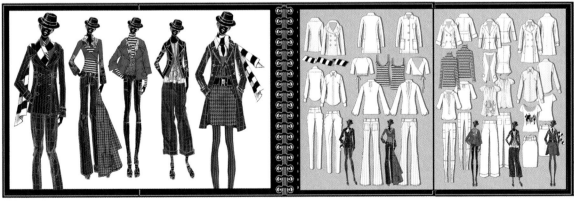

Your Resume and Online Uses

- When you send email to a potential employer, include your resume with your sample groups. You'll also include it on a CD or DVD. Of course, having a personal contact or knowing of a specific hiring opportunity will increase your chance of success.
- With an online digital portfolio, you can include your resume or replace it with short descriptive text and contact information. Some people deal with the resume question by creating a download link to their PDF images. This encourages viewers to find out more about you while your portfolio is still fresh in their minds.
- In some situations, you might want to use the bio plus contact approach. Separating your resume from your portfolio can be useful for confidentiality. If your resume is on a standard Web page, search engines like Google can pull it up. If you are actively looking for a new job while you're still employed or have had issues with a former employer that might come up in an interview, this information might be better left less accessible.
- A resume is best written and designed to be printed and read offline. Anything that will slow a download like placed art will discourage people from accessing it. Better not to use images for your online portfolio or one attached to e-mail.
- Use your name as the file title, not "resume." Otherwise, how will anyone remember to whom your PDF belongs?

Tips for Resume Writers

- Put contact information at the top of your resume. If you have more than one page, put it on both pages.
- Make sure your email address sounds professional, not cute or sexy.
- Include a summary of your qualifications and experience near the top of the resume. This allows busy employers to pick up key words instantly about your background, which may be exactly what they are looking for.
- When you write a job title that you have held, summarize your responsibilities in that position. (This is called a responsibility statement.)
- Begin sentences with active verbs such as *managed, created, designed,* and so on. Avoid pronouns like *I, we, us, they,* etc.
- Avoid abbreviations, acronyms, and industry jargon. If you must use an acronym, spell the words out, then place the acronym in parentheses; for example, *Computer-Aided Design (CAD).*
- Be willing to revise your resume until it is exactly what you want. It is too important to trust a first draft as the ultimate product.
- You do not need to mention or include references in a resume or personal information like age, marital status, children, and so on.
- Numbers one through nine can be written out. Numbers 10 and up can be written numerically.
- Use words that target the fashion profession rather than your previous job experiences.

Common Mistakes

Remember, your resume is the first impression a future employer may have of you. It serves as your sales kit, business card, and friendly reminder of who you are and what you have to offer. So spend the time to make it right. Want to make a poor written impression? Here's how:

Poor Spelling In the age of spell check, there is no excuse for misspelled words. They tell people that you are sloppy. Spell check even if you think you are good at spelling. Everyone spells some words incorrectly, and everyone makes typographical errors.

Bad Grammar If you don't spell well, chances are your grammar isn't perfect either. Grammatical errors are trickier to catch than spelling errors. Microsoft Word does a pretty good job of preventing the worst grammatical goofs. If you don't mind interruptions as you work, set Word to prompt you. To do this, go to File>Preferences (Windows and Mac Classic OS)/Word> Preferences (Mac OS X). In the dialog box, you can choose to have Word highlight spelling and grammar errors as you type, so you can fix problems as they arise.

Fractured Headlines Spell checkers don't check words in all capital letters unless you tell them to. You are less likely to notice mistakes in all cap words because they are usually headlines or captions. Allowing Word to check uppercase words is usually worth the added hassle of false positives.

Photoshop Blind Spots You can type text into every art and design program, but Photoshop and many other design and illustration programs don't have an automatic spell-check function. Write everything in a text program that has a spell-check function and then cut and paste the text into whatever image or development program you're using.

Verbal Overflow Strange but true: People who hate to write almost always write too much once they start. Just as minimalist design is the art of deleting until you get it right, the trick to good writing is good editing.

Too Many *And*'s Don't use the word *and* unless it's in a series of things. *Books, periodicals, and annual reports* is fine. The following sentence is incorrect: *This project was created to serve the needs of the clients who wanted to focus their brand and they planned to use it for future online projects.* It's actually two sentences glued together. Run-on sentences, besides being bad writing, are hard to read and understand onscreen.

Too Much Capitalization Be aware that all-cap words create emphasis. Use them carefully.

RESUME

CHRIS ATWATER

567 Rosewood Lane, Burbank, California 91505, Chris@gmail.com

OBJECTIVE

Entry-level Design Assistant position to allow for growth and experience in the field of fashion design.

PROFILE

Motivated, energetic, passionate about fashion, detail-oriented, extremely
organized. A BFA degree from one of the top fashion schools; graduated with
an excellent GPA, awards from mentors, scholarships, and work-study grants.
Worked with design professionals in two demanding summer internships and in
the school mentor program. Accustomed to working in high-pressure situations and meeting tough deadlines.

SKILLS SUMMARY

- Pattern making
- Presentation boards
- Trims purchasing
- Fabric purchasing
- Proficient in Photoshop and Illustrator
- Screening and hiring models
- Excellent technical flats/specs
- Line sheets
- Fabric treatments
- Dyeing and silk-screening

PROFESSIONAL EXPERIENCE

Communication and technical skills

- Assisted in production of Spring and Fall Fashion Shows for small design house
- Assisted in fittings for shows and for production
- Made appointments and worked with fabric and trim salespeople
- Created complete line sheets for design company for all seasons
- Assisted patternmaker in interpreting designer sketches
- Created press kits for fashion shows, including illustrations and text

Detail mastery and organization

- Organized all fabric swatches and trims in design room
- Created online folders for scanned croquis and flats
- Worked as liaison with production to meet essential deadlines

EMPLOYMENT HISTORY

Rozae Nichols, Los Angeles, CA: Design Intern, Summer 2008–2009, Summer 2010 The Gap, Burbank,
CA: Retail sales, 2006–2007
BJs Restaurant, Burbank, CA: 2005–2006

EDUCATION

Woodbury University, Los Angeles, CA, BFA in Fashion 2011
Los Angeles Valley Community Collage, Van Nuys, CA, 2004–2005

BUSINESS CARDS AND CUSTOM ENVELOPE

Additional Tools to Make an Impression

If you have targeted a particular company, you will want to go the extra mile to make a good and lasting impression. Remember, you are probably competing with others who are doing the same, and a lack of comparable effort can make you look bad.

- Leaving a *stylish business card* with an employer can never hurt. You are demonstrating that your good taste and attention to detail extends beyond just your book or your appearance. Some of our students make wonderful "custom" business cards that are miniature art pieces. Such an approach is more likely to leave a lasting impression than a standard information card from the neighborhood print shop.
- When you write a *thank-you note* on beautiful stationery following the interview, you can include another business card, just in case.
- It also makes sense to create a good *leave-behind image*. Make reduced color copies of one of your best groups to leave with an employer following an interview. If someone is looking at a lot of portfolios, it can be easy to confuse applicants or forget how much they liked a particular book. Resumes are only so much help, because they do not have your picture on them. A beautiful design group image with your contact information can help an employer remember you.

Cover Letters

Although writing cover letters may seem like an intimidating task, an effective letter can get your foot in the door of targeted employers. A note that introduces you and your genuine interest in what they do will make your resume stand out from the crowd. On the other hand, resumes sent without a letter often end up in the trash. Therefore, it is worth your time to learn to write cover letters effectively.

This is not as complicated as it seems. Cover letters, like most business transactions, have a somewhat set formula, which you can personalize with your unique set of circumstances. If you approach the process in a logical manner, you will soon feel like an expert. But understanding the function of the letter is critical. Unlike your resume that lists a lot of facts about you, the cover letter speaks directly to someone at a company and explains exactly why you are contacting that person, what you know about the company, and why you would like to work there, in as brief a manner as possible.

Such a communication creates a critical first impression of you before you ever walk through the door. A good letter can infuse an interviewer with interest to meet you and see if you are as informed and enthusiastic as your prose indicates. Of course you need to project an honest version of yourself; false expectations are impossible to fulfill.

There are three kinds of cover letters that you are likely to write. The first is called an *application letter.* You use this form when you hear of a specific job opportunity and write a letter responding to that information. The second type is called a *prospecting letter.* You write this to inquire of a company about possible positions. The third can be called a *networking letter,* in which you are writing to someone in a position to provide contact information or other guidance that could help you in your job search.

Each kind of cover letter must be formulated specifically for its intended purpose, in addition to being personal to the company or person you are writing to. You want to explain why you are interested in the position and also highlight the skills and experience you have that would most appeal to that employer.

SAMPLE APPLICATION LETTER

July 2, 2012

Director of Personnel
Parallel Designs
578 Broadway
LA, CA 90007

Dear Mr. or Ms. [Contact Name],

I am responding to your recent ad in *Apparel News* requesting applications for an entry-level design position in your company. Because I am very familiar with your wonderful organic clothing and Parallel's enlightened design philosophy, I am extremely interested in interviewing for the job. Given my education and work experience, I think I would be an ideal candidate. Having recently graduated from [your school], I have had four years of rigorous and extensive training. My design mentors included some illustrious people in the field and my projects related to environmental concerns as well as marketable contemporary separates. [Name] awarded my design with his silver thimble. I also had the opportunity to intern for [design firm] and functioned as [your job description] for two summers. Such experience allows me to approach my career with confidence, knowing that my employers felt my contribution was invaluable. Although they offered further employment opportunities, my ambitions lead me to Los Angeles to work for a company like Parallel whose principles reflect my own values.

 I would very much like to have the opportunity to discuss with you my interest in your company and my potential contributions. My resume is enclosed. I will be in Los Angeles next week and could be available for an interview until the end of the month. You can contact me at [your information]. Of course, references can be furnished upon your request. Thank you for your consideration and I look forward to hearing from you soon.

Sincerely,

Janine Gower

SAMPLE NETWORKING LETTER

November 2, 2012

Ms. Tilda Twining
Design Director
Lucky Clothing
550 7th Avenue
NY, NY 10007

Dear Ms. Twining,

I am a recent graduate of [your school] in Los Angeles. I am writing to you at the suggestion of my design instructor, Edward Canton, who worked for your company for a number of years. Having had the privilege of interacting with him on several design projects, I have found his encouragement about my work and future goals extremely helpful. Knowing I have lived solely in Los Angeles but want to work in New York, he thought that you might be willing to meet with me, however briefly, and advise me about the current industry there and how I might best approach finding the right entry-level position for my skill set and interests. I am enclosing my resume for your reference.

 Although I certainly understand that you have a very busy schedule, your guidance would be much appreciated and would help me find my career path. Your own illustrious career speaks to your ability to navigate the field with consummate professionalism. I will be in town next week and will call your office for an appointment at your earliest convenience. I promise not to take too much of your time, and I certainly look forward to meeting you.

Sincerely,

Joe Turner

[Your contact information]

A networking letter like the one above can also lead to job offers. Ms. Twining may be impressed enough with this young man and his connection to her former colleague that she hires him herself. The more people you meet, the more opportunities you will find, so don't be shy, and don't hesitate to ask people if they know anyone who might want to hire you. But don't take it personally if they say no.

 A prospecting letter is similar to the previous samples, but more direct. "I would like to work for your company because [reasons] and I am wondering if you have any postions available."

More Cover Letter Tips

- **Write to a person.** Find the name of the person who has the power to hire you. This is not likely to be someone in Human Resources, although you may send that department a copy of your letter. Form letters indicate that you are mass-mailing and are too lazy to research for the right person. Form letters also prevent you from following up. Chances are it will end up in the trash.

- **Have a focus and a point.** Answer these basic questions: (a) What can you do for the company? (b) What is your current situation? (c) Why do you want to work for this company? and (d) Why are you qualified for this position? You are not ready to apply for a job at the company unless you can answer these questions.

- **Keep it short and sweet.** A few paragraphs with short, direct sentences are enough. Too many letters have long, rambling sentences that are hard to read. Use bullet points where possible.

- **Write it as you would say it.** Avoid overly formal language. Keep it conversational.

- **Communicate positive energy and personality.** Let glimpses of your style come through. Employers hire not only for skills but also for likeability and "fit" with the culture. They want an employee who is thrilled to work for them.

- **Commit to follow up.** Follow the Golden Rule of cover letters: If you don't plan to follow up, don't waste the postage. Your career simply isn't that important to other people. They may mean to contact you but have other, more pressing priorities.

- **Don't restate the resume:** Summarize, explain, expand, or reposition your skills. Answer the unspoken questions. Your resume and history may induce puzzling questions or issues that cause employers to think twice about hiring you. ("How did an art history major end up working for a design company doing production?") Use the cover letter to reassure the employer that you have a plan for your career. Example: "While I've enjoyed the past four years doing freelance design, I've missed the camaraderie and pride that comes from working for a team-oriented company."

- **Eliminate excessive use of *I, me,* and *mine.*** After writing the first draft, count the occurrences of the words *I, me,* or *mine.* Rewrite to eliminate most of those words. For example, change "I bring nine years of accessory design experience" to "You'll get an employee with in-depth experience in team work and new product development."

Winning the Interview

What do you suppose we mean, *winning* the interview? Can you be a winner only if you get the job? Or are you a winner if you get through the process with flying colors, even if someone else ultimately gets the position? We believe the latter is correct. Interviewing is an important game that you can learn to play well. You can even have fun if you view it as an interesting exercise. Taking the time to study the game plan and practice your moves makes sense. If you don't blow your interviews by being too shy, too loud, or too aggressive, chances are you are going to walk into the right interview one day and do all the right things, and they are going to hire you. That is a great feeling!

So, what are the right moves?

1. **Stay cool and calm.** Even if your stomach is turning flip-flops, no one has to know. If you have rehearsed what you want to say, smile, and speak slowly and clearly, you can probably pull off a great interview.
2. **Do your homework.** If you research the company before your interview, you can answer confidently when they ask why you want to work for them, which they will do if they're smart. Come up with an answer that is true, so you can be sincere when you say it.
3. **Be positive, but don't overdo it.** If you come on too strong with positive statement after positive statement, they may start to doubt your sincerity. Let them tell you some of the good things about the firm.
4. **Shake hands firmly and look them in the eye.** Even if you are very shy, you can practice these two things until you're reasonably comfortable.
5. **Rehearse.** (No, really.) Get someone you trust to practice with you, preferably someone who understands the process. Have your partner ask you some of the common questions below, and be prepared to answer all of them. Practice showing your portfolio, going through all the pages, and plan what you want to say. If you say something that is especially effective, write it down.
6. **Be on time.** This is critical, and will continue to be critical if you get the job. So get a watch, buy an alarm clock (or two) and leave much earlier than you think you should. Many talented people lose good opportunities because they are chronically late.
7. **Don't try to be funny.** You can be subtly witty if that is your strength, but generally people want to know that you will take the job seriously.
8. **Don't talk too much.** When people are nervous, they often talk incessantly.
9. **Say something smart.** Even if you have a strong accent, speak up and let them know you have opinions. Be prepared with a short anecdote about yourself that shows your strengths.
10. **Dress for success.** See the facing page.
11. Bring a fact sheet in case you need to give them references or former job information.

Commonly Asked Interview Questions

1. What is your ultimate career goal?
2. Why should we hire you rather than someone else?
3. What do you know about our company?
4. What can you do for this company that no one else can?
5. Why did you choose the fashion industry?
6. How well do you deal with pressure?
7. What is your best quality? Your worst?
8. Where do you expect to be five years from now?
9. Are you willing to travel in this job?
10. Are you willing to relocate for this job?
11. How long would you plan to stay with our company?
12. Which of your accomplishments are you proudest of?
13. Can we contact your references before we make you a job offer?
14. Can you describe a situation in which you solved a difficult problem?
15. Is there anything else you would like to tell me about yourself?
16. What motivates you?
17. Are you prepared to work overtime? How much? On weekends?
18. Why do you want this job?
19. If you disagreed with your supervisor, how would you handle it?
20. Do you prefer to work, as a team, or on your own?

Be prepared with a business card and a well-written resume.

Dressing for the Interview

You're a designer, so this is pretty important. You want to have the right image for the job. But you don't have a lot of money to buy expensive designer clothes, so now you are worried. Looking just right for an interview can be a stressful exercise. Here are some ideas to make it easier.

Note the balance between solids and patterns and the way everything works together in this attractive closet image. You can design and merchandise your own closet just as you would a group for your portfolio. It pays to keep editing out things that don't really work so you can easily find the things that do!

GoodMood Photo/Shutterstock.com

Things to Consider

1. Relax. No one expects a person applying for an entry-level job to have expensive clothes.
2. On the other hand, especially at a cutting edge company, an interviewer will expect you to have a look and a style that says you care about clothes.
3. You can show you follow fashion by wearing a current trend. For example, if polka dots are big, you might buy a cute blouse with polka dots and also wear cute, cutting-edge shoes. The rest of your outfit could go more classic so you don't look like a fashion victim.
4. Don't walk in covered with designer logos, even if you can afford Gucci and Chanel. You will just look like you're insecure and trying too hard.
5. Well-chosen vintage pieces look great on young people, and can be bought for reasonable prices. This is another way to show your discriminating taste and ability to go outside the retail box.
6. You want to look fashionable but not over the top. Avoid anything too revealing, too skin-tight, too loud, or costumy. Don't wear a mini-skirt that you can't sit down in. Look tasteful, not overtly sexy. You don't want to send the wrong message.
7. Well-made tailored pieces are always good business attire, but take care not to look too basic and conservative. Have a little fun with your dress and accessories.
8. Gear your outfit to the company you are interviewing for. If it is a jean company, for example, it would be okay to wear a great-looking pair of fashion jeans.
9. Organize your closet. See what goes well together and plan your interview outfits. You may have to go back to a company several times before they hire you, so be prepared with some different looks. A relatively small investment in current accessories or a well-cut trouser can be a smart move. Your parents may be happy to help if they believe it can get you a job.

The Experienced Designer

If you have been working in the industry for a while, your situation is different from that of someone who is trying to land a first job. One of the first things potential employers may ask you is, "Why did you leave your last job?" They may also want to know why you left the one before that. Many designers move quickly from job to job, and this resume naturally makes employers wary. The truth is, though, that moving to a new job is often how designers make better salaries. If a company is "stealing" you away, it is generally compelled to pay you more than your last position.

There are some things about the industry that young designers should know before they get jobs. Every company is different, but it is fair to say that you will run into one or more of the situations mentioned below if you work for a while in fashion. Be aware that you are building not just a career but also a reputation that will follow you all the way to retirement, so you want to be not only prepared but also thoughtful about how you will handle certain situations when they arise.

Things to Consider

1. Try to stay at a job as long as you are learning something, even if it's not your ultimate position. One year is really the shortest time you should stay. Otherwise you may look a bit flaky.
2. If you feel you aren't learning anything at your job, be proactive. See if your boss will let you take on a new project or move to another division. You never know what a change can do.
3. Very few designers make much money in the beginning of their careers. One of the ways salaries increase is by changing jobs. A new employer who wants to hire you away is likely to offer more money. But jumping too often can, as we have said, create a negative reputation.
4. Working conditions vary quite a bit, and they can be pretty bad in some places. If you are learning a lot, you may be willing to put up with sub-par conditions, but don't do anything that will endanger your health.
5. You may work very long hours with few or no breaks. If you love what you're doing, that should be okay, but be prepared to devote yourself to your career, at least until you have reached a level where you feel more secure.
6. The creative part of your work often takes second place to what can be the tedious side of the business: endless meetings and a lot of red tape. You need to work to maintain your enthusiasm and passion. Becoming negative or cynical will only make you more expendable.
7. There is a lot of competition for the good jobs. Even when you have a job, someone may be "plotting" to replace you. Most creative fields are like this, because creative people don't want to end up filing or answering phones.
8. Some companies foster an atmosphere of competition because they think their employees will work harder. You may or may not thrive in such an environment.
9. If you can see your way to being supportive and positive to other people, you may get support back in kind. It's worth a try. Teamwork generally produces better results than individuals working only for themselves.
10. Some design company owners are happy to change designers regularly, with the idea that their company will have a fresh look every season. If you find you are in that kind of company, learn what you can, but be ready to move on.

When You Are Ready to Start Your Own Business

Many books are written, classes taught, and organizations formed just to help entrepreneurs start their own businesses. We cannot give you all the advice and knowledge you will need when and if you are ready to venture out on your own. We can offer some ideas to help you begin:

1. Make a business plan. The Web has plenty of advice about how to do this; ideally, you want to find material specifically geared to fashion. Include your goals, both the more realistic and the big dreams.
2. Research your area of business. Know who your competition is and what they do that you would emulate and what you want to do differently.
3. Make an outline. Have a big picture plan. What do you want to see at the end of the year? In five years?
4. Find an experienced fashion person who can advise you, and show him or her your plan. Don't avoid the hard truth if your plan seems unrealistic, but get a second opinion.
5. Consider a partner who knows the business end. If you want to focus on the creative aspects, you need someone who loves the "dollars-and-cents" side of things. Make sure it is someone you can trust.
6. Think about employee issues. What is realistic? If you hire an employee, that person is counting on you for a paycheck. You may want to start on a freelance basis and see how things go.
7. What about investors? Would it be better to stay independent, or will you run out of money before you really get established? Sometimes you have to pay your expenses before you make any profits, so you need to have some cash flow.

Building Your Own Business

Market Research

You need to research in an organized manner. Certain questions should be answered before you ever start building your business:

1. Who is your target customer? Be specific.
2. What other companies are doing something similar? How will you be different?
3. Who is the most cutting-edge among your competition? The most commercial? How will you position yourself in relation to them?
4. How can you create an advantage for your company? How do the other companies market their products? Can you do it better, more, and so on? Make sure you budget time for the sales aspect of your business.
5. What level of quality does your competition offer? Will your product be better? Does that mean more expensive?
6. How much time will it take to produce your product? Do you have an advantage if the competition is producing overseas?

Financial Planning

1. Ask yourself if you realistically have the funds to start a business. Can you start very small and grow, or do you need more cash right now? Putting everything on a credit card can quickly get you into financial difficulty. It's better to wait a bit and see if you can find an investor or save more money first.
2. It will be easier to get noticed and build a customer base if you put quality over quantity. There are plenty of cheap goods out there, and you probably cannot compete with the cheapest because they are mass-produced.
3. You can sell in a number of places, both retail and online. Explore as many avenues as you can, but don't spread yourself too thin. Make sure you can fill your orders or people will be angry.

Relationships

1. These are key to success. Network, find people with similar goals that you might work with, and find people who might want to help. Check out fashion shows, art shows, fundraisers, and so on.
2. Be more social with the right people. A conversation is good, a drink or meal together is better. If they can help you, then you should pay.
3. Don't stop once you get established. You need to keep building new relationships to grow and branch out. Get involved with people who can help you move to the next level.
4. Be honest and keep your word. Your reputation is everything.

Organizing

1. Create systems for inventory, for vendors, for e-mail contacts, and so on.
2. Learn to use Excel so you can keep good records.
3. Think carefully about things like packaging, hang tags, and labels. Build your brand with a clear concept in mind.

MEN'S CASUAL JACKET
STYLE # 346
NYLON AND MESH

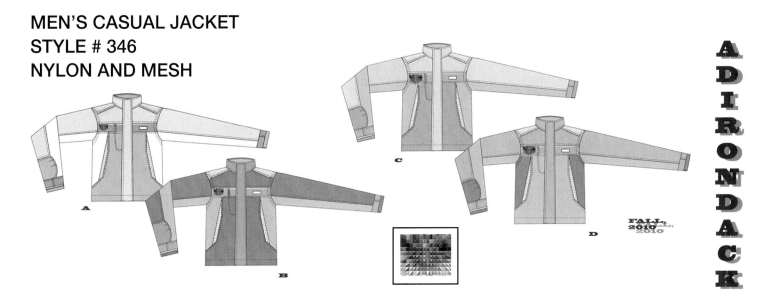

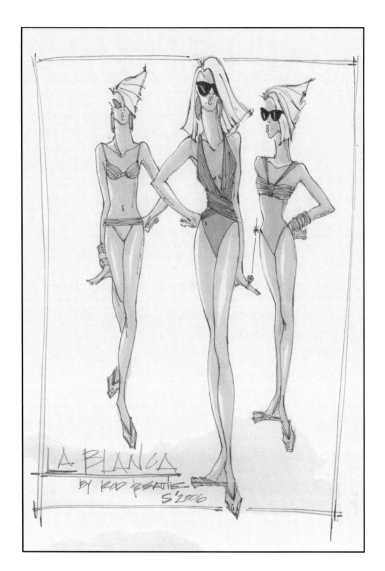

Designer: Rod Beattie

As a California native and experienced swimwear designer, Rod Beattie definitely has something to say about what women wear in and near the water. His designs reflect a modern point of view resulting in styles that are chic and sophisticated while remaining wearable. "I'm not a big fan of retro and don't enjoy recycling the past. I believe in experimenting with a new leg line, a different strap, a modern color combination," says Beattie.

Rod began his career in fashion at several contemporary sportswear houses in Los Angeles, including Theodore and Max Studio, before making the switch to swimwear in 1988. As designer for La Blanca swimwear, Beattie quickly grew the women's swimwear line to a volume of about $30 million. After six successful years with La Blanca, Beattie moved on to design for Anne Cole Collection swimwear. His clean design aesthetic and skill for exceptional fit was a perfect match for the collection's reputation for tailored women's swimwear. In March 1999, Beattie left Anne Cole Collection and returned to La Blanca as head designer with his name on the label. For over a decade, La Blanca by Rod Beattie was the top-selling swimwear label at better retail outlets throughout America. At the end of 2010, Beattie joined forces with venerable swimwear manufacturer A.H. Schreiber to build the next major swimwear brand. Bleu/Rod Beattie launched in Summer 2011.

Press Packets

Suppose you are in the enviable position of designer Rod Beattie, known as America's number-one swimsuit designer. You will likely need a press packet to help generate publicity for your exciting new line. Even if you are just getting started, you may be able to connect with the press, so it's worthwhile to check out Rod's professional approach to this key calling card.

The first thing you'll need is at least one eye-catching image. Rod still can do a mean illustration, so he has included one of his own croquis drawings in the packet, as shown above. Second is a flattering photo of Rod (at right) with an example of his clean, elegant design work.

Third is a well-written blurb that tells all about Rod, his relevant work history, and his business venture, with an ecstatic quote from his new boss. (See the following page for a great example.) Together it makes an impressive and newsworthy package.

Design Point of View

A modern design aesthetic with clean contemporary lines, brilliant saturated color and a bold graphic approach.

Contemporary swimwear with roots in Southern California's sun-drenched environment, bold prints and bright color palette.

Consumer Profile

The Bleu/Rod Beattie customer is a modern woman of any age (core group is 25 to 55). She is confident and independent in today's fast-paced world. She is strong, sensual and modern, with great fashion sense. She shops better department stores and specialty stores (including catalogs and online) looking for contemporary swimwear of the highest quality and best fit. She loves travel and frequents spas and resorts. A wardrobe of swimsuits – from bikinis to tankinis to maillots plus cover-ups – is a must for her active lifestyle.

The word *missy* is not in Beattie's vocabulary. And he hopes it is soon banished altogether from the swimwear industry. "I know many chic women of all ages, and not one considers herself to be *missy* (updated or not!)"

Vision for the Future

Use technological advances in fabrication and production to create sleek, sexy, contemporary swimwear for a worldwide customer base.

Designer Background

Over twenty years in swimwear design, and a record number of retail best-sellers (according to the NPD Report), have earned Beattie the title "America's #1 Swimsuit Designer." Beattie recently left swimwear maker Apparel Ventures Inc. where he had designed the successful La Blanca swimwear collection for seventeen years. From 1994 until 1999, Beattie designed swimwear for top swimwear label Anne Cole Collection, at that time a division of Warnaco. At the end of 2010, Beattie joined forces with venerable swimwear manufacturer, A.H. Schreiber to build the next major brand in swimwear. A new contemporary designer label, Bleu/Rod Beattie is currently in the works and will debut in mid-2011. Beattie lives and works in Southern California.

Questions Interviewers Might Ask If You Are Changing Jobs

If you are moving from one company to another, the questions are likely to be different. Employers want to know that you are not a troublemaker and that you have a positive attitude even though you may have had some difficult times in your jobs.

1. **What do you think of your last boss?**
 Be careful about saying anything too negative about your former boss. The interviewer might not want to think you would be talking about him or her that way at a future date. *You can say that you have a different philosophy that matches better with the company you are interviewing with.*

2. **Why haven't you found a new job yet?**
 Again, be positive. You can say that you want to work for a really creative company (larger or smaller, more team-oriented, whatever suits the bill) like this one, so you have waited to get the right position.

3. **How long do you think you will stay with our company?**
 You might say "I generally plan to stay in a position for at least two to five years." You are not promising, but this would reassure them that you aren't just biding time until something better comes along.

4. **Have you had any recent job offers? Why did you turn them down?**
 It may be tempting to make something up, but tell the truth. Fashion is a small world, so inventing fake employers is not a good strategy. If you did turn down a job, again make it a positive about the company where you want to work.

5. **Can we contact your references before we make you a job offer?**
 If you are in a job, it is perfectly acceptable to say no if your references are your present employers. If you can provide a reference from someone who won't care if you're changing jobs, do so.

6. **Can you describe a situation where your work was criticized?**
 Again, be as honest as you can and still put a positive spin on things. You want to show that you are not threatened by criticism, and that you are proactive in finding a good solution to improving your work.

7. **Would you accept a job for less money than you earned before?**
 If you would, then say why: an opportunity to learn, a downturn in the economy, etc. If you wouldn't, say so.

8. **What in your past job or jobs did you like the most? Why?**
 If you have left this job, you may not have a lot that is positive to say, but it is better to talk about something you learned, or a helpful colleague. This shows you find the positive in any situation and learn from it.

9. **What in your past job or jobs did you dislike the most? Why?**
 Be careful not to sound too complaining or negative. If you know the negative situation is different at the company you are interviewing for, that is a good opportunity to show off your knowledge. For example, "I am really interested in working with China, and I never had that opportunity at my other job. I know that would be a key part of the job at your company."

10. **Would you prefer to be a leader or a follower?**
 Be careful about presenting either case too strongly, because even if you want to be a leader, you may have to start out as a follower.

11. **If you disagree with your manager or supervisor, how would you handle it?**
 Use this to show you are reasonable and always keep things on a professional level.

12. **Would you be willing to take a drug test or polygraph (lie detector) test?**
 The more open you can be, the better off you are. Have a clean conscience and you won't have to worry!

nurit yeshurun

323·xxx xx12 nuritnurit@xxxx.com xxx xxxx role st brooklyn, ny. 11206

work experience

converse by john varvatos, ny april 2008- present
men's woven's designer
-design all men's woven shirting, woven bottoms, knit bottoms, denim, accessories
-collaborate and plan color and concept for every season
-style and plan look books for buyers
-execute all tech packs, cad design
-work closely w production team to stay on top of calendar
-team with tech to rework fits to better accommodate our changing customer

calvin klein, better specialty retail, ny june 2007- april 2008
men's knits designer/ cad designer
-design all men's cut and sew knits and graphics, approx. 22% of business
-execute all tech packs, graphic artwork and print design
-collaborate and plan color and concept for every season
-branding/marketing artwork, ie. back neck labels, hang tags, logos
-work closely w tech team, sourcing team, and buyers in all stages of development

american rag cie. (macy's merchandising group), ny july 2006- june 2007
associate designer (all categories)/ graphic designer
-responsible for designing outerwear, woven shirting, woven bottoms, and knits
-graphic/print design
-create tech packs and work closely w tech, and production teams
-maintain constant communication between design and overseas vendors
-approve labdips, trims, strike-offs and manage time in action calendar
-work in fittings to ensure correct design details and newly developed fits are being followed

mens inc. (macy's merchandising group), ny sep 2005- june 2006
assistant knits designer
-design men's cut and sew knits
-lab dip and time in action maintenance
-graphic/print/stripe design
-attend and participate in fittings

mattel, la. ca may 2003- aug 2005
designer
- design clothing and prints for "My Scene" doll line
- trend researching
-work side by side w graphic artists, pattern makers, and marketing

freelance clients, ny 2005- present
- mr. chips- young men's graphic design
- triple five soul- young men's and women's graphic design
- american rag- young men's graphic design
- french connection UK- men's apparel, graphic, and branding design
- ocean pacific- girl's and boy's graphic design

qualifications
- highly skilled in photoshop and illustrator applications along with flex plm, excel, word
- Experienced in both hand and computer aided flat rendering
- Well rounded knowledge in classifications of knits/wovens/outerwear
- Strong graphic and print design skills

achievements
-responsible for doubling sales in less than a year at converse by john varvatos
-responsible for high double digit sell throughs on all categories for American Rag Cie.
-winner of the Council of Fashion Designers of America nationwide design competition (scholarship)
-winner of the Council of Fashion Designers of America and federated nationwide design competition
(job placement)
-3.95 GPA, dean's list, otis college

education
-otis college of art and design bachelor's of fine arts degree-2005

reference
references available upon request

Designer: Caroline Chon

Although Caroline Chon did this photo shoot for the company she was working for, she could just as easily have created this cute presentation material to promote her own brand. (Yes, that is Caroline posing.)

Designer Profile

Caroline interned at Mattel and at Disney, where she continues to freelance. She worked as a designer at Scrapbook/Crafty Couture and fell in love with Hello Kitty. Determined to learn about the licensing world, she got a job at Mighty Fine, the biggest Hello Kitty apparel licensee, as a designer/merchandiser.

She is currently at SMA as a creative director. She designs apparel and graphics and is also the art director for a group of graphic artists.

Advice for future grads

Network. Network. Network. All the jobs I've had came from networking and word of mouth. Be authentic, work hard, have a good attitude, and believe in yourself. Above all else, remember to be happy and have a firm handshake.

Keeping Your Job

Because good jobs are not easy to come by, once you have a job, you want to hang on to it until you are ready to leave. You can make yourself a valuable employee who not only stays in the job, but gets raises and promotions as well. Here are twenty tips you may find helpful.

1. **Participate in company social activities.** If your boss goes to the trouble and expense to have parties or picnics, you should show appreciation by showing up. If co-workers get the feeling you see yourself as too good to hang out with them, they won't be there to support you in crunch times.
2. **Network, network, network.** Have at least two appointments every week that can pull energy into your company and also provide a safety net for you if things should go wrong. If the people you meet can be helpful to your company, make sure you let your boss know what you are up to. Don't be shy about your ability to make connections.
3. **Manage yourself.** Stay busy and create your own projects when none are assigned. (But be careful about spending unauthorized money.) Being proactive is one of the key ways you can demonstrate your value.
4. **Don't be a maverick.** When economic times are tough, you want to focus on core issues rather than engaging in what could be expensive and unproven strategies.
5. **Create allies within the company.** Scope out the personalities in the company first until you understand the power structure. Choose people you work with who can help you and make them your friends. You can do this by asking and respecting their advice, showing you support their success, and helping them when you can. It's likely they will respond in kind.
6. **Seek mentors.** If you can find a person of influence and experience who will mentor you, this is extremely valuable. Make sure you nurture the relationship and show your appreciation often. If you do not follow your mentor's advice on a key issue, make sure you explain why.
7. **"Size up the culture and show a strong work ethic,"** says Andrew J. DuBrin, a professor of management at the Rochester Institute of Technology in Rochester, N.Y. "Don't walk around saying, 'It's Wednesday—hump day—and Friday will be here soon.'" This will project an immature attitude that encourages people not to take you seriously.
8. **Dress and act in accordance with your company culture.** If you work in a more prim-and-proper environment, don't show up in wild outfits, bragging about your hot date from the night before.
9. **Take pride in your work.** Tossing things together at the last minute and making excuses about your sick mom won't cut it. Don't think you can fool people consistently, because you can't.
10. **Remember it's a job!** Young employees often talk about having "fun" at work. If you love your work, chances are you will enjoy yourself some of the time. But remember you work to make money for the company, not to be entertained.
11. **Observe the protocol of staff and design meetings.** Are they formal or informal? Do co-workers use their laptops and check their phones for text messages, or would that drive the boss nuts? If you're not sure, refrain from both and just listen and contribute.
12. **Admit mistakes.** If you make a mistake, as everyone does at some point, immediately take responsibility. Don't blame someone else, as you'll only be creating an enemy, and the truth will come out. Saying, "I'm sorry. It won't happen again" makes you look both honest and mature.
13. **Leave your personal life at home.** Don't talk constantly about your life outside work. If you are having problems, you may need to confide in your boss so he or she understands, but don't broadcast your issues. If someone confides in you, be discreet. Don't gossip.
14. **Know what's expected.** Make sure you understand the expectations for your position and then follow through. It's possible to fit in and still be yourself.
15. **Money isn't everything.** Don't project the attitude that you only care about the paycheck. You will kill any chance to progress in your career.
16. **Keep up with your deadlines.** Deadlines must be met in the fashion industry, so take them very seriously or you will be gone. Work late and even on weekends if you have to.
17. **Observe cubicle etiquette.** Don't have phone conversations that you don't want everyone to hear. Personal items should be tasteful and mature.
18. **Don't send personal emails at work.** The company's email system is for business. Don't write anything that you don't want your boss to read. Many systems will send all emails to a master file that he or she may peruse.
19. **Don't take credit for other people's work.** This will only come back to haunt you. Give credit where it is due.
20. **Don't get romantically involved with co-workers.** One or both of you will probably lose your job as a result of the inevitable fallout.

CHAPTER SUMMARY

Because designers need to be organized multitaskers, all the skills you have practiced and learned by moving through these chapters will serve you well when you do get that great job in the industry. Preparation is not only the key to creating a great portfolio, but it is also the secret to the entire process of winning and keeping the position you deserve. When you are networking, which is vital these days for any creative career path, you need the tools to impress the right people so they will remember your name. Everything from a well-organized wardrobe to sophisticated business cards and other materials must be well thought out and reflect your professional identity.

Creating your personal brand is a life-long project because you will keep growing. You will develop new aspects to your personality and new skills to add to your career profile. If all goes well, you will also have rewards and public acclaim that ultimately will be part of your presentation. Many portfolios of designers who have been in the field for a decade or more fill up with magazine and newspaper write-ups of their work. But maintaining your ability to create and draw a group of exciting designs should also be a goal. You never know when that dream opportunity will come your way with a company asking you to do something "just for them." You want to seize that opportunity, not shrink from it because you are so out of practice.

You can also stay prepared by constantly "feeding your head" with the latest shows and the best blogs, and by checking out what other designers are doing in the Web marketplace. If you reach the point when you are ready to start your own business, all that research will pay off. But even in a steady job, knowing what is happening is vital. You do not want to be the one who "draws a blank" at the mention of a high-profile name. It is also tempting to just do research on the Web, but getting out to the stores and seeing what is selling, trying on the best new silhouettes, and chatting with the salespeople who see your customers every day is extremely valuable. We all have to work harder these days to stay in touch with the "real world."

Another vital part of your professional practice must be keeping up with technology and the new programs that relate to your part of the industry. Social networking is part of almost any creative job description, and staying in touch with old friends in the business provides a safety net of contacts when you are forced to leave a job. If you start a blog or create a website, then maintenance and updating must become part of your routine.

All these issues reflect the various aspects of your persona that, managed correctly, will make you the consummate professional. This is something you can take pride in and also feel confident that it will all pay off at the bank. Success, though not a guarantee of happiness, is more likely to lead to job satisfaction than continual turnover in your job status. Chances are you also have some student loans to pay off, so some stability is extremely helpful in getting that obligation over with as quickly as possible and moving on with your life.

We sincerely hope this text has been helpful in preparing you for all these challenges, and that you will soon be happily ensconced in a good and creative job that is the beginning of life-long success. Good luck!

DESIGNER: OLA YINKUS

 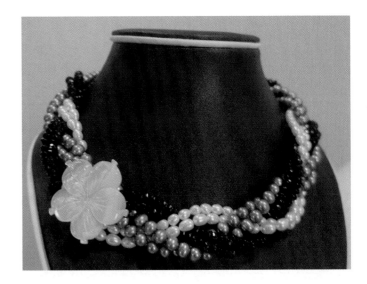

Designer Ola Yinkus creates this beautiful jewelry line and sells it at her own website, http://www.rayosgem.com/

PORTFOLIO
JULIE HOLLINGER

RESUMES and HANDOUTS

KEEP EXTRA RESUMES AND HANDOUTS
IN THE SIDE POCKET

julie hollinger

8811 lowry drive
los angeles, ca. 90027
323-666-8654

juliehollingerpascal@gmail.com

juliehollingerpascal@gmail.com 323-661-9832

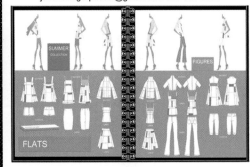

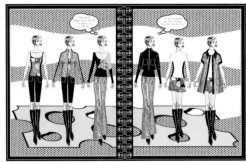

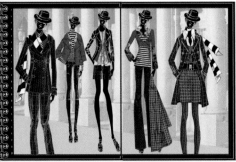

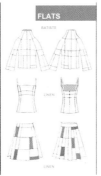

JULIE HOLLINGER

8811 LOWRY DRIVE, LOS ANGELES, CA. 90027 juliehollingerpascal@gmail.com

Objective	Design challenges within a creative environment

Experience

2011-Current Woodbury University
PROFESSOR
* Junior Design Mentor and Senior Portfolio Mentor

1984-2009 Otis College of Art and Design
PROFESSOR
* Full Professor in the fashion design department
* Responsible for the Syllabi for Senior and Junior level classes
* Assisted with the production of the Scholarship Benefit Show

1979-1993 Robes of California
DESIGNER
* Designed and oversaw the development of all products
* Produced quality flat sketches to ensure clear communication
 between design and production
* Collaborated with pattern makers and sample makers on the
 production of all products
* Supervised updating and maintenance of all changes through production
 and communicated with all parties involved
* Organized and oversaw fittings and made notes regarding construction,
 fit, and fabric changes for pattern makers on first through production patterns
* Worked with dye houses, fabric and trim suppliers, and grading houses
 on delivery and quality of products

1979-1981 Chinese Laundry
RETAIL STORE
* Partner in retail store selling vintage military sportswear
* Contributed creative input evenings and weekends

1976-1979 Hollinger/Jones
DESIGNER
* Produced contemporary sportswear collection
* Creative partner in this contemporary business

* *I worked as a full-time designer at Robes and taught at Otis simultaneously.*

Personal Strengths: Organized, hard working, self motivated, conscientious regarding deadlines.

THE CONVERSATION BUBBLE

Pop Art Figure

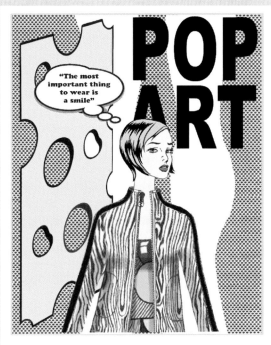

This group is inspired by Lichtenstein's DC Comic Art. I created a figure for this group in the style of his translation of the comic book art. This mood board was created from one of the design illustrations. I added a Pop Art background also reminiscent of Lichtenstein's art, borrowing elements he used in his work.

This group has fully rendered flats that bring the concept to life.

POP ART

INSPIRED BY LICHTENSTEIN

MULTI PRINT

WOOD GRAIN TWILL

SOLID KNITS AND WOVENS

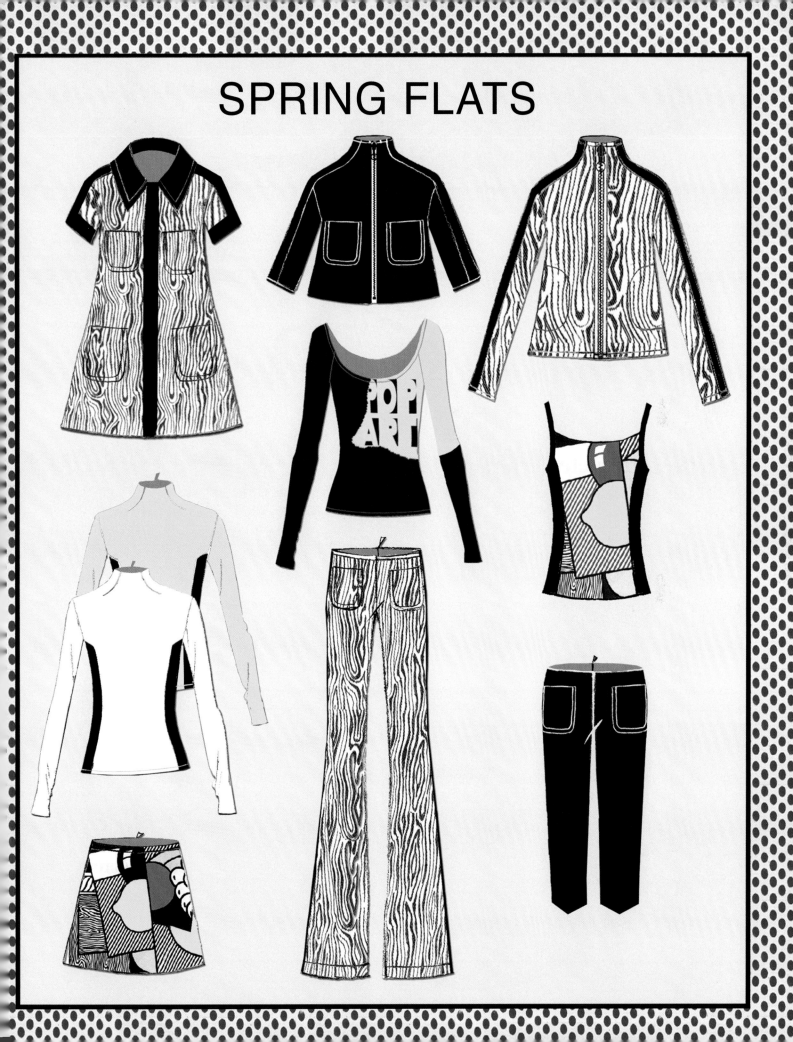

SPRING FLATS

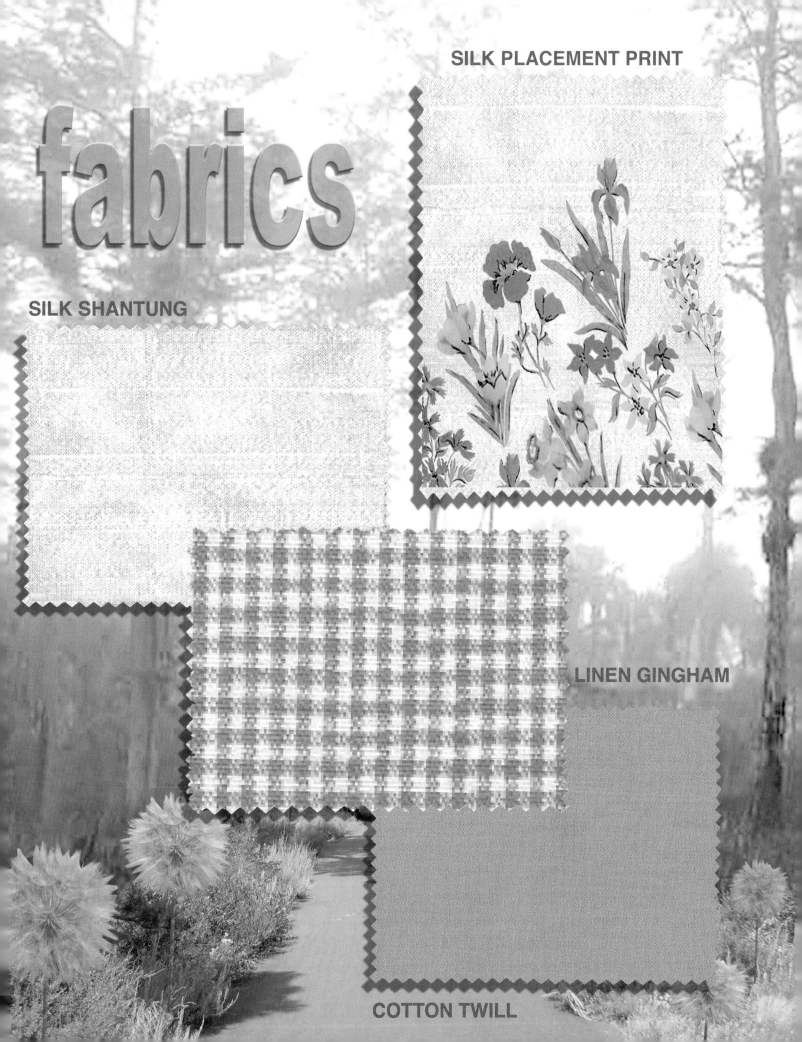

fabrics

SILK PLACEMENT PRINT

SILK SHANTUNG

LINEN GINGHAM

COTTON TWILL

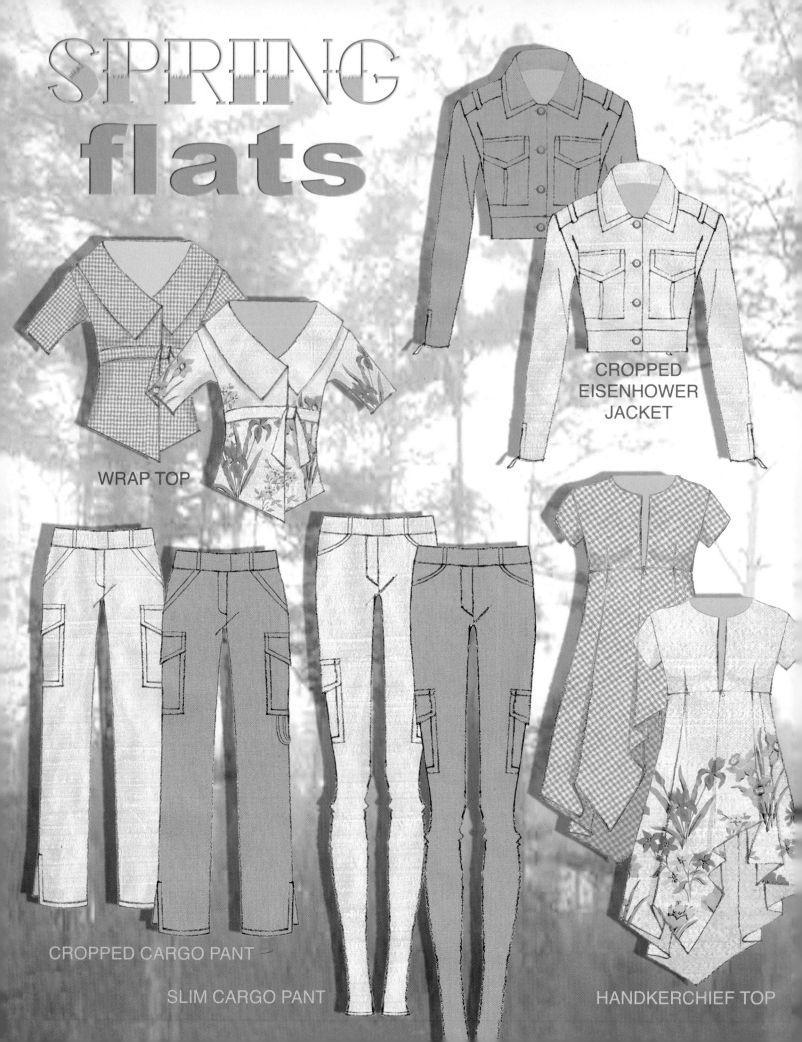

SPRING
flats

WRAP TOP

CROPPED
EISENHOWER
JACKET

CROPPED CARGO PANT

SLIM CARGO PANT

HANDKERCHIEF TOP

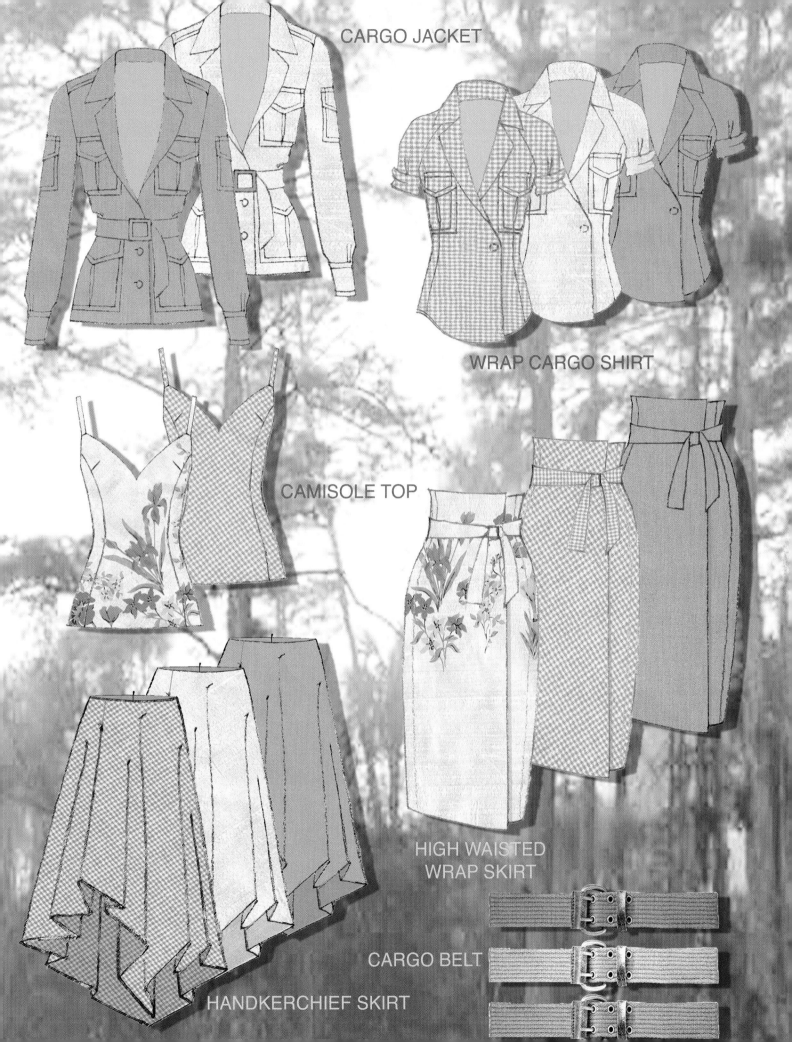

CARGO JACKET

WRAP CARGO SHIRT

CAMISOLE TOP

HIGH WAISTED
WRAP SKIRT

CARGO BELT

HANDKERCHIEF SKIRT

inspiration for spring

spring flowers inspire

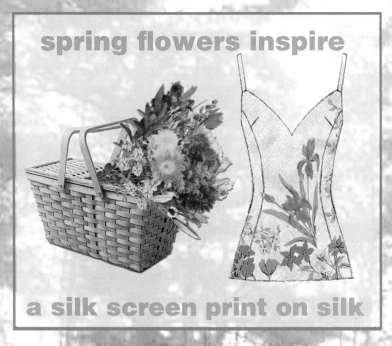

a silk screen print on silk

gingham tablecloth drapes into a skirt

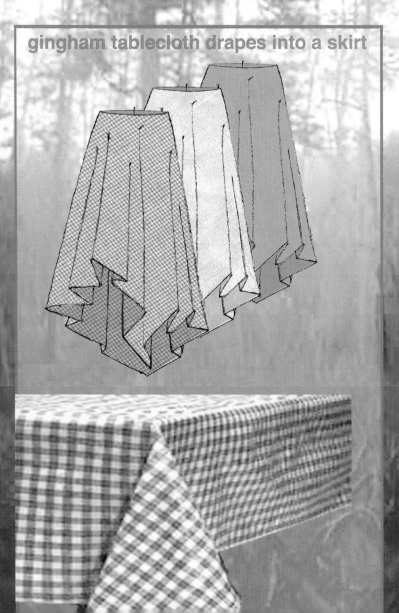

3/4 view figure sets the mood

SUMMER
INSPIRATION

The Eames meadow is a perfect location for a summer garden party.

GARDEN
PARTY

The summer group has two points of focus. One is the fabric treatment and the other is a fun silhouette that allows a breeze to float under and cool the body.

FABRIC TREATMENT

THE FABRIC TREATMENT IS INSPIRED BY THE GEOMETRIC WINDOWS OF THE EAMES HOUSE

A side view is the best pose to show the silhouette. In the summer group I wanted a modern look and also a stylized approach. This gives the group a distinct personality.

INSPIRATION: EAMES CASE STUDYHOUSE

BATISTE LINEN
CANVAS

SUMMER
GARDEN
PARTY

CANVAS

LINEN

**BATISTE
LINEN
CANVAS**

INSPIRATION
FOR THE
**FABRIC
STORY**

BATISTE

SAMPLE OF FABRIC TREATMENT

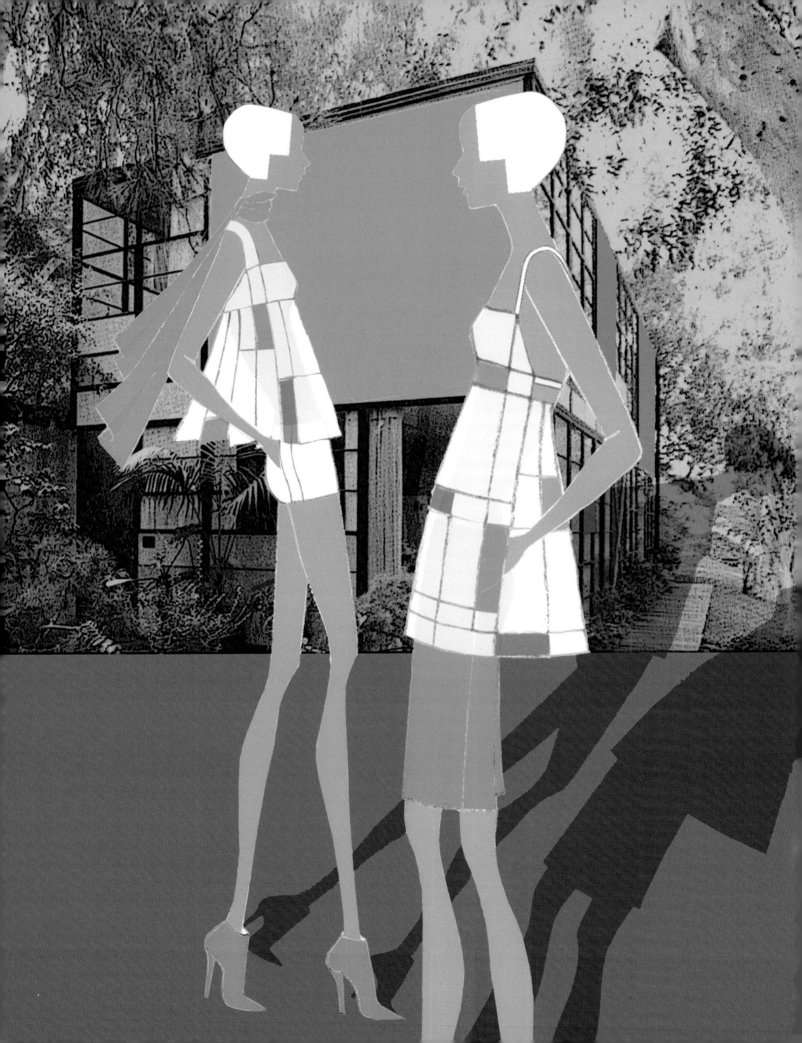

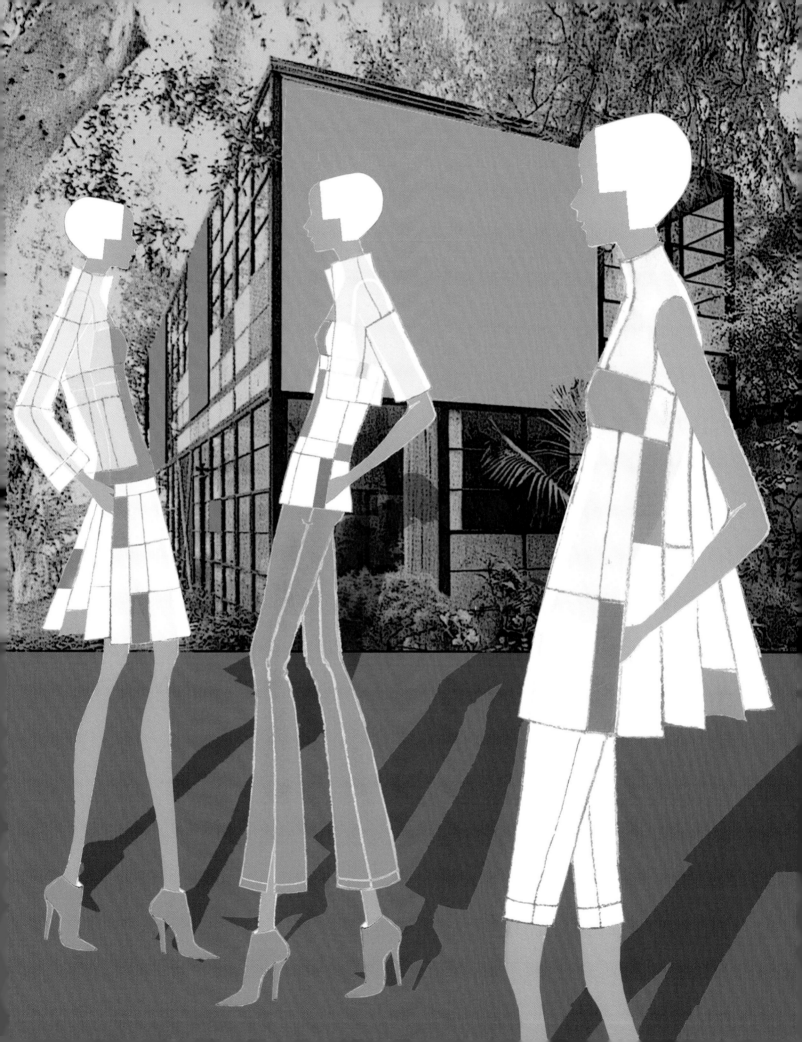

SUMMER
COLLECTION

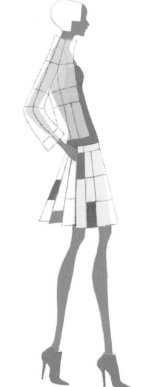

BATISTE

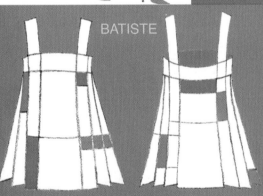

BATISTE

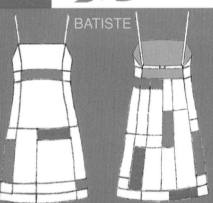

BATISTE

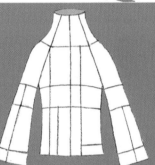

CANVAS

BATISTE SCARF

LINEN

LINEN

FLATS

LINEN

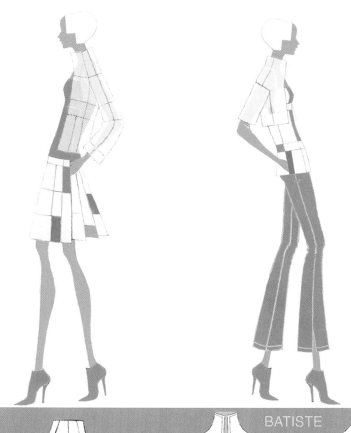

FIGURES

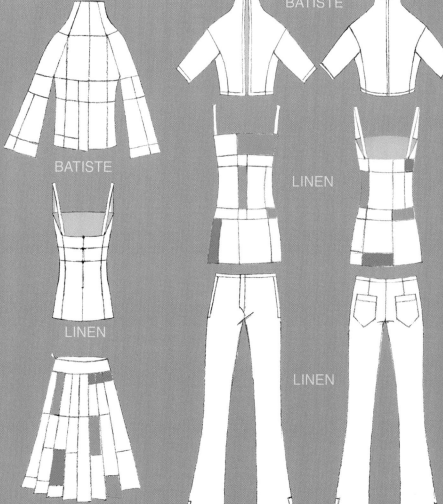

BATISTE

BATISTE

BATISTE

LINEN

LINEN

LINEN

LINEN

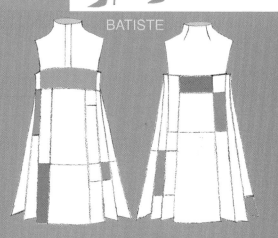

CANVAS

FABRIC STORY

SILK

WOOL PLAID

BLACK DENIM

WOOL HOUNDSTOOTH

COTTON PRINT

STRIPE SHIRTING GRAPHIC

STRIPE KNIT

ALLIGATOR JAQUARD

LEATHER

KNIT PONTE

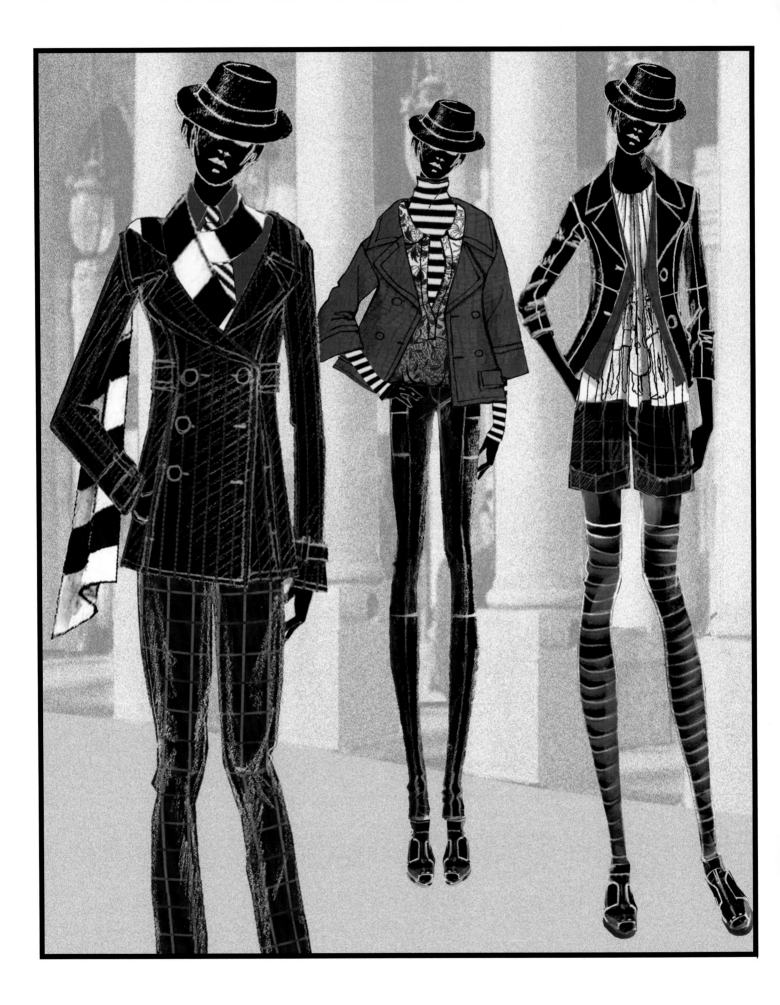

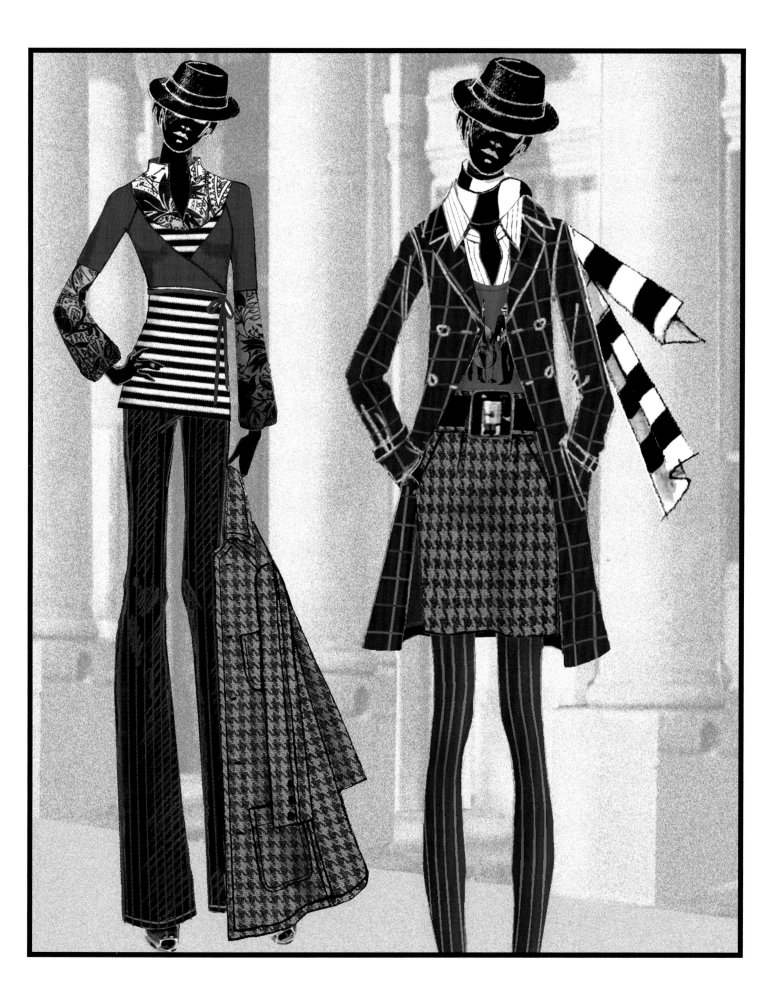

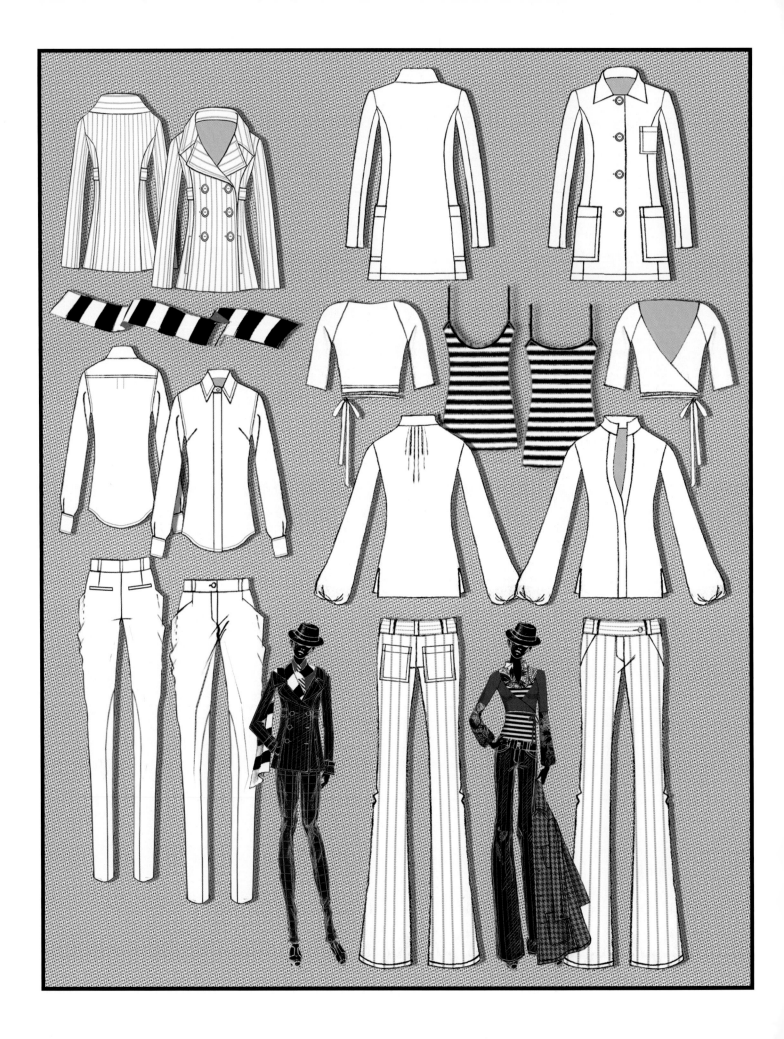

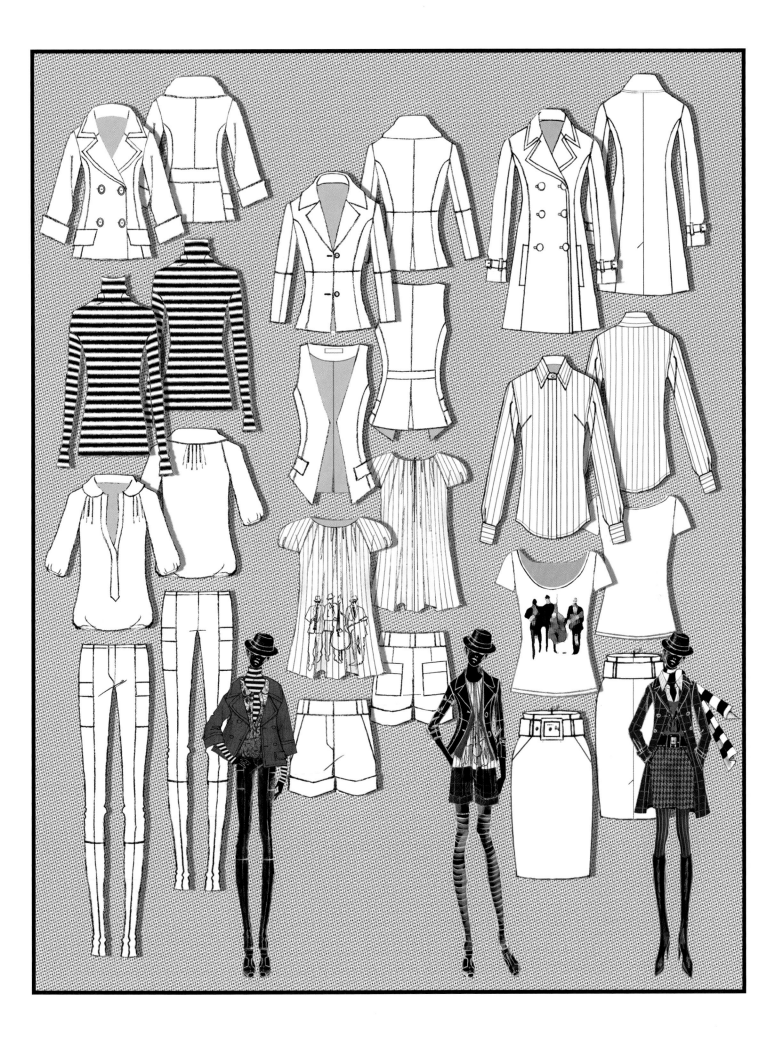

STREET JAZZ PLAYS A FALL BEAT

CONCEPT AND INSPIRATION

STREET
JAZZ IN
NEW
ORLEANS

NAMING
YOUR
FABRICS
GIVES A
FUN MOOD
TO THE
GROUP

jazz trio stripe

ombre trumpet
floral

poor boy
stripe

ew orleans
alligator

undstooth jive

satchmo stripe

FABRIC TREATMENTS,
GRAPHIC STRIPE,
OMBRE OVER DYE PRINT,
STITCHED STRIPE DENIM,
T-SHIRT SILK SCREEN GRAPHIC

GRAPHIC

A SILHOUETTED
FIGURE CREATES
THE LOOK OF
THE GROUP

JAZZ GROUP INSPIRATION

FALL 2

INSPIRATION

TRAVELING TO MAJOR CITIES FOR BUSINESS CLOTHES THAT WILL WORK FOR MEETINGS AND LOOK GREAT FOR DINNER IN THE EVENING.

SHAPE

BODY-CONSCIOUS CLOTHES

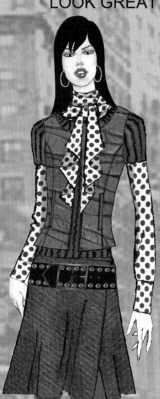

CHINESE KNOT BUTTON

EMBROIDERY ON PINSTRIPE

HAND CROCHET SWEATERS

CUSTOM QUILTING

WARM LAYERS

THE MUSE AND FIGURE FOR THIS GROUP HAS A STRONG CONFIDENT LOOK.

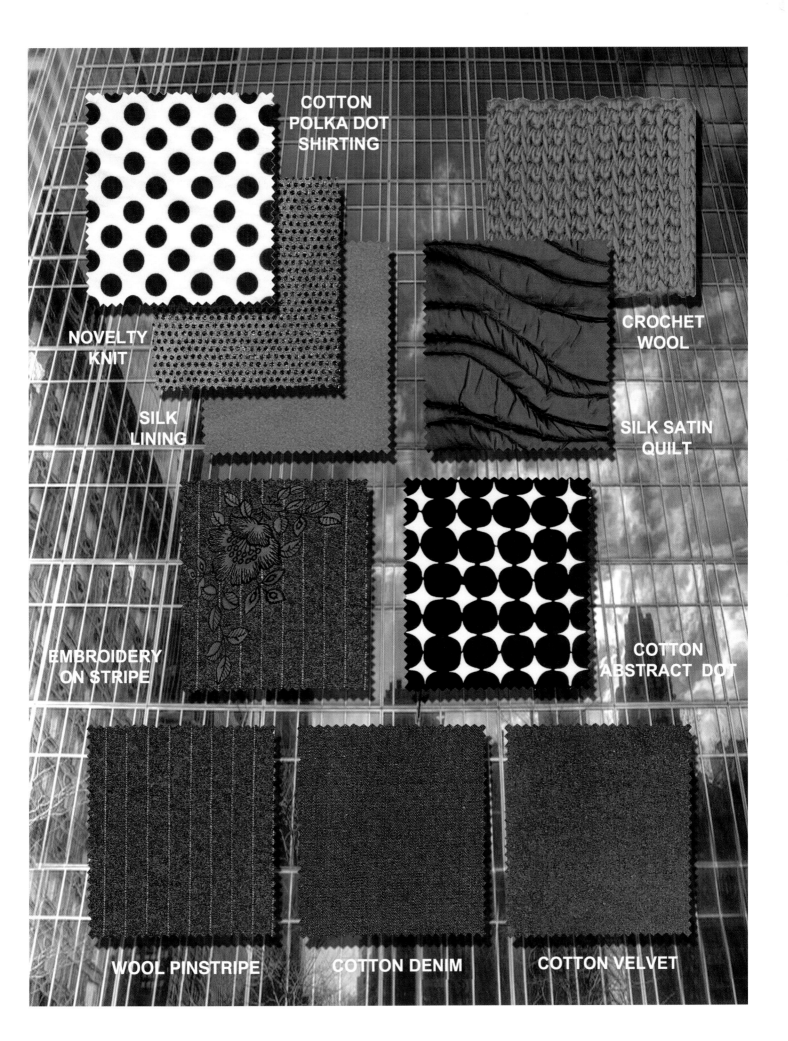

COTTON
POLKA DOT
SHIRTING

CROCHET
WOOL

NOVELTY
KNIT

SILK SATIN
QUILT

SILK
LINING

EMBROIDERY
ON STRIPE

COTTON
ABSTRACT DOT

WOOL PINSTRIPE

COTTON DENIM

COTTON VELVET

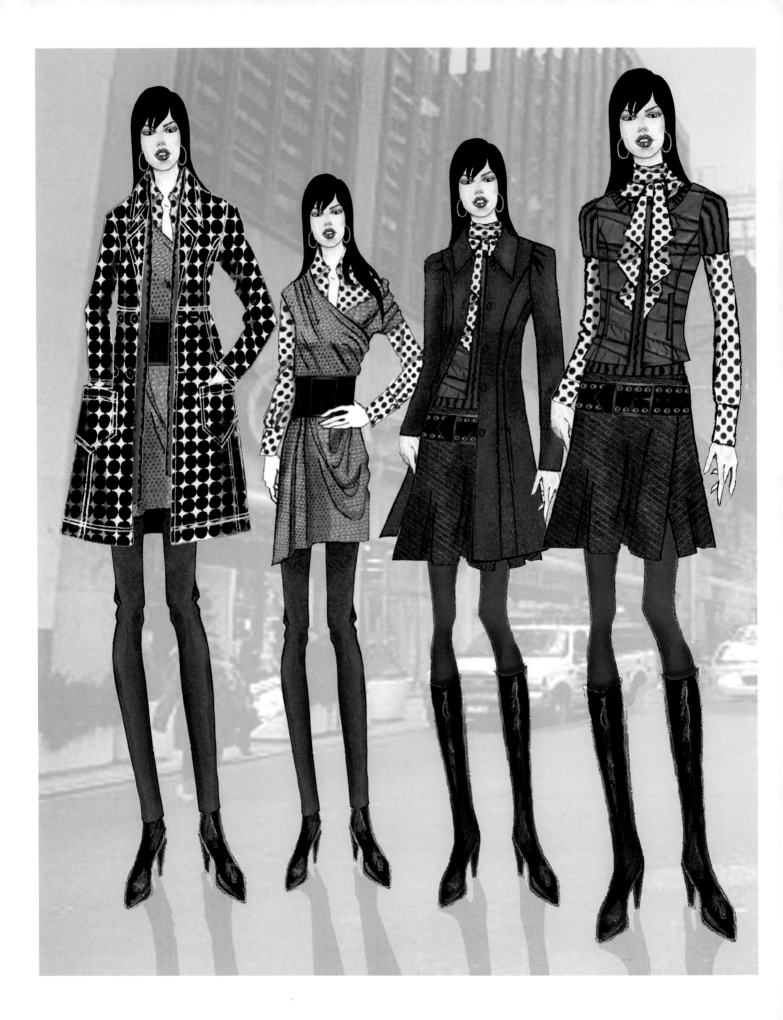

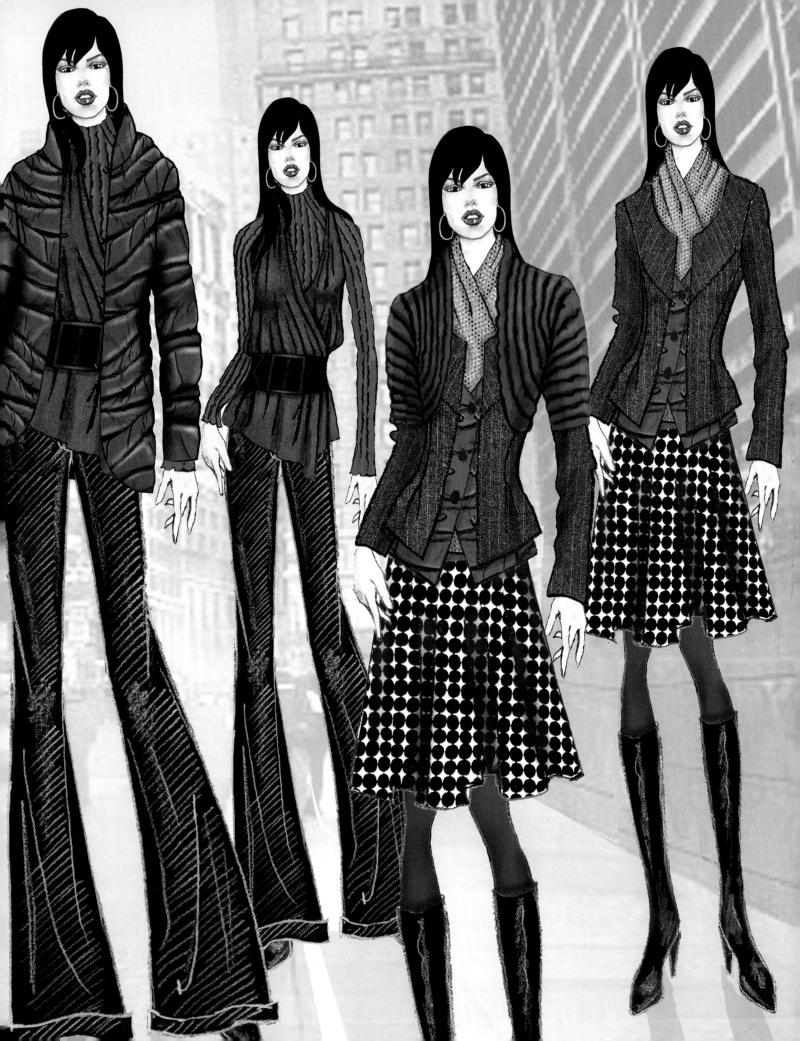

WINTER/FALL 2 FLATS

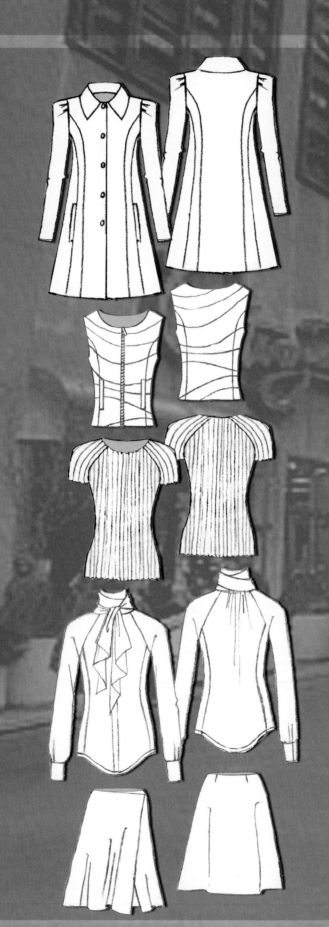
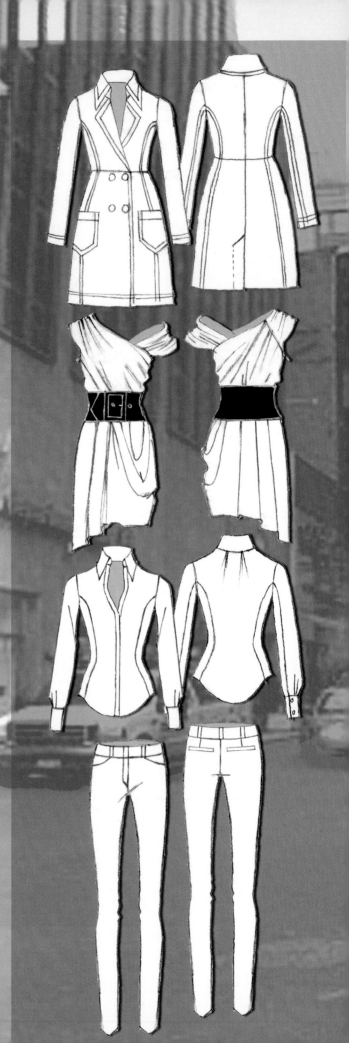

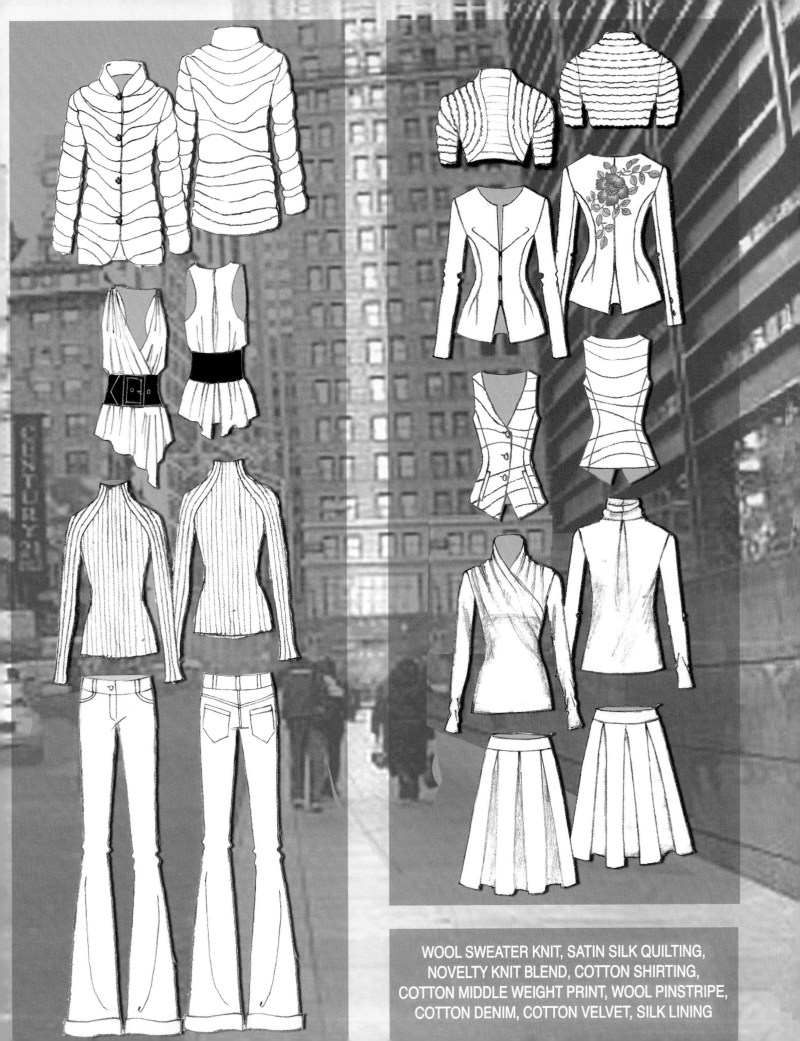

WOOL SWEATER KNIT, SATIN SILK QUILTING,
NOVELTY KNIT BLEND, COTTON SHIRTING,
COTTON MIDDLE WEIGHT PRINT, WOOL PINSTRIPE,
COTTON DENIM, COTTON VELVET, SILK LINING

THANK YOU FOR LOOKING AT MY BOOK.
I LOOK FORWARD TO HEARING FROM YOU.

Index